BREAD, WINE, & MONEY

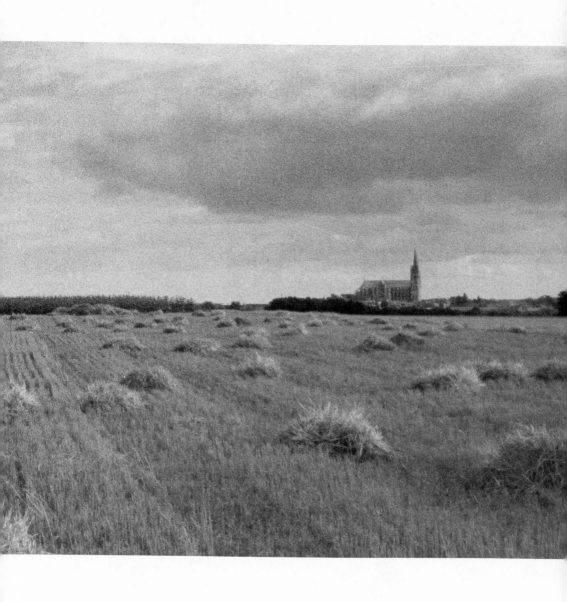

1. View of Chartres (Getty Center for the History of Art and the Humanities)

JANE WELCH WILLIAMS

BREAD, WINE, & MONEY

The Windows of the Trades at Chartres Cathedral

THE UNIVERSITY OF CHICAGO PRESS
CHICAGO AND LONDON

Jane Welch Williams is assistant professor of medieval art history at the University of Arizona.

The University of Chicago Press, Chicago 60637
The University of Chicago Press, Ltd., London
© 1993 by The University of Chicago
All rights reserved. Published 1993
Printed in the United States of America

02 01 00 99 98 97 96 95 94 93 5 4 3 2 1

ISBN (cloth): 0–226–89912–8
ISBN (paper): 0–226–89913–6

Library of Congress Cataloging-in-Publication Data

Williams, Jane Welch.
 Bread, wine & money : the windows of the trades at Chartres
Cathedral / Jane Welch Williams.
 p. cm.
 Includes bibliographical references and index.
 1. Glass painting and staining, Gothic—France—Chartres.
2. Glass staining and painting—France—Chartres. 3. Occupations in
art. 4. Cathédrale de Chartres. I. Title. II. Title: Bread,
wine, and money.
NK5349.C6W55 1993
748.594'51—dc20 92-11269

CONTENTS

ILLUSTRATIONS

(following p. 264)

Color Plates

Black and White Plates

ACKNOWLEDGMENTS

For the conceptual basis of this book, I would like to thank Otto Karl Werckmeister. He suggested the topic to me when I was a graduate student in one of his seminars at the University of California in Los Angeles. He directed my dissertation on the windows of the trades at Chartres Cathedral. He gave me the courage to publish my work as a book. For these reasons, I am happy to dedicate this book to him.

The help and support of many other people and institutions have also contributed to the final product you hold in your hands. I am grateful to the Art Department of UCLA for the Dickson Travel Fellowship which made possible a long research trip in Europe. I am grateful to the National Endowment for the Humanities for a Travel to Collections Grant that made possible the completion of one part of the research. I am especially grateful to the University of Arizona for granting me the subvention that made possible the color plates, without which the argument would be less striking. I am also grateful for travel grants from UCLA, the University of Chicago, the University of Illinois in Champagne-Urbana, the University of British Columbia, and the University of Arizona which have made it possible for me to participate in scholarly conferences, so important to my awareness of progress in the field of study to which I have dedicated the remainder of my life, and to which this book is my first major contribution.

As several of my former colleagues in the graduate program at UCLA have commented recently in the acknowledgments for their books, the excitement about art history engendered there in the 1970s and 1980s was uniquely motivating. I will always be indebted to the students and faculty for their friendship and for the challenge of their minds. Amongst the friends I cherish, I would like to thank Barbara and R'afat

Abou-El-Haj, Ruth Klein, Hélène Setlak-Garrison, Carol Knicely, Serge Guilbaut, Tom Cummins, Holly Clayson, Kathleen Corrigan, and Joan Weinstein. Amongst the faculty, I would like to thank Arnold Rubin, Robert L. Benson, Susan B. Downey, Iloi Kalavrezou-Maxeiner, Nicos Hadjinicolaou, and Richard H. Rouse.

Since I began teaching, I have been lucky to have the encouragement and advice of many colleagues, all of whom I would also like to thank. I should mention especially Meredith Lillich, Sandra Hindman, Michael Camille, Ann D. Hedeman, Jeryldene Wood, Robert Ousterhout, and Alan Bernstein. I am also indebted to the many students whose inquiring minds I have enjoyed and whose interest in my book has been a great impetus for me.

I would like to acknowledge the monumental research on the windows at Chartres Cathedral by Yves Delaporte, to which my own work is only a commentary. And I would like to thank the many people in France who helped me accomplish my work, the *guardiens* of the cathedral, the *bibliothècaires* of many libraries, dedicated personnel at the Monument Historiques and many other French institutions. I would especially like to thank M. Jean Villette for his learned counsel, M. Petit of Thivars for mounting the roof of the cathedral with me to judge the age of crucial sections of stained glass, and, for her tireless help, generous hospitality, and cheerful encouragement, Madame d'Armancourt of Lèves.

I wish to thank the following people whose help was so important to the completion of this study: David B. Dennis, John Day, Neil Hathaway, Laurie Heitz, Sandy Holquin, Ruth Ann Lawn Johnson, and Becky Zigler. My special thanks are extended to those people at the University of Chicago Press who have honored me with their professional help and made possible the publication of this book: Karen Wilson, John McCudden, and Martin Hertzel. And I would like to thank all the members of my family whose loving patience made it possible for me to carry out my work.

BREAD, WINE, & MONEY

INTRODUCTION

A whole book . . . might be written as a commentary on the
thirty or forty trade corporations here depicted. It would exhibit
the commercial history of a medieval shrine, the mart of pil-
grims, and the bazaar of the devout.

Cecil Headlam, 1902[1]

In an uncanny way, this quote serves well as an introduction to my
work on the so-called windows of the trades at Chartres. The project
plunged me into the murky waters of medieval commercial history,
and in the end I came to realize that the scenes of tradesmen actually
created in sum the image of a medieval fair. The result certainly is not
what Cecil Headlam had in mind. This book challenges the prevailing
interpretation of the windows of the trades and, by extension, the ca-
thedral of Chartres.

The appearance of trade windows in French churches in the thir-
teenth century resulted from the twelfth-century rise of industry and
commerce in towns. Artisans and merchants at work appear in the
lowest register of a number of early Gothic stained-glass windows, in
locations previously reserved for the ruling class. Above the scenes of
commerce and industry, the windows are filled by religious imagery.
Trade windows first appeared at the cathedrals of Chartres and Bourges
around 1200, but many more survive at Chartres than at Bourges.[2] In
forty-two windows at Chartres, one can count tradesmen making,
transporting, and selling their wares in 125 depictions of at least
twenty-five different occupations.[3] These work images appear almost
equally in the clerestory beneath huge figures of saints and in the
lower-story windows beneath pictorial cycles of saints' lives and bib-
lical events (plate 2).[4]

I have attempted to explain the significance of the trade windows
through an extensive study of three trades represented at Chartres:
bakers, tavern keepers, and money changers. The choice of these trades
focused attention on bread, wine, and money, whose uses in medieval
society were ubiquitous as means of exchange, tithing, and offering.

The first chapter describes the state of research on the windows of the trades at Chartres, with some of my own modifications. Chapter 2 presents a historical account of the conflict-ridden urban society in which the cathedral of Chartres was built and financed. Chapters 3, 4, and 5 are case studies of the trade windows where bakers, tavern keepers, and money changers are depicted. I have summarized the evidence about these occupations, described the images, and considered their relationships to the accompanying religious imagery in each window. Iconography, social practices, liturgy, and exegesis weave a complex web of relationships between the hagiographic narratives and the scenes of everyday life. These historical considerations allow me to interpret the function of each window within its cathedral context.

In the last chapter, I have undertaken to analyze my evidence and its broader implications about the function of art at a time of social change. Credit has been given to the sophistication of the cathedral clerics who devised these innovative windows to address specific audiences and to meet the contemporary challenge to their traditional authority posed by the transformations underway in late feudal society.

CHAPTER ONE

THE LITERATURE AND SOME MODIFICATIONS

... the paintings on which are represented the corporations of arts and trades that have contributed, it might be by their dues or by their manual work, to the construction of this superb building.

Antoine P. M. Gilbert, 1824[1]

In contradiction to the previous literature, this book argues that the windows of the trades at Chartres Cathedral represent required offerings by the faithful and the obligatory presentation of work or its product by tradesmen employed by the cathedral canons and bishop. Only one early scholar of Chartres, Antoine Gilbert, writing in 1824 and quoted above, thought similarly that trades might have contributed by their labor to the enterprise, or were assessed dues for the cost of the windows.[2]

Since his early speculation, art historians and historians have contrived a different account of the trade windows at Chartres, still repeated today in guidebooks and scholarly literature. According to this expanded narrative, the images of artisans and merchants in the windows were drawn from life in the early thirteenth century. The trades had organized themselves into religious and professional groups that worshiped at the cathedral and donated windows in honor of their patron saints. The bishop and chapter of the new cathedral were the champions of municipal liberty, coexisting peacefully with the townsmen and the count. Town tradesmen gained their prosperity from the sale of their fine merchandise at cathedral fairs and at markets outside the region. The cathedral represents the cooperative effort of all classes of society to rebuild a sanctuary for the Virgin after a disastrous fire.[3] Attractive as this picture might be, it has little foundation in historical facts at Chartres.

The History of the Literature on the Trade Windows

The traditional view of the historical circumstances surrounding the building of the cathedral of Chartres and the significance of the trade

windows has developed in five stages. Before the mid-nineteenth cen-
tury, it was mistakenly believed that the present cathedral was built in
the early eleventh century by Bishop Fulbert.[4] Despite the relatively
undeveloped nature of the city and its trades at this early date, scholars
discussed the windows of the trades as donations from trade organiza-
tions of Chartres.

The second historiographical stage was provoked by the discovery
around 1845 of an early thirteenth-century text entitled *The Miracles
of the Blessed Virgin Mary in the Church of Chartres*.[5] This collection
of miracles included a description of the events following a disastrous
fire in 1194 that destroyed Fulbert's cathedral. According to this dra-
matic account, the people's dismay after the fire turned to exhilaration
when the cathedral's relic of the Virgin was found to have survived the
flames. The relic was a sheer white cloth believed to have been the
garment that the Virgin wore when she gave birth to the Christ child.
It is still displayed in procession on the Virgin's feast of the Assump-
tion at Chartres (plate 3). The discovery of its survival from the fire
lifted the people's spirit, and they vowed to rebuild the sanctuary of
the Virgin. In 1850, Marcel Bulteau wrote a new description of the
cathedral, now recognized as Gothic, including a new account of the
rebuilding after the fire of 1194 based on the miracles text,[6] in which
he simply repeated the already accepted idea that the town trades do-
nated the windows which depict them.[7] Bulteau later expanded his
work into a three-volume monograph which remains the most exten-
sive history of Chartres Cathedral.[8]

In the early twentieth century, two specialized studies were pub-
lished which became the standard works on the trade windows. In
1917, Geneviève Aclocque published a historical study of the trades at
Chartres, with an appendix containing a brief description of the trade
scenes in the cathedral.[9] She claimed that the professions at Chartres
formed religious associations and professional groups in the twelfth
and thirteenth centuries. Lacking any documentation prior to the
fifteenth century, with the sole exception of the late thirteenth-
century wool-workers' statutes at Chartres, Aclocque cited the win-
dows themselves as her primary evidence.[10] Then, in 1926, Yves
Delaporte published a monograph on the stained-glass windows of
Chartres Cathedral, illustrated by three volumes of photographs taken
by Etienne Houvet.[11] He reiterated the idea that the town trades do-
nated windows, and expanded Bulteau's description of the work im-
ages, basing himself mostly on Aclocque's study of the trades at
Chartres.[12] Delaporte also depended upon the early eighteenth-century
descriptions of the window imagery by Alexandre Pintard, assuming
that many of the industrial processes dating from the Middle Ages
were still in use in the seventeenth century and were familiar to Pin-

tard.[13] Subsequent authors have cited Aclocque and Delaporte, whose works remain the standard texts on the trade windows of the cathedral.

Otto von Simson's book, *The Gothic Cathedral*, inaugurated a third stage in the development of the literature. He elaborated on the significance of the trade windows, emphasizing the importance of the trades to the town, the religious devotion of the tradesmen to the cathedral, and the mutually beneficial association between town trades and the cathedral. Underlying his account were assumptions about faith as an operative principle in medieval society unifying all classes in support of the church.[14] He referred repeatedly to the collection of medieval charters published in the *Cartulaire de Notre-Dame de Chartres*,[15] but he had to ignore the social conflict between the town and the cathedral revealed in this collection in order to put together his arguments. His claims that the trades' fine products were renowned and brought profits from sales beyond the region, and that the fairs at Chartres brought many pilgrims and buyers from outside the region, likewise have little basis in the historical record.[16] A highly idealized description of a devout, harmonious, and successful effort to build a monument had evolved in the art-historical literature.

The works of Jan van der Meulen and André Chédeville in the early 1970s marked a new and fourth stage in the literature. These scholars based their works on objective evaluation of archaeological and documentary evidence rather than on tradition. Van der Meulen hypothetically reconstructed nine wooden bridges which originally connected surrounding canonical and episcopal residences to the cathedral. He found the physical evidence for the connection of adjacent buildings to the cathedral in the open doorways high up in exterior buttresses (plate 4), which he thought must have led to the bridges (plate 5). He suggested that a network of protected passageways may have been motivated by the canons' fear of harm from the townspeople and the bishop's concern for his own safety.[17] But van der Meulen was primarily concerned to show the irregularities in the structure, not in the society.[18] His important work on the dating of the windows, discussed below, is part of this larger purpose.

In 1973, the French historian André Chédeville published a richly detailed, monographic study of the social and economic conditions in Chartres and its region from the eleventh through the thirteenth centuries, based on a thorough reading of the published and unpublished archival documents from the area.[19] From all his reading of the documents, Chédeville concluded that the level of economic activity in the town was relatively unadvanced in the thirteenth century. The trades remained under the control of the count's provost during the first half of the thirteenth century. Production of local artisans met local needs but did not yield much export, with the exception of some sales of

mediocre-quality wool in a few extradiocesan markets. Wheat was the
major product of the region. The economic growth of Chartres was
dependent on the expansion of its cultivated land, which reached its
limit by the mid-thirteenth century.[20] Chédeville regarded the high
proportion of food trades in the windows as confirmation of his conclu-
sions about the rural, closed nature of the diocesan economy. For him,
therefore, the trade windows attested to the enormous devotion of the
trades, not their economic prosperity.[21]

With similar scholarly depth, Martin Warnke in his *Bau und Über-
bau* (1979) cast a much wider net, to study the financing of medieval
construction in general.[22] He traced the efforts of medieval building
patrons to finance their building projects through appeals to outside
resources when their own funds became insufficient. He shows how
this broadened resource base was achieved through claiming a com-
mon good that justified construction. Eventually, all classes of society
contributed to building churches—as they did, for example, at the
Gothic cathedral of Chartres. Warnke quotes extensively from the *Mir-
acles of the Virgin* text to demonstrate how the support of the lowest
classes of society was described in order to justify a construction to
which they could actually contribute very little.[23] Warnke seems to
have accepted the medieval documents from Chartres and Bulteau's
history of Chartres at face value, and hence in this instance failed to
rise above the level of medieval and nineteenth-century ecclesiastical
ideology, no matter how progressive his assertions. One of his crucial
arguments, that all contributors to a medieval construction thereby
gained a claim to it, remains idealistic and unsubstantiated. Despite
the open-minded and trenchant work of these three scholars, espe-
cially that of Chédeville, several major new books have recently ap-
peared which repeat the traditional, unfounded story of the financing
of the cathedral and the trades' cooperation in the endeavor.[24]

John James's work on the construction of the cathedral, first pub-
lished in 1977, belongs to this phase also, since he looked anew and
with great diligence at the evidence in the stone of the building itself.[25]
His claim that the building was erected from the bottom up in succes-
sive layers, reasonable as it may sound, has been highly controversial
because it negates much previous scholarship on the subject. His find-
ings are pertinent to this study insofar as they bear upon the dating of
the windows.

A new step in the evolution of the literature on the windows of the
trades has recently been published by Wolfgang Kemp, who applied his
"reception theory" to the study of some of the historiated windows of
Chartres. This attempt to look at medieval art through a grid of post-
modern theory opens up the possibility of a re-envisioning of the win-
dows. But his apparent lack of familiarity with local history in docu-
mentation and his failure to read the newer works of Chédeville and

van der Meulen place his understanding of the trade windows squarely within the traditional account of them set forth by Aclocque and Delaporte.[26] His brief look at local history led Kemp to assume the situation in Chartres was similar to that of later and more advanced medieval economies.[27] My contribution, I hope, will be to give historical foundation to our understanding of the trade windows.

The Iconography of Work in the Windows

At the outset, certain misconceptions about the nature of the imagery need to be corrected. The images of work were not drawn from life, as Delaporte imagined.[28] Instead, artisans in stained-glass created most of the scenes of work from seven types of figural compositions (see plates 7 and 8, figs. 1–7):

fig. 1. Two antithetically posed figures, confronted or addorsed, bending over their work
fig. 2. Worker bent over his work with arms extended in an exaggerated curve
fig. 3. A man standing in profile bent over his work
fig. 4. Sales scene: a merchant and client facing each other and gesturing in conversation
fig. 5. Sales scene: a purchaser giving a coin to a seller
fig. 6. Sales scene: a man holding a product up to show a client
fig. 7. A seated man working with his hands in front of him

When two figures are shown working together, they are most frequently arranged antithetically, usually confronted, although occasionally addorsed (plates 7 and 8, figs. 1, 4, 5, and 6). Another frequently repeated composition is that of a worker bent over his work with elbows extended in an exaggerated curve (plate 7, fig. 2 a–d). This pose had become a sort of sign for the expression of the physical stress of labor in medieval art.[29]

The compositions were repeated to illustrate the same trade in different windows. For example, the same scene of two men degreasing leather by pulling it around the column between them appears in Bays 111 and 167 and the image of a wheelwright raising his axe to shape a wheel repeats in Bays 45 and 64 (plate 8, fig. 8, a–d).[30] Figural compositions also repeat in the illustration of different trades. For example, an armorer in Bay 4 and a shoemaker in Bay 7 are in identical poses; the same is true of the apothecary in Bay 60 and the turner in Bay 77 (plate 8, fig. 7, a–d). Another apothecary in Bay 60 raises a scale like the changer in the adjacent Bay 61 (plate 9, fig. 9, a–b). Poses for wielding hammers are ubiquitous, but have been varied slightly to suit the situation. Two similar poses, for example, are those of the man shoeing

a horse in Bay 59 and a builder working on a roof, in Bay 45 (plate 9, fig. 9, c–d).

Work motifs like those at Chartres reappear in other Gothic trade windows; for example, in the contemporary cathedrals of Bourges and Rouen, and also in later thirteenth-century trade windows at Beauvais, Amiens, St. Quentin, Tours, and Le Mans, which confirms the use of copybooks by itinerant artisans.[31] Compare the fishmongers in the St. Anthony window of Chartres with those in the St. Julien window at Rouen Cathedral, or the weaver in Bay 39 at Chartres with a weaver depicted in a window at Amiens (plate 9, fig. 10, a–d). The stained-glass painters, like the manuscript illustrators, must have had copybooks of stock compositions and poses to use in creating new images. Many more examples of almost identical images of tradesmen in different locations over time should not surprise us, considering the respect for tradition and the habit of copying models ubiquitous in medieval art.

The resultant schematization of work into a series of stock poses has the effect of regimentation. The ethos is actually a continuation of that projected by the traditional imagery of the labors of the month. Within a limited set of movements, each worker submissively and eternally repeats his task. The message of endurance in one's labor in life, acceptance of the impossibility of change, is given a sensual beauty of translucent color and an ideological dignity in its religious setting in the windows of Chartres.

The general idealization of images of medieval society mandated that the upper classes should be pictured in the windows of Chartres praying—except for knights, counts, and kings of fighting age, who usually appear in armor on horseback. The urban work force at Chartres works. Thus, the three orders of medieval society, those who pray, those who fight, and those who work, are segregated in the windows by what they do. Duby has shown that the third order changes in medieval written descriptions in the early thirteenth century to include artisans and merchants, where before there were only *rustici* or peasants.[32] So the visualization of the third estate in the windows had a certain new intellectual currency. The segregation of the trades from the upper orders of society by type of imagery was further accomplished by their separation in different parts of the cathedral. The trades appear in the aisles, the nave clerestory, the ambulatory, and the apse. The clergy and nobility appear primarily in the clerestory of the transepts and choir (plate 10).

The clergy of Chartres and Bourges asked the stained-glass artisans to create a large number of images of the tradesmen and merchants in their towns—a subject never before treated so broadly in medieval art. The artisans undoubtedly turned first to their copybooks, where they may have had images of money changers, masons, spice sellers, and other subjects that they needed in order to portray events in the Bible

and in the lives of saints.[33] In some instances, the stained-glass arti-
sans derived motifs from these long-standing medieval pictorial tradi-
tions for the representation of labor, most prominently from depictions
of the labors of the months.[34] The pictures of trades in small groups
had occurred before in isolated instances—in Spain and Italy, for ex-
ample—but it is highly unlikely that the stained-glass artisans had
seen these experiments.[35]

In some instances, the designs apparently were drawn from grave-
stone bas-reliefs of late Roman artisans and merchants. These Gallo-
Roman reliefs still survive profusely in France.[36] They were, so far as I
know, the only example available to the people of northern France of
the sort of broad representation of urban work that suddenly appeared
in the trade windows of Chartres.

There had not been a demand for a broad number of depictions of
town work since the late Roman Empire, the last time in history when
such urban commercial activity was important enough to receive artis-
tic representation. I believe that the clergy had these antique images in
mind as models for their new panorama of urban work. One can find
instances where the closeness between the antique and the Gothic im-
ages argues that the Gothic artisans actually drew from original Ro-
man reliefs into their copybooks to fulfill their new commissions.
Consider the resemblance between the two men carrying a big basket
at Chartres in Bay 120, and men carrying a big basket on a late Roman
relief in Trier (plate 9, fig. 12, a–b). We see such a method of carrying a
load in medieval labors of the month, and biblical illustrations of the
spies bringing back grapes from Canaan (plate 9, fig. 12, c–d). But the
style and pose of the men at Chartres so closely follow the late Roman
model, it seems the stained-glass artisans have actually copied their
motifs directly from the antique stone (plates 26 and 54). Even the
little shapes of the dog's legs beneath the Roman basket are simulated
by the little flowers beneath the Gothic one.

An instructive comparison is that of the display of cloth that contin-
ued in various recensions in medieval art. The Chartres fur seller dis-
plays a fur coat in a fashion similar to that of the late Roman cloth-
seller commemorated in a grave relief at Bourges (plate 9, fig. 11, a–b).
The late Roman image of a group of men around a displayed cloth, the
most famous example from the Igel column in Trier, found Roman-
esque expression in a Cistercian manuscript, but the Cistercian artist
completely changed the style and concept of the image (plate 9, fig. 11,
c–d). The stocky Roman figures whose actions and implements com-
memorated their occupations became a model for the Gothic recogni-
tion of a new, dynamic social power.

The images of work are usually depicted in residual spaces that re-
sult from the interruption of the geometric and curvilinear armature
designs in the windows by the straight edge of the window bottoms.

The spaces that the scenes occupy tend to be irregularly shaped and smaller than the narrative spaces above them. The stained-glass artisans manipulated the poses of the figures to fit into these spaces. Most of the working figures are too large to fit without bending forward, but that still does not allow for figures as large as those above in the religious narratives. Their bent-over poses gives the workers the effect of atlantid figures that hold up the rest of the window on their shoulders, for example, in the Good Samaritan window, Bay 6 (plate 11).[37] The workingmen are generally clothed in the short frock of the Gothic working class, and tend to be of stockier proportions than the figures above them in the religious narratives (plates 11 and 12). Their appearance is very much like that of the figures in the late Roman reliefs. On the other hand, men who sell luxury goods like furs or striped wool stand erect and, in style, dress, and proportion, are similar to the typical Gothic figures above them in the religious narratives, as in the window of St. James, Bay 37 (plate 73). In this way, a sort of class differentiation is made between lower and upper levels of work based on the differentiation between physically hard work and the relative ease of selling luxury merchandise.

However they may have been conceived, the image of tradesmen and merchants in the stained glass of Chartres constitute a repertoire of formulas for the depictions of different types of actions and occupations, specified and enlivened with details of tools, products, and work environments.

The Organization of the Trades

Scholars have long assumed that the individual tradesmen and merchants depicted in the windows represented town professional organizations, or religious confraternities, or both.[38] The long history of debate over the reasons for and manner of the growth of trade guilds in medieval Europe has tended to give the impression of widespread trade organization in Europe in the twelfth century.[39]

However, the local historical evidence in the center of France in general and in the region of Chartres in particular does not support such assumptions. The count taxed and controlled the tradesmen directly through his officers, appointed masters over some of the town trades, and sometimes assigned their taxes to ecclesiastical institutions other than the cathedral in the town. While Chédeville reported this information in his chapter on the "Les activités urbaines," his main purpose was to amass and assess the evidence of economic activity in the urban centers of the area.[40] In 1981, Reinhold Kaiser published a study of the extent of episcopal authority compared to that of the king and local princes in medieval France. From his reading of local documents, he concluded that the trades at Chartres were organized under a master appointed by the count and hence were controlled by him.[41]

Surviving documents from the twelfth century show that the counts appointed masters over three trades: the furriers, tavern keepers, and fish sellers. In 1131, Count Thibaut IV had appointed a master over the furriers, who was to pay the leprosarium one hundred sous yearly.[42] This was a payment of rent which the master owed the count for his position, and the count assigned it over to the leprosarium. In 1147, the same count appointed a master over the tavern keepers at Chartres, at the same time ordering the tavern keepers to cancel their annual corporate meal and instead to pay thirty sous through their master to the leprosarium.[43] This was a different situation, in that the corporate meal is a symptom of medieval trade groups. However, by itself, it cannot be taken as a sign of the tavern keepers' independence but just the opposite, since this particular group was brought into close supervision in 1147 by the count. Count Thibaut V granted the fish sellers in town a sales monopoly in 1164, in return for an increased annual stall rent of twenty-five *livres* eighteen *deniers*, and an annual payment of ten livres to the chapel of the Hôtel-Dieu.[44]

Two more trades are on record in the first half of the thirteenth century in this manner. In 1210, the shoemakers had a master, but the document does not mention how this came to be so.[45] In 1249, the dean of the cathedral chapter ordered the butchers who sold meat at a stall in the cloister to discontinue their coalition. They had evidently formed it in order to refuse as a group to sell meat on credit to the canons, and the dean then fined them for refusing the credit![46] Hence by mid-century, when the windows were presumably finished, only five trades besides the wool producers are known to have had some sort of organization: three had a master placed over them by the count, and one—the cloister butchers—had its organization outlawed by the chapter's court. The situation of the shoemakers remains unclear; all we know is that they had a master.

Wool production was the most important trade in the town, the only one, as far as we know, that exported outside the region. In the early thirteenth century, Count d'Oisy appointed twelve jurors over the wool trade.[47] This was the first important step toward trade organization at Chartres. Not until 1268, eight years after the cathedral was finally consecrated, was the first trade statute at Chartres finally issued to the wool workers.[48] Count Jean de Châtillon issued the wool workers' statutes, based on trade practice reported by his twelve jurors. The statutes allowed new wool carders to join the trade for a fee of twelve deniers paid to "la confrairie."[49] Nothing indicates that this meant a religious confraternity. In any event, the first mention of a trade confraternity in the documents at Chartres is this one, dated to 1268. There is no other documentation which suggests that trades in the town had independent guild status or had religious associations directly with the cathedral during its construction.

The Iconography and Inscription of Donation

Although there is scant evidence for the donation of any of the thirteenth-century windows, scholars have consistently assumed that the town trades donated the trade windows.[50] According to Delaporte, donors were depicted in 116 windows of the original 173 installed in the cathedral. He listed these donors by social class:[51]

Kings, princes, and lords	44
Ecclesiastics	16
Artisans	42
Diverse donors not identifiable or not members of the above classes	14
Total	116

Traditional donor classes appear in traditional donor poses in the bottom register of many of the windows. Donor representations are frequently referred to in the literature as "signatures." However, there is reason to doubt that donation can be assumed from "signatures" in stained glass. The earliest such "signature" is the image of Abbot Suger at the feet of the Virgin in the bottom of a choir window at Saint Denis.[52] Suger collected funds for the windows and directed their production during his abbacy. There is no evidence that he actually paid for any particular window himself.[53]

The fact that the windows at Chartres (and also Bourges) are the first examples of the representation of the working class as donors to the church in France is never brought out in the literature, even by Delaporte. Art historians simply assume the images of work commemorate window donation because of the analogy of their location to that of the depictions of traditional donor classes in many other windows at Chartres, also assumed to indicate window donation.

This unexpressed circular reasoning is broken only by a few special cases. Of the 116 windows that Delaporte believed on the basis of "signatures" to have been donated, only seven contain any indication that the windows were donated by the people memorialized in them. Four of these windows contain donation inscriptions that refer to people who unfortunately are difficult to identify precisely: Count Thibaut, Cardinal Stephen, an anonymous group of farmers from Nogent (there were several local towns of that name), and an anonymous group of men from Tours.[54]

The other three windows are trade windows which contain unusual and provocative suggestions of window donation. In the third register from the bottom of the window of Sts. Theodore and Vincent, an inscription appears whose meaning is not entirely clear due to abbreviated words, obscured letters, and interrupting lead repairs. Delaporte translated the inscription: "The brothers of Saint Vincent, those who

gave this window, are remembered in all the masses sung at this altar." Scenes of wool workers appear to either side of the inscription. The juxtaposition has been taken to mean that wool workers formed a confraternity of St. Vincent. However, the window apparently is a composite of glass from previously dismantled windows. Its lower two registers contain scenes from the life of St. Theodore, and in the corners of the bottom register, where trade scenes usually appear, instead there are censing angels—usually found at the top of windows. Scholars all agree that the window has been reconstituted from scraps. Lacking any further information, one must conclude that the original appearance of the window is unknown, and that insufficient evidence exists to prove the weavers were members of a confraternity who donated a window to the cathedral.[55]

Two trade windows—the window of the Good Samaritan and the window of St. Stephen—show men kneeling and holding up what appears to be miniature stained-glass windows (plates 11 and 13). These scenes are in the bottom register of the windows opposite scenes of men making shoes.[56] Because of this juxtaposition, it has been assumed that shoemakers donated the windows. In the Good Samaritan window, an inscription in a semicircular band in front of the men kneeling with a little window states: "SVTORES O." Delaporte thought the "O" might have been meant to abbreviate *Obtulerunt*, and hence the inscription ought to be understood to mean: "Shoemakers offered (it)."[57]

The problem with this interpretation lies in the costume of the men kneeling. They are dressed in long, upper-class robes, whereas the shoemakers in the pendant scene are simply dressed in the short *cotte* of artisans. This same difference appears in the St. Stephen window scenes. Presumably, then, the men kneeling are of a different social class than the shoemakers. Because of the sumptuary laws of medieval life, which regulated costume by class, one must assume that two different classes of men are depicted in these pairs of scenes. I do not know of any specific documents from Chartres which might explain the social relationship between the two groups, beyond the one indication that the shoemakers had a master.[58] It could be that there were various shoemakers in the town in different areas of jurisdiction whose masters together offered the window. Very little information at all has come to light about the shoemakers in the region; one can only say that the explanation could not have been quite as simple as Delaporte thought.

The rest of the trade windows do not contain inscriptions nor do they show traditional images of offering. Hence, it cannot be assumed that the workers shown in the windows represent donors, and the significance of the images of work in the lowest register of the windows at Chartres remains an open question.

The Relationship of the Trades to the Religious
Imagery of the Windows

The well-known fact that trade confraternities venerated specific saints in France in later centuries led to the modern assumption that the saints honored in windows of the trades at Chartres were selected by trade groups to express their devotion to patron saints.[59] Émile Mâle and Geneviève Aclocque thought that trade confraternities at Chartres donated windows in honor of their patron saints, but no documentation for this type of association survives from Chartres until long after the thirteenth century.[60] Further diminishing the likelihood of such an explanation at Chartres is the fact that many trades are depicted in more than one window, and these windows are dedicated to different saints. Conversely, different trades appear in several windows dedicated to the same saint. The known association of trade groups with particular saints in later centuries finds practically no correspondence with the conjunctions of trades with saints in the windows. In short, the explanation must lie elsewhere at this innovative and formative moment.

There are two ways that trades are related to the religious imagery above them in some windows. One is association by analogous content of imagery or occupation, and the other is by the commemoration of a historical event. The latter occurs specifically in two windows in which similar scenes in the lowest register depict what would seem to be a family group,one of whom caries a white banner with a red legging on it. In the apse clerestory window of Aaron, Bay 121, the three principal figures in the group seem to look up in veneration at the image of the Virgin in the adjacent window, perhaps to commemorate a pilgrimage to Chartres (plates 27 and 67). In the other window, Bay 74, the group seems to venerate St. James, who stands above them wearing a robe covered with pilgrimage shells.[61] In this case, the window may commemorate a pilgrimage to Compostella, but this is pure speculation.

Delaporte pointed out relationship by analogy in six of the windows, and thought that in these cases tradesmen chose to donate windows dedicated to saints whose legendary activity was related in some way to their own work. He pointed out such analogous imagery in three windows of building trades at Chartres. For example, in the window of Noah in the north aisle, Bay 64, carpenters and barrel makers work with axes in the bottom register. Above, Noah builds his ark with an axe, and his sons cultivate grapes and stamp wine from them in a barrel.[62]

We do not know if particular tradesmen or trades groups actually donated the windows, nor can we claim that they selected a patron saint to honor. These are separate issues. The analogies drawn by the windows between the work of men in the thirteenth century and the lives of long-departed saints are further evidence of a sanctification of

work, a new valuation of labor that the windows of the trades them-
selves announced.[63] The relationship between the trade and the saint
represented in any particular window may have been idiosyncratic at
this early stage of a new idea in the adaptation of the traditional donor
space to those who worked in medieval society.

The Chronology of the Windows

Any attempt to date the windows must take into consideration the
three dates known from medieval documents concerning the construc-
tion of the cathedral: 1194, the date of the fire which destroyed the
Romanesque building, and hence the earliest date when reconstruc-
tion could have begun; 1221, the date of the charter concerning the
installation of the choir stalls; 1218–24, the traditional dating of the
poem written by Guillaume de Breton praising the new vaults of
the cathedral.[64]

Within these dates, Yves Delaporte dated the windows based on his
opinion of their style. He believed that the aisle and nave windows
were made first, then the windows of the choir, ambulatory, and chap-
els, and finally the transept clerestory windows.[65] Subsequent writers
accepted Delaporte's conclusions. His relative chronology accorded
with the theory that the building was built from the west to the east.
But conflicting theories that the building was constructed from east to
west or from the crossing outward towards east and west confused the
supposed chronology of the windows.[66] Jan van der Meulen debunked
all previous argumentation concerning the chronology of the windows
in 1967, wiping the slate clean, but offered no clear alternative.[67]

John James's argument, published first in 1977, that the cathedral
was built from its foundations up in ascending layers suggests a differ-
ent relative chronology for the windows.[68] Claudine Lautier, in her
new study of the style of individual painters in the lower-story win-
dows, asserted that the same painters worked in different parts of the
lower story, and hence concluded that the windows of the lower story
must have been painted within a short period of time.[69] She does not
say so, but this accords with John James's theories in a general way.
James discerned changes in the stonework which he arbitrarily as-
cribed to yearly building campaigns. He based his relative chronology
of the construction on the *terminus post quem* drawn from the *Philip-
pidos* of Guillaume Le Breton. Taking the dates of 1218 to 1224 sug-
gested by his reading of Delaborde, who published the poem, James
chose a middle date of 1222 as his terminus for most of the work,
which he nonetheless thought continued until 1226 and after in its
final stages.[70] This gave him a space in which to assign a year to each
of the over forty campaigns of work he diagnosed in the fabric.

He thus arrived at the hypothetical stages of construction when win-
dow templates could have been made for the lower- and upper-story
windows: the aisle-window templates could have been begun by 1203

at the earliest, the ambulatory templates by 1206–8, the nave cleres-
tory templates by 1218, the choir clerestory templates by 1219–20, and
the apse clerestory templates by 1224.[71] Even if the windows were be-
gun at these dates, the actual installation could not have occurred until
later, when the vaults over the windows were finished. James reasoned
that, since the clergy more likely waited to spend money for windows
when they could actually use the space that windows would enclose,
the dates would move forward to the time when the temporary roofing
was removed from over the aisles, nave, and choir. James comple-
mented his calculations with architectural drawings of the construc-
tion progress yearly, which I reproduce here for their visual impact. He
calculated that the aisle had its vault completed by 1205 (plate 14), and
that the ambulatory was roofed over during the campaign of 1208–9
(plate 15).[72] The upper nave windows could have been installed in 1223
(plate 16), and in 1226 the permanent vault over the choir could have
been completed, allowing the temporary roof at the triforium level of
the choir and the building scaffolding to be removed and the stained
glass in the choir to be installed (Plate 17).[73] The subsequently pub-
lished *Corpus Vitrearum Recensement* still dated the windows on the
premise that the cathedral was built from west to east.[74] Here are the
conflicting dates according to James and the *Corpus:*

Location	James's dates	CVR dates
aisle windows	ca. 1205 or after	1205–15
ambulatory windows	ca. 1208–9 or after	1210–36
nave clerestory	ca. 1223 or after	1205–15
choir and apse clerestory	ca. 1226 or after	1210–25

The main discrepancy in the figures is James's dating of the nave
clerestory to 1223 or afterward, which results from his contention that
the building was constructed from the bottom up. Jan van der Meulen
consistently rejected James's publications,[75] while the local learned so-
ciety which first published his book, and the local scholar Jean Vil-
lette, have supported his findings without question.[76]

 Earlier dates for the cathedral and its windows were published in the
local journal, *Notre-Dame de Chartres,* in 1988 by Jean Villette and C.
Deremble-Manhes. Villette's dating was based on John James's work,
but he chose to extrapolate parameters for the windows differently
than I have.[77] For example, he used the James date of 1205 as the latest
date possible for the aisle windows, which he assigns to 1199–1205,
presumably because 1199 was the date, according to James's relative
chronology, when the size of the windows in the aisle could have been
determined.[78] He probably pushed these dates back in time in response
to the reassessment of the dates of Guillaume Le Breton's writings
about the cathedral published concurrently by Deremble-Manhes.

 Deremble-Manhes criticized the prevailing notion that the evidence
of the completion of the vaults of the cathedral and its ornamentation

found in Guillaume Le Breton's works should date between 1218 and
1224. By a more careful reading of Delaborde's comments in his 1882
publication, *Oeuvres de Rigord et de Guillaume Le Breton, historiens
de Philippe Auguste,* Manhes found that the dates Delaborde finally
decided upon were much earlier than the first dates he mentions in his
introduction. This change had apparently gone unnoticed by influen-
tial scholars in the intervening years. Basing her new dates on a thor-
ough reading of Delaborde's introduction, she posits a span of 1214–17
for Le Breton's crucial statements about the completed vaults of
Chartres Cathedral.[79] Deremble-Manhes did not consult the presti-
gious studies of either John Baldwin or Gabriel Spiegel,[80] both of whom
reject such early dates. Baldwin dates the first crucial text in the *Gesta*
to 1216–20, and the second, *Phillipidos,* to 1216–26.[81] The situation
of these texts is quite complex, as they were compiled and added to
over time, so that it is impossible to date precisely the comments
embedded in them about Chartres. The dates assigned the texts by
Spiegel and Baldwin accord nicely with the hypothetical dates of the
windows designated by both James and the *Corpus.*

For my purposes, it is most interesting to note that with either the
hypothetical chronology of John James or the *Corpus Vitrearum,* the
windows would date to the reigns of two bishops.[82] Bishop Renaud de
Mouçon presided over the reconstruction of the Gothic cathedral until
his death in 1219, and presumably saw the installation of the lower-
story windows in the aisle and most of the ambulatory. His successor,
Bishop Gauthier, who held office from 1219 to 1234, presumably saw
the installation of the clerestory windows in the nave, choir, and
apse.[83]

Summation

The revised account of the trade windows and the starting point of this
study is as follows: The trades at Chartres made and sold their prod-
ucts for immediate local consumption within a predominantly rural
society. The images of artisans and merchants at work in the windows
of Chartres constitute variations on a limited set of figural poses and
compositions. They do not represent organized trade groups, and not
all of them may represent donors of the windows. We do not know why
particular occupations were combined with particular saints or reli-
gious subjects in the windows. The original lower-story windows of
the trades at Chartres were probably installed early in the thirteenth
century during the episcopacy of Renaud de Mouçon; and the upper-
story windows were probably made slightly later, during the episco-
pacy of Gauthier.

It will be interesting to see if any changes in the representation of
the trade windows occurred from the lower to the upper story, and if
such changes may relate to changing historical circumstances. A
closer look at the contemporary events surrounding the installation of

the trade windows will suggest a very different interpretation of their sponsorship. But the issue of the relationship between the work images and the religious subjects in the windows must await the case studies of the trade windows of baking, wine selling, and money changing to follow. The local charters and liturgical documents will prove the most provident in the search for the social function of the combined imagery of the windows in the cathedral.

CHAPTER TWO

THE HISTORICAL CIRCUMSTANCES

The sculptured decoration and stained-glass windows convey an ideology which is not only religious but also informs us of particular emphases that are given to them, indirect echoes of social relationships and of tensions that one can detect there.

André Mussat, 1982[1]

The history of Chartres in the Middle Ages has been written many times,[2] but the social conflict in the town has been given little attention and has never been thought to have affected the artistic expression of the cathedral. While the social conflict at Reims during the construction of the Gothic cathedral has long been aired in the art-historical literature, the similar circumstances at Chartres remain closed away in the books of Latin charters and underplayed in scholarly literature. The tensions at Chartres created by the bishop, canons, and count competing for town jurisdiction did affect the fabric and the imagery of the cathedral. This interaction of art and feudal politics motivated peaceful images in stained glass of the kings, nobles, bishops, canons, merchants, and tradesmen all fulfilling their appropriate role in the maintenance of the church. The church windows thus belied the social reality while at the same time directing the attention of each viewer to the proper behavior for Christian salvation.

The windows are now taken at face value, as simple historical documents of a simpler past when faith in God ordered everyone's life. The purpose of this chapter is to counter this impression by considering two aspects of the history of Chartres which provide an essential basis for arguments to follow: the antagonism between the various social groups in the town and the economic basis of the cathedral's construction.

The Antagonisms

Recent art-historical literature emphasizes the peaceful relations between the bishop and chapter of the cathedral on the one hand, and the count and countess of Chartres on the other. These accounts claim

that the cathedral chapter encouraged municipal liberty for the towns-people, and dwell on the eager cooperation of all social classes in the cathedral's reconstruction.[3] Ecclesiastical documents, while obviously presenting a biased view of events, nevertheless reveal a very different picture.

The Strife among Clerics

The cathedral itself was a house divided. Increasing tensions were building in the thirteenth century over the conflicting claims of bishop, chapter, and chapter dignitaries that would become the major source of conflict in the fourteenth century at Chartres.[4] Numerous charters with painstakingly precise legal statements of rights reveal the need to protect these rights from encroachment.[5] Sometimes the charters resolved a dispute between dignitaries, as did the 1181–83 agreement between the dean and his provost, Renaud de Mouçon (the future bishop), regarding rights to sales taxes and customs at the cloister fairs.[6] Sometimes the chapter drew up charters attempting to prevent encroachments on its rights by new dignitaries. When the chapter elected a new dean, it specified that he would have no claim on income from stalls set up in the cloister, seeking to preempt his claim to this income.[7] Occasionally the pope was called upon to intervene, as when he confirmed the rights of the archdeans in 1195,[8] and spelled out the cantor's rights to appointments in the choir in 1221.[9]

Most dramatic are the increasing tensions between the chapter and bishop, which show the chapter emerging more and more as the stronger power. A cryptic papal decree of 1195 prohibits the bishop from attempting to inhibit the privileges of the dean and chapter.[10] In a letter of the same year, the pope confirmed that the bishop was held by oath to the customs of the church.[11] In the chapter's new customs drawn up in 1200, a zeal bordering on animosity is evident in the chapter's determination to guard its privileges from episcopal intrusion.[12] These customs stipulated that "even the least canon of our church is completely free and immune from the jurisdiction of the bishop."[13] The document repeatedly insisted on the chapter's exclusive right to declare interdict in its areas of jurisdiction, including the church and the city of Chartres—normally a bishop's privilege. The customs further stated that if the bishop should try to cancel the chapter's liberties, the chapter could interdict the cathedral, to the bishop's "confusion and punishment."[14] The chapter sought and received papal confirmation of its rights.[15] The editors of the *Cartulaire* appropriately called the chapter's powers "quasi-episcopal."[16]

The System of Oaths

Tensions in the balance of power at Chartres can be seen in the proliferation of oaths that different authorities and their dependents were

required to make. The bishop, in the inaugural ceremony of his entry into the city, swore a series of oaths intended to establish the limits of his power vis-à-vis the canons and the count. In the count's castle chapel, the bishop swore to the count that he would never threaten the count's authority.[17] And he twice swore an oath to the chapter, first at the priory of Saint-Martin-au-Val and again on the steps of the cathedral, repeatedly promising that he would honor the chapter's customs and privileges.[18] According to the *Polypticon* of 1300, each canon on his induction swore several different oaths before the chapter: first, a short oath confirming his legitimate birth, denying any simony, and promising never to receive his daily distributions fraudulently; then a longer oath promising to respect many specifically described customs of the church of Chartres and to support the chapter in its business "against the count of Chartres and Blois and his bailiffs, ministers, and servants."[19] He also swore a separate oath "for the sustenance of the burgher *avoués* (the ecclesiastics' adopted serfs at Chartres) and the renewing of peace concerning the *avoués*."[20] Finally, he swore an oath in the presence of the count's ministers promising not to permit the dean and chapter to defend a usurer, and to prevent *avoués* from practicing usury.[21] These oaths, recorded at the end of the century, reflect earlier antagonisms.

The chapter further protected its rights and guarded against its fears by demanding oaths from manumitted serfs, *avoués*, and newly arrived Dominicans and Franciscans. Before receiving manumission, the chapter's serfs swore never to take part in the formation of a commune at Chartres or elsewhere, and to try to prevent such a formation. Failure to conform to this promise would cause immediate return to servitude.[22] Newly adopted *avoués* also swore never to join in the formation of a commune.[23]

Each new Dominican prior at Chartres swore an oath to the chapter, promising that he would preserve its interdicts and respect its customs, liberties, and authority. He further promised not to acquire anything other than movable goods in the chapter's area of jurisdiction without its consent.[24] Franciscans swore a similar oath.[25]

The evidence of these oaths is somewhat contradictory, since it shows the power of the canons who were able to demand them and at the same time reveals their apprehensions. They feared disloyalty from new canons in their struggles against the count and his officers, they feared communal organization of the town, and they feared that other ecclesiastic institutions would weaken the effect of their interdicts or cut into their economic privileges.

Bishop and Canons against Count and Countess

The nineteenth-century editors of the *Cartulaire*, E. de Lépinois and Lucien Merlet, remarked that the charters they published revealed a permanent state of war between the two powers at Chartres in the thir-

teenth century.[26] Indeed, the documents suggest that the riot of 1210, when the townspeople's anger exploded in the cloister, was only a particularly visible moment in a continuous urban power struggle. Count Louis I of Blois and Chartres (died 1205) gave charters of franchise to Blois and Châteaudun but not to Chartres, undoubtedly because of the hostility of the bishop and canons.[27]

The bishop held both sacred and secular rule until the third decade of the tenth century, when the king evidently enfeoffed the county of Chartres and Blois to Thibaud I the Tricker,[28] creating a division of powers whose particulars are not clearly described until the late fourteenth century, in a document which is obviously unreliable.[29] In the twelfth and thirteenth centuries, the uneasy division of economic and jurisdictional rights in the town was increasingly disputed by ecclesiastic and secular powers, each seeking advantage. The count had the right to set and collect taxes and exercise justice in the town outside the area around the cathedral (see plan of town, plate 18).[30] However, the count divided many of these town taxes equally with the bishop. The chapter had jurisdiction of the area immediately surrounding the cathedral known as the cloister, the locus of cathedral fairs (see plan of cloister, plate 19).[31] None of these separations of power was complete in practice and all were frequently contested.

During the building of the cathedral, the secular rule was held most of the time by widowed countesses whose income was seriously depleted by the cost of their husbands' fatal crusades. These countesses fought to keep or increase their economic rights, acting through their officers at Chartres.[32] The biggest cause of contention between the counts and countesses on the one hand and the bishops and canons on the other was the "liberty" of the cloister, that is, the exemption of the cathedral precinct's inhabitants from the count's authority.[33] The pope repeatedly confirmed this exemption.[34] It was not the rule itself which caused the contention; what infuriated the count and his officers was the special use of this exemption by cathedral ecclesiastics who brought town tradesmen into the cloister to live and to serve them, and thereby exempted these adopted serfs from the count's taxes and jurisdiction.

The Adopted Serfs or Avoués

In the twelfth and thirteenth centuries, the bishop, canons, clerks, and provosts of the cathedral increased the number and usefulness of their serfs (euphemistically referred to in documents as their "family") by adding men and women who formerly had lived in the jurisdiction of the count.[35] The documents report that men and women were made serfs of an ecclesiastic, or transferred from burgherhood to the service of an ecclesiastic,[36] or were called into service (advocare); hence, these serfs came to be called advocatii in later thirteenth-century docu-

ments.[37] Modern literature uses the French *avoués* to describe these domestic serfs, but they were not like *avoués* in other towns, who usually were armed protectors of the churchmen and their property.[38] When these serfs at Chartres "crossed over" the boundaries of the cloister (plate 18), the count's ministers tried to continue extracting taxes from them and, when refused payment, either confiscated the personal possessions of the adopted serfs or seized them by force, incarcerating and sometimes killing them.[39] Conversely, to regain their new serfs and the confiscated goods, the cathedral officials invoked their jurisdiction over their serfs and the immunity of the cloister.

The dispute between the count and the chapter over the adopted serfs had gone on in this way at least since the mid-twelfth century. Around 1193, it became necessary to have the dispute arbitrated. Archbishop Guillaume aux Blanches-Mains of Reims, and Queen Blanche, questioned representatives of both parties and ruled concerning the dispute. But even after their judgment in the chapter's favor was officially promulgated at the court of the king,[40] the matter remained unresolved, since, in 1194, the pope had to write to the archbishop and archdean of Sens to urge them to quickly settle the same dispute.[41] The papal legate was at Chartres to help resolve these matters when fire destroyed the cathedral on June 10, 1194.[42]

Immediately after the fire, from July of 1194 until March of 1195, the archbishop and archdean of Sens questioned witnesses on the sides of the countess and of the chapter, in order to ascertain what the custom had been, and what had been so far determined by the previous arbitrators, the archbishop of Reims and the queen. Witnesses named fifty-two adopted serfs who crossed over from service of the count to that of cathedral personnel; specifically mentioned were three bishops, five provosts, four canons, three clerks, four archdeacons—and eleven other clerics. Of the fifty-two adopted serfs, the former occupations of thirteen are stated: two had been officers of the count, two others had been officers to unspecified high nobility, and nine were tradesmen. The tradesmen were: three potters, a barrel maker, a fuller, a changer, a woodworker, a shield maker, and an ironworker.[43] These trades can be seen in the windows of the cathedral, with the possible exception of potters and fullers.[44]

At the end of the inquest in 1195, the archbishop and archdean of Sens announced the "definitive sentence in the matter" of the *avoués*:

> the townsmen of Chartres may be freely allocated to the canons of this same church, that is, townsmen who cross over to their domestic service to be received and protected . . . enjoying the same liberty as the canons themselves, together with their possessions and families, leaving behind, nevertheless, all engagement in business and usury, with the exception that, if they wish, they may buy and sell wheat in

the time of the harvest, and wine in the time of the vintage,
just as the canons do, and they may make cloth from the
fleece of their sheep to sell without lay customs, to the per-
fection of which, if anything is lacking, they may be sup-
plied from any other place without the paying of sales
tax. . . . Concerning all their feed and their crops, they may
act under the same liberty.[45]

We learn from this document that the canons' adopted serfs bought
and sold wheat and wine, and made and sold cloth. They could buy
wool in addition to the wool from their own sheep in order to weave
fabric to sell for a profit. These were not necessarily the main activities
of the *avoués*, but freedom from the count's taxes must have increased
their profitability. The *avoués* were part-time wine merchants, fabric
weavers, and fabric merchants, occupations which also appear in the
so-called trade windows.[46]

Furthermore, other trades depicted in the windows worked in the
cloister. The chapter had the rent from and jurisdiction over a butch-
er's stall in the cloister.[47] It had its own wheat and ovens for baking
bread within the cloister.[48] And, of course, masons and sculptors were
building the cathedral in the cloister. So far as I know, among the oc-
cupations depicted in the windows, only apothecaries and leather
workers are not mentioned practicing their trades in the cloister in the
thirteenth-century documents. But they must have been there during
fairs, and probably some men of these occupations also enjoyed the
permanent commerce and protection of the cloister.

It is likely that the bishop and canons used their own serfs to provide
the goods and services that they would otherwise have had to purchase
at a higher price from tradesmen in the count's sector of town.[49] This
would be in keeping with the long-standing tradition of medieval ec-
clesiastical institutions to maintain self-sufficiency through depen-
dent artisans who supplied the basic needs of their community. It has
long been known that the bishop had many of his own artisans at
Chartres, as did the bishop in Paris. The documents concerning *avoués*
show that the canons also had their own artisans and tradesmen in the
cloister. Whether the windows depict town tradesmen or cloister serfs
is a question, never raised until now, that this study attempts to an-
swer.

The cloister serfs were not entirely satisfied with their situation. At
the same time that their status was assured by the archbishop, some of
them were trying to form a commune. In June of 1195, Pope Celestine
wrote to the dean and chapter granting them the right to prohibit their
serfs from contriving such a "conspiracy" and ordering the dean and
chapter to prevent them from doing so, by force if necessary.[50] Thus it
is not surprising that some of the chapter's serfs took part in the clois-
ter riot fifteen years later.[51] The pledge of allegiance required of the

avoués, in which they swore never to form a commune, probably was inaugurated around this time by the canons in response to an actual threat of communal organization.[52]

The Riot of 1210

The settlement of 1195 was short-lived. Already in 1207, the chapter and countess again were snatching each other's serfs. King Philip Augustus himself had to order a solution to their dispute over a mere three serfs. The struggle was apparently so intense that the king had to decree that both contending parties should be able to take their serfs safely through each other's land.[53] In 1210, events which are only sketchily recorded in the documents led to a violent uprising. Early in that year, the provost of the countess imprisoned a clerk of the choir and a serf of the archdeacon of Dreux. The dean's court sentenced the provost to pay a fine.[54] This may have provoked the anger which eventually ignited into mob violence in October of that year, but the outburst undoubtedly was the result of animosities built up over many years. The people of the town, including at least 200 tradesmen, rushed up the hill to the cathedral cloister with sticks and stones to vent their fury (see the cloister plan, plate 19). Here, in abbreviated form, is the ecclesiastical account of the cloister riot:

> It happened in the city of Chartres, in October 1210, on a Sunday afternoon, that a great crowd dared to violently attack the home of Guillaume, the dean, and his household because a certain serf of the dean's had berated and verbally abused one of the town rustics of the countess. When the countess's marshal and the provost had been summoned by the chapter, even by the king, so that they might repel the furious crowd . . . instead they attempted to incite the people. Indeed, a crier was dispatched throughout the city who cried out in the street and by-ways to the mob that they all rush upon the dean's home with their arms to demolish it. . . . The dean, as soon as he saw the increasing rage of the mad mob grow, fled to the church. . . . Many of the sacrilegious crowd were wounded, and some of them succumbed to a merited death. . . . looting continued at night with light from burning candles.[55]

Not by chance did the crowd attack the dean's house; it was the dean who headed the ecclesiastical court that had ruled against the count's officers. It was these officers who were said to have incited the mob. The clergy responded after the riot by declaring interdict in the town and its suburbs, stripping the main altar of the Virgin bare, even placing the crucifix and shrines on the pavement. Priests pronounced excommunication and anathema daily from the pulpit.[56] However, further trouble ensued:

The sacrilegious were not made contrite; rather their hearts became more hardened. On the fifteenth day after the perpetrated sacrilege, while one of the priests, as had been decreed, was pronouncing the word of the malediction, a loud and mocking clamor of the surrounding crowd entered into the church. For this reason, the Lord was all the more provoked to anger. Therefore, a fire was started by his anger, beginning from a certain lower quarter along the bank of the river Eure which moved up to the city and destroyed almost all of the homes of the sacrilegious right up to the cloister of Blessed Mary. . . . On the very week after the act of sacrilege, the dean and almost all the canons with him approached Philip, the illustrious king of France. . . . In the following week, on a pilgrimage, he [the king] visited the church at Chartres.[57]

The clerical writer described the fire before the king's visit, apparently for dramatic effect, although the visit seems to have occurred before the fire. This inversion allowed the writer to describe the fire immediately after the anathema, and hence to attribute the fire to the Lord's punishing fury against the rioters.

The king had come at the request of the dean and canons during the second week after the riot to view the damage. He left 200 livres donation to the building works, and rushed off after only an hour, leaving three knights to investigate the canons' grievances and report to him. The king was probably ill at ease in a town wracked by such violence as was immediately visible from the church steps. And he undoubtedly did not relish punishing the townspeople of Chartres, since he had gained advantages elsewhere by siding with townspeople. Later in Paris, the king himself publicly declared his judgment that the marshal and the provost should pay the dean and certain other canons for the pillage and damage. Since the king had previously urged the chapter to leniency and the chapter had committed themselves to comply,[58] the clergy canceled the excommunication and interdict, and restored the cross and shrines to their usual locations. However, as soon as Bishop Renaud returned from the Albigensian crusade, a delegation of canons went to the king to ask him to set the still undetermined amount of the fines against the marshal and provost.[59]

The king declared that the malefactors . . . should be fined 3,000 Parisian livres in coin: of this sum, 500 livres he ordered to be paid to the bishop, 1,500 to the chapter, of which the dean should have sixty livres specifically imposed for the injury done to him. He ordered that a third part from the aforementioned penalty be paid to his treasury. Moreover, the king decreed that the malefactors and their accomplices, concerning whom the chapter had made express complaint by name, in a procession to the church in sight of the entire

population, should be stripped, carrying rods in their hands, and when the procession was finished, they should be beaten before the altar of the blessed Virgin Mary.[60]

Apparently the bishop sent a contingent to Paris to plead with the king to set this extraordinarily large financial penalty. The king cooperated but charged dearly, retaining 1,000 livres, or one-third of the fine, for himself. The king was careful not to fine the count of Chartres directly, but the count must have actually paid the fine, since it is unlikely that his officers could have come up with such huge amends themselves.

The cathedral clergy did not want the townspeople to forget or to repeat their transgression, and inaugurated yearly liturgical penance for the riot. For years afterward, crowds of inhabitants came to the cathedral on the anniversary of the riot on the second Sunday in October to attend a ceremony of expiation at the altar of the Virgin Mary.[61]

The Mid-Thirteenth-Century Crisis

However, nothing appears to have been settled at Chartres. Five years after the riot, in 1215, violence erupted again over the same issue. The count's provost captured a number of the chapter's serfs and horses. He tortured and hanged one of the serfs. A court composed of the bishops of Paris, Orléans, and Senlis fined the provost 300 marks (later adding thirty more livres), and required that, to replace the murdered serf, the count's provost, marshal, and castellan should personally deliver one of the count's serfs to the cathedral to replace the dead serf in a most extraordinary manner. They were required to carry the replacement serf on a litter to the cloister gallows and thence to the cathedral— enacting the resurrection of the dead serf.[62]

The continued enmity between the counts and the chapter reached a climax in the mid-thirteenth century. In 1249, the provost of the countess once again captured and hanged one of the chapter's serfs. The dean ruled that the countess and the provost should pay the chapter 150 livres in fines and damages, and that the provost should march naked in the streets to the church and endure public whipping before the cathedral altar of the Virgin Mary. Shortly thereafter, two of the countess's men dragged a cleric from the cathedral and held him captive. The dean imposed an even harsher punishment: the countess and provost had to pay a fine of 400 livres, and the provost had to undergo three penitential processions and whippings. In addition, the dean ordered the two men responsible for the abduction banished from the district to live forever in the Holy Land.[63] In 1252, the dean and chapter asked the bishop of Orléans to extend excommunication of the countess of Chartres to his diocese.[64]

Hostilities continued unabated. In the following year, 1253, crisis brought violence again. The countess's provost and the chapter dis-

puted jurisdiction of a street bordering the cloister. The townspeople's sympathies remained with their secular officers, since the chapter excommunicated the provost and interdicted the town.[65] A melee occurred in which the count's men killed two of the chapter's *avoués*. Cantor Renaud de l'Épine was appointed arbitrator of the jurisdictional dispute, whereupon he was murdered on the cathedral steps when he was on his way to matins, by a knight named Colinus and his accomplices.[66] The chapter and bishop became frightened for their lives and left Chartres for five years, residing first at Mantes and then Etampes.[67] The archbishop of Sens banished the canon's murderer, Colinus, and an accomplice, who was Colinus's brother and a canon of Chartres, for fifteen years.[68]

The duplicity of the town tradesmen in this is especially revealed in the king's subsequent actions. The chapter appealed to the king, who took twenty town burghers hostage and forced two hundred members of all the trades, the agents of the count, and the "people" to swear they would do no further harm to the chapter.[69] Apparently in order to feel safe, the canons felt obliged to purchase the right to close the cloister from the count for an exorbitant 1,000 livres, as well as a yearly payment of twenty livres.[70] With this agreement, and with permission from Innocent IV to hold matins at five in the morning because of the insecure condition of the cloister at night, the chapter returned in 1258.[71]

The Defensive Constructions

From very early in the construction, the architects planned and built in the cathedral a network of passageways suitable for protection and defense. While some of these passages may never have been so employed, others certainly were.

Van der Meulen's reconstruction of the cathedral's passageways is based on a variety of archaeological and documentary evidence (plate 5).[72] Bridges are known to have connected the bishop's palace, the chapter's meetinghouse, and the chapter's library with the discontinuous "dwarfs' galleries" at the east end of the church. From these raised outer passages, one could reach the interior floor of the church by way of stairways inside the eastern buttresses (plate 6). Stone bridges still connect the northern flank of the choir to the sacristy, and the floor of the ambulatory with the chapel of Saint Piat, formerly the chapter's meeting house.[73] Van der Meulen also showed that originally a bridge connected the confessor's chapel to the chapter library, and it is especially suggestive that the chapter's meetinghouse and library were connected to the quarters of the commander of the bishop's troops.[74]

The existence and purpose of some other passageways are conjectural. Doors are still visible, one above the other, on the exterior of the

third buttresses east of the transept on both sides of the choir (plate 4). In the interior of the church, in approximately the same location, doors below open onto the floor level and doors above open at the springing of the vaults. Each pair of upper and lower doors are connected by spiral staircases within the buttresses. Van der Meulen conjectured that wooden bridges may have been planned to connect these doors from the buttresses to ancillary buildings, and from the choir to a wooden choir screen that separated the canons from other worshipers in the cathedral. He demonstrated that the lower door in the northern buttress was originally connected by a bridge to the chapel of Sts. Sergius and Bacchus by way of the *Chambre des Comptes*. John James, however, found no evidence of wear on the thresholds of buttress doors,[75] which may suggest they were never put to the use for which they were intended.

Stairways from the floor level to the roof level mount within the two towers that frame the main north and south porch doorways. Scattered up the stairways, slitted window openings allow views on to the porches and on to the cathedral interior.[76] Another set of stairs ascended from the floor to the roof at the inside juncture of the aisles and western towers, giving access to the triforium and the aisle roof, as did the other six buttress-tower stairways, so that one could ascend to those upper passages from any of eight stairways around the interior perimeter of the building, and presumably could then choose either to go down again at another location or out over bridges to other buildings.[77]

The set of eight inside-buttress stairways is an unusually large number for Gothic cathedrals, and the open doorways high up in the fabric with no apparent purpose are almost unique, suggesting a purpose beyond the usual accommodations for building and maintenance workers.[78] Since the conflict between the canons and the count's officers was already intense enough to warrant royal and papal mediation before the reconstruction began, the canons probably built this network of passageways partly for protection and defense.

We know that the canons wanted the cloister enclosed in a wall for their defense. They refused to return from voluntary exile in 1258 until they had purchased from the count the right to build it.[79] They continued to pursue this goal, buying the necessary land throughout the remainder of the thirteenth century, but they did not finally succeed in completing the wall until the fourteenth century.[80] The count responded to the threat of the wall's fortifications by building counter-fortifications adjacent to those of the chapter at every possible portal.[81]

A New Interpretation of the Trade Windows

The count and countess repeatedly challenged the power of the bishop and canons. Conflicts between the townspeople and the bishop and

canons were further evidence of this power struggle. While the bishop
and chapter united against their secular enemies and the threat of mu-
nicipal organization, they increasingly jockeyed for power and privilege
among themselves, with the chapter emerging as the superior force.
These antagonisms appear in the very sources cited by historians and
art historians who deny that conflicts existed in the thirteenth cen-
tury.

The main cause for all the contention and conflict between the ec-
clesiastics and the town was the churchmen's adopted serfs or *avoués*,
many of whom were artisans and merchants. This unusual feature of
the social relations at Chartres coincides with the extraordinarily large
number of innovative trade windows in the cathedral. In view of the
rebellions and smoldering resentment of the townsmen, I believe that
the images in the windows of tradesmen and merchants represent in-
dividuals and groups of individuals who worked in the cloister, the
cathedral *avoués*. They could have been compelled to assist in the
building fund, or they may have voluntarily given over part of their
profits for such windows. In any case, the windows were a new inven-
tion, and their meaning in this innovative moment may not have been
what the formula they established came to mean later and elsewhere.
The changing social formation which ultimately caused the creation
of trade windows was fraught with animosity and conflict at Chartres.
The windows present idealistic representations of the peaceful labor of
city workers in support of the church. At Chartres, this statement of
an ideal could have made sense only within the cloister. For the towns-
men outside of the cloister, it was intended as a visual lesson in Chris-
tian piety.

The Financing of the Cathedral

Art historians have yet to reconsider the financing of the Gothic cathe-
dral of Chartres on the basis of Chédeville's economic study of the
diocese.[82] The new literature on Chartres still reiterates the traditional
story of the cathedral's financing derived from a thirteenth-century
miracle text.

The Miracles of the Virgin

The crucial passage occurs in the first of twenty-seven miracles in a
collection entitled *The Miracles of the Blessed Virgin Mary in the
Church of Chartres*, presumably written by a cleric of the cathedral
around 1210.[83] According to this text, fires destroyed not only the ca-
thedral but the town as well. The people were in despair, especially
because they believed that the Virgin's veil, the most precious relic of
the cathedral, had been consumed in the flames. A papal legate was in
town at the time to help settle the chapter's dispute with the count

over its adopted serfs. After the fire, he spoke to an assembly of the townspeople and pleaded for the rebuilding of the sanctuary. While he spoke, the canons, who had saved the relic from the flames, had the veil of the Virgin carried up from the crypt, and the people's despair turned to joy (plate 20).[84]

According to the *Miracles* text, the survival of the veil was a sign that the Virgin herself permitted the old building to burn because she wanted a new and more beautiful church to be built in her honor. Overjoyed at the reappearance of the Virgin's veil and accepting it as a sign of her desire for a new church, the people pledged their possessions they had salvaged from the fire for the rebuilding of the cathedral. All social groups contributed to the project. The bishop and chapter contributed most of their revenues to the construction for three years.[85] At the end of that time, the money ran out. The Virgin then performed other miracles throughout the diocese and even beyond in order to attract pilgrims to donate money, products, and free labor for the project.[86]

In such miraculous hyperbole, historical verity is hard to identify. The *Miracles* text encourages the reader to make offerings at the altar of the Virgin, presumably because these gifts were normally assigned to the clerk of the works. Despite the fact that the text contains miracles invented some fifteen years after the fire to raise money to carry on reconstruction, scholars have consistently accepted the text as an accurate, dependable historical source.[87]

As Chédeville has shown, the miracles were reported primarily in the diocese outside of the town (plate 21)[88] and hence were intended to raise more income for the reconstruction from this broader constituency. This reaching out for funds beyond the town itself may be related to the town riot of 1210, a time when the population of the town of Chartres itself was in no mood to make donations to the cathedral. Just at this time, according to John James's calculations, construction on the cathedral dropped off dramatically (plate 22).[89] And, as Warnke correctly observed, the enormous fine that the king indirectly charged the count after the riot of 1210 was undoubtedly intended to replenish the building fund.[90] Local social controls and economic resources were breaking down, motivating the chapter to bolster the economy of the town and the building fund of the cathedral through the collection and dissemination of miracles that would increase pilgrimage.[91] According to the *Miracles*, the famous Cult of Carts, which first took place at Chartres during the rebuilding of the west facade in 1144, recurred after the fire.[92] The promulgation of such events in the *Miracles* must not be seen merely as a means of stirring the diocesan poor to further donations of raw labor. What was needed were funds for artists and artisans more accomplished than they. The repetition of the Cult of the Carts and its depiction in one of the aisle stained-glass windows

was more importantly an indirect appeal to the super-rich for dona-
tions.[93] With the same strategy, the canons also traveled about France
and even to England, exposing their sacred relics to the population at
large to raise money for the rebuilding.[94]

The Support of the King of France

The relationship between bishop and king seems to have functioned to
the temporary political advantage of both. However, the king definitely
had the advantage in the long run, as he increasingly gained financially
by taxing the cathedrals of his realm, while at the same time taking
over more and more land and privileges that had been their patri-
mony. The king had the opportunity to affect the choice of new bishops
at several points in the episcopal election process.[95] After the bishop's
consecration, the king received the bishop's fealty and then the bishop
received the regalia from the king, who held the rights and insignia of
unoccupied sees.[96] As head of the supreme court of his realm, the king
frequently judged controversies brought before him by the bishop and
chapter of Chartres, usually ruling in their favor.[97] The king main-
tained his role as protector of the church at Chartres,[98] and enacted his
royal judicial power by confirming many of the chapter's and bishop's
contracts.[99] Bishop Renaud was a close relative of the king and went
on crusade with Philip Augustus in 1191, and again in 1210 and
1213.[100] He stood beside the king against the pope in the king's marital
crisis in 1200, when Bishop Renaud was one of thirteen bishops of the
realm who refused to publish the papal interdict and suffered tempo-
rary papal suspension of their episcopal functions.[101] Bishop Gauthier
was a confidant of Queen Blanche.[102] He supported Louis VIII and
Queen Blanche in their wars,[103] and he served on the *conseil* of St.
Louis.[104] Thus, the kings saw to it that the bishops were allies, the
bishops helped to fight the kings' battles, and the kings supported the
chapter and bishops in their quarrels with the counts, countesses, and
local nobles. Meanwhile the kings slowly and inexorably assumed feu-
dal overlordship of the region.[105] So far as we know, all the royal house
contributed to the cathedral during its entire building period was 200
livres.[106]

The Changing Economic Situation of the Bishops

The two bishops during the building period, Bishop Renaud de Mouçon
and Bishop Gauthier, both came from the high nobility and had mon-
astic backgrounds.[107] As bishop of Chartres, each in turn held a large
episcopal domain in the diocese, and commanded powerful knights as
vassals.[108] These bishops enjoyed the king's sponsorship of their ap-
pointments, and his political support after their election.[109] Both re-
turned these favors, supporting King Philip Augustus, Louis VIII,

Queen Blanche, and King Louis IX by actively assisting them in their military campaigns, undoubtedly at considerable expense. Bishop Renaud must have pressed his economic exploitation of the town to the limit when he prepared to go on the Albigensian crusade in 1210. However, according to John James, Bishop Renaud's return from the Albigensian crusade late in 1210 marked the beginning of increased building activity, suggesting that the bishop may have undertaken the crusade with the expectation of gain, and returned with considerable plunder.[110]

The reign of the two bishops spans a long period of time during which their financial circumstances seem to have changed dramatically. The episcopal income was more or less fixed, with little chance for augmentation,[111] while inflation increased the cost of episcopal pomp and ceremony.[112] Early in his reign, Bishop Renaud built an episcopal summer palace and, in 1190, he gave the chapel of Sts. Sergios and Bacchos, adjacent to the cathedral, to the canons.[113] This generosity changed to dangerous avarice after the fire of 1194, when he undertook to sell ecclesiastical appointments and was punished for his simoniac misuse of collations.[114] The enormous personal indebtedness that the next bishop, Gauthier, accumulated during his episcopacy is important evidence of the inadequacy of his personal income to meet his official needs.[115] The income of the bishops seems to have been more than adequate before the rebuilding of the cathedral, as evidenced by Bishop Renaud's munificence, and less than adequate toward the end of the reconstruction, to judge from Bishop Gauthier's debt.

The Trades' Economic Contribution to the Cathedral

The town of Chartres was small—according to the latest estimate, the population of the town and its suburbs in the thirteenth century was less than 7,000, compared to much larger estimates for other contemporaneous cathedral towns: 40,000 for Paris, 30,000 for Rouen, 20,000 for Arras, and 10,000 for Reims.[116] The backwardness of the town economy has already been described. Chédeville shows that Chartres did not participate in the "grand commerce" of the period,[117] and that production at Chartres and the little towns of the diocese was almost entirely for local consumption. At Chartres, where the trades serviced such a small population, and remained dependent on different feudal overlords, how could they have accumulated sufficient funds to pay for a window? The answer would, of course, depend on how much a window cost, and we do not know that. There is some indication that a lower-story lancet might have cost at least 30 livres or 7,200 deniers.[118] That would seem to be an excessive amount of money for small numbers of men in a small town recently ravaged by fire to be able to accumulate. Both the varying profitability and the relationship to the cathedral of different trade groups are at issue.[119]

The Chapter's Increasing Revenues

The chapter used the traditional methods of broadening the symbolic support for the building project that Warnke has discussed.[120] But the building went ahead rapidly primarily because the economic expansion of the early decades of the thirteenth century brought increased revenue to the canons.[121] The renowned wealth of the diocese of Chartres was already evidenced by the cathedral's support of its large chapter of canons. Although they did not take a vow of poverty, most canons of Chartres were not wealthy by virtue of inheritance.[122] The canons of Chartres were less aristocratic than those of other chapters, since many of them were from local, lesser nobility and even burgher parentage.[123] Yet collectively the seventy-two canons of Chartres formed the largest and wealthiest cathedral chapter in France,[124] due primarily to the chapter's diocesan wheat lands. If there had been a major local wheat-crop failure and ensuing famine, it would have been possible that the chapter's ability to pay for construction stopped suddenly after three years, as the *Miracles* text claims. But we have no record of a local crop failure.[125]

Documents show that the chapter's income was increasing not only because of the economic rise of the period. Even before the cathedral burned, the canons had launched a long-range effort to increase their income which continued into the thirteenth century. They focused on the rich lands controlled by the chapter's four provosts, secular administrators who had increasingly extracted surpluses for their own benefit.[126] The canons took away the provosts' fiefs, first by revoking their jurisdictional rights in 1171—heavy amends were one of the most effective means of skimming off excess profits[127]—and then, in 1193, by eliminating the provosts entirely and adding their revenues to the income that the canons divided amongst themselves as prebends.[128] According to the boast of one former bishop, this doubled the prebend revenues.[129]

The canons' campaign to increase their income after 1194 was certainly in part prompted by the need for building funds, for when the drain of reconstruction began to be felt, the chapter actively sought to regain alienated tithes.[130] Both the increasing number of bequests and donations recorded for the period in the necrology, and the increasing payments to the canons to maintain the offices and memorial services, suggest the canons' awareness of the economic value of their prayers.[131] They clearly sought to increase the yield of their cult through the extraterritorial transportation of relics,[132] the invention of new miracles enhancing the relics' efficacy, and written claims for the universal importance of the site.[133] The canons' efforts to raise money peaked around 1210, which suggests that the riot of 1210 may have been caused by unusually burdensome taxation of the town by the canons and bishop.

The Material Base of the Diocese

How then did this little town manage to build its colossal cathedral? The cost of the building remains undeterminable.[134] It must have been a major drain on the local economy, judging from the chapter's aggressive efforts to raise income, the bishop's increasing impecuniousness, and the townspeople's increasing animosity. The enormous amount of building going on concurrently in northern France greatly diminishes the likelihood of sizable support from outside the diocese.[135]

The bishop and canons' main economic resource, however, was not the town, or contributions from outside, but the grain grown on the fertile land of the diocese. The local economy reached its apex when the region's arable land was completely cultivated sometime in the second decade of the thirteenth century, the decade when the cathedral reconstruction was essentially completed.[136] Therefore, the grain income recorded in the *Polypticon* of 1300 represents a fairly accurate record of the financial resources of the bishop and chapter eighty years earlier, during the building period, although value estimates would need adjustment due to intervening inflation. In 1300, the bishop took in 796 muids (1,575 liters) of grains from tithes and *champarts* (lord's tax on harvests), worth an estimated 1,500 to 2,500 livres and had other income of around 1,700 livres.[137] The income of the canons is more difficult to estimate, due to the different information available. The canons had 3,000 to 3,500 hectares of arable land worth an estimated 5,000 livres of income in 1300, plus tithes and champarts whose combined value has not been calculated, but which must have been greater than that of the bishop, and other revenues worth around 1,100 livres.[138] Chédeville's maps of the cereal production in the diocese and the chapter's share of that production in 1300 are revealing (plates 23 and 24).[139] It was the cultivation of grains which provided the material basis for building the cathedral.

Conclusions

The bishop and canons, who felt the absolute necessity of rebuilding, aimed to rebuild rapidly on a scale competitive with other major cathedrals in process of construction. The high priority given the rapid reconstruction of the cathedral created a real economic squeeze on local resources that evidenced itself in various ways around 1210 and thereafter. While we cannot say precisely how much the cathedral cost, we can see in the documents how the financial strain of rebuilding affected the canons, the bishops, and the townspeople. The chapter at Chartres had just doubled its income when the cathedral burned, and received royal support in its power struggle with the count and his provost. At the same time, the canons prepared for the economic campaign necessary to reconstruct the cathedral by solidifying their rights and privileges through confirmations from the pope and the dean of

Sens. The canons must have paid for most of the rebuilding themselves through the exploitation of their diocesan, labor-intensive agricultural production primarily devoted to grains. One can say with confidence that the cathedral was ultimately paid for by the labor of peasants and serfs in the surrounding wheat fields. In this sense, the traditional photograph of the cathedral taken from across the wheat fields of Beauce, so that the building seems to arise from the wheat, conveys an unintended symbolic truth (plate 1).

Competition for power and the need for increased income were major concerns of the ecclesiastics at Chartres who ordered the imagery that filled the windows of their new cathedral. The apparent lack of complete coherence in the iconographic content of the stained glass may not be due to the failure of contemporary scholarship to comprehend a programmatic scheme, or the vagaries of donor preferences, but rather to the shifting alliances and purposes of the canons and bishops during the years of construction. The chapter was the most powerful political entity in Chartres. Undoubtedly, one or more canons were in charge of the building works, as had been the case in the past.[140] However, the canons were not the only ones in a position to determine the window imagery. The bishop was still a major power with close royal ties, noble connections, and the right to nominate the dignitaries who administered the cathedral.[141] Any ideology discernible in the imagery is likely to have been variously conditioned by the interests of the bishop and the canons.

CHAPTER THREE

THE OFFERING OF BREAD

The fervent spirit ... obeying the divine commandment through love, not necessity, will offer warm and very pleasing bread to God the Father, and he will receive a blessing.

Pierre de Celles, *Liber de Panibus*, ca. 1175[1]

The Bread Scenes

Piles of bread appear in five prominently located windows of the trades at Chartres (plate 25). No other French cathedral features bread to such a degree. This unique aspect of Chartres Cathedral has always been interpreted to signify that local bakers donated the windows, although there is no documentation to support the claim.[2] I will argue that the bread imagery has a documented explanation in the medieval practice of offering bread in the churches of Chartres. The importance of bread at Chartres is exemplified by the long treatise about bread excerpted above, written by Pierre de Celles, before he became bishop of Chartres.

One huge basket of bread is the centerpiece of all the stained-glass imagery in the cathedral (color plate 1 and plate 26). At the base of the central window in the apse clerestory, Bay 120, two men are depicted carrying the bread basket. Above this basket of bread, in ascending registers, are the Annunciation, the Visitation, and at the top, the Virgin enthroned with the Christ child (plate 54).[3] At the base of the adjacent window, Bay 119, two men stand on either side of a similar basket of bread, and one of them holds up a loaf from the pile (plate 28). Above them, in ascending registers, are Moses at the burning bush, Isaiah enthroned (plate 29), and, at the top, a censing angel (plate 69).[4] A third basket of bread is depicted at the base of the center window in the apostles' chapel, directly east of the choir, Bay 34 (plates 30 and 31). The basket rests on the ground between two men, one of whom sells a loaf from the table in front of him to a man who carries more bread in his sling. To either side, bakers prepare the loaves for baking. On the

left, a man kneads the dough and on the right three men shape loaves for the oven (plates 32 and 33).[5]

Similar scenes of men making bread, transporting it in a huge basket, and selling it appear in two south-nave clerestory windows near the west front. At the base of window Bay 68, two men carry a basket of bread, and in ascending registers above are a small scene of a baker at work and a large figure of St. James Major (plates 36 and 37).[6] In the adjacent lancet, Bay 69, a man purchases a loaf at a bread stall beneath a large figure of St. Peter (plates 38 and 39).[7]

A similar basket of bread appears in the center of the south porch carved in stone on the upper register of the trumeau socle. A nobleman kneels beside it, while two smaller figures on either side of him hold out loaves (plates 41–44). The figures on the lower level are badly damaged, but one can still see a loaf of bread on a table in front of one of the seated figures (plates 45 and 46). The famous trumeau figure of Christ holding a book and giving a blessing surmounts the bread scenes on the south porch socle (plate 40).[8] Most art historians have maintained that the basket of bread on the south porch was destined for charitable distribution,[9] while the baskets of bread depicted in the windows were simply the products of bakers. Yet one wonders if these almost identical baskets could have had such different meanings.[10]

Although these bread scenes were probably installed in the cathedral at different stages of its construction, the coordinated locations suggest that they are conceptually connected. On either side of the trumeau with its basket of bread, the embrasures of the central portal contain column statues of the apostles; similar statutes in the embrasures of the left portal represent martyrs, and in the embrasures of the right portal, confessors (plate 48).[11] Thus the sculptures of the portals portray, from left to right, martyrs, apostles, and confessors, matching the dedications of the three main ambulatory chapels—the chapel on the left was dedicated to the martyrs, the center ambulatory chapel to the apostles, and the chapel on the right to the confessors.[12] The tympana of the side portals also depict martyrs and confessors. Hence there is a deliberate coordination of the imagery of the three portals with the dedications of the ambulatory chapels.

Looking at a plan of the cathedral (plate 25), one can see that the three south entrance portals and the three eastern radiating chapels align at the ends of central axes that turn at a ninety-degree angle before the choir. The side entrances led thereby directly along the sides aisles of the choir to the side chapel altars. The center entrance led to the crossing, where one had a clear view of the choir clerestory over the choir screen and of the main altar through the doors of the choir screen. The images of bread baskets are along the central processional axes that lead to the main altar, and by the side aisles to the chapels.

This was a liturgical coordination when the chapels were the destination of vespers processions before feast days.

The matching of the portal iconography with the chapel dedications confirms that the south porch was conceived as a main entrance to the thirteenth-century cathedral. This was a practical arrangement, because it faced the largest exterior open space around the cathedral, the area where cathedral fairs occurred periodically. The two bread scenes in the south nave clerestory appear just inside the west entrance. Hence, bread scenes appear in the cathedral at its main public entrances, over the main altar in the choir, and in the easternmost chapel. The central feature of bread in the cathedral accurately symbolized the importance of bread to the local economy.

The Importance of Bread at Chartres

Bread was the primary product of the region. Most of the labor force in the diocese was engaged in grain cultivation,[13] and bread made from the winter crops of wheat and rye was the staple diet for everyone.[14] Wheat of the best quality was a luxury food in the eleventh through the thirteenth centuries. The lower classes ate mostly rye and dark bread.[15]

The bishop and chapter, who were by far the largest grain growers in the diocese, kept close control of their wheat. The canons' spacious new granary, Loëns, which they had rebuilt in the thirteenth century on the north side of the cathedral, was filled with the finest grains of the diocesan farms (plate 19).[16] The granary stood next to the chapter's prison, and together they attested to the canon's immense power over the region.[17]

Storing of grains did not always successfully avoid mildew and rot. As a result, many people suffered from *mal des ardents* or ergot after eating bread made from fungi-infected rye grain.[18] The problem was so great that the chapter established a hospital in the cathedral crypt, especially for the treatment of the disease.[19] Further health problems must have been caused by the medieval custom of adding different fillings to dough such as mashed or powdered beans, clay, even sawdust to stretch the use of precious grains at times of poor harvests.[20] Hence the quality of the grains used to make bread was crucial to health. The lower the economic status of the individual, the more likely he or she was to eat bread made from badly stored or fouled grain.

Bread was not only the basic food; it was also used instead of money to pay many obligations, such as various taxes, tithes, procurations, food and lodging (*gîtes*), canonical distributions, vassals' wages, and different payments to parish priests.[21] Although at Chartres the money economy was well established, these traditional payments of bread persisted.

Of all the different taxes paid with bread, the most common was the tax called *cens* which serfs, colonists (*hôtes*), and minor vassals paid for the use of their lord's property.[22] Small amounts of bread, chickens, and deniers frequently were required to pay the *cens*.[23] This was a payment in recognition of the lord's suzerainty.[24] At Chartres, bakers paid most of their taxes in bread, including, frequently, their stall tax and sales taxes.[25] The *fournage* tax for the use of local ovens was often paid in bread.[26] Tithes were also paid with bread. In an agricultural region such as Chartres, most of the tithes were divided into large and small tithes (*grossae et minutae decimae*) and firstfruits (*primitiae*). Loaves of bread were part of the small tithes.[27] The practice of paying obligations with loaves of bread was not unique to Chartres.[28] Even the king exacted periodic payments in bread and wine from his subjects in Orléans and later in Paris to compensate him for his stabilization of coinage.[29]

Because bread was the basic food, it ranked with wine as the item most frequently specified for traditional honorary payments, such as *procuration* and *gîte*.[30] The canons and clerics who took part in lengthy liturgical processions and ceremonies sometimes received specified types of bread and other refreshments during intermissions.[31] The canonical distributions, that is, the canons' share in their own common income, as distinguished from the income they received from their prebends, included a regular allotment of bread,[32] plus bread distributions paid to canons who performed specified liturgical services.[33] Bread is frequently mentioned as a means of partial payment for services rendered by serfs, vassals, and clerics.[34] Included in the fiefs that the bishop of Chartres contracted to his carpenter, his janitor, his vine keeper and to the clerks and lay servants of the choir was the regular payment of a specific number of loaves of different types and extra loaves when the bishop was in town and on specified feast days.[35]

The ubiquitousness of bread payments is striking. Such payments in kind are usually associated with a closed economy, and are generally thought to have passed out of existence with the rising use of coinage in the twelfth century. The continued importance of bread as a means of fulfilling obligations at Chartres symbolized the people's ties to the wheat land, and to each other through feudal payments.

The importance of bread at Chartres found theological expression in the treatise entitled *Liber de Panibus* which Pierre de Celles wrote for John of Salisbury when the latter was bishop of Chartres (1176–80).[36] Pierre de Celles expounded upon the exegetical significance of biblical events related to bread in keeping with the long medieval scholarly tradition of typological analysis. But his book is unique because he used bread as the organizing principle of his text; it contains twenty-seven chapters, twenty-five of which he named after different kinds of bread. He used each kind of bread mentioned in the Old Testament as

a springboard for a theological discussion of the superiority of the New Testament bread, which is the body of Christ, explaining how the Old Testament breads anticipated the true Christian bread of salvation. Pierre de Celles succeeded John of Salisbury as bishop of Chartres in 1180, and died shortly thereafter, in 1181.[37] His successors, the builder bishops Renaud and Gauthier, undoubtedly knew his *Liber de Panibus*. The book presents an elaborate, learned exposition of the importance of bread to the Christian faith. It is, therefore, the intellectual counterpart to the central imagery of bread in the cathedral which Pierre de Celles's treatise may have inspired.

The Bakers at Chartres

Considering the importance to the economy of Chartres, it is surprising to find that bakers did not have a good reputation there. In the twelfth century, Gilbert de la Porrée, a chancellor of Chartres, remarked to John of Salisbury that in his experience all the incompetents and unemployed of the town tended to drift into the bakers' trade, because it was thought to be an easy one.[38] In fact, bakers were exploited and held in strict feudal dependency until late in the thirteenth century at Chartres, undoubtedly because of the importance of bread to the area's economy.[39] The serfhood of bakers is attested by the outright gift of a number of them to abbeys by the count in 1121 and by the vicomte in 1226.[40] For most of the thirteenth century, the town bakers had no trade guild. There is no evidence that the lords of Chartres even appointed a master over their bakers.[41] They operated as individual producers under direct control and taxation of their lords. The lords charged the bakers for their grain, and charged them for mill and oven use.[42] The bakers also had to pay taxes for the transportation of grain and bread on roads and bridges, sales tax and stall rental, in addition to tithes, feudal head taxes, and so on.[43] The trade was not an economically advantageous or attractive enterprise.

The Chapter's Bakers

Most bakers in the town were subject to the count, but some bakers worked for the various abbeys and minor feudal lords in the town. Yet others worked for the canons and bishop within the confines of the cloister. Most of our knowledge of the chapter's bakers comes from the *Polypticon* of 1300,[44] which reveals a highly developed system for the administration of the chapter's wheat and the distribution of bread made from it, directed by a canonical officer known as the *chambrier*. He supervised the chapter's storehouse, the Loëns,[45] and directed distribution of the "bread of Loëns" to each of the canons.[46] Two clerks of Loëns registered grain stores, and kept accounts of wheat delivered to the bakers of Loëns and of bread to the ovens.[47]

The highly systematized record of receipts and their theoretical as-
signment to celebrants of particular liturgical rites recorded in the
1300 *Polypticon* undoubtedly represents the accumulation of customs
over a long time, some clearly dating back to the early thirteenth cen-
tury.[48] For example, distributions of the chapter's bread for attendance
at Matins services already were established in the twelfth century.[49]
The measure of Loëns wheat goes back at least to 1119.[50] There were
four ovens in the cloister, including the bishop's and canons' own
ovens, verifying a large production of bread within the cloister.[51] It is
likely that the bakers appearing in the windows are cloister bakers,
under the direct control of the canons and bishop.

Types of Bread at Chartres

Because the sizes and shapes of the loaves depicted in the windows
vary, we need to know the types of bread produced at Chartres and their
uses, in order to discern the significance of the images. Bits of infor-
mation about the types of bread at Chartres are found scattered in the
sources. People ate different types of bread according to their social and
economic status. Simple, small, dark loaves made of the coarsest,
cheapest grains were the food of the humble, the poor, the peasants,
and indigents. The bread worth a denier was the common, everyday
bread of the townsmen and better-positioned workers. Large, white
loaves of the finest wheat were the food of the upper classes, who also
ate a variety of specialty breads made in unusual shapes and of expen-
sive ingredients. These different sizes and types of bread also were stip-
ulated for different types of payments.[52]

The clearest description of the types of bread made in thirteenth-
century France appears in Parisian bakers' statutes, recorded by the
king's provost, Etienne Boileau, in 1268.[53] Bakers in Paris made three
sizes of bread for ordinary use, distinguished by price: the *doubleua* at
two deniers, the *denrée* at one denier, and the *demie* at one obole. The
size shifted according to the price of wheat, while the price remained
constant.[54] In addition, there were two special types of bread distin-
guished from ordinary loaves by their size: (1) bread for presentation,
larger than ordinary bread and a delicate white (called *gâteaux* or *gastel
à presenter*), and (2) bread for gifts to the poor, for presentation by vas-
sals to lords, and for taxes, smaller than ordinary loaves (called *echau-
dées* or *oubliés*).[55]

The evidence from Chartres suggests that very similar types of bread
were made there. Average loaves costing one denarius, sometimes
called *mediani*, were made at Chartres, like the *denrée* in Paris.[56] Fine
white loaves, called *panes consuetudinales* at Chartres, as well as
loaves presented at Christmas, Easter, and Ascension, must have re-
sembled the Parisian *gastel*.[57] Apparently similar were breads called
alberon and *candidus*, used to meet different obligations where the

purpose was to honor or treat the recipient.[58] Special cakes called *tortelli* (made of flour, eggs, and sometimes ground meat) also appear in the charters for honorific purposes.[59] Another specialty bread was the *canistrellos* or *canistrum*, made in the shape of a basket used to hold blessed bread.[60] *Panes natalitius* were Christmas breads made for vassals' presentation in recognition of their lord's dominion, and probably were like the *echaudées* in Paris, which were smaller than ordinary loaves. Similar small loaves were served as a snack for the canons on processions to the suburban church of Saint-Chéron.[61] As in Paris, breads called *oubliés* were used as *cens* payments to overlords.[62] The common *michia nigra*, made from rye, and *michia alba*, from wheat, appear as breads paid to vassals.[63] Accordingly, bread presentations in church varied in type and in purpose.

Bread Presentations at Local Churches

Bread presentations in church fulfilled different kinds of obligations: some were required church offerings, and others originally were based on secular, feudal taxes. Secular and ecclesiastic obligations are conflated in the documents, in accordance with their confusion in medieval practice. In principle, bread presentations to churches fulfilled three basic kinds of obligations: oblations, tithes, and customary payments.

Bread Oblations

Oblations were offerings of all kinds, regarded as compulsory, that the faithful made at churches during major feasts.[64] At Chartres, they frequently took the form of bread. For example, bread was part of the oblations presented to the prior of Clausum Villare in 1195 at the feasts of Christmas, Easter, and Pentecost.[65] Bread oblations were made in 1213 to the abbey of Saint Père and to the priest of Anet at Christmas, Easter, All Saints, and Ascension.[66] Bread probably was part of oblations even when the documents do not specify it, as, for example, the oblations presented to the priest of Chandai in 1142 at the five annual feasts of Nativity, Epiphany, Purification, Easter, and All Saints.[67] Presentation loaves at major feasts were usually large, fine white loaves, and the offering loaves destined for charitable distribution were smaller than ordinary penny loaves.

Bread Tithes

Loaves of bread formed part of the small tithes (*minutae decimae* or *menues dîmes*) that parishioners were expected to deliver to their parish church, along with small animals, wool, hides, fowl, goats, vegetables, fruits, etc.[68] These parish tithes frequently were ceded to secular lords and appear in twelfth- and thirteenth-century documents as

part of secular donations returned to ecclesiastical institutions.[69] For example, in 1125 a local lord donated small tithes, including a bread tithe, to the monastery of Sainte-Trinité at Tiron.[70] Where possible, tithes were delivered to the church to which they were due, usually during the Sunday mass.[71] The bread tithes were undoubtedly large in quantity at Chartres, and yet I have not found any evidence of the type of bread used for this important purpose. They were probably smaller than ordinary loaves, like those in Paris.

Bread Customary Payments

Customary payments, other than tithes and oblations, also were expected to be presented to local churches. Bread along with deniers and candles often were designated *altarium* and hence constituted revenues for a priest.[72] Most likely the deniers and candles were actually payments to the priest for blessing some bread for parishioners.[73] Bread, candles, and deniers were also sometimes paid to secular lords, but apparently as the result of the purchase or appropriation of church revenues.[74] These breads were probably the *mediani* or regular-sized loaves worth one denier, since the interchangeability of bread and deniers eventually led to the elimination of the bread payments in favor of money. Parishioners presented bread to their priest as an honorary payment at Christmas.[75] These were probably the *panes consuetudinales*, the large white loaves like the Christmas loaves in Paris.

Whatever the original nature of these different bread presentations may have been, whether secular or not, free-will or required offerings, they came over time to be obligatory presentations.[76] Bread payments to churches on feast days must have been very large at times, since many disputes arose over them between opposing claimants, especially between monks and priests.[77] The number of loaves must have been sizable when, in 1213, the monks of the abbey of Saint Père at Chartres and the priest of Anet, a parish church, settled their dispute over the parish oblation bread. The monks agreed to receive two-thirds of the bread, and the priest one-third.[78]

The Offering of Bread in the Cathedral

The sources speak of bread offerings to the parish churches, not to the cathedral. But considering the prevalence of the practice in the diocese, and the large amounts of bread owed to the chapter and the bishop, this lacuna seems to be due to the commonplace occurrence of the event and chance survival of documents. Besides, the cathedral functioned as a parish church for different groups of people. Parishioners of the little church of Cronis were required to go to the cathedral for Ascension day, and women seeking purification also went to the cathedral, except on the day when a priest attended their chapel.[79] The ca-

thedral seems to have been the parish church for the *familia* of the canons and of the bishop, including the *avoués*. When the cathedral functioned as a parish church, it must have received parish offerings.

There are other reasons to believe that the canons of Chartres received bread offerings at the cathedral. There were seventy-two churches and 155 villages and hamlets in the lands owned by the chapter, from which the canons received some of the *altarium,* as well as tithes, champarts, cens, capitation, taille, and high-justice amends.[80] In 1193, the part of this income which had been diverted to the provosts reverted to the canons.[81] The canons thereby gained the right to all the church presentations formerly handed over to the four ousted provosts. Documents show that the bishop and chapter sometimes returned rights to parish offerings to the parish priests, and sometimes did not.[82] The bishop received loaves on certain feast days. Some of his customary taxes were in yearly bread payments, particularly at Christmas, when he received seventy-one loaves from two villages, Mondonville and Disconfectura.[83]

Throughout the local charters, bread presentations are linked with major feast days. It was precisely on feast days that diocesan people were allowed to stop work and leave their parishes in order to go to the cathedral.[84] They must have come from the town and the surrounding villages with loaves to present to the bishop and chapter in the offering procession.

The Liturgy of Bread Offering

According to Jungmann, medieval bread presentations took place on feast days during the offertory procession at mass, following recitation of the Nicene Creed and accompanied by antiphonal singing of the choir.[85] By the ninth century, bread brought to church in this manner by the congregation for the Eucharistic meal was being replaced by small, unleavened wafers supplied by the clergy.[86] Concurrently, the original liturgical practice of offering bread and wine broadened to include all rural products as well as objects for ecclesiastical and domestic use.[87] The clergy tried to integrate all these presentations into the offertory procession. There was no distinction in intent or in disposition between voluntary gifts and prescribed offerings such as tithes required by the parish priest from his parishioners. Churchmen regarded all presentations as gifts to God and designated them oblations.[88] The historical change from bread offerings for every mass to bread presentations at festal masses took place as part of this larger transition. The custom of blessing bread after presentation underwent a concurrent transformation.

The bishop, who was usually present on major feasts, would have received and blessed the loaves offered at the altar. In his important study of bread payments and bread blessings in France, George Schrei-

ber found that the benediction of bread occurred throughout the diocese of Chartres.[89] His evidence comes from charters that record payments to parish priests for blessing bread, called *denariis panis benedicendi*.[90] He found indication of the feasts associated with these blessings at Luray in the Oise, where loaves of bread were part of the mass offerings on the four annual feasts, namely, Christmas, Easter, Pentecost, and All Saints, and at the mass for the dead on the second day of the week.[91] Schreiber postulates that the benediction of bread offering took place so ubiquitously that record of the practice was seldom necessary, and hence very little documentation survives.[92]

We do have a description of the bread-offering ceremony written in the thirteenth century by Bishop Durandus of Mende, who previously had been the dean of the chapter of canons at Chartres. According to Durandus, subdeacons and acolytes received the oblations from the people and carried them to the bishop, who touched the bread offerings as a mark of respect for the holy bread of sacrifice.[93]

The Distributions of Bread Offerings

Since the bishop and chapter no longer used bread presentations for communion, what did they do with the bread presented to them? They had three possibilities.

Eulogy Bread

The loaves were often blessed, broken into pieces, and distributed back to the congregation as eulogy bread. The practice was widespread throughout medieval France.[94] The *panes benedicti* in the charters must have been synonymous with eulogy bread, or *eulogia*, known from early Christian times when *eulogia* was blessed bread served at Christian communal meals called *agape*.[95] The custom of distributing eulogy bread began around the ninth century when communion bread changed in form to an unleavened wafer.[96] The clergy continued to take communion regularly, but the congregation did so less and less. Since people received the Eucharist infrequently, eulogy bread functioned as a substitute for it.[97] By the thirteenth century, lay people took communion so infrequently that the Lateran Council of 1215 established a required minimum observance of communion once a year at Easter.[98] Despite the ruling, eulogy bread continued to be distributed at Easter.[99] The substitution of eulogy bread for communion was so commonly practiced in the late twelfth century in Paris that Bishop Maurice de Sully preached the necessity of penance before taking eulogy bread.[100] The custom of offering eulogy bread to be blessed continued for centuries, and is practiced in rural France even today.[101]

Invariably the eulogy blessings recalled Christ's multiplication of

the loaves.[102] Usually, after the service of mass ended, the bishop blessed the eulogy bread.[103] There is a prayer for the blessing of eulogy bread in the thirteenth-century Pontifical used by the bishop of Chartres: "Bless, Lord, this bread as you blessed the five breads in the wilderness and let all who receive it obtain health of the body and of the soul."[104] The prayer is not accompanied by directions for its use, but the bishop of Besançon, who used this same prayer to bless eulogy bread, then distributed the bread saying: "Take and eat this in remembrance of the Lord's supper."[105] By these prayers, the bishop all but transformed the eulogy bread into the eucharistic host.

Charity Bread

Bread presented to churches on certain feast days was distributed to the poor.[106] Durandus wrote an elaborate ceremony for the distribution of bread to the poor on Ascension and Pentecost. A deacon read an account of Christ's miracle of the multiplication of the loaves, and when the officiant blessed the bread, he again recalled the miracle.[107] It seems likely that bread distributions to the poor at Chartres Cathedral took place in similar liturgical form on Ascension and Pentecost, with the reading of the same prayer of blessing in the Pontifical which recalled Christ's miraculous multiplication of the loaves.

Altarium

Thirdly, the bishop and canons sometimes may have kept the loaves for their own use, as did the parish priests.[108] This may have occurred through the custom of canonical distributions—the payment in money, bread, and other commodities that the canons awarded themselves for their participation in every liturgical service.[109] Or the canons could well have used the bread to provide for their lesser clerical assistants and their household retinues.

Historical Description of the Bread Scenes in Their Contexts

On the basis of the liturgical presentation, blessing, and distribution of bread in medieval France, we can now try to interpret the scenes of bread and their context in the cathedral. Included in this consideration of the imagery are the iconographic traditions from which the scenes of bread were derived, the relationships between the images of bread and the accompanying traditional religious imagery, and the social and liturgical implications of these constructs in the cathedral. It is best to begin with the socle in the south porch, since it stands at the entrance to the Gothic cathedral, and, in this way, introduces the rest of the bread imagery.

The Trumeau Socle on the South Porch

The nobleman on the south porch trumeau kneels beside a basket of bread, which he seems to be offering to the huge figure of Christ standing over him (plates 40 and 41). The basket must be a *canistrum*, the basket in which blessed bread was kept, and from which it was distributed.[110] The noble's head tilts back as he gazes upward at Christ, who blesses the bread (plates 41 and 42).[111]

The noble's hands, now broken off, may have been raised in prayer, or may have held up a loaf. Two men in working-class *cottes* on either side of him assist in the ceremony. To the right, behind the nobleman, an attendant in a *cotte* steps forward holding before him a sling full of loaves, looking outward toward the faithful who approach from the right (plate 43). To the left of the aedicula, another *cotte*-clad attendant stands behind the basket and leans over it, holding up two loaves in his left hand, as if to hand loaves to faithful on his right (plates 42 and 44). He looks over the basket and down the steps, as if he were looking toward any viewer approaching from below on the left side. His right arm reaches forward, broken off at the elbow; it must have originally held out another loaf. I believe that both attendant figures are shown distributing bread. The noble is both the offerer of the basket of bread, and the prayerful recipient of eulogy.

The scene represents the offering and distribution of eulogy bread. Other recipients are not depicted in this register of the socle but can be imagined to exist to either side of the trumeau, suggested by the glances and gestures of the attendants outward toward the passersby to either side. They are, in effect, passing out eulogy bread to the faithful who approach the entrance, and thereby are preparing them for the actual ceremony to take place within the cathedral (plate 44).

The meaning of the figures in the lower register of the socle is more difficult to determine since they have been badly damaged (plates 45 and 46). A nobleman with his cloak drawn across his body sits in the center behind the remains of a table. His head is completely broken off. One can still see part of the table on his lap, and the table's feet on the corners of the stone base. A loaf, flat on the bottom like those in the upper scene, lies on the table before him. The man's arms are broken off above the elbows, so that it is difficult to picture their original gestures; the movement of the drapery on his upper torso seems to suggest that he was reaching out to his right toward the figure dressed in a *cotte* who approaches him. This figure's arms are gone, but the bunches of fabric folds over his right shoulder almost exactly duplicate those of the man with a sling above, so that we can imagine he originally also held loaves in a sling. He looks out toward any people who may approach from the left side of the socle.

The noblewoman seated next to the headless man has lost her facial

features and arms. One can see the broken extension of the table at her waist. Her arms seem to have been directed to her right, like those of the man seated next to her. Both seated figures are dressed in noble attire, and both seem to reach out toward the man with a sling full of loaves.[112] This attendant must be distributing eulogy bread to them. The other possibility, that they were reaching out to offer bread, seems unlikely, since they are not kneeling, like the nobleman above them.

According to long tradition, the kneeling man in the upper register of the socle is Pierre Mauclerc, count of Dreux, who is said to have donated the entire southern portal. This claim is based solely on the stained-glass representations of the shield of Dreux in the windows below the southern rose.[113] Jan van der Meulen proposed, contrary to this traditional view, that Count Louis of Chartres and Blois, who van der Meulen thought was a generous benefactor of the cathedral, appears in the socle as the donor of the portal.[114] Jean Villette agreed with this interpretation; moreover, he believed that the scene represents Count Louis distributing charity bread on the occasion of his marriage to Catherine of Clermont on or before 1202, since the count wears a flowered headband which brides customarily presented to their new husbands. Unfortunately, he gave no source for this argument.[115] Villette argues that John James's early dating of the south portal sculpture to 1198–1205 allows for his interpretation of the imagery, since after 1209 the countess entered into serious conflict with the chapter.[116]

Villette's conjecture that a noble wedding occasioned the bread offering might seem plausible, but it does not explain what is happening in the lower register.[117] The representation of the count on the trumeau needs more explanation, since the conflict between the count and the chapter was already very serious when the cathedral burned in 1194. And it is doubtful that the count's wedding would be the centerpiece of the cathedral's main entrance, in view of the bad relations between the count and the cathedral. Van der Meulen and Villette based their claim that Count Louis was a great benefactor of the cathedral on his testament in the *Cartulaire*, not on his donation of the head of St. Anne.[118] In his will, Count Louis left seven and a half pounds for the celebration of his and his mother's and wife's anniversaries, and one hundred sous yearly from which six denarii were to be distributed to every canon assisting at the anniversaries. This is not a very large bequest to the cathedral, contrary to what van der Meulen and Villette maintained.

Jacques Weber has recently conjectured that the trumeau socle imagery represents another example of baker donation. The kneeling figure, he believes, was the head of the confraternity of bakers.[119] He likens the dress of the kneeling figure to that of the kneeling men in the window of St. Stephen, discussed above, who offer a model of the window over an altar (plate 13). These men, he believes, may have been

members of a confraternity of shoemakers. This argument has some
obvious merit, insofar as Weber has observed the attire of these differ-
ent figures closely and tried to make sense of it, but I believe his con-
clusion is wrong, because the bakers did not have a master or a confra-
ternity. Weber's effort marks a change from the previous literature but
is not convincing. Only men of high rank could wear a full-length gar-
ment, so despite the lack of a *surcot* here, the man is of high rank.
Furthermore, the kneeling man's attire may originally have been
painted with identifying blazons. All the Gothic statuary at Chartres
was painted, as was the interior stonework as well.[120] In any case, the
big basket of bread is surely a noble-sized offering.

I agree with van der Meulen and Villette that the noble figure is most
likely the count of Chartres, especially since the portal faced the
count's castle nearby in the town. It is likely that the kneeling figure
of the count was placed in its position and context on order of the
clergy to show how counts ought to behave—with proper humility be-
fore the cathedral. This does not rule out the idea that the statute was
meant at the time to commemorate a pious donation. The most im-
pressive gift of the count to the cathedral was the head of St. Anne,
which presumably arrived at Chartres after the death of Count Louis
on crusade. My favorite hypothesis, just as speculative as the rest, is
that the statue recalls exactly what it represents, his pious donation of
eulogy bread, prior to his departure for the crusade.

Some scholars have claimed that the bread was intended for distri-
bution to the poor.[121] Count Louis's will requested that money left over
from the 100 sous he assigned to pay the canons for his anniversary be
given over to the *refectionem pauperum de Elemosina Carnotensi*.[122]
Any remainder was most likely assigned to support the kitchen of the
Hôtel-Dieu next to the cathedral, for the feeding of the poor. It is true
that the loaves are marked with a circle and an interior cross, like the
loaves depicted in the St. Anthony window and the St. Thomas win-
dow at Chartres, loaves that those saints are giving to the poor (plates
34 and 35).[123] But these are the small breads called *echaudées* or *oub-
liés*, made not only for gifts to the poor but also for vassals' presenta-
tions to lords and for taxes. Since there are no poor depicted in the
socle, and the count is kneeling reverently, it is more likely he is offer-
ing bread as a symbol of homage or devotion. In any case, the trumeau
and its socle have the effect of welcoming the onlooker, inviting all
worshipers to enter the church, make offerings, and receive eulogy
bread.

The figure of a man kneeling in offering beneath the feet of Christ
in the trumeau has a long-standing, widespread tradition in medieval
donation iconography; a well-known example would be the Bâle altar
frontal of Henry II now in the Cluny Museum in Paris.[124] The image
of a man seated before a table with a loaf of bread in the lower register

of the socle appears in labors of the months—for example, on the west facade at Chartres—to indicate the month of January.[125] In the cycle of labors, it suggests the fruits of harvest preserved for the winter months. On the socle, the loaves suggest the fruits of harvest at Chartres.

Above the count of Chartres on the trumeau socle, Christ stands on two serpent-like creatures (plate 40). He illustrates Psalm 90 (91), wherein God treads on the asp and basilisk, lion and dragon.[126] In the psalm, God says: "Because he hoped in me, I will deliver him: I will protect him because he hath known my name. He shall cry to me, and I will hear him: I am with him in tribulation, I will deliver him, and I will glorify him. I will fill him with length of days; and I will show him my salvation."[127] Christ blesses all who approach the portal, and simultaneously blesses the bread offering and the count of Chartres kneeling beneath him.

The image of Christ is charged with liturgical meaning. Standing on the serpent and asp, Christ appears at the beginning of the Vere Dignum in the thirteenth-century Chartres pontifical (plate 82).[128] This prayer followed the offering procession and summed up the meaning of the offerings as sacrifices to God.[129] The trumeau applies this specifically to the offering breads.

On either side of Christ in the portal embrasures, the apostles stand atop little figures of their tormentors who crouch in socles beneath their feet; on Christ's right is St. Peter above Simon the Magician, then St. Andrew and St. Thomas stand over the monarchs who ordered their martyrdom (plate 47).[130] The parallel is usually drawn between Christ trampling the lion and dragon, and the apostles trampling their tormentors.[131] But the count kneeling beneath the feet of Christ and looking up at him also can be seen as part of the row of tormentors. The difference is that Christ blesses the submissive count and his lavish bread offering even as he symbolically triumphs over him.

Above, in the tympanum, Christ appears at the Last Judgment. Amongst those who walk peacefully off to Paradise in the lintel, a little figure of the count reappears, identified by the circlet of flowers he wears in his hair, just like the one he wears below in the trumeau socle.[132] Considering the almost continuous antagonism between the count and the cathedral ecclesiastics, this is a suggestive arrangement. Both images, on the socle and on the lintel, show how the count should behave and how the church can save him.

The wider liturgical significance of the porch derives from its portal figures of the martyrs, apostles, and confessors (plate 48). These are the categories of saints invoked in the litanies at festive masses, especially on All Saints day,[133] when bread presentations were expected at local churches.[134] Hence it is not an exaggeration to say that the basket of bread offering on the trumeau is a key to the unity of the whole program of imagery on the south porch portals.

The Apse Clerestory Scenes of Bread

The basket of offering bread on the trumeau reappears in the center of the apse clerestory. Beneath images of the Virgin, two men carry a huge basket of bread (color plate 1 and plate 26). The loaves are very large, bigger than the men's heads, and totally unmarked. This must be the extraordinarily large white bread made especially for festive presentation, known in Paris as *gastel à presenter* and prepared in Chartres as *panis consuetudinales*, or Christmas bread. The hugeness of the basket, far bigger than the basket beside the kneeling count in the trumeau, suggests that it contains the offerings of many different people on a major feast day. The *canistrum* is suspended from the men's shoulders on a pole passed through loops in the basket's rim, which bends with the weight of the bread. The man in front holds a brace under the pole with his right hand, while steadying the pole with his left hand. He glances back over his left shoulder at his companion, who also holds a brace in front of him beneath the pole with his right hand, and reaches forward to steady the basket with his left hand. The weight of the basket still rests on the men's shoulders, but their forward motion is impeded by the braces in front of them. The braces' position, and the men's action, indicate that the men are about to rest the basket on the braces. The men pause in front of an arcade, and two little flowers grow up from the ground beneath the basket. But the men prepare to place the basket down directly beneath the Virgin. The scenes seems to suggest that the bread has been collected from the faithful outside and is carried to the Virgin in the choir as offering.

The two men wear very different clothes. Since clothing marked social rank in the Middle Ages, the contrast must have been significant. The man in back has a bared chest, and looks as if he has hiked his skirt up at the belt. Perhaps he has just come from the ovens.[135] This brings to mind the quote from Pierre de Celles' *Liber de Panibus*, cited at the beginning of this chapter: "he will offer warm and very pleasing bread to God the Father, and he will receive a blessing."[136] The warm bread is a metaphor for Christ, who offered his living body. The suggestion that the bread came straight from an oven is even more explicit in the almost identical scene in the window of St. James in the nave clerestory (plate 37).

But the man in front wears a purple *cotte* with green trim, a sort of formal working *cotte* or servant's dress. He may have been a lay *marguillier* or clerk of the choir, or even one of the *marguillier's* valets. Although we do not know how these men were dressed at the time, we know that there were two lay *marguilliers* who lived in the cathedral, opened its doors, lit the lamps and candles, and watched over the cathedral's property. Carrying rods, they preceded the mass celebrant at his entry and exit, and at the offering outside of the choir. Two valets assisted them in their task.[137]

A similar basket of bread stands on the ground between two young men in the base of the adjacent window to the right, dedicated in ascending registers to Moses and Isaiah (plates 28 and 29). Like the leading basket carrier in the adjacent scene, these men both wear purple *cottes* with green trim, cut somewhat longer than usual. They both have startling blond hair. They may be the two *marguilliers*, or their two valets. Columns rise to either side to support a braced lintel, giving the impression of an interior setting, perhaps a temporary wood *jubé*.[138] The man on the left holds up a loaf above the basket, like the attendant on the socle. The man on the right turns to look at this loaf while gesturing outward in the opposite direction. The scene is similar to the images of attendant figures holding out loaves on the trumeau of the south porch (plates 42, 43, and 46). Like those figures, this man seems to be inviting the faithful to receive eulogy bread. The central location of the apse scenes in the most holy part of the cathedral, visible from all over the dark nave, suggests the widest possible extension of his inviting gesture. The divergent movement of the two scenes expresses the actual movement toward and away from the altar at separate moments of a liturgical offering and distribution of bread (plate 27). The scenes illustrate what actually occurred at the cathedral mass on feast days.

Iconographic Traditions for the Bread Scenes

Most of the prototypes for this bread imagery at Chartres are not to be found in twelfth-century images with a long medieval tradition, but rather in late Roman and early Christian art. On early Christian sarcophagi, a man stands beside a big basket of bread and holds up a loaf, in a manner similar to the men on the trumeau socle and in the apse. He gives bread to a group of men at a table (plate 49). Precedents for the small kneeling figures arranging loaves on a pan in the Apostles' window also appear on these early Christian sarcophagi (plate 50).[139]

The stained-glass painters apparently adapted some motifs from late Roman bas-reliefs to meet the new demand for work imagery. Most striking in this regard is the stylistic resemblance between the scene of two men carrying the huge basket of bread in the center apse and a similar scene on a late Roman bas-relief now in Trier (compare plate 26 with plate 52).[140] On the relief, two men carry a huge basket of grapes suspended from the men's shoulders on a pole passed through loops in the basket's rim. The pole bends with the weight of the basket. The man in front steps forward while glancing backward over his left shoulder toward the second man, who reaches forward with his left hand to steady the pole. A similar iconographic tradition appears in the labors for the month of December in eleventh-century English manuscript illumination, although the men are carrying grain in the basket, and the style is quite different (see plates 55 and 56).[141] But the

specific parallels to the late Roman bas-relief, particularly in the way the lead figure turns back, suggest direct adaptation of the Roman example. Even the two flowers growing up from the ground beneath the basket at Chartres echo, in their triangular bases and spatial separation, the triangular voids between the front and back legs of the little dog beneath the late antique basket in Trier. The late Roman relief at Trier and the Gothic glass painting at Chartres are similar in form, that is, in proportions, pose, dress, the turn of the heads, and the movement of limbs.

Large baskets of bread for distribution to the poor are fairly common in thirteenth-century stained glass. Besides the examples in the St. Anthony and St. Thomas windows mentioned above, another such scene is known to have appeared in the lost section of the Miracles of the Virgin window at Chartres.[142] A similar scene still can be viewed at Rouen Cathedral, where the sainted Bishop Severus hands bread to the poor from a huge breadbasket like the *canistrum* in the apse clerestory at Chartres (plate 57).[143] The poor always appear clustered together and reaching out for the bread. The only recipients of bread depicted at Chartres are buyers, with the possible exception of the two badly damaged noble figures in the lowest register of the trumeau socle, who appear to have received loaves from an attendant figure. The recipients at Chartres were the living congregation.

At Clermont-Ferrand, a mid-thirteenth-century window dedicated to St. Austremoine contains a scene of the saint distributing eulogy bread. The saint stands on a wooden platform raised above a crowd, and offers a loaf of eulogy bread to a man beneath him with his hands raised in prayer.[144] The imagery is an explicit representation of the distribution of blessed bread, which I believe is also depicted in two earlier examples at Chartres, in the south porch trumeau sculpture and the apse window of Moses and Isaiah.

The Window of the Virgin in the Apse Clerestory

The window of the Virgin, Bay 120, illustrates the offering of bread in the bottom register. In ascending registers above the bread offering in Bay 120, two events in the life of the Virgin are depicted, the Annunciation and the Visitation, and at the top, the Virgin is enthroned with the Christ child (color plate 4 and plate 54).

In the windows Jesus' own statements in the Bible establish his association with bread: "I am the bread of life" (John 6: 35, 48), and "I am the living bread which came down from heaven" (John 6: 41). Jesus' institution of the sacrament of the Eucharist at the Last Supper, when he gave the twelve disciples bread, with the words: "This is my body, which is given for you. Do this for a commemoration of me" (Luke 22: 19), further explains the significance of the window.[145] Any appearance

of Christ together with bread must have referred to the eucharistic sacrament.

The sacramental function of bread motivated exegetes to explore the significance of bread in the Old and New Testaments as anticipating Jesus and the Virgin. Pierre de Celles' *Liber de Panibus* belongs to this exegetical tradition. Biblically derived meanings of bread were collected in late twelfth- and thirteenth-century *Distinctions*,[146] such as the *Distinctions* of Petrus Cantor (d. 1197),[147] and the *Distinctions* collected by Alan of Lille (d. 1202).[148] The collections were intended as aids for preaching, since they set forth the long exegetical tradition in selective summary. The exegetical meanings of bread, therefore, apparently were popularized in sermons at the time the windows were made.

Because communion bread was a symbol for Christ's body, Mary's body was also associated with bread. Pseudo-Germanus considered the entire loaf of bread a symbol of the body of the Virgin Mary. From her body, the body of the Lord had been extracted; and so the eastern eucharistic practice developed of extracting the center of a loaf and distributing the remaining parts to the faithful as the "bread of the body of the Virgin."[149] Pierre de Celles compared the Virgin's womb to an oven in which bread is baked, and to an iron vessel in which bread is baked—the bread in both cases signifying Christ.[150]

The idea that Christ grew in Mary's womb like bread rises in an oven was developed further in early thirteenth-century Moralized Bibles in Paris. In these large illustrated Bibles, the biblical scenes with their textual counterparts alternate with scenes that illustrate a typological commentary or moralizing statement concerning the biblical scene.[151] Here we find repeated the juxtaposition of bread with the Annunciation to the Virgin. One of the Moralized Bibles, now in Vienna (Ms. 2554, fol. 27), combines a scene of Israelites putting their offering bread in an oven (Lev. 2:4) with a depiction of the Annunciation (plate 60). The text accompanying the two scenes explains them:

> It came to pass that Moses and his people took a bread and they put it in an oven and then they took it out. That the bread was put in the oven by God's commandment signifies that Jesus Christ was put in the Virgin's womb by the commandment of the Father of heaven and by the annunciation of the angel.[152]

In the next pair, the bread offering of the Israelites above the altar is likened to the Virgin's presentation of Christ over the altar (plate 61).[153] Thus the biblical and exegetical understanding of Christ as the bread of life and bread as the body of Christ is anticipated in the Old Testament story of offering. Pierre de Celles wrote that another typology for the Annunciation in the Old Testament was the manna collected in a

golden urn at God's command (Ex. 16: 32–36), since manna anticipated the body of the Lord.[154] The golden basket in the window seems to connect with this exegesis as well, recalling its Old Testament prototype.

The presentation of bread before the figure of the enthroned Virgin with the Christ child in the apse recalls representations of the Magi bearing gifts to the Virgin and Child. Medieval depictions frequently show the three Magi approaching with their gifts, and the Virgin seated in a stiff, frontal pose. Forsyth showed that this pose is characteristic of many wooden cult statues worshiped in early medieval and Romanesque churches. She cited documentation that the clergy placed these statues on the altar at Epiphany and presented gifts to the statues in liturgical reenactment of the Magi's presentations.[155] According to the Bible, the Magi offered gold, frankincense, and myrrh (Matt. 2:11), but, in the Christian catacomb of Sts. Peter and Marcellinus, the Magi offer the Virgin and Child large loaves of bread instead.[156] Another precedent for the depiction of bread being offered to the Virgin at Chartres appears in two capitals at Le Puy, where figures, each offering a large loaf, approach the Virgin seated between them (plate 59).[157]

The stiff, frontal pose of the enthroned Virgin with the Christ child on her lap symbolized the *Sedes Sapientiae* or Throne of Wisdom.[158] In the exegetical tradition, Mary was compared to the throne of Solomon. Since the word of God became incarnate through Mary, she was the seat of wisdom.[159] The traditional exegetical understanding of the virgin *Sedes Sapientiae* as the antitype of the altar which supports the eucharistic bread appears on the west facade at Chartres in the mid-twelfth-century right portal tympanum (plate 63). There, the Virgin sits enthroned with the Christ child above depictions of the Nativity and Presentation in the Temple; these scenes show Christ on an altar or altar-like manger, and so represent his body as the eucharistic sacrifice.[160]

The main attractions of pilgrimage to Chartres were the statue in the crypt and the cathedral's major relic, the veil of the Virgin, thought to be the cloth worn by the Virgin when she gave birth to the Christ Child.[161] Ilene Forsyth found that the two essential iconographic features of the *Sedes Sapientiae* images in Romanesque sculpture were their rigid, symmetrical, formal frontality and their resemblance to an idol, appropriate for cult statues.[162] The Virgin at the top of the tympanum over the right portal of the west facade repeats the image of the statue in the crypt of the Virgin as the *Sedes Sapientiae* (plates 62 and 63). The formal, frontal pose and statue-like quality of the thirteenth-century Virgin and child in the apse window were deliberately created to replicate and refer to the venerated Romanesque cult statue kept in the crypt (compare color plate 4 and plate 62).[163]

When the Gothic cathedral was built, a new silver-sheathed cult statue of the Virgin and child, posed like the crypt statue and the west-front Virgin, was installed on the main altar in the choir with the holy veil.[164] Thus the focus of worship, pilgrimage, offering, and miraculous power was shifted to the main altar from the crypt. Cardinal Stephen kneels before an image of the new statue in one of the Gothic ambulatory windows, Bay 53 (plate 65). Pilgrims and worshipers henceforth brought gifts to the new statue and awaited miracles at the main altar.[165] The Miracles of the Virgin window in the south aisle depicts the scene (plate 64). In the apse clerestory, the Virgin and the blessing Christ child enthroned in Paradise accept the bread offering depicted in the window beneath them, just as the statue of the Virgin and Child on the main alter beneath the window would have symbolically received the bread offered there.

The statue and its counterpart in the window legitimate the offering of bread and its distribution at the altar. Christa Ihm noted that the images of the enthroned Virgin and Child in the apse of Byzantine churches served to legitimate the communion liturgy at the altar beneath them.[166] There is a difference between the older tradition mentioned by Ihm and the scheme at Chartres, since the eulogy bread was not the true eucharistic sacrament; it was not transubstantiated into the body of Christ,[167] and hence did not unite the partaker with the Godhead.

In the apse, Christ sits enthroned on the Virgin's lap gesturing in blessing (color plate 4). His solemn demeanor and tonsure imbue him with the air of a bishop. Beneath the Christ in the same lancet, men set down a huge basket for bread offering (color plate 1 and plate 54). Iconographically, the composition of Christ blessing the bread offering beneath him is related, if tenuously, to the multiplication of the loaves, when Christ blessed bread in the desert to feed the multitudes (plate 66).[168] And it is this New Testament event which is the closest antecedent in biblical history to Christ's inauguration of the eucharist.[169] The bishop, echoing Christ's pose, cited the multiplication of the loaves as the legitimating precedent for his blessing of eulogy bread at the main altar beneath the window.

All these coordinated meanings came together in greatest force on the feast days of the Christmas season at Chartres: Advent, Christmas, Epiphany, and Purification. These are the Christmas feasts when, more than at any other time of year, people made bread presentations to the church.[170] The bishop himself expected quantities of bread offerings at that time.[171]

The image of the enthroned Virgin and Child was especially associated with Epiphany, January 6, when the Magi's gifts to the Christ child were commemorated. The gospel readings for the Epiphany sea-

son narrated both the visit of the Magi and the miracle of the multiplication of the loaves at Galilee,[172] recalled in the blessing of eulogy bread. This miracle was believed to have been performed by Christ on the anniversary of Epiphany.[173] Epiphany was one of the feasts when people in the diocese of Chartres were expected to make bread presentations to their church.[174]

The image of the Virgin with her child on her lap is also appropriate for Purification, celebrated February 2. This was a major feast when obligatory presentations of bread were made to local churches.[175] Women came to the cathedral throughout the year with bread for their own purification, extending the significance of the imagery to such occurrences.[176] The feast was also associated with distribution of eulogy bread.[177]

The top central image of the Virgin and Child in the apse clerestory is the focal point of the entire stained-glass program. The seal of the chapter of canons at Chartres carried the same image of the *Sedes Sapientiae*.[178] For the elite who had seen the seal, the window was a reference not only to the great patron saint but to the power of the great chapter of canons of the cathedral. The offerings were made to the statue of the Virgin on the main altar, a concept which the window of the Virgin above reinforced. The depiction of big white festal loaves carried in a huge basket directly beneath the Virgin in the choir windows was the quintessential scene of offering in the cathedral.

The Window of Moses and Isaiah

The other windows in the apse clerestory complement and expand upon the theme of the central window of the Virgin (plate 54). The window to the right of the center window is dedicated to Moses and Isaiah (plates 27 and 29). Above the scene representing distribution of eulogy bread, Moses appears on Mount Horeb as described in Exodus 3:1–6, removing a sandal from his right foot while gesturing toward the burning bush. He is identified by an inscription above his head, as well as by his exaggerated horns.[179] In the next medallion above, Isaiah appears enthroned wearing a Phrygian cap and holding a blooming stalk. Christ emerges from the top of the bloom, raising his hand in blessing. The iconography repeats in smaller scale the image of the burning bush beneath it.

There were two medieval traditions for the representation of this scene of the burning bush from Exodus. In one, the Virgin appears in the bush, in accordance with the exegetical interpretation of the bush not consumed by fire as the figure of the Virgin birth.[180] The other tradition, prevalent at the time in the West, and repeated at Chartres, showed Christ atop the bush.[181] Moses with Christ in the burning bush had appeared in other typological programs associated with the Virgin

birth, just as the two are combined at Chartres. In the reconstructed
setting of the choir windows of Arnstein-an-der-Lahn (ca. 1160), the
scene of Moses before the burning bush appeared in the bottom of a
window beneath two other Old Testament typologies of the Virgin, and
next to the Annunciation, the Nativity, and the Baptism of Christ in
the adjacent window.[182] A Gothic typological window at Canterbury,
now lost but known from a description written in the fourteenth cen-
tury, contained, in its center, the Annunciation and Visitation, and in
its side typological panels, Moses and the burning bush.[183] In the Vir-
gin window in the chevet at Laon, dated to 1210–15, a more complete
cycle of the Virgin birth is accompanied by typological scenes, again
including Moses and the Christ in the burning bush.[184] Hence the ar-
rangement of subjects at Chartres is a traditional one honoring the
Virgin.

The Overall Themes of the Apse Imagery

The closely coordinated themes of the apse imagery have only been
partially recognized (plate 27). Delaporte commented that the figures
in the four lancets flanking the Virgin in the central window of the
apse are her precursors and prophets.[185] But no one to my knowledge
had argued the case in any detail until Jacques Weber and Odile Cler-
mont discussed the programmatic coherence of the symmetrical sym-
bolism in the windows.[186] The windows of the apse repeatedly show
the Old Testament figures holding blossoming rods or branches, refer-
ring to their prophecies or to them as prototypes of the Virgin. On one
side of the Virgin and Child, Isaiah holds a blooming stalk, referring to
his prophecy of the Virgin birth of a savior from the royal line of Jesse
(plate 29).[187] On the other side, Aaron holds a budding rod, by which
God demonstrated the exclusive right of the family of Aaron to the
priesthood (plate 68).[188] Aaron's budding rod also was understood by
exegetes in this way to anticipate the Virgin birth of Christ.[189] Not by
chance, Aaron and Isaiah appear on either side of the window of the
Virgin (plate 27). Their actions relate directly to the center scenes of
the Virgin, who herself holds a floriated scepter at the top of the center
window.

The two outermost windows of the five lancets in the apse repeat
the idea of prophecy manifested in a blossoming rod. On the left, Bay
122, David holds a blossoming scepter (color plate 11 and plate 71). He
is Jesse's son, the royal ancestor of Mary, as predicted by Isaiah. Weber
and Clermont left out the significance of Ezekiel, Daniel, and Jere-
miah, who do not hold blossoming rods in the apse windows, but all
of whom were traditionally included among the prophets of the Virgin
birth of the savior on the Tree of Jesse.[190] In keeping with the exegetical
thought visualized in the apse windows, Jeremiah sits opposite David

in the outermost lancet to the right, Bay 118 (plate 72). His vision of an almond branch in early bloom, the "virgam vigilantem," was interpreted to signify the Virgin.[191]

The hitherto unnoticed resemblance between the typological scheme in the apse and on the west facade shows the same thinking there underlying the choice of prophets. Adelheid Heimann argued convincingly that the position of the prophet figures on the west facade pilasters was determined by their typological coordination with the New Testament frieze of Christ's advent in the capitals above their heads.[192] Ezekiel and Daniel, distinguished by their Jewish hats, are pendant to each other in the outer windows beneath David and Jeremiah respectively. They are similarly paired at the top of the door posts on either side of the left portal of the west facade. Daniel in the west-facade relief holds "the stone cut without hands," which was interpreted as a prefiguration of the Virgin birth. Just above him, the Virgin Mary sits enthroned with the Christ child on her lap, receiving the gifts of the three Magi.[193] Ezekiel appears on the left of the portal just beneath the frieze relief of the Flight into Egypt. Ezekiel, as the prophet of exile, was thought to prefigure this flight of Christ.[194] The apse typological program in honor of the Virgin had its intellectual prototype in the first cycle of the life of Mary north of the Alps at the west facade of Chartres.

The Images of Offering in the Apse

In these windows, prominent images of Old Testament prophets are superposed in large scale over smaller-scale images of contemporary life. Because the prophets in the lateral apse windows relate directly to the center window images of the Virgin, the lowest register of the lateral windows logically should also relate to the image in the lowest register of the center window—that of bread offering.

Beneath Aaron, and pendant to the scene of bread distribution, three people approach the center window in a religious procession (plate 67). An acolyte in front swings an incense bowl and holds up an incense cup, repeating the actions of the angel at the top of the window (Plate 69). Behind the acolyte, an older youth holds up a flag painted with a red stocking. Close behind them, a man identified as Gaufridus by inscription, wearing a pilgrim's purse, follows with his hands raised in prayer toward the Virgin. He is followed in turn by a woman, in upper-class dress, who holds her open hand to her chest, as if in awe. The man, woman, and flag-bearer all look up at the Virgin; they appear to be pilgrims making a procession toward her.[195] The liturgical direction of the group's procession meets the bread offerers beneath the Virgin. It is a festal movement of liturgical offering and worship, whose consequence is the offering of eulogy bread to the worshipers in the pendant scene to the right.

The scenes in the lowest register of the outer apse windows (Bays 122 and 118) also imply offerings. In the outermost window on the left, beneath Ezekiel, a man raises an axe above his head, about to swing down with all his force to sever the neck of the blindfolded calf standing before him (plates 70 and 71).[196] The scene was evidently placed beneath Ezekiel, since, in the Old Testament, God instructed Ezekiel to kill a calf and offer it before his altar (Ezek. 43: 19–21). The theme of liturgical offering consistent in the lowest register of the three center apse windows is also carried out in this scene. Again, there is a repetition of the typological thought of the west facade pilaster reliefs, since there one sees an Old Testament priest sacrificing a heifer beneath the Last Supper.[197] The exegetical implication of the sacrifice of the animal was the sacrifice of Christ himself, reenacted by the liturgy of communion, and of its substitute eulogy bread.

The idea of offering already suggested in the bottom register of the other four windows extended to the merchants' wool and fur depicted in the window of Daniel and Jeremiah, the outermost window on the right (plate 72). In the lowest register on the left, a man measures a bolt of blue cloth stripped with red (color plate 6); on the right, a man holds up a fur coat in front of a seated man.[198] The wool is especially important. According to the *Protoevangelium of James*, Jewish priests gave the Virgin Mary purple and scarlet wool to spin for a new curtain in the Temple. She hurried home to spin, and it was then that the angel of the Annunciation appeared to her.[199]

The wool merchants of Chartres appear in the windows selling striped cloth. In the window of Daniel and Jeremiah, Bay 118, a merchant measures red cloth striped with blue (color plate 6) and in the window of St. James, Bay 37, a merchant's assistant measures green cloth striped with red (plate 73). The wool of Chartres described in the wool workers' statutes of 1268 was "dyed cloth, red and blue striped."[200] It is exactly this combination of stripes that the Christ child wears in the *Sedes Sapientiae* image at the top of the center window in the apse (color plate 4). The Virgin's outer robe is purple with red stripes, her inner robe green with red stripes. In the Annunciation scene, the Angel's outer robe is purple with blue stripes, and his inner dress is green with red stripes; the Virgin wears an outer robe of purple with green stripes and an inner robe of green with red stripes. In the Visitation, both women wear striped cloth; the woman on the left, who is most likely the Virgin, wears a blue dress with red stripes like the Christ child above her. The Angel in Bay 121, flanking the Virgin enthroned in Bay 120, wears a red robe with blue stripes (plate 69). Throughout the apse, the prophets wear striped cloth. The visual analogies in the apse imagery created by the repetitions of blossoming rods have their analogue in this repeated imagery of striped fabric. The local merchants, in effect, offer striped wool for the holy figures, recalling

the biblical precedent of Mary's offering. The scenes in the bottom registers seem interrelated in their meaning of liturgical offering, or sacrifice. The scene of bread offering to the Virgin takes its place as the center of this larger context.

The Old Testament Figures and Bread Offering

Certainly, the primary reason that Moses, Isaiah, Aaron, David, Ezekiel, Jeremiah, and Daniel surround the Virgin is that they prophesied her. But all of them were also associated in a prophetic way with bread offering. We have seen that the image to the right of the bread offering in the central lancet depicts bread distribution beneath Moses and Isaiah. There were many reasons to have depicted Moses with bread. The practice at Chartres of baking loaves to give the church as part of the small tithes is ultimately based on the moment in Genesis when God spoke to Moses to instruct him on how the holy days should be kept. God told Moses: "Out of all your dwellings, you shall offer two loaves of the firstfruits, or two tenths of leavened flour, which you shall bake for the firstfruits of the Lord" (Lev. 23:17–18). Pierre de Celles quoted the passage in his discussion of the bread of the firstfruits.[201]

Other associations of Moses with bread are found in the Bible and in exegetical literature.[202] It was Moses whom God instructed to set out offering bread on the altar of the Tabernacle: "And thou shalt set upon the table loaves of proposition in my sight always" (Ex. 25:30). The bread offerings of Moses and Aaron were the Old Testament prototypes of the bread offerings depicted in the window. Exegesis interpreted the bread of proposition to signify the manna of God,[203] and the manna in turn was a type of the Christian bread of salvation. The morning after Jesus multiplied five loaves to feed a multitude, he told the people: "Moses gave you not bread from heaven, but my Father giveth you the true bread from heaven" (John 6:32).

Isaiah's association with bread in the Old Testament was noted by the collectors of *Distinctions*.[204] The bread in Isaiah 4:1, "And in that day seven women shall take hold of one man, saying: We will eat our own bread," is interpreted in the *Glossa Ordinaria*: "Our bread is Christ, the rod from the root of Jesse, and the blossom."[205] Hence Isaiah is seen to prophesy the bread of the Eucharist and this prophecy is tied to his blossoming rod. David received the holy bread from Achimelech the priest (1 Kings 21: 2–6). In one of the Moralized Bibles in Vienna, the five loaves he received signified Christ's body on the altar, given by good priests at Easter.[206] David, anticipating Christ's multiplication of loaves, distributed bread to a multitude (2 Kings 6:19). Daniel survived a lion's den twice, the second time under Cyrus. He was there six days, and might have perished of starvation if he had not been fed bread by Habacuc (Dan. 14:30–38). This bread was understood to prefigure the Eucharistic bread of Christ which brought salvation.[207]

Citing many such examples linking these figures with bread, Pierre de Celles discussed the bread of proposition and quoted the passage in Leviticus 24: 5–9 in which God commands Moses to tell Aaron that these loaves must be made of fine flour.[208] Pierre de Celles commented that it was Aaron and his sons who offered bread in the Old Testament, according to God's directions,[209] and compared their bread sacrifice to Christ's sacrifice of his own body.[210] Moses offering two loaves in the time before grace signified the two natures of Christ, which were one bread in the time of grace.[211] In Jeremiah's Lamentations, the hungry yearn for bread.[212] Ezekiel made bread to eat according to God's command to survive the impending ruin of Jerusalem.[213] Surely the clergy at Chartres in the thirteenth century were aware of Bishop Pierre de Celles' treatise, and saw the added exegetical dimension of bread associated with the prophets of the virgin birth of Christ.

Thus there are many related themes in the apse windows. The overall themes of the imagery are the Virgin Mary as mother of Christ, the advent of Christ in the world, the Old Testament prophecies of the virgin birth and the royal lineage of the Virgin, the contemporary offering of bread and other products of human labor to the Virgin, and the biblical precedent for these offerings. The Old Testament prophecies and their New Testament fulfillment are combined with the contemporary offerings and their Old Testament precedent.

The Apostles' Window

The window of the Apostles in the center of the central ambulatory chapel dedicated to the apostles contains three scenes of bread and thirty-one scenes of the life of the apostles (plates 74–77).[214] The bread scenes appear in the lowest register of the Apostles' window (plates 30 and 75). In the middle, a merchant is selling bread (plate 31). A large basket of bread appears on the ground in front of a table on which more loaves are displayed. The basket's shape is different from the *canistra* in the apse and socle (plates 26 and 43). The *canistrae* had sides which slope outward toward the top, and they are woven horizontally in even rows, without any of the vertical supports left showing. This basket is smaller, its sides are vertical, and its vertical supports are clearly drawn in, without any indication of intervening horizontal weaving. The bread, too, is different from that depicted in the apse. It is much smaller, and marked with a circle enclosing a cross. The loaves and basket resemble those in the scenes of St. Anthony and St. Thomas giving bread to the poor in windows dedicated to them at Chartres (plates 34 and 35).[215] These loaves must be the unusually small breads called *echaudées* or *oubliés*, like the ones we know were used for charity in Paris.

To the right of the table covered with bread, a man lifts a loaf from the table with his left hand while reaching across the table with his

right (plate 31). He is a merchant, identifiable by his long robe and tight cap.[216] Opposite him, a man in a plain green *cotte* stands with his body facing away from the table, his right hip thrust out to help sustain a sling full of loaves suspended from his shoulder. He twists his head and chest back toward the table and reaches out with his left hand, which is holding a large coin to pay for his bread purchase. The men's hands almost touch across the table as they carry out the exchange. Possibly the man is buying one more loaf with his coin, to add to the bread in his sling; or he could have bought all his loaves from the merchant, and then the single coin would symbolize his payment for them. In the trumeau, men with slings also appear (plate 41). This window scene differs from those on the trumeau and apse in that here bread is sold, while there breads are offered and distributed. Hence the purpose of the bread here seems somewhat ambiguous, but its holy purpose is affirmed by the scene adjacent to the left.

There, a baker bends over a large kneading trough, his arms arched out in his effort to work a big lump of dough (plate 32).[217] Its destiny is symbolized by the representation of his kneading trough as a golden, altar-like form. The baker's work is sanctified, as its product will serve the Christian church. This meaning has been accentuated by a later grisaille repainting within the lump of dough showing a bearded man with closed eyes, presumably the dead Christ, whose body the dough symbolizes.[218] A smaller, attendant figure, the baker's apprentice, stands with a jug in hand, ready to add liquid to the dough. Beside him, a large cauldron full of liquid suspended from a hook heats over a fire.

In the pendant scene to the right, three men bend over a table, forming loaves from lumps of dough (plate 33). The man on the right hands a round ball of dough down to the two smaller figures kneeling in front of the table. Between these figures, a large pan holds nine loaves. The apprentice on the left sets an eleventh loaf on the pan, while the apprentice on the right holds out another loaf—the twelfth—toward him. Not by chance, the pan is about to hold twelve loaves, since the rest of the window is dedicated to the twelve apostles. The three bread scenes show the kneading, forming, and selling of loaves. These are stages of work necessary to make possible the liturgical offering of bread depicted in the trumeau and the apse.

The scene in the Apostles' window of standing men making bread seems to lack medieval precedents. The closest antecedents I have found are the first-century B.C. bas-reliefs on the funerary monument of the baker Eurysaces in Rome,[219] and similar, related images on the third-century A.D. bas-reliefs of the Igel funerary monument now in Trier (plate 51).[220]

Like the apse windows, the window of the apostles was conceived to illustrate biblical content but has exegetical implications, and also il-

lustrates contemporary liturgical custom (plates 74–77). The lower part of the window illustrates the calling of the apostles, and the upper part of the window depicts the apostles carrying out their mission from Christ to teach his message and perform his sacraments. Jesus teaches his apostles, instructs them to baptize, to perform the Eucharist and ritual feet-washing. The cycle ends with the apostles' final mission at Pentecost, when they were filled with the Holy Spirit, symbolized by the dove, and given the power to speak in foreign languages so that they could conduct their mission throughout the world (Acts 2:1–4) (plates 77 and 80).[221] Thus, the window proclaims the apostles' right to lead and expand Christ's church on earth.

Exegetical associations of bread with the apostles links the literal meaning of the window with contemporary practices. As we have already seen, the bakers at the base of the window prepare twelve loaves for the oven, which symbolize the twelve apostles, whose lives are illustrated above. Traditional exegetical typology saw the twelve loaves of proposition in Leviticus 24 as an Old Testament prefiguration of the twelve apostles.[222] In a thirteenth-century French Moralized Bible at Oxford (Bod. 270b, fol. 52r), the offering breads set out on the altar of the Old Testament tabernacle (Ex. 25:23–29) signify the twelve apostles. This commentary is illustrated by a scene of the apostles at the Last Supper. Similarly, in a French Moralized Bible now in Vienna, the Old Testament breads of proposition anticipate the twelve apostles.[223] In his *Liber de Panibus* Bishop Pierre de Celles included this idea that the twelve loaves of the Jewish temple anticipated the twelve apostles.[224] The bakers in the bottom of the window lay out twelve breads on a big flat pan to be baked, suggesting this traditional typology within a scene of ordinary life.

Two scenes at the top of the window are related especially to the scenes of bread at the bottom of the window. The Last Supper, panel 26, illustrates Jesus instituting the communion sacrament with bread and wine (plate 77). The apostles are grouped symmetrically on either side of Jesus at the table, with the exception of Judas, who appears in front of the table. Jesus, larger than the apostles, holds up his goblet, and blesses it. According to the Gospel of Matthew 26: 27–29, he gave thanks to God, and said; "Drink from it, all of you. For this is my blood, the blood of the covenant, shed for many for the forgiveness of sins." In the gospel account, Jesus had already picked up some of the bread from the table, and blessed it, and broken it into pieces for his disciples, saying: "Take this and eat it; this is my body." Hence the window invokes the very words used to bless the eulogy bread that the priest broke in pieces and distributed to the people.[225]

A panel directly above the Last Supper depicts Christ ascending into Heaven (plate 80). The apostles stand on the ground looking up at

Christ, who has all but disappeared into a cloud.[226] Typology which likened bread offering to Christ's Ascension appeared in the Moralized Bibles. The bread offering of the people of Moses is likened in Vienna 2554 to Christ's self-offering pictured by his Ascension: "That the people offered to God the bread that was put on a spit and that God received it means Jesus Christ, who was put on a spit and tortured on the cross which offered him to the Father at Ascension, and he received him."[227] The same analogy appears in Vienna 1179 (plates 78 and 79).[228]

Directly above his Ascension in the Window of the Apostles, Christ reappears in Paradise standing behind an altar flanked by candles (plate 81). He seems to have taken his place at the heavenly altar immediately, almost simultaneously with his Ascension. He blesses with his right hand and holds up a large, round, white object with his left hand.[229] When one stands beneath the window in the chapel of the Apostles, the object appears to be oval, just like the white loaves in the basket at the bottom of the window. I believe it was meant to be eulogy bread.

High-powered binoculars and photographs taken with high-magnitude telescopic lenses reveal that the white object is marked within by thin black lines to signify the traditional medieval concept of the world. A horizontal line divides the orb in half, and a vertical line divides the upper half. Within the upper quarters, the Alpha and Omega are inscribed. This is the traditional *Mappa Mundi*, but it is upside down! The usual *Mappa Mundi* showed the Orient in the upper half of the orb, and the lower section divided in half: the left half was Europe and the right half Africa.[230] The globe at Chartres is usually divided in half in its upper part, contrary to the traditional depiction.[231] Hence Christ holds the globe as if it were the tripartite world, but upside down. This causes the globe to look like a loaf of bread viewed from the side. Christ holds up bread, not the orb.

Bread is frequently represented marked this way in medieval art, that is, shown with a line dividing the loaf in half, and another line dividing the upper half into quarters, as if to show a side view of the bread's markings, for example, in the Vienna Moralized Bible.[232] Christ holds up a similar object in Bays 37 and 40 at Chartres. But I know of no other example of Christ holding up a loaf of bread over the altar of Heaven.

The image seems to have been derived from that of Christ's imperial majesty, in order to represent his eternal liturgy. Similar scenes of Christ seated upon an altar appear at the top of nine lower-story windows at Chartres. In five of these, he holds up a globe without subdivisions; but in these scenes, he does not have candlesticks to either side as in the Apostles' window.[233] The Apostles' window scene is unique amongst these related images. Nor do the other scenes of Christ at the top of the lower-story windows have such a direct rela-

tionship to the scene immediately beneath them. In the Apostles' window, the loaf in Paradise has its counterpart directly beneath in the scene of the Last Supper.[234] This liturgical character of the window is unique.

The suggestion of dual meaning in the scene is not without precedent. Meyer Schapiro commented on a similar purposeful ambiguity in the scene of Christ holding up the Eucharist in a twelfth-century manuscript in the treasury of the church of Saint-Etienne in Auxerre. Schapiro argued that the wafer in this case could be interpreted as a coin, which it resembled.[235] Similarly at Chartres, Christ can be seen to display his imperial power, and to hold up bread at the heavenly altar.

In the window, Christ does not hold a little communion wafer but a large loaf—the eucharistic symbol of Christ's sacrifice in the form of its contemporary substitute, eulogy bread. This is the bread offered before the altar, blessed by the bishop, and distributed back to the worshipers as eulogy. It is therefore significant that when the bishop of Chartres stood facing east at the main altar in the choir, he could look up and see Christ at the heavenly altar in the top of the Apostles' window.

The liturgical implications of the window were many. In the thirteenth-century calendar of Chartres Cathedral, feasts in honor of the apostles Andrew, Barnabas, Bartholomew, James the Evangelist, John, Mathias, Matthew, Paul, Peter, Philip and James the Less, Thomas, Simon, and Jude are mentioned.[236] This comes to fourteen apostles, an anomaly explained by the confusion over the name of the twelfth apostle after the disgrace of Judas.[237] Mathias was chosen by lot to fill the vacancy, according to Acts 1:15–26. Paul and Barnabas were also mentioned in the New Testament as apostles. The Chartres clergy celebrated most apostles' feasts separately, and some in traditional pairs. At vespers on the evening preceding these feasts, the canons made a procession to the apostles' altar in the apostles' chapel.[238] The only exceptions were the vesper processions to the altars of St. Peter in Chains and St. James Major in the crypt.[239]

The window depicts biblical events commemorated with important temporal feasts which were especially associated with bread—Holy Thursday, Pentecost, and Ascension (plate 77). On Holy Thursday, commemorating the Last Supper, six priests and the bishop consecrated quantities of hosts for Easter in advance, since none could be consecrated on the next day, which commemorated Christ's death.[240] Ascension and Pentecost were the feasts when bread was traditionally blessed and distributed to the poor.[241] The bread represented in the bottom of the window must be the *echaudées* or *michia*, loaves smaller than ordinary ones that were made for gifts to the poor.[242] Ascension and Pentecost were also days when obligatory bread presenta-

tions were expected at local churches, presumably to serve this charitable purpose.[243] The images of offering bread at the bottom of a window were combined with traditional religious imagery which refers to feasts associated with bread offering.

The Windows of Sts. James and Peter in the Nave Clerestory

Two south clerestory lancets in the second bay of the nave depict huge figures of St. Peter and St. James Major (plates 36 and 38). Beneath these figures, in much smaller scale, there are images of the making, transporting, and selling of bread similar to those already described.[244] The window of St. James, Bay 68, nearest to the west entrance, has two bread scenes in two registers at its base. In the upper register, a man, apparently a baker, sits on a golden kneading table holding a baker's tool (plate 37).[245] A bowl with a spoon in it beside him presumably holds his dough, and hanging next to him is a mold, a *moule à gaufres*, for making large cakes.[246] Two of these huge cakes appear to float in midair, like emblems, on either side of the composition; two more appear on either side of the arch above him. In the left-hand corner, the small structure with an arched opening whose interior glows red, accented by a sort of flame, must be an oven. The baker appears about to mold and bake special presentation breads, perhaps *tortelli* like those mentioned in the list of payments that the managers of the chapters' farms freed the serfs from paying in 1149.[247]

In the lower register, two men carry a large basket of bread in a scene very similar to that in the center of the apse, with some variations. A setting is suggested by a door, from which the men seem to have just emerged. That they might have come from an oven is not clear, since ovens were usually bee-hive shaped constructions built in the open. The men are attired in a manner similar to those in the center apse, but they are in reverse order: the man in the front is bare-breasted and the second basket-carrier wears a short green *cotte*. Again, there is the suggestion of fresh-baked, or warm bread, as in the apse clerestory.

The second window, Bay 69, depicts St. Peter above a scene of a bread stall similar to that in the Apostles' window in the ambulatory chapel (plates 38 and 39). The merchant is on the left, seated behind a table on which a row of ordinary-sized loaves are displayed. However, he holds up a large, white presentation bread to a buyer opposite him. The buyer stands behind the table and leans over to pick up a presentation-sized loaf with one hand and to hold out a coin to pay for it with the other hand. The merchant extends his right hand to take the coin. A third large loaf rests on the table between them. Here the depiction of the one coin is not realistic, since the large bread was surely worth more than one denier, yet no coins larger than a denier were in circulation at the time.

The bread scenes in these two windows represent variations on the theme of making, transporting, and selling bread already observed in the Apostles' window and the apse.[248] The fact that they reappear associated with two major apostles links them to the apse window of the apostles. There is nothing specific here to suggest that the large loaves were meant for offering except their size, but I believe their size would have made their purposes obvious to the medieval viewer, who would have understood the loaves to be made specially for different presentations.

The closest contemporary imagery of bread appears in the window of St. John the Evangelist at Bourges (plate 53).[249] This window is one of a series of so-called trade windows in the ambulatory of Bourges Cathedral, presumed to have been made at approximately the same time as the lower-story windows of Chartres Cathedral.[250] The window has two bread scenes in the bottom register. One depicts bakers removing bread from an oven, a scene which does not appear at Chartres.[251] The other depicts a bread stall similar to those in the window of the Apostles and the window of St. Peter at Chartres. At Bourges, the table is piled with white loaves, and a noblewoman on the left leans over the table, selecting bread to buy. She picks up one loaf with her right hand, and passes another to the bread-seller behind the table, who reaches out with both hands to take it—or possibly he has just handed the loaf to her. A man on the right leans over the table to pick up another loaf. The scene is quite similar to that in the bottom of the St. Peter window at Chartres, but at Bourges there is little to indicate that the loaves are offerings. However, the Visitation appears immediately above the pile of loaves for sale at Bourges, just as the Visitation appears above the offering of bread in the Chartres apse, suggesting at Bourges the same relationship between the feast of the Visitation and offering bread as at Chartres.

Another scene of a bread stall similar to those at Chartres appears at Auxerre in a stained-glass pictorial cycle of Mary of Egypt. Mary stops to buy loaves before her penitential trip into the desert. She stands at the left of a table piled with bread, and holds up three loaves with her right hand while gesturing to a bread merchant with her left hand. He sits behind the table and raises his hand toward her as if he is speaking.[252] The depiction of bread-selling in contemporary life at Chartres and Bourges appears at Auxerre as part of a hagiographic cycle.

The only other thirteenth-century windows with depictions of bakers appear at the cathedral of Le Mans, dated to approximately 1265, presumably later than the clerestory windows at Chartres.[253] The scenes are still quite traditional in their composition, but their repetition in the choir beneath sainted bishops and monks presents a different kind of association from that of the bread scenes at Chartres.

The two nave clerestory lancets at Chartres show bread imagery beneath the two most celebrated apostles in the cathedral. Above depictions of the preparation and transportation of bread, St. James appears within an architectural framework, holding his pilgrim's staff and dressed in a toga dotted with shells, symbolic of the pilgrimage to his shrine at Santiago de Compostela. His gaze is directed toward the east and his body turns slightly in that direction (plate 36).[254] Another, similar figure of St. James appears in the fourth clerestory lancet to the east, Bay 74. Beneath this St. James, a group of pilgrims similar to those in the apse window, Bay 121, raise their hands and their eyes upward toward St. James in prayer.[255] St. James of Compostela was strikingly popular in Chartres Cathedral, perhaps because Chartres was a station on the road to Compostela from Paris. His feast was celebrated on July 25. At vespers the evening before the feast, a procession in his honor proceeded to the chapel in the crypt dedicated to St. James and St. Christopher.[256] Four other stained-glass windows in the cathedral were dedicated to him.[257]

Adjacent to St. James in Bay 68, and above the depiction of a man buying bread from a bread-seller, St. Peter appears within an architectural framework, draped in a purple toga and holding his attribute, the keys given him by Christ (plate 38).[258] He, too, faces in an eastward direction, but looks upward, perhaps toward the Christ who blesses in the oculus above him.[259] St. Peter was also a very popular saint at Chartres. He appeared repeatedly in the cathedral in column statues and in stained glass.[260] The clergy celebrated three feasts in his honor: the feast of the Chair of St. Peter on February 22, the feast of St. Peter in Chains on August 1, and the anniversary of his martyrdom (and St. Paul's) on June 29. Vesper processions on the second feast proceeded to the altar of St. Peter in Chains in the crypt,[261] but the others presumably went to the Apostles' altar in the ambulatory chapel.

A definite sense of movement from west to east is implied in the two windows—first, because the saints turn toward the east, as if attending a ceremony there; and second, because the bread scenes beneath them move narratively from west to east, that is, from bread preparation and transportation to bread sale. This sense of offering preparation and saintly liturgical movement toward the altars in the eastern part of the cathedral ties together, as it were, the heavenly and earthly liturgies.

The significance of the large white loaves prepared beneath St. James and sold beneath St. Peter as offering breads seems to refer to the large loaves of finest flour made for Christmas, Easter, and Ascension offerings, and for honorary presentations. And this suggestion is strengthened by the writing of Pierre de Celles, who wrote in the *Liber de Panibus* that bread made of the finest wheat flour is divine beyond human understanding, and is offered upon the altar to the Lord.[262] The suggestion in the window imagery of freshly baked loaves is also sig-

nificant. Pierre de Celles ends his treatise on bread by commending the offering of hot breads as firstfruits, because the ultimate and supreme bread was hot, that is, the living Christ, who was the firstfruit of God the Father.[263]

Conclusion

The importance of bread in the economy of Chartres is matched by its importance in the imagery of the cathedral. The scenes of bread in the windows and on the trumeau depict the preparation, the liturgical presentation, and the distribution of bread in the church. They occur along the central axes of the church, the routes followed by the offering processionals. The scenes of bread in the windows and on the trumeau are artistic evidence of a social practice, implicit in local documents. In each location where the bread scenes appear in the cathedral, biblical imagery evokes major feasts when bread presentations were required—Christmas, Epiphany, All Saints, Ascension, Pentecost, Purification, Easter. The conjunction of images of bread production, offering, and distribution with traditional iconography of the major feasts makes reference to the actual festival procedures. Only in the windows at Chartres is there an explicit emphasis on the actual offering of bread. While the bread scenes at Bourges and Le Mans may also refer to such liturgical offering, they do not actually depict it. The central placement of bread imagery at Chartres is also unique.

Not by chance, the third miracle in the new collection of miracles of the Virgin, written around 1210, relates a reenactment of the multiplication of the loaves. It follows immediately after the description of the miraculous events which led to the decision to rebuild the cathedral. Christ, at the Virgin Mary's request, increased five loaves to feed a multitude of hungry worshipers who were pulling carts of wheat to help with the new cathedral's construction.[264] The message is the same in each location at Chartres where bread appears: Christ provided for his church and for the bread of mankind. Christ provided the people with the means to make bread and the people returned their gifts to him in thanks. The prayer to bless eulogy bread cited the multiplication of the loaves, implying that Christ really provided the loaves that were ceremonially offered on feast days.

Each station of the sequence of bread images portrays a different aspect of the benefits accruing to the offerer, extended to him by Christ through the auspices of the bishop and canons. At the portal, expiation of sin through the intercession of Christ welcomed the worshiper; in the chapel, he saw the sanctification of work whose product served the church, and he was reminded to purchase his offering. In the choir, the offerer received, in exchange for his offering, the sacrament or its substitute, the eulogy.

The bishop and canons received bread offerings for the Virgin, blessed the bread, and distributed it back to the people as spiritual nourishment. The images of bread offerings proclaim the importance of the offerings to the cathedral. But the loaves of bread were economically insignificant to the clergy, who were very wealthy men. They were not bickering over their share of the bread presentations like parish priests and monks. The loaves were important to the peasants and artisans, who by their offerings participated in the liturgy at which they were otherwise only observers. This was a spiritual principle, an ideology promoted by the bishops and the canons—not by the bakers.

It was most likely the chapter's Loëns bakers who prepared the offering bread, and the chapters's *avoués* who sold it in the cloister. Work was ordinarily prohibited on Sundays and feast days.[265] The chapter may have granted special permission to its *avoués* to bake and to sell bread on these days, particularly during the fairs that coincided with the Virgin's feast days. The bread was probably made from the chapter's wheat stored at Loëns, acquired through the chapter's feudal rights and landholdings in the diocese. This suggests a scenario in which the canons actually profited from each stage of the process. By redistribution of offered bread as eulogy or charity, the bishop and canons fulfilled their obligation to provide not only spiritual care but also social welfare.

The imagery treats the bread as a free-will offering. Although some may have been voluntary, so far as we know from legal documents most of the bread presented to churches on feast days was prescribed. This contradiction between ideology and reality was mediated by the liturgical transformation of the bread, first into an offering, and then into the substitute sacrament of eulogy. The scenes urge generous offerings and pious work for the cathedral and imply the peaceful cooperation of the townspeople and the count. But social reality harshly contradicted these ideological premises.

Wheat production was the occupation of over 90 percent of the diocesan population. Peasants and artisans performed the labor necessary to produce the piles of bread, and their labor ultimately made possible the funds to rebuild the cathedral. Bread symbolized the peasants' labor in the wheat fields, without which neither the town nor the cathedral could have existed.

CHAPTER FOUR

THE OFFERING OF WINE

For the talk of and the renown
Of the good wines he had heard
Which were sold at Chartres,
Clear, whole, pure, and delicious.
He was curious to drink them. . . .
So that upon arriving there,
He headed straight for the tavern. . . .

Jean le Marchant, *Miracles de Notre-
Dame de Chartres*, 1252–62.[1]

The Wine Scenes

Images of men holding up goblets filled with wine appear predominantly in windows on the north side of Chartres Cathedral (plate 83). The most striking instance is in the Lubinus window in the north aisle, Bay 63 (plates 84–89).[2] In the border at the base of the window, and in the first center semimedallion above it, men hold up goblets of wine for sale. In the vertical borders on either side of the pictorial cycle of the saint's life, fourteen men hold up goblets of wine as if offering them to the saint, and high up in the center of the window, a priest brings wine to the altar for mass. In the Lubinus oculus of the north nave clerestory, directly above the Lubinus lancet in the aisle, two men offer cups of wine to the sainted Bishop Lubinus seated between them (plate 90).[3] The oculus was undoubtedly added later in the construction of the church, but was deliberately placed in the same bay as the Lubinus window in the aisle, and repeats its theme. I have found no images like these of wine offering in other thirteenth-century French cathedrals.[4]

The emphasis on the imagery of wine at Chartres was more pronounced originally, since the lost lower-story window in the north transept dedicated to St. Lawrence, Bay 57, had figures down the center holding out goblets of wine.[5] In a different typology, clerics are depicted kneeling before huge goblets of wine atop altars in four clerestory lancets and one oculus of the north transept (plates 92–94).[6]

Two windows in the south transept also emphasize goblets of wine, with the image of Christ holding a chalice in the center of the south

rose[7] and another image of a cleric praying before a huge chalice on an altar in Bay 100 (plate 95).[8]

Excepting the Christ, all the men with goblets of wine have been identified as donors of the windows in which they appear, despite a complete lack of documentation. The laymen holding up goblets are said to be tavern keepers.[9] The clerics are simply called priests.[10] Whether the images represent window donation can not be resolved without more evidence than has so far been found. However, there is a historically based explanation for the profound sense of offering that the images evoke, in the medieval practice at Chartres of offering wine in church.

The windows had not received much scholarly attention until recently, beyond Yves Delaporte's short description of the scenes.[11] Since I began work on the Lubinus window in 1978, other scholars have published research on the lower-story windows of St. Lubinus and St. Lawrence. One, a graduate student of Madeline Caviness, Carole DeCosse, published a summary of her master's thesis on the Lubinus window in *The American Wine Society Journal* of Winter 1986, which took into account the saint's legend and some of the well-known local history of the wine trade, and described briefly the coordination of the images of wine in the center medallions with those of the saint's life in the lateral semimedallions. Her reading of the secondary literature and the imagery was competent but led to the same conclusions which had already been traditional in the literature.[12]

Another scholar who has worked on the Lubinus window is Wolfgang Kemp, a German of international reputation. He published a book on the narrative windows of Chartres in 1987 entitled *Sermo Corporeus,* in which he devoted a long section to the Lubinus window,[13] and he discussed the window in an article published in 1988.[14] In general, the positions of both DeCosse and Kemp concerning the meaning of the Lubinus window and the related St. Lawrence window are similar to each other, and to those in the previous literature. Kemp argues from a broader base of knowledge and theory, but both he and DeCosse agree that a confraternity of tavern keepers in the town donated the Lubinus window.

Colette Deremble-Manhes also studied the window of Lubinus as part of a much larger study of the lower-story windows at Chartres Cathedral. She has a broad base of knowledge about local medieval history and liturgy to bring to her analyses. In her unpublished thesis, she focused astutely on the window of St. Lubinus as an exemplar of the office of bishop.[15] In the book on the legendary windows at Chartres which she coauthored with her husband, Jean-Paul Deremble, and published before the completion of her thesis, she lists the tavern keepers along with other trades as window donors.[16]

I have elected to present my own arguments here, free of specific debate with these scholars, since my own work has always been intended to rewrite the historical discourse that they have essentially repeated.[17] I will first present pertinent social history about wine before I proceed to a close analysis of the imagery of it.

Wine Production and Consumption at Chartres

The wine of Chartres was praised in the thirteenth-century miracle text quoted above, suggesting the miracle's intent to attract pilgrims and travelers by praising the local wine.[18] Already in the eleventh century, the town of Chartres was surrounded by vineyards. Wine was the privileged drink of the elite.[19] During the twelfth century, new plantings of vines and the installation of many new presses greatly facilitated and expanded wine production and consumption.[20] Wine was produced from numerous new, small plots as well as large old ones.[21] Smaller lords and ecclesiastical establishments that planted new vineyards leased them to tenant farmers, who retained some of the wine for themselves.[22] Consumption amongst the population grew from the eleventh to the thirteenth century, along with the increased plantings of new vines.[23]

The bishop's vineyards were the oldest and finest in the region.[24] The bishop's income from wine apparently did not increase very much because it was based primarily on his old vineyards and feudal rights.[25] On the other hand, the chapter's income from wine was continually growing, due to the lay donation of vineyards to the cathedral and increased revenues in tithes and taxes from the new vineyards.[26] The canons' wine income was further increased after the dismissal of the four provosts in 1194.[27] In order to assure good management and optimum yield from their old, enclosed vineyards, the canons appointed managers (closiers) over them, who often utilized day workers for labor.[28] The canons contracted other vineyards to tenant farmers.[29]

By the thirteenth century, vineyards covered the banks of rivers and slopes of valleys in the diocese of Chartres. But the region's wine production was entirely consumed locally.[30] Wine had become a staple of the local diet. The daily ration for laborers was one loaf of bread and one liter of wine.[31] Corvée workers were allotted wine daily.[32] The food which the bishop provided for his household staff included portions of wine.[33] Daily portions were allotted the cathedral canons,[34] and drinks of wine or wine mixed with spices were served to the canons during breaks in long liturgical services.[35] Local monks' consumption of wine increased along with its local accessibility.[36] Wine consumption must have been considerable in the town of Chartres, estimated to number around 7,000 inhabitants, where the bishop received eighty livres during his temporary monopoly of wine sales in the town, indicating

that some 3,200 barrels, or 116,793 liters, had been opened.[37] The bishop undoubtedly held his monopoly sales during major religious feasts, when the influx of pilgrims would have increased consumption.[38]

The almost total disappearance of vineyards in the region today is undoubtedly due to the failure of the local wine to stand up to modern comparison with the wines of the nearby Loire River valley. Even in the Middle Ages, the wine of Chartres varied widely in quality. The ordinary wine made in the region was white, but there were some highly valued local red wines as well.[39] The quality of wine depended on the quality of vineyards—the best wine came from the big, old vineyards.[40] New vineyards tended to produce lesser-quality wines, presumably because the best locations for viticulture had already been planted.[41]

Wine pressed by foot, called the wine of the *foulage*, was highly prized.[42] All the images of labor for the month of September in the cathedral show a farmer standing in a barrel crushing grapes with his feet to extract the most prized quality of wine (plates 106 and 107).[43] The dregs left over from foot-pressing were transported to mechanical wooden presses which produced lesser-quality wine.[44] New wine was valued, but old wine was not, and barrels were important investments which could be reused, so an effort was made to empty barrels in the late summer to make them available for the next harvest.[45]

Wine, like bread, continued to be used for the payment of obligations at Chartres in the midst of a predominantly money economy. In the twelfth and thirteenth centuries, men frequently paid taxes on wine production and sale with wine itself.[46] These taxes were numerous. Besides the tithes, small and large, and firstfruit payments, there were charges for transportation, weighing and measuring, taxes against the tenants to pay the lord's tavern keeper, and taxes against the tavern keeper for every barrel opened. The chapter's tenant farmers paid half of the cost of delivering the chapter's wine harvest, taxes for measuring wine, taxes on the total wine production, tithes, wine-press fees, and half of the cost of maintaining and protecting the *clos*.[47] Payment in wine pressed by foot was preferred to money payment for any obligation on vineyards, and was frequently stipulated.[48] Not all wine payments satisfied obligations bearing on wine production and commerce. The king's taxes for his "conservation of coinage" were paid in bread and wine, the so-called *panis et vini* taxes, recorded at Orléans and later in Paris.[49] The social importance of wine was clear in the chapter's practice of welcoming important visitors with a drink of its best wine, and in the local custom of concluding contractual agreements with a round of wine for the participants.[50] Significantly, small taxes were often paid in cups of wine.[51] It seems there are several possible explanations for the images of men holding up wine cups in the windows.

The Sale of Wine at Chartres

Who might the tavern keepers in the Lubinus window have been? Each holder of high justice had the right to appoint tavern keepers in his own territory.[52] Medieval tavern keepers were originally serfs or vassals appointed by lay and ecclesiastical lords to sell their surplus wine.[53] The most powerful lay and ecclesiastical lords in France also established for themselves the right to sell their wine to the exclusion of all others during certain times of the year, called the *banvin*.[54] In the region of Chartres, these bans were generally set during religious feasts, when consumption was greatest.[55] We know that the count had the ban of Pentecost at Chartres in 1193, and probably also that of Easter.[56] Although the canons surely also sold wine in the Middle Ages during special bans, the earliest record of the chapter's bans is from the seventeenth century, when the chapter had the count's old bans of Pentecost and Easter, and the bishop had that of Christmas and three weeks thereafter.[57]

Landlords had long sold their excess wine in a monopolistic manner, but with the growth of production the broader market necessitated a change in distribution methods. In order to increase their profits and fill demands, lords gradually abandoned monopoly sales in favor of a tax also called *banvin* that they charged others who sold wine during their temporary monopoly.[58] Thus, the meaning of the word *banvin* changed. The original function of tavern keepers gradually changed, and taverns remained open as much of the year as was economically feasible.[59] Around 1180, the count agreed with the bishop to set *banvin* at three sous per six barrels of wine.[60] According to Chédeville, the price of wine stayed the same thereafter, but the measures by which it was sold were diminished.[61]

The meager information about taverns in local documents can be more fully understood by comparison with more ample documentation in other French towns. In Paris, wine criers advertised the wine of each new barrel tapped in a tavern by calling out its price and quality at the crossroads, and by offering a sip of it to passersby from covered goblets called *hanaps*.[62] At Bourges, a town similar to Chartres in size and agricultural economy, tavern keepers originally sold wine in small amounts to customers who brought their own containers; it was carried away and consumed elsewhere. Eventually they allowed drinking on the premises and served simple meals.[63] Then, tavern keepers set up a sign over home or stall to attract customers, sending out a wine crier to announce the tapping of each new barrel.

Apparently, this development occurred at Chartres, where charters attest to the presence of tavern keepers and wine criers from the early twelfth century.[64] Most of the taverns (*tabernae*) in charters from the region of Chartres in the twelfth and thirteenth centuries were places

set up temporarily to sell small amounts of wine to be carried away.[65]
The system allowed both lords and small tenant farmers to sell wine
that they did not want for themselves. Just as at Bourges, some taverns
at Chartres eventually allowed customers to drink on the premises.[66]

The Count's Tavern Keepers

The count had his own tavern keepers. The feudal relationship be-
tween the count and his tavern keepers is clear in the 1147 charter of
Count Thibaut IV of Chartres:

> I, Thibaut, Count of Blois, . . . do wish that the tavern keep-
> ers of Chartres who were accustomed once a year at a certain
> time to dine together, because this was seen to extend to
> gluttony, ask them to denounce it in order that they might
> desist from this and give yearly thirty sous to assist the
> brothers of the Leprosarium of Grand-Beaulieu, who have
> pleased me by asking diligently, and they [the tavern keep-
> ers] should deliver every year on the feast of All Saints thirty
> sous from all of them to their master, to be accepted and
> paid to the brothers of Grand-Beaulieu. This I commended
> and conceded because they hold their offices from me and I
> instituted it by their holding my hands, and let not any dis-
> pute rise up over this thing. . . . [67]

This document has been cited as proof that the tavern keepers formed
a confraternity in the twelfth century, because of their communal
meal.[68] Kemp argued that their feast was proof of the tavern keepers'
organization into a group which had freedom to act and to donate win-
dows. Whether or not a communal meal indicated a confraternity is
debatable, but at any rate the count prohibited the custom in 1147. The
count appointed his tavern keepers and they pledged feudal homage to
him. The count directed their "charity" to the leprosarium; the tavern
keepers had no say in the matter. In 1163, Pope Alexander III confirmed
the leprosarium's revenues, including the "gift" of thirty sous yearly
from Count Thibaut *ex clamatoribus vini.*[69] This must be the same
thirty sous that the tavern keepers began paying in 1147; but sixteen
years later, in 1163, it is said to be paid "from the crying of wine." The
expression undoubtedly was meant to indicate that the payment came
from selling wine, but it also shows that wine-crying had begun to be
practiced at Chartres.[70]

The next record we have of the count's tavern keepers dates to 1220,
when the widowed Countess Isabelle of Chartres awarded her marshal
and his heirs the mastership of her tavern keepers and wine criers,
taking care to retain the major justice over them, and lordship over her
marshal:

> I, Isabelle, Countess of Chartres . . . have given and conceded
> to [John de Coulrage] and his heirs the mastership of my

tavern keepers of Chartres and the criers of wine outside [*Curratorie de vino deforis*] to hold in perpetuity by heredity right the full jurisdiction of the same tavern keepers and criers. Excepting however the greater jurisdiction which is to be retained to me on the same things concerning the taverns and the same wine-crying. Besides two measures of wine that my tavern keepers of Chartres were accustomed to owe to me and were accustomed to hand over annually on Easter, I have conceded to the same John and to his heirs in similar fashion to have by hereditary right. Besides this, however, I have accepted John as liege man and both he himself and his heirs will exhibit to me and my heirs about this same thing similar homage, paying five sous whenever they visit.[71]

This charter, hitherto unpublished, is not well known in the literature. It shows that the master of the tavern keepers was appointed by the count or countess, not elected by his peers—something not made clear in the document of 1147. It is interesting to note that the tavern keepers paid wine, in place of money, as a sort of feudal cens payment, to their new master—another example of the local preference for wine payments to money payments.

The Chapter's Tavern Keepers

The count's control of the taverns in his territory in the town is clearly documented in the thirteenth century, whereas that of the chapter is not found until later. The first surviving documentation of a tavern in the cloister dates to the early fourteenth century.[72] However, the canons probably had been selling off their own excess wine in cloister taverns in the twelfth and thirteenth centuries. Because of the canons' expanding wine receipts, they undoubtedly had more wine than they needed to serve the cult and their own tables. The canons were clearly engaged in the commerce of wine by 1195, when they bought and sold wine during harvest.[73] They probably bought up the wine production of the many small vintners in the region.[74] Their zeal to accumulate excess wine is also evidenced in their effort to continue receiving all feudal vineyard payments in wine instead of money.[75]

The canons' most profitable commercial outlet for its surplus wine would have been taverns in the cloister. The chapter held the high justice of the cathedral precinct, which was immune from the count's taxes, as papal bulls in the twelfth century repeatedly confirmed.[76] The canons naturally would have sought to maximize profits and attract pilgrims to spend money in the cloister, rather than in competitive taverns in the count's part of the town. The abbey of Saint-Père held a tavern in its area of jurisdiction in town, as a charter issued by King Philip Augustus in 1208 indicates.[77] It seems likely that the canons

similarly had a tavern in their jurisdiction, especially during the feasts of the Virgin, when pilgrimage to Chartres was heaviest and the cloister was a busy fairground guarded over by the chapter's dean.[78]

If this is true, then the chapter also had wine criers, crying their wine in the cloister. In 1327, the chapter prohibited wine criers from working any longer in the cathedral nave because of the disorder they caused there, but permitted them to continue working in the crypt.[79] Historians have thought that the canons were helping these criers to avoid the count's taxes.[80] But the chapter's desire to sell its wine in competition with the count's taverns in the town would more convincingly explain its willingness to tolerate wine criers in the cathedral. The criers were presumably advertising the chapter's wine, and no one else's.

Wine criers shouted hyperbole and metaphor to entice customers, judging from the wine crier's call in Jehan Bodel's popular play, *Le Jeu de Saint-Nicholas*, written at Arras around 1200:

> New wine, just freshly broached,
> Wine in gallons, wine in barrels,
> Smooth and tasty, pure full-bodied
> Leaps to the head like a squirrel up a tree
> No tang of must in it, or mold—
> Fresh and strong, full, rich-flavored
> As limpid as a sinner's tears
> It lingers on a gourmet's tongue—
> Other folks ought not to touch it.[81]

It is surprising to think of wine criers shouting their colorful calls in the cathedral nave. That the canons allowed such an interruption of the religious activities in the cathedral was most likely due to their desire to entice customers to their own taverns, and not to those of their antagonist, the count.[82]

The Wine Presentations at Local Churches

Just as wine was used to make all sorts of payments, so also wine was presented at local churches to fulfill many different kinds of obligations. Wine tithes were due from all wine production, and appear as parish rights and transferable revenues in local documents.[83] Small wine payments were part of the firstfruits or small tithes due to parish churches.[84] Diocesan parish churches expected *altarium* presentations of farm products such as wine, linen, and candles on feast days.[85] It is, therefore, likely that even when wine was not stipulated, it was presented to local churches for oblations, firstfruits, and tithes.[86] Wine was an important means of provisioning, and hence appears as a major portion of the payments promised in the foundation of a new chapel in 1208.[87] Customary payments and taxes paid in wine were donated to

local churches by the laity and clerics to pay for anniversary celebrations.[88] The persistence of bread and wine payments at Chartres indicates the essentially agricultural economy of the region.

The bishop and canons undoubtedly received many payments in wine, and many of these were the kinds of payments that were frequently incorporated into mass-offering presentations. The bulk of the bishops' and canons' wine receipts came from their own farms.[89] They received half of the total harvest, as well as numerous wine taxes, from their tenants. The tenants generally paid the harvest tax (*terceau*) of two barrels per acre,[90] plus taxes for use of the canons' press, for measurement of the wine, and other small taxes, all probably paid in wine.[91] The canons had the right of *terceau* on most of the vines in the suburbs of Chartres as well.[92] The farmers in Saint-Lubin-des-Vignes paid the chapter for the use of their local wine press in cups of wine, which were assigned to the rich Matins account.[93] Some farmers paid their wine tithe to the canons instead of to their local parish,[94] and the chapter must have received a large share of the *altarium* from its parishes.[95] The presentation of payments on feast days was the custom, and it is therefore logical to think that people came on feast days with their small wine payments to the cathedral. In that case, the people would have offered the wine liturgically.

The Liturgical Offering of Wine

The lay practice of offering wine at mass continued in the twelfth century, long after the early Christian custom of presenting bread and wine for the Eucharist had almost completely died out.[96] Schreiber found evidence of obligatory wine presentations in the diocese of Chartres and elsewhere in France.[97] The more rigidly prescribed the payment, the more deliberately it was drawn into the offeratory procession on specified feast days.[98] Where possible, people who brought such payments would have carried them to the altar in the mass-offering procession, or otherwise would have delivered wine to the Loëns, and afterward attended mass to offer spiritually the product of their work.

The Distribution of Ablution and Eulogy Wine

Small wine presentations brought to church were collected in large containers, like those which had been used in the early Christian period for the collection of wine offerings for communion.[99] In the thirteenth century, the proceeds were not generally used for communion, since the clergy usually provided their own special communion wine.[100] Only the celebrant and his assistant at mass took communion regularly; the people did not usually do so except at Easter.[101] When the congregation did take communion, they received only the wafer, not the consecrated wine.[102]

After eating the host, communicants sometimes took a sip of uncon-
secrated wine or wine mixed with water called ablution wine, offered
to them to insure that none of the holy particles would be lost.[103] Since
the blood of Christ was seldom given to the laity, this ablution wine
served, in part, as a remembrance of it.[104] From the thirteenth century,
the custom of giving ablution wine after communion became more
and more general.[105] Ablution wine was even given to children and
infants at baptismal communion at Easter.[106] Wine blessed after mass
and offered to the congregation in small sips was, therefore, similar to
the bread substitute for the Eucharist called eulogy. It functioned the
same way, as a communion substitute, and was sometimes even called
eulogia, but more often "blessed wine."[107] Small wine offerings col-
lected on feast days probably served for oblation wine, although the
infrequency of lay communion suggests that the canons sometimes
retained wine offerings for their own use.

Historical Analysis of the Images of Wine and Their Contexts

Based on the record of wine commerce and offering in medieval France,
we can now try to reinterpret the scenes of wine in the north aisle and
north transept of Chartres Cathedral. I include in the consideration of
each window my findings on the iconographic tradition from which
the scenes of wine were derived, the relationships between the images
of wine and the accompanying traditional religious imagery of the
windows, and the social and liturgical implications of these constructs
in the cathedral.

The Lubinus Window in the Aisle

The Lubinus window has five interrelated themes about wine set out
in geometrical order. At the base of the window, wine is advertised. In
sequence up the center of the window, wine is transported, stored, and
carried to the altar for mass. In the vertical borders, fourteen men offer
goblets of wine to St. Lubinus, whose life is illustrated in the middle
panels. We will see that the separation of the saint's life from the cen-
tral medallions is not consistent, since some of the scenes about wine
can be understood to illustrate the events in the life of the saint.

Four scenes at the base of the window depict the crying of wine at
Chartres. In the lowest register above the border, the center half-
medallion depicts a scene which has no basis in the saint's legend
(color plate 2, plate 86, panel 1, and plate 96).[108] Yves Delaporte de-
scribed it this way: "Here is a tavern: a hoop, without doubt a sign, is
hung from a rod. The owner has come outside and presents a cup of
wine to a client who is seated in the open air."[109] Although he offers
no proof, Delaporte was right. The barrel-hoop sign, a loop suspended

from a stick in the scene, marks the entrance to a tavern. A similar sign marked the entrance to a tavern in Bodel's play, *Le Jeu de Saint-Nicholas*.[110] This sign became mandatory for taverns employing wine criers in Paris in 1415.[111] Evidently, the tavern is located in or adjacent to a tower, since the sign projects from the side of a tower that abuts a building. This tower must be understood as a gate; it is similar to the one through which Bishop Lubinus rides astride a donkey in panel 119 of the window.

In the foreground, a man in tradesman's *cotte* offers a drink from a goblet to a man dressed in merchant's attire slouched on a fat bag.[112] The tradesman holds up the lid of the goblet with his left hand. A smaller tradesman behind him who is surely crying wine holds a stick in one hand,[113] like the crier in Jehan Bodel's play.[114] In the window, he raises his left hand to his cheek and tilts his head back to call out. The combined actions of the two tradesmen accord with the work of individual wine criers described in Parisian statutes recorded in 1268[115] and less fully documented in earlier statutes at Bourges.[116] The few documents about criers at Chartres quoted above suggested that crying wine had become a separate occupation from tavern keeping by 1220, but in earlier times had been combined. The two men in the scene are likely a tavern keeper and a wine crier, especially since wine criers did not work in pairs,[117] and tavern keepers did sometimes call the wine of their taverns themselves in close proximity to the taverns.[118] The two men are advertising the wine of the tavern behind them.

The three small scenes in the bottom of the border repeat the theme of wine-crying in panel 1 directly above them. The two corner scenes are slightly differentiated pendants, composed antithetically. In the left corner (plate 86, panel 22), two men are walking toward the center of the window. The man in front carries a covered goblet and the man behind him carries a stick in his right hand and holds his left hand to his cheek. In the right corner (plate 86, panel 24), conversely, the man in front carries a covered goblet in his left hand and holds his right hand to his cheek; the man behind him grasps a stick. In the middle scene (plate 86, panel 23), a woman seated on a cushion holding a moneybag looks toward a man holding a covered goblet who is walking away from her, probably having already offered her a sip of wine. A foliate form places the center scene out-of-doors. The man carrying the covered goblet holds one hand to his cheek as if to call out, an action relegated in other scenes to the man with a stick.

Both prospective clients in these scenes seem to be well-to-do travelers. The woman is well-dressed and holds a moneybag in her lap. She is apparently a pilgrim. The well-dressed man in panel 1 is probably a traveling merchant resting on his bag of wares.[119] Thus the four panels at the base of the window seem to depict wine-crying at Chartres, spe-

cifically to a wealthy pilgrim and a merchant—suggesting that wine was available in a nearby tavern to those who could afford to pay.

I believe that these tavern keepers must have been advertising the chapter's wine for sale in the cloister.[120] The tavern represented in the window may have actually adjoined the early medieval town gate, *Port du Cadran* (also known as the *Porta Nova*), that stood in the thirteenth century just outside the St. Lubinus window (plate 19).[121] Directly beyond the gate extended the chapter's storehouse, the Loëns, whose basement served as the chapter's wine cellar.

I found no previous tradition for the representation of wine-crying in medieval art. Traditions of artistic representation imposed themselves as models for the imagery of wine because of their similar appropriate subjects. The stained-glass designers apparently derived the scene at Chartres from the common and closely related iconography of a standing priest or bishop, accompanied by an attendant, giving communion to an ill or dying person (plate 103). [122] They did this in preference to showing a tavern interior, for which there were pictorial precedents in the Prodigal Son cycle and in illustrations of taverns like those in the *Carmina Burana* now in Munich (plates 101, 109, 110). The iconography of mass for the ill carries with it the notion that the Church provides for the needy. An example of this prototypical imagery appears in another window in Chartres Cathedral dedicated to St. Julien the Hospitaler (plate 102).[123] A priest offers communion bread and wine to St. Julien's dying master, who reclines in bed as Saint Julien lifts his master's head to receive the sacrament. The scene is unusual in that such depictions do not normally show wine offered in a chalice, only the host, in conformity with contemporary practice.[124] Sometimes, mourners appear at the bed of the dying person with their hands raised to their cheeks in a gesture of grief.[125]

In panel 1, the stained-glass designer apparently adapted this iconography by dressing the priest in workman's attire to indicate a tavern keeper, dressing the sick person as a merchant seated on his traveling bag, and transforming a mourning relative into a youth in working clothes with head thrust back to shout. The tavern sign on the building in the background sets the stage for the action. The chapter's tavern keeper provides refreshment for the traveler's body, just as the canons provide salvation for his soul in the scenes above.

The Farmer Delivering Wine

Above the scenes of wine-crying, the first of the three central medallions illustrates wine being transported from the countryside (plate 86, panel 2 and plate 97). The scene has no basis in the saint's legend. The stained-glass artisan rendered the scene with lifelike details. The horse pulls the heavy barrel forward, pushing hard with his hind legs and

lunging against his collar. The barrel's big lashings add to the impression of the barrel's weight and importance.

The medieval invention of the horse collar revolutionized horse power in the twelfth and thirteenth centuries, and, at the same time, the construction of larger wheels made heavier loads possible. Depictions of horses pulling carts changed accordingly to show the horse able to throw his weight forward and pull much greater weights. The closest depictions that I have found to the horse and rider in the window are in an early thirteenth-century copy of a manuscript of Herrade de Landsberg, which has none of the liveliness and sense of immediacy of the window scene.[126] The large wheel in the window, larger than in the manuscript, and the forward physical thrust of the horse, seem to display a pride in contemporary harnesses and wheels, and an ability to portray them. The driver sits atop the horse, not in the cart. Similar scenes appear several times in the windows at Chartres, where the cart serves to transport a person or an object of honor or worship.[127]

The man conducting the horse-drawn cart is most likely a farmer delivering a wine payment to the chapter's celler.[128] He might have been a tenant farmer, or a serf working on the chapter's land, or a serf delivering a wine tithe or wine payment for an anniversary. The month must be September, since that is when the wine harvest usually took place at Chartres.[129] Wine carts rattling along outside of the cathedral by the Port du Cadran gate on their way to the chapter's cellar, the Loëns, must have been a familiar sight at harvest time.[130]

The Wine Cellar

The barrel on the cart in panel 2 reappears in panel 3 in an ecclesiastical cellar (plate 87, panel 3, and plate 98). It looks like the chapter's cellar, the Loëns (plate 99), which was reconstructed in the thirteenth century.[131] Its beauty was praised in the *Polypticon* of 1300:

> Near the cloister on the side of the Porta Nova (Port du Cadran), the chapter has a most beautiful atrium which is called Loëns . . . and in the same place is a most beautiful stone cellar with many most beautiful barrels in which there was placed wine of all vineyards of the chapter's enclosed vineyards, and all the other vineyards of the chapter, which was distributed every day to the canons residing in the church.[132]

In the window, the floriated capitals topped by an impost block and the vaulted space they support look like a conceptualized image of the thirteenth-century Loëns cellar.[133] Within the vaulted interior, a deacon stoops to draw wine from the huge barrel into a cruet.[134] This panel and the next, while completing the center theme about wine, may also be seen to depict the life of St. Lubinus. They will be taken up again in the ensuing discussion of the hagiographic pictorial cycle.

The scene of a deacon bending over to draw wine into a cruet for mass was derived from depictions of the labors of the month. The artistic depiction of the labors first occurs frequently in France in the twelfth century, especially in the region of Saintonge and Poitou. This western French cycle typically depicts wine only once with a scene of grapes being crushed in a vat, to symbolize September.[135] However, an earlier, divergent cycle which emphasizes wine was known at Chartres. It was copied into an eleventh-century martyrology for the chapter of Notre-Dame.[136] The personification of August raises a mallet to secure hoops to a barrel in preparation for the wine harvest. September picks a bunch of grapes from a vine, holding a basket just beneath to receive the grapes. October draws wine (plate 105).[137] Dressed in working clothes, he leans slightly forward holding a large pitcher beneath the flow of wine coming from a hole in the end of the barrel in front of him. The pitcher is almost full, and he appears about to stop the flow by plunging the tapered stake he holds in his right hand into the opening in the barrel. He needs only to lean forward slightly since the barrel is posed in midair before him. In the Lubinus window, the barrel sits on the floor so that the deacon must stoop over to fill his cruet (plate 98). Hence the thirteenth-century image has changed in such a way that it is much more realistically drawn, and more ideologically conceived, since the man before the barrel must kneel down to draw wine as if he were making obeisance to the barrel.

The most striking difference is the barrel's greater size. In the eleventh-century depiction, the men are bigger than the barrel; in the thirteenth-century scene, the barrel is bigger than the man. In actuality, the size of barrels diminished and the cost of wine increased between the eleventh and thirteenth centuries.[138] One may infer that, from the ecclesiastical point of view, the importance of human labor had been devalued in the course of two centuries relative to the importance of its product. The thirteenth-century image suggests commodity production which the historical evidence of the wine trade confirms.

Wine at Mass

The deacon drawing wine into a cruet reappears just above in panel 4, where he brings the cruet of wine to mass (plate 88, panel 4, and plate 100). The designer of the mass scene strove for accuracy of detail to specify the purpose of the mass and the precise moment represented in the ceremony. The priest and deacon celebrate the liturgical commemoration of the beginning of St. Lubinus's episcopacy in mid-September.[139] This is suggested by the placement of the scene of the mass directly adjacent to that of Lubinus's ordination as bishop (plate 88, panel 17). It is confirmed by the two candles in the mass scene—a

small one on the altar and a large one some distance from the altar to the right. These candles follow directions for the use of candles at the two feasts of St. Lubinus. A document from Chartres dated ca. 1280 asserts that the bishop and treasurer owe the sacristans two candles for these feasts: a processional candle and a large candle:

> On the vigil of Saint Piatus, at first vespers continuously until after compline of the feast day, they [the sacristans] are held to place before the *capsa* of Saint Piatus one processional candle and one other large candle; similarly (it is done) on the two feasts of Saint Lubinus. . . . [140]

Delaporte assumes that the *capsa* in these liturgical directions refers to the reliquary containing Lubinus's head.[141] Van der Meulen, however, has argued that *capsa* instead refers to the shrine which contained several saints' bodies, including the bodies of Sts. Piatus and Lubinus, in the easternmost center of the choir.[142] The directions for the arrangement of the candles just quoted strengthens his argument.[143]

We can infer that the large candle to the right of the mass scene in the window is set before the newly erected shrine called the *capsa*, in the eastern end of the thirteenth-century Gothic choir, where the body of Lubinus was interred. The altar of celebration is most likely the altar in the choir where commemorative masses were said, located between the shrine and the main altar (plate 50, no. 20).[144] Again, the schematic architectural background seems intended to specify location—a curving, vaulted arcade passageway behind the figures, suggesting the ambulatory surrounding the choir.

Hence, we can conclude that the mass depicted celebrated the saint to whom the window is dedicated. It was the festal mass held in St. Lubinus's honor during the wine harvest. The assisting deacon has already decked the altar with the corporal, the blessed linen that covered the altar from oblation until after communion.[145] The small candle on the altar indicates the moment of holy sacrifice.[146] The officiating priest blesses a host in his left hand. The assisting deacon, approaching with the cruet of wine, holds in his left hand a liturgical knife to be used for the ceremonial cutting of the host. Both men bow their heads. The officiant recites the *Suscipe sancta Trinitas*—the offertory prayer traditionally recited while bowing before the altar, just before the *Vere Dignum*.[147] The *Suscipe sancta Trinitas* prayer from the twelfth-century Sacramentary of Chartres evokes the meaning of the moment.

> Receive Holy Trinity this oblation that I offer to you in memory of the incarnation, nativity, passion, resurrection, and ascension of our Lord Jesus Christ, and in honor of all your saints who pleased you from the beginning of the world, and in honor of [St. Lubinus] whose feast is celebrated today and whose relics are cherished here in order that it

might bring honor to [him] and to us salvation and in order
that [he] might deign to intercede for us in heaven whose
memorial we make on earth.[148]

The mass scene represents this moment of liturgical offering of the
gifts of the faithful.[149] Completing the *Suscipe sancta Trinitas* prayer,
the celebrant petitioned the congregation to pray for him as he pre-
sented their gifts to God.[150] Again quoting from the twelfth-century
Sacramentary from Chartres, he said:

Pray brothers for me to the Lord that my and your sacrifice
may be accepted in his sight.[151]

The response to this petition, made by the assistant in the name of all
present and frequently intoned by them as well, was:[152]

May God receive the sacrifice from your hands for your and
our salvation, that of all Christians, and of all the souls of
the faithful departed.[153]

These prayers, said at the moment depicted in the mass scene and just
afterward, unite the scene with the figures offering wine in the window
border.

The mass scene in the Lubinus window is unusual at Chartres,
where the windows contain surprisingly few other representations of
actual liturgical performance.[154] Other scenes of altars abound, and
usually represent either devotion or donation,[155] but they lack the pre-
cise indications of the moment in the liturgy or the accuracy of the
liturgical paraphernalia that are so pronounced in the Lubinus window
scene. In the thirteenth century, mass was typically represented at the
moment of the elevation of the host.[156] The elevation was proclaimed
essential to the orthodox celebration of mass by the bishop of Paris in
1210, and it was a physical demonstration of the very aspect of the true
faith denied by the Albigensian heresy,[157] then under attack by the
bishop of Chartres. The elevation of the host appeared in a liturgical
manuscript from Chartres, now lost.[158] However, the window scene at
Chartres emphasizes wine. The host was elevated during the canon of
the mass, after the *Vere Dignum*.[159] The moment represented in the
Lubinus window mass precedes this, and deliberately represents the
moment when wine arrived at the altar.

The Wine Offering

In traditional configurations of offering and submission, fourteen men
in the vertical borders, seven on either side, step forward toward the
altar holding out a *hanap* of wine in one hand and gesturing in offering
with the other. Each of them steps forward on his own semiroundel
with bent knees; most of them bow their heads, but a few look toward
the altar. They thus form a double offertory procession up the window

to the altar where Lubinus's commemorative mass is in progress
(plates 85, 86–89, panels 25–31 and 34–40).[160] In addition, two men
without *hanaps* of wine appear in the border procession. A man in calf-
length white attire and cap with a bag hanging from his neck steps
forward with the aid of a cane toward the center of the window (plate
87, panel 33). A man in a full-length red cloak with a hood stands
facing the center of the window and gestures as if in conversation or
offering (plate 87, panel 32). From their attire, they appear to be a pil-
grim and a merchant or a wealthy burgher,[161] joining into the proces-
sion of wine offerers. Since pilgrims and merchants would naturally
have come to Chartres on major feast days, their presence further
strengthens the impression of a feast-day procession here.

The men who offer wine at the mass of St. Lubinus are either tavern
keepers, wine criers, or tenant farmers—the three occupations repre-
sented in the center of the window. They may very well have been the
chapter's tenant farmers from the suburb nearby called Saint-Lubin-
des-Vignes, who paid their *terceau* or harvest tax to the chapter on the
feast of St. Lubinus in September, and also paid some of their wine
taxes to the chapter in cups of wine.[162] An eighteenth-century record
of vineyard tenants paying fourteen pots of new wine per quarter ar-
pent of vineyard states that the practice was known to have been of
"ancient" origin. Hence the fourteen goblets in the window may rep-
resent the thirteenth-century expression of this custom. We know that
the chapter had tenant farmers to produce its wine, and must also have
had tavern keepers and wine criers to sell its wine. No matter what
their occupation, the men offering wine in the window most likely
fulfilled some customary presentation due to the chapter on the har-
vest feast of St. Lubinus. The liturgy of offering at mass would have
transformed their payment into a free-will, liturgical offering.

The enlivenment of the border with sixteen figures in semiroundels
is almost unique at Chartres; the only other instance is that of the
angels in the border of the window of St. Lawrence in the north tran-
sept. As a rule, borders are floriated or patterned. However, a compart-
mented border or frame, each compartment enclosing a single figure
holding an offering, was not new to medieval art. The twenty-four el-
ders, seated peripherally to the Godhead in Romanesque compositions
of John's vision described in Revelation 4 and 5, frequently appear in
this way, as, for instance in a Romanesque drawing originally con-
tained in a twelfth-century missal, now in the treasury of the cathedral
of Saint-Etienne at Auxerre.[163] The format encloses little figures of the
seated elders in individual compartments in the border. Each elder ex-
tends a goblet, or in some cases his cithara, in liturgical manner toward
Christ figured in relatively gigantic scale in the center.

The prototype, iconographically and structurally, appears at Chartres
in the thirteenth-century rose of the south transept. The elders hold

up jugs in the two outer concentric rings of stained-glass medallions. In the center, Christ sits on an altar in paradise and holds up a chalice of wine (color plate 9).[164] He conducts the heavenly mass surrounded by elders with offering containers, in close analogy to the earthly celebration in the Lubinus window. According to Revelation 4 and 5, the elders hold golden bowls of incense to join in the heavenly liturgy. Christ in the center offering wine is a medieval invention to specify that the heavenly liturgy is a mass.

An Old Testament pictorial tradition of wine offering signified charity. Moses, following God's command, ordered the Israelites to bring a contribution for the temple to the Lord (Ex. 35:4–9). The Oxford Moralized Bible shows the Israelites holding up containers of wine over an altar (plate 108). The commentary beneath the scene explains that the wine stands for charity.[165] Another contemporary example appears in the border of a window at Lyons where Charity holds out a chalice.[166] The figures offering wine to Bishop Lubinus in the Chartres oculus and those offering wine at his commemorative mass in the aisle window derive from figures of Charity, but wear thirteenth-century working clothes. The pictorial cycle of the life of the sixth-century Bishop Lubinus is also cast in contemporary thirteenth-century guise.

The Pictorial Cycle of the Life of St. Lubinus

Now we turn to the traditional religious imagery associated with the scenes of wine. The window dedicated to St. Lubinus in the north aisle contains a traditional type of pictorial hagiographic narrative, but it is the only known pictorial cycle of the life of Lubinus.[167] The primary source for the literal meaning of these scenes is the legend of the saint,[168] which contains a brief account of Lubinus's childhood, a long narration of his monastic life, followed by a description of his miracles and deeds after his ordination as bishop of Chartres. The date and author of the original text are unknown.[169] The earliest known copy of the legend dates to the eleventh century.[170]

Bulteau and Delaporte consulted the legend in order to explain the scenes in the window, but they did not systematically analyze the correspondences to and variations from the text in the pictorial content, which is my aim in the following study. Bulteau and Delaporte believed that the St. Lubinus window is unusual in that the center panels are not part of the pictorial narrative but refer to the window's donors.[171] It is undeniably true that the first two center panels, panels 1 and 2, have no basis in the saint's legend (plate 86). However, the remaining center panels, while they do complete an independently coherent series of images about wine, can also be seen to participate in a general way in the pictorial cycle of the saint's life. Therefore, panels 3, 4, and 5 will be included in this comparison of text and images.

Like most of the historiated windows at Chartres, the Lubinus window was designed to be read from left to right and from bottom to top. The first two lateral panels do not portray any events from the published life of the saint (plate 86, panels 6 and 7).[172] Together they form one scene, which perhaps depicts a story about the saint's early life not recorded in the legend.[173] The next four lateral panels (plate 86, panels 8–11) illustrate Chapter 1 of the text concerning the events in Lubinus's youth. The scenes show Lubinus minding sheep and learning to read. In the fourth scene, panel 11, he practices reading while his fellow sheepherder drinks wine; this companion is not mentioned in the text.[174]

The next series of scenes (plates 87 and 88, panels 12–16, 18) illustrate Lubinus's life as a monk. Lubinus entered a monastery for eight years, where he was cellar keeper and continued his studies.[175] Then he traveled in France seeking a holy man, St. Avitus, whom he finally met in Perche. Lubinus became cellar keeper for St. Avitus, and after the saint's death the bishop of Chartres ordained Lubinus a priest, placing him in charge of the monastery at Brou. During his monastic life, Lubinus began to perform miracles, revealing his saintly stature.

In the center scene, panel 3, a tonsured man in priestly attire leans forward to draw wine into a cruet from the spigot of a wine keg within a vaulted interior.[176] It suggests Lubinus carrying out his monastic chores as cellar keeper (cellarius), but shows him in the robes of a deacon, an ordination that he received only after he had left his cellar keeper tasks at Le Perche and assumed charge of the monastery at Brou. Nor does the scene fit comfortably with the surrounding panels, where Lubinus appears in monk's robes, and is nimbused. The scene stands in the center of the window, and seems to be deliberately ambiguous, so as to form part of Lubinus's monastic life and at the same time take its place in the central sequence of images of wine for mass.

The next center panel is a sequel to this. A priest gestures toward a chalice on the altar before him while a deacon approaches him with a cruet of wine. Certainly, the deacon with the cruet can be interpreted to be Lubinus. (The window has already shown Lubinus with a cruet in panel 12.)[177] Lubinus became deacon and then priest at Brou. According to the legend, this occurred after he was at Le Perche, and before he became a bishop. The scene of mass appropriately stands between illustrations of these occupations on either side (plate 88). But there is no mention of the saint celebrating mass in the legend. The scene is ambiguous. It also portrays the canons celebrating the anniversary of Lubinus's ordination as bishop.

In the legend, when Lubinus became a monk, he performed many miracles. The six scenes in the window of Lubinus's life as a monk selectively emphasize his monastic travels; none of them portray his

miracles. The center panels 3 and 4 shows Lubinus as deacon, but simultaneously maintain the central medallions' focus on wine. They serve to merge the two separate themes in the window, the life of Lubinus and the wine's sacred purpose. The center panel in the window, panel 3, is the crucial juncture of these two themes.

King Childebertus appointed Lubinus to succeed Bishop Aetherius at Chartres. The next five panels (plates 88 and 89, panels 17–21) illustrate Lubinus's life as the bishop of Chartres, described in Chapters 14 through 27 in the legend. These chapters extol Lubinus and describe the many miracles that he performed during his episcopacy. The legend ends with an account of Lubinus's funeral, a eulogy, and a prayer to the saint. The window illustrates the ordination of Lubinus as bishop of Chartres, shows him traveling in his diocese, but performing only one miracle.[178] At the summit of the window, Christ appears above the clouds blessing with his right hand and holding a book inscribed with the alpha and omega in his left (plate 89). The scene beneath the figure of Christ is the only one of Lubinus's numerous miracles described in the text which is shown in the window.[179] Christ's appearance suggests a twofold meaning, depending on its horizontal or vertical reading. Christ can be seen to witness Bishop Lubinus's miracle; the clouds affirm Christ's physical presence at the miracle because they extend laterally into the panels with the miracle scene. Christ can also be understood to witness the mass that is directly below him.

There are discrepancies between the aspects of the saint's life emphasized in the pictorial cycle and in the narrative account. In the legend, one chapter deals with Lubinus's youth, twelve with his monastic life, and fourteen with his career as bishop. Lubinus's miracles are the main subject of over half of the legend's twenty-seven chapters. The saint's miracles predominate in the office of St. Lubinus as well.[180] In contrast, the window's designer emphasized the saint's youth and almost completely eliminated the miracles.[181] On the other hand, over half of the window's scenes refer to journeys, which is consistent with the notable importance of the saint's travels in the text.[182] The selection of subjects in the window seems primarily to have been made in order to parallel metaphorically the stages of the saint's life with the different uses of wine.

The Associations of Lubinus with Wine in the Window

The central panels present as separate theme about wine and are set off artistically from the rest of the window (plate 85). The five center panels are superimposed over sets of four lateral panels each; by their superimposition, red background, and heavy framing these center panels seem to stand out, emphatically projecting their scenes about wine (see color plate 2). All the wine scenes, including the little half-

roundels of wine offerers in the border, have red backgrounds. The scenes of the saint's life surrounding the center medallions have blue backgrounds, which causes them to recede, and further accentuates the red panels. The first two center panels show secular persons with wine, the second two center panels show clergy with wine. Wine as nourishment in the lowest panel is subordinated to the transportation, preparation, and use of wine for mass. Christ's culminating appearance in the top panel can be seen to indicate his presence at the mass celebrated below, in an anagogical progression.

A determining factor in planning the window seems to have been the coordination of the content of each set of four lateral hagiographic scenes with the content of the center panels around which they are composed. The rising clerical rank and spiritual power of the saint in the lateral narrative scenes is coordinated with the ascending order of secular and sacramental use of wine in the center panels.[183] The sanctification of wine appears as a metaphor for his increasing holiness, which culminates with his episcopacy, not his death, as is usual in hagiographic narrative cycles. The keys he receives to the cellar may have been meant to allude to St. Peter's keys to Paradise (plate 88, panel 18). The practical import of this is that the bishop of Chartres stores and dispenses the wine of salvation. The window's intentionally ambivalent central depiction of Lubinus the cellar keeper not only ties together the stories about the saint and wine; it also ties together the historical past with thirteenth-century experience.

The moral contrast between wine used for secular nourishment and wine used for the holy sacrament recurs in the hagiographic panels. The secular use is represented by a fellow shepherd, not mentioned in the text, who drinks wine while the youthful shepherd Lubinus studies his letters (plate 86, panel 11). The sacramental use of wine is introduced by implication in the next narrative scene (plate 87, panel 12), where Lubinus enters monastic life and beside him there is a cruet, presumably intended to hold wine for mass. The cruet and the drinking shepherd are not to be found in the legend; they underline the message about wine found in the center panels.

The Veneration of Lubinus at Chartres

Lubinus was the legendary founder of both the chapter and the school of Chartres.[184] He was also credited with establishing the extent of the diocese.[185] In the thirteenth century, his cult at Chartres was second only to that of the cathedral's patron saint, the Virgin Mary. The canons celebrated two feasts yearly in his honor, one a highly embellished "double" feast, an honor accorded only five other saints at Chartres, namely, St. Ann, St. Nicholas, St. Ambrose, St. Piat, and St. Mary Magdalene.[186] He ranked as the highest confessor-saint in intercessory prayer. The dedication of sixteen regional churches to him, and his

worship beyond the region, attest to his widespread popularity.[187] He was especially worshiped in the early church, as the central chapel dedicated to him in the lower crypt indicated.[188] His continuing importance is evident from the chapel in the choir created in his honor after the thirteenth century.[189] Another image of Lubinus in the thirteenth-century cathedral glass is now lost,[190] but a stone relief of the saint survives on the south porch.[191] St. Lubinus appears on the south porch healing his eventual successor, St. Calectric (plate 104). Lubinus was best known in the thirteenth century as a healing saint.[192] The special office of St. Lubinus mentioned above was written for the celebration of his feast on September 16. It was apparently composed during the era of St. Fulbert at Chartres, to be used in place of the regular office for the celebration of saints.[193]

Lubinus was associated with wine at Chartres. A local chapel dedicated to him stood in the midst of vineyards in the suburb of Chartres named after him, Saint-Lubin-des-Vignes.[194] The cathedral clergy made a procession to this chapel during Rogation week.[195] It was from the parish of Saint-Lubin-des-Vignes that farmers mentioned above presented part of their wine tax in cups to the cathedral.[196]

The Lubinus Oculus

High above the aisle window in a nave clerestory oculus, Saint Lubinus appears enthroned in full episcopal regalia, holding a book in his left hand and giving a blessing with his right hand (plate 90). Two symmetrically posed men holding *hanaps* of wine walk towards him from either side. They wear identical white *cottes*, edged in purple at the collar and hem, and tight caps. They look very similar to those men who formally offer eulogy bread to the congregation in the apse clerestory. Beside the saint's nimbused head, his name is inscribed in capital letters: S. LEOBIN(US).[197] He blesses the two men bearing offerings to him, just as the thirteenth-century bishop might have done in the choir on the feast-day mass of St. Lubinus.[198] Due to the darkness of the cathedral's interior and the window's luminous color, the nave and aisle windows viewed from the nave appear as one diaphanous wall,[199] where the Lubinus window in the aisle appears directly beneath the oculus in the clerestory. Iconographically, the procession in the aisle window culminates in the oculus—in a liturgical image of wine offering.

The design of the oculus is especially close to that of the personifications of Charity and Humility bowing toward St. Heribert on his shrine in Deutz, suggesting again the derivation of the wine offerers from the image of Charity.[200] But the wine offering in the oculus occurs in the heavenly zone of saints in the clerestory. The scene conforms to the repeated representation in the nave oculi of a frontally seated,

sainted bishop flanked by antithetically posed worshipers, a configuration which recurs in eight of the fourteen oculi.[201] St. Lubinus in the oculus is one of a series of hierarchically-scaled bishops, venerable precedents for the prestige of the living bishop, projected above the nave where the worshipers would have gathered for mass on feast days.[202] At the same time, the Lubinus oculus deliberately coordinated in location and subject with the aisle window of Lubinus beneath it.

The Lost Window of St. Lawrence

The window of St. Lawrence, Bay 57, in the lower story of the north transept's west wall was destroyed in 1791, and replaced with grisaille, leaving only its frame of censing angels.[203] Alexandre Pintard's armature sketch and description of the St. Lawrence window are the only evidences of its pictorial cycle (plate 91).[204] The window, unlike most, was read from top to bottom, and its center panels, judging from Pintard's description, did not belong to the history of the saint.[205] Prominence of place in the seven center panels was accorded eight figures holding "cups," as described by Pintard.

23. Angels who descend.

20. Two figures with cups, one of whom carries his to a seated person.

15. Two persons holding a sign talk.

12. Two addorsed figures each holding a cup, one of which is turned upside down.

7. Two little addorsed figures each holding a cup.

4. Two little addorsed figures each holding a cup.

1. A king crowned with fleur-de-lis, two persons.[206]

Delaporte thought the eight figures with cups were tavern keepers like those in the St. Lubinus window. In this case, he thought they donated the window to honor a saint who, as deacon, poured wine into the mass chalice.[207]

Considering the unusual downward reading of the window's hagiographic cycle, the addorsed figures holding out cups must also have been read from top downward, toward the viewer's space, rather than upward as in the St. Lubinus windows. These men with "cups" make sense as a second stage of the same type of ceremony portrayed in the St. Lubinus window. The topographical arrangement of the two windows at both ends of the northern aisle suggests that such a liturgical sequence may have actually begun in the western part of the north aisle and terminated in the north transept; we have already seen such

a two-stage sequence in the liturgical offering and distribution of blessed bread in the choir windows. The St. Lawrence window probably depicted distribution of ablution wine—which would explain the upside-down cup.

Pintard's descriptions of the scenes in the lost window of St. Lawrence are not always sufficiently clear to allow for confident identification.[208] As a result, we cannot entirely reconstruct a clear picture of the window's hagiographic cycle. Furthermore, there is nothing in the legend to explain the men in the window with cups. These figures were inserted down the middle of the window similarly to the way the scenes of wine were put up the center of the Lubinus window. Like Lubinus, Lawrence was a deacon, and hence would have served wine at mass, but there apparently was no representation in the window of St. Lawrence performing this role. St. Lawrence was frequently represented in his deacon's attire, as he is in fact in one of the nave windows at Chartres.[209] The St. Lawrence window in the transept stood immediately above the altar of the Holy Angels, donated by King Louis IX in 1259.[210] The images of wine offerers appeared in the window moving downwards toward the altar directly below them, suggesting a functional coordination between the window and an altar even before this dedication.

The Transept Clerestory Scenes

In the eastern clerestory of the north transept, the lower portion of four contiguous lancets repeats four times the same image of a priest kneeling before a huge chalice atop an altar table covered with a cloth (plates 92 and 94). A scene like those in the four lancets reappears in one of the cusped oculi above the middle pair of lancets (plate 93).[211] The authenticity of these windows has been questioned, and it seems that they may have been remade sometime between Gaignière's sketches of the clerestory windows in the late seventeenth century and now.[212] Gaignière's sketches, however, show essentially the same iconography, so the discussion here remains viable. In the eastern clerestory of the south transept, a similar image of a priest, standing in prayer before a huge chalice on an altar, appears at the base of the window of Sts. Gervais and Protais, Bay 100 (plate 95).[213]

The priests praying before cloth-covered altars topped by large chalices are praying at mass. Only during mass was the altar covered with a cloth and the chalice displayed on the altar.[214] It is not possible to specify the moment in the mass that these images illustrate, since the celebrant at mass would have had occasion to kneel and to pray often before the chalice.[215] The repetition of these kneeling celebrants creates the effect of a major festive celebration.[216]

Large chalices such as those depicted in the windows were called *calices ministeriels.* So long as communion was distributed in both

kinds, they were used to hold consecrated wine for the faithful, and to hold small portions of wine brought by the faithful to be consecrated for communion.[217] Although communion in both kinds for the congregation gradually ceased, wine donations at mass continued. There is evidence of the continued presence of these huge chalices in church treasuries all over Europe from the eleventh through the fourteenth centuries.[218] This is probably the use intended for the large silver vase given to the sacristans of Chartres in the thirteenth century.[219] The large chalices apparently continued to be used at Chartres to receive wine offerings.

So many large chalices of wine could have had their use only at a time when either large wine presentations were expected or large distributions of ablution wine were anticipated, or both. This would have been most likely at Easter time, on Maundy Thursday, when large amounts of communion wafers were blessed for mass at Chartres,[220] and when, by church edict, the faithful were expected to take communion.[221] Sometimes eulogy bread was distributed on Maundy Thursday, followed by a drink of ablution wine.[222] Franz published several medieval eulogy-wine blessings for Maundy Thursday, all of which recall Christ's miraculous transformation of water into wine at the marriage in Cana, just as the eulogy blessings of bread recall Christ's miraculous multiplication of loaves.[223] The imagery suggests that the north transept had an important role in the liturgical collection and distribution of wine. This most likely occurred at Easter time, when wine was served as ablution at the end of mass.

Thus, the lancets of the eastern clerestory of the north transept show apostles standing over a repeated composition of offering (plate 92). The scheme of these lancets, depicting priests kneeling beneath huge apostle figures, and Christ in an oculus above blessing them, recalls the scheme of the central portal of the south porch (plates 40 and 48). There, the count of Chartres kneels beside his huge basket of bread offering, and the blessing Christ stands over him in the trumeau, with column figures of the apostles on either side.

The repeated images of big chalices of wine offered at mass are conceptually in line with the long tradition that Jesus provides the wine necessary to his feasts; this had its beginning in the New Testament story of the marriage at Cana. There Jesus transformed water into wine to provide for a wedding feast, an event which medieval exegesis interpreted to anticipate the Last Supper.[224] Consequently, the miracle at Cana and the miracle of the multiplication of the loaves were both seen as prototypes of the eucharist, and their representations were sometimes paired artistically in obvious allusion to their similar meanings.[225] The two miracles have their thirteenth-century counterparts in the miracles of the Virgin of Chartres, written down in 1210. In these miracles, immediately after the Virgin's wondrous multipli-

cation of loaves, she brought about the miraculous replenishing of wine. A group of clerics and lay people were making a pilgrimage from Pithiviers in the diocese of Orléans to Chartres, pulling a huge wagon loaded with grain for the new cathedral.[226] At Le Puiset, a town in the diocese of Chartres, the townsfolk offered them wine; it was "of very sweet flavor and very delicate color," and they eagerly drank it up.[227] Christ himself refilled with even better wine the jar which had been emptied by the pilgrim's thirst. The pilgrims quenched their thirst, rejoicing at the Virgin's miracle and the delicious taste of the wine.[228] As in the Lubinus window, so also in the miracle, the spiritual joy of offering is conjoined with the sensual pleasure of wine.

Wine imagery is concentrated on the north side of the cathedral. Men appear offering small goblets of wine in the aisle windows of St. Lubinus and St. Lawrence, and priests appear praying before large goblets of wine in the north transept clerestory. The product of physical work, as Grodecki proposed, was given over to the church in return for spiritual satisfaction.[229]

Why all this wine imagery on the north side of the cathedral? I believe it had to do with liturgical practices in that location, such as the presentation of wine at the harvest feast of St. Lubinus. Although I cannot yet prove it, I believe the practice of the expulsion of penitents on Ash Wednesday and their welcome back at Easter took place at the north transept, and the Easter bread and wine were served the faithful afterward in the northern transept area. Not by chance, the image of Christ holding up a chalice of his blood in the center of the south transept rose window beams its reddened orb across the dark interior toward that opposite space. But there is another, economic dimension to the imagery of wine on the northern side of the cathedral.

The Ideology of the Images of Wine

Unlike the cultivation of wheat, which was absolutely essential to the economy of Chartres, the cultivation of wine was primarily a privileged enterprise. This corresponds to the impression that, for all its deliberateness, wine imagery in the cathedral is less pervasive than bread imagery. It is concentrated on the north side, away from the main entrances on the west and south, but near the chapter's wine cellar.

Sacred imagery of wine is combined with representation of wine-drinking for pleasure. This seems to be an attempt to amend contemporary moral condemnation of such drinking. The most visible scenes in the aisle window of Lubinus—those at the window's bottom which are just above eye level—show criers hawking the chapter's wine. These scenes lead up to images that proclaim wine's spiritual purpose, where wine becomes a metaphor for a saintly life. The central wine-crying scene suggests that tavern wine refreshes the weary traveler.

This is in stark contrast to contemporary Church law and moral teachings.

Wine-drinking had become so widespread that temperance, generally defined as moderation, became the most emphasized virtue in thirteenth-century France.[230] Official church posture condemned taverns and excessive drinking. The Fourth Lateran Council of 1215 urged clerics to regulate their wine-drinking or abstain from it since it induced inebriation, "exile of the mind . . . and . . . arousal of desire."[231] The Synod of Rouen in 1235 urged priests to enjoin their parishioners from frequenting taverns because they were "the occasion of innumerable sins."[232] Furthermore, the Fourth Lateran Council forbade the clergy to take part in commercial dealings.[233] By depicting wine consumption in the windows, and by opening taverns in the cloister, the canons were not only transgressing the spirit of church law by encouraging drinking; they were openly disobeying canon law's proscription against their involvement in commerce.

Elsewhere in France, a veritable campaign against drinking and taverns developed in thirteenth-century art. Contemporaneous moralized Bibles condemned taverns as places of carnal sin. In the Codex Vindobonensis 2554, bad priests of the Old Testament signify "those who haunt taverns and bordellos and agree to devour the worldly delights of the flesh (plate 109).[234] In the Oxford Moralized Bible, the illustration of God's warning to the Israelites in Jeremiah 13:12–14, that he will punish them by making them drunk so that they will turn against each other, is accompanied by a moralizing parallel which shows a tavern scene juxtaposed with a scene of a priest celebrating mass (plate 110). The explanatory text states: "This is the drunkenness by which we forget the precepts of God and by which the human race is full of vices and sins."[235] The depiction in the Oxford Moralized Bible of the Prodigal Son squandering his inheritance (Luke 15:13) shows him gambling at a dice board while two prostitutes fondle him. One of them holds a goblet of wine over his head (plate 111). The moralizing parallel equates the Prodigal's dissipation with pagan carnality.[236] Medieval plays portray taverns as the hangouts of thieves and prostitutes. A recent study analyzed the tavern locus in medieval French plays as the antithesis of the Christian worldview, a *castellum diaboli* of chance and physical luxuries.[237] The window seems to contradict this reputation by correlating rather than opposing the sphere of the tavern and that of the Christian life.

The chapter's ambivalence in the face of rising condemnation of taverns is resolved in one of the stories of the *Miracles of the Blessed Virgin Mary in the Church of Chartres*. A pilgrim, on arriving at Chartres, "didn't want to go immediately to the church with his friend, but hearing that the purest, clearest wines were sold at Chartres, he entered a tavern."[238] The pilgrim enjoyed his drink of

wine but failed to obtain the miraculous healing afforded his compan-
ion, who bypassed the tavern to go straightaway to the Virgin's altar.
The story did not say that the wise pilgrim refrained from going to a
tavern, only that he went first to the altar. Later in the thirteenth cen-
tury, a French version of this miracle extolled further the wines of
Chartres sought by the irreligious pilgrim:

> For the talk of and the renown
> Of the good wines he had heard
> Which were sold at Chartres,
> Clear, whole, pure, and delicious.
> He was curious to drink them
> And to see cups of wine
> Which did not bother him
> Since he'd learned nothing of virtue
> For he was drooling for
> Good wine and good food
> For which his stomach was the recipient.
> So that upon arriving there,
> He headed straight for the tavern
> As he was wont to do,
> Since he wanted good wine
> To try and to drink at his leisure.[239]

The chapter could hardly display a negative attitude toward taverns if
it utilized them to attract and to profit from pilgrims and travelers.

Whoever directed the designs of the nearby Noah and Prodigal Son
windows apparently realized this. He excluded from the Noah window
the biblical account of how Noah became drunk and lay naked in his
tent (plate 112).[240] The omission of Noah's drunkenness at Chartres is
striking in view of the increasingly dramatic depiction of this aspect
of the story in early Medieval and Romanesque art, for instance in the
Aelfric Paraphrase in the British Museum,[241] the Saint-Savin-sur-
Gartempe frescoes,[242] and the San Marco mosaics in Venice.[243] Omis-
sion of Noah's drunkenness in the window is especially significant,
since the Noah window at Chartres is the largest known medieval rep-
resentation of Noah's story. In the window of the Prodigal Son, the
scenes of the Prodigal squandering his inheritance are noticeably lack-
ing any suggestion that he was drunk with wine, as was traditional for
his pictorial cycle in medieval art (plate 113). The tavern scene in the
window depicts him playing dice; there is no indication of wine in
goblets or barrels.[244] According to the windows of Chartres, Noah and
the Prodigal Son did not get drunk. It seems that in these windows as
well as the Lubinus windows, economic concerns motivated the alter-
ation of religious imagery.

The Lubinus windows are far removed from the focus of the saint's
worship in the choir, where his relics were preserved,[245] yet they align

with the chapter's cellar a short distance to the north (plate 19). The decision to feature wine in the north aisle window, and later the north clerestory, must have been based in part on this topographical relationship. It serves to justify the chapter's large wine store by connecting it to the sacramental purpose of wine.

Ideological justification of economic enterprise and social privilege underlie the content of the windows. The aisle window of Lubinus depicts what was going on around it at the September feast of the saint, with an immediacy not usually found in medieval art. The geometric relationships of the figures express an ideal social order. The Christian hierarchy is depicted by scale and placement, rising from tiny figures of the wine criers and tavern keepers, to the much larger figures of the canons at mass, to the enormous figure of Christ, who blesses this arrangement. The wine offerers act out their economic and spiritual dependency. Those who work provide for those who pray for them.

CHAPTER FIVE

THE OFFERING OF GOLD AND SILVER COINS

Lay not up to yourselves treasures on earth: where rust and moth consume, and where thieves break through and steal.

But lay up to yourselves treasure in heaven: where neither the rust nor moth doth consume, and where thieves do not break through, nor steal.

For where thy treasure is, there is thy heart also.

Sermon on the Mount, Matthew 6, 19–21

The Scenes of Money Changers

The prominence of money changers in the cathedral stained-glass is surprising, since Christ himself expelled money changers from the temple. For most of the medieval era, Christian moralists condemned their activities.[1] Christian treasures were good deeds, as the Sermon on the Mount so poetically expressed. The money changers in the windows of Chartres are weighing precious-metal vessels, testing coins, and negotiating transactions with clients. They work behind tables laden with piles of coins which represent the prevalent means of payment in the early thirteenth century, as well as the prevalent means of pious offering.

Money changers appear in four stained-glass windows in different parts of the cathedral, and originally they appeared in a fifth window, now lost but known from Pintard's description (plate 114). Large scenes of money changers appear in the clerestory at either side of the entrance to the apse, one at the base of the window of St. Peter, Bay 123 (color plate 3, plates 115 and 117),[2] and the other at the base of the window of St. John the Baptist, Bay 117, opposite the St. Peter window (plates 118 and 120).[3] In the north aisle, two scenes of changers appear in the bottom register of the window of Joseph the Patriarch, Bay 61 (plates 127 and 128).[4] Directly above the Joseph window in Bay 164 of the north nave clerestory, changers are depicted working beneath the huge figure of an apostle (plates 131 and 132).[5] A lost window that also depicted money changers was dedicated to St. Blaise in Bay 12, in the lower story of the south transept's eastern wall, just inside the portal of the confessors (plate 133).[6]

None of the windows has been the subject of a special scholarly inquiry. They have been summarily included in the theory that the town trades donated windows.[7] Indeed, the money changers of Chartres seem to have attained sufficient wealth to have been generous donors to the cathedral, but there is little documentary evidence that they were. I have a rather long story to tell about money at Chartres, in order to finally assess the historical meaning of these images of money changers in the cathedral.

The History of Local Coinage

Money never ceased to circulate in the region of Chartres in the early Middle Ages, but it was supplanted to a major degree by exchange in kind, valued by money amounts or by ingots of silver and gold. Local coins, called *chartrains*, were minted at Chartres since the ninth century.[8] In the course of the eleventh century, one finds mention of the coins of Chartres and Châteaudun in documents, suggesting that payment was expected in those coins.[9] The growing economy of the twelfth century was accompanied by an increasing division of public authority, the multiplication of local mints,[10] and the increasing specification of particular coins for money payments in documents. The count of Chartres and Blois, who had the right to mint money in his realm, enfeoffed that right to his viscount in Châteaudun, and to his vassals at Perche, Saint-Aignan, Celles, Romorantin, and Bresse. A rapid increase in the minting of silver coins in France occurred after 1168, undoubtedly due to increased demand but made possible by the discovery of new silver mines in eastern Europe.[11] Local monies prevailed in the region until the second half of the twelfth century, when devaluation became a concern. The coins of Paris, Tours, Étampes, Poitou, and the Anjou began to replace local coins as specified means of payment.[12] Royal coinage was increasingly popular because of its reliability relative to that of baronial coins.[13] In the thirteenth century, most princes changed the appearance of their coins so that they would resemble royal coins closely, until King Louis prohibited copying the royal coins in 1262.[14] However, the local baronial money remained the primary coin of local exchange until the king finally purchased the mint of Chartres.[15]

The Devaluation of Coinage

According to the usual medieval practice, whatever prince or lord held the royal right to mint in his domain had the right to set the value of that money, both in terms of its accounting and exchange value with other coinages, and in terms of its real value—that is, its silver content. He was expected to take advantage of this prerogative in case of important needs.[16] He might raise funds by devaluation (lessening of

the size, weight, or silver content of coins), by renewing the coins (charging for replacement of worn coins), or both.[17]

The devaluation of medieval coinage began in France in the ninth century, and continued for most of the medieval era. In the twelfth century, the silver denier everywhere in France declined in weight as well as in silver content.[18] The most dramatic devaluation occurred when Louis VI (1108–37) cut the silver content of the *parisis* to 0,500 fine.[19] Most feudal lords followed his example and devalued their coins to a slightly greater degree than the parisis.[20] When fear of a further devaluation of the parisis arose in the later twelfth century,[21] a corresponding fear of the chartrain's devaluation appeared in documents at Chartres.[22]

Drastic devaluation of coinage throughout France in the twelfth century reduced real income because prices inflated when devalued coins were used in exchange.[23] Town tradesmen and merchants found themselves allied with the nobility in their fear of coinage devaluation, while long-distance traders and lords who had borrowed heavily welcomed the chance to repay money-valued debts in devalued coinage.

Lords with mints were faced with a hard choice. They could enjoy increased income from their mints and lessen the strain of indebtedness by devaluing the coins, but at the same time they had to accept decreased purchasing power from their money rents. Or they could give up extra profit from devaluation in favor of stabilized coinage and a secure income. Their decision to stabilize was generally made for them by the king's policies.

The Conservation of Coinage

Louis VI first showed royal interest in the conservation of stable coinage, apparently after experiencing the difficulties caused by his own devaluations. Louis VII, shortly after his accession in 1137, granted the burghers and knights of Étampes and Orléans a guarantee of stable coinage in response to their requests, but demanded in return that they pay him money taxes. He agreed that he would maintain the coins at the same size, weight, and alloy as his father had done, in return for which he would collect from the knights and burghers one hundred livres payment for redemption of the money on the feast of All Saints every third year. He further stipulated that he would require the same tax that his father, Louis VI, had charged for this concession, that is, two deniers on each modius of wine and winter wheat, and one denier on each modius of oats, to be collected every third year. This tax was popularly known as *tallia panis et vini*.[24] In 1183, Philip Augustus continued the money tax in Orléans.[25] But at Paris he apparently did not establish the tax and its concurrent promise of stable coinage until much later, in 1202,[26] and he was still collecting it in 1222.[27] Lords and bishops all over France followed suit.[28]

No record survives from Chartres of such guarantees to "conserve" the coinage, or of money taxes. Nor can one determine if the coins were devalued at any particular moment, since from the reign of Count Thibaut I the Tricker in the early eleventh century until Count Charles de Valois in the late thirteenth century, the coinage was "anonymous," that is, without the name of the presiding lord or the date of the coin's manufacture.[29] The counts were allied indirectly to the royal house during the building period of the cathedral, since they were the feudal vassals of the counts of Champagne, who in turn were direct vassals of the king.[30] The powerful house of Champagne held the mints of Provins and Troyes, while the bishop of Meaux held the mint of Meaux. All three of these coins circulated interchangeably. In 1165, Count Henry I issued a charter confirming the bishop's right and guaranteeing the coinage of all three mints.[31] Since the count of Chartres' liege lord "conserved" his coinage, it is likely that the vassal followed suit.

Indeed, Count Thibaut V of Chartres and Blois (1152–91) and his wife Alix publicly guaranteed the coinage of Blois by inscribing the text of their pledge to stabilize the coinage in stone on a town gate of Blois.[32] The inscription promised not to debase the coinage and not to charge a money tax for conserving it. This was probably copied from a charter issued soon after Count Henry II's confirmation in Champagne in 1165.[33] Thibaut V was the king's seneschal, a powerful man at the royal court, where he undoubtedly spent most of his time. He must have been concerned to maintain the peace at Blois, and even more to maintain his income from the town to support his courtly expenses.

Although we have no proof, it is likely that Count Thibaut V also guaranteed his coinage at Chartres. But after Count Thibaut V's death in 1190, Chartres was for the most part ruled by widowed countesses whose incomes were depleted by the crusade expenses of their husbands. Bishop Gauthier undertook a major building project in a town whose temporal government was weakened. We will see that he attempted to exercise control of the mint, probably in order to stabilize the coins of Chartres and counter the king's aggressive appropriation of local coinage, as only the stronger lords with relatively stable coinages could hold out against the king's financial policy.

The Attempt by Philip Augustus to Regain Royal Minting Rights

The effort of Philip Augustus to eke out a money tax while maintaining local mints was short-lived. He and his successors sought instead to centralize minting of royal money in order to squeeze local, feudal money out of circulation. Philip Augustus used money as a political instrument to consolidate his power and to enforce simplification of the monies in his domains. Françoise Dumas has recently published an excellent summary of the effectiveness of this policy.[34]

Despite his promises in late twelfth-century communal charters not to change local coins, the king's aim was to regain all possible mints.[35] He closed down the mints of Étampes, Orléans, Roye, Saint-Quentin, Amiens, Péronne, Boulogne, Beauvais, and Crépy. By the end of the first quarter of the thirteenth century, the royal parisis became the dominant coin throughout the north of France.[36]

In a sweeping reform of the monetary organization of his realm around 1204, Philip Augustus limited the circulation of baronial coinages to their own territories by edict, while assuring his own coins free circulation throughout his lands and the barons'.[37] This ruling extended to the coins of Chartres. Upon defeating Jean-sans-Terre in 1205, Philip Augustus took over the mint of Tours, and soon the *tournois* was the coin of most of southern and western France.[38] He minted the tournois in Rennes, to supply coinage for the west, and for his newly conquered lands in Normandy.[39] By 1223, Philip Augustus had established his two royal coins, the parisis and the tournois.[40] He sought by the superior value of his coins to dominate the circulation in areas where, for varying reasons, he could not simply retake minting rights, and he slowly bought up those rights from lords willing to sell them. The royal coins became associated with the extension of royal power.[41]

The Coin of Chartres

Just as the royal coins and their imitations came to symbolize the king's political predominance, so the coin of Chartres, the chartrain, and its imitations in the region, stood for the political leadership of the count of Chartres. The counts and countesses minted coins in Chartres and Blois, and enfeoffed the right to mint to various vassals.[42] These secondary mints attempted to align the size, weight, and silver content of their coins and the images on them with those of more economically powerful coins of Chartres in order to increase their circulation.[43]

The coins of Chartres displayed a cross within a circle of pearls, surrounded by the inscription "Car [no] tis Civitas," and on the obverse, a distinctive, banner-like image intersected by three dots or *besants* (plate 135, #11).[44] Lesser feudal mints adopted similar designs.[45] Hence the extent of the use of coins of the chartrain type effectively marked the extension of the political area of Chartres (plate 136).[46] However, as the king took over more and more feudal mints in the thirteenth century, and especially after he limited the circulation of feudal coinage, smaller mints in the diocese began to change the appearance of their coins to make them look more like the royal coinage.[47] It was at this historical moment that the bishop reasserted his control of the money changers at Chartres.

The Importance of Money Changers at Chartres

The money changers at Chartres also ran the local mint. This duality of roles put them at the crux of the rapidly expanding monetary economy and the political conflicts for the control of local coinage. Changers appear in local documents in the late eleventh century, but they must have been active for a considerable period before that, since local coins already had been manufactured for over 200 years.[48] Chédeville has traced genealogies of fathers, sons, and nephews with the names of Radulfus and Gaulterius, variously identified as moneyers, changers, and goldsmiths. He concluded that the changer profession was hereditary at Chartres and that the changers were at the same time minters and craftsmen who produced precious-metal objects.[49] The evidence is scant, but it is rendered convincing by the fact that these occupations were traditionally hereditary, and traditionally combined in western Europe.[50]

The money changers cannot have been Jewish. In 1172, Count Thibaut V burned to death a group of Jews in his town of Blois.[51] Although we have no record of it, he probably conducted similar pogroms in Chartres, since the synagogue at Chartres was converted into a hospital attached to the parish of Saint-Hilaire in 1179.[52]

The number of changers in the thirteenth-century town is not known. However, in 1192, Countess Adèle of Chartres and Blois proclaimed that:

> the changers of Chartres, in the love of God and for the keeping of the soul of my good husband Count Thibaut, have given and have granted for perpetual possession their revenue from the Change of Sundays to the church of Bourdinière and to the brothers who serve God there.[53]

She listed eight changers by name and described their donations.[54] One might think that these were all the changers in town, since it seems likely that she would have compelled all the town changers in her homage to pledge this remembrance. But I believe that the chapter probably had its own changers, at least during cloister fairs. If not, and if there were only eight changers in town in 1192, it is remarkable that their number had increased almost fivefold by 1389, when thirty-nine changing tables were recorded at Chartres—and no evidence of a dramatic increase of town population or of pilgrimage.[55] One of the *avoués* identified in the inquest of 1195 was a money changer. Hence the exact affiliation of the money changers in the windows remains unsure.

Countess Adèle's charter of 1192 reveals that changers kept tables open on Sundays despite the usual church restrictions. It does not say if this meant every Sunday or not, but it certainly suggests that commercial exchange occurred even on Sundays. Perhaps this activity was

limited to exchange used for visits to church, such as the purchase of offering bread, or pilgrims' tokens, or local coins to carry to the altar.

To sum up, the changers at Chartres engaged in three activities: minting, money exchanging, and goldsmithing. All three activities seem to have been profitable. Money changers sold coins in circulation in their area to those who paid for them with foreign, noncirculating coins,[56] since mint lords customarily prevented use of other lords' coins in their own seigniory.[57] The changers frequently calculated the exchange rate for foreign coins on the basis of their intrinsic value by assaying the content of pure metal that they contained.[58] Some coins, like the king's widely circulating parisis and tournois, exchanged at a preestablished rate.[59] Changers also negotiated exchange of local coins for precious-metal ingots or objects, or whatever else may have been acceptable at the time.[60] They worked every day at Chartres at tables set out on a town street which was eventually named after them.[61] Apparently changers were required to work in the open air at legged tables in part to prevent them from defrauding their clients by slight-of-hand tricks.[62] In France, the increasing tempo of commerce from the eleventh to the thirteenth century, the diversity of coinage, and the frequency with which the silver content in coins changed caused the changers' service to become increasingly needed. This was especially true in a pilgrimage center such as Chartres.

Changers' profits came from whatever small fee they charged for their services,[63] and from the difference between the market price of local money and the mint price.[64] Their expenses apparently were not very large,[65] except for the taxes they paid.[66] The changers probably carried most of the foreign coins that they received in exchange as well as defective and recalled coins to the mint to be recycled into new local coinage.[67] Considering the demands of their other activities, the changers of Chartres undoubtedly had assistants to help them man the changing tables.

In their function as minters, the precious-metal merchants of Chartres probably directed a shop of workmen.[68] They minted silver deniers, with the distinctive banner-like insignia originally derived from an antique coin.[69] The minting profits of lords, known as *seignioriage*, were derived from the difference between the legal value of the coins and the cost of their manufacture. The lord assigned part of this feudal benefice to his minters to pay them.[70] Minters traditionally received their share of the mint profits, called *brassage*, by retaining a certain percentage of the coins that they manufactured.[71] Minters bought their equipment and the metals they processed, and paid their workers' wages. Because minters shared the mint's income with their lord, both stood to profit more when coins were required to be turned in for new ones, and a fee was charged for this.[72] Similarly, both stood to profit more when the silver content in new coins was diminished.[73]

Minting was not a full-time occupation, since coins were only minted periodically. The combination of functions whereby changers at Chartres were given the right to make, sell, and exchange coinage allowed them to plan their activities for their own maximum benefit.[74]

The money changers at Chartres were also goldsmiths who produced gold and silver vessels and costly objects of embellishment for the cult, the home, and noble personages.[75] It seems that nearly every major ecclesiastic had a personal treasure of objects made by goldsmiths, since almost every canon and bishop in the necrology bequeathed at least one piece of gold jewelry or a silver receptacle to the cathedral.[76] In 1212, Dean Willelmus left a gold necklace and gold ring with emeralds, in addition to money and property.[77] Another dean left all his silver vessels, weighing twenty marks, in 1234.[78] In 1250, a chancellor left a gold crown, a gold ring with emeralds, and two silver basins.[79] The local goldsmith shops must have had a lively trade in luxurious objects both for the cult and for the local canons and nobility.

Chédeville found hardly any evidence that the money changers of Chartres loaned money or functioned as bankers.[80] The practice of keeping written accounts of loans existed at the time, whereby ledger entries of deposits and contracts served as evidence in courts. But few thirteenth-century ledgers survive, and thus lack of evidence at Chartres should not rule out the possibility that banking was practiced there.[81] Although we cannot prove it, the changers probably took deposits, loaned money, and functioned as primitive bankers, especially since there were no Jewish merchants at Chartres.

The Prestige and Wealth of the Changers

The wealth of the individuals who were diversely called moneyers, changers, and goldsmiths in the twelfth and thirteenth centuries is clear from their generous donations to local monastic houses, especially Saint-Père and the leprosarium of Grand-Beaulieu.[82] In 1101, Radulfus, a minter, bequeathed one hundred sous to Saint-Père for his soul, and left his heirs only a house and his hereditary right to mint.[83] But some fifteen years later, when Radulfus wrote a second will, he had multiplied his holdings at least fivefold.[84] By 1221, another changer's son, Bartholomeus, when stricken with leprosy, bequeathed the leprosarium of Grand-Beaulieu 220 livres.[85]

The low level of economic activity at Chartres undoubtedly limited the wealth of the metal merchants there. Nonetheless, they seem to have enjoyed some social mobility.[86] In 1225, the son of a goldsmith named Radulphus was a regular canon of the town monastery of Saint-André.[87] Another became a cathedral canon,[88] and another a town squire.[89] The changers of Chartres apparently did not achieve as much economic success and social recognition as those of their calling in other towns, probably due to the lack of communal government in

which they could gain real political power, as did the changers at Beauvais.[90]

During the building of the cathedral, major economic changes were underway in France that affected adversely the local changers. Centralization of minting under royal control, increasingly enforced by Philip Augustus, diminished the activity and profit of local minters.[91] Their troubles at Chartres were increased by the financial difficulties of the counts, who sought tighter control of their revenues, and by the sagging interest of their ecclesiastical patrons in accumulating relatively unproductive goldsmith treasures.[92] These changes occurred when indebtedness had become a general condition of the upper classes in France; and local records suggest that the economy of Chartres operated on extensive borrowing.[93] For example, the oath which *avoués* took, in which they swore not to practice usury, is a sure indication that some of them had been money lenders.[94] Usually lay lords borrowed from ecclesiastical institutions, but ecclesiastics also borrowed heavily, and frequently died in debt.[95] Under these circumstances, it seems probable that the local money changers began to lend money. This was a time when money changers' economic activities had expanded to include lending money in France generally.

The Changers' Relationship to the Cathedral

In view of their donations to other establishments, the lack of recorded donations to the cathedral by the metal merchants of Chartres is striking. There is ample evidence during the twelfth century that they sought salvation for their souls by donating to monastic houses, but I know of only two donations to the cathedral, by a minter and a goldsmith, and neither date from the building period.[96] In fact, only a few dated documents attest to any associations between the metal merchants at Chartres and the cathedral:

1. Cathedral charters of 1181 and 1183 were witnessed by men described as *monetarius* and *cambitores*,[97] evidence that changers and a minter were either in the ecclesiastical court when the charters were signed or were available nearby.

2. In 1194, Robert de La Monnaie, who was apparently from a minter's family and hence probably originally practiced the family occupation, had become a canon and risen to the rank of subcantor.[98]

3. In the deposition regarding *avoués* of 1194–95, it was sworn that one money changer had left the count's service to become an *avoué* of the chapter's provost at Auvers.[99]

4. In 1224, the canons ordered the *mercerii* on the south porch to move to a house and stall between the porch and the main tower.[100] Branner translated *mercerii* as "money changers,"[101] and indeed Du Cange does cite one instance of this common usage.[102] If these were money changers who installed themselves in the cloister, they would

have been responsible to the chapter.[103] However, the *mercerii* that were moved from the porch may have been petty merchants selling such things as pilgrimage tokens.[104]

5. In a charter of 1225, King Louis assigned the protection of the cathedral and its possessions to a local moneyer.[105] The king considered himself the military protector of cathedrals, and this assignment of responsibility suggests that the moneyer had military capability appropriate for a minor noble.

These few documents suggest a somewhat closer relationship in the early thirteenth century than before, between some metal merchants and the cathedral. It is tempting to infer that this came about because some changers were lending money to cathedral officers. The bishop and canons were trying to finance their enormous building enterprise as well as the bishops' crusades. Bishop Renaud de Mouçon of Chartres led reinforcements to the Albigensian crusade in the summer of 1210, and was actually gone when the riot in the cloister took place. In 1226, the new Bishop Gauthier and other local nobles joined the new King Louis VIII on the same crusade.[106] Crusading was expensive. When Bishop Gauthier died in 1234, he left a huge debt of well over 2,500 livres, probably partly incurred in preparation for crusade.[107] The circumstantial evidence suggests that the changers drew closer to cathedral ecclesiastics to whom they lent money during this time.

The Conflicting Claims to the Money Changers and the Mint

The few documents we have about the control of the minters and changers at Chartres suggest that the bishop was trying to reassert his rights over them in the early thirteenth century. Judging from these documents, the count and bishop both had claims to the money changers, and these claims seem to shift and overlap and contradict one another.

The Count's Claims

Count Thibaut I apparently received the right to mint when King Raoul of France died ca. 960.[108] According to medieval practice, he would have invested minters and changers with their privileges, by which they gained the status of public officials, and they in turn would have pledged fealty to him.[109] The count clearly took advantage of the right to mint and sell coins, since he still received a yearly tax from the changers of Chartres called a *scutum* in the twelfth century, evidence of his continuing control over them. The *scutum* seems to have been a yearly rent for the dies and matrices used to strike money which the changers held in fief.[110] In 1183, Count Thibaut V and his children donated his tax on two of these *scuta*, one of which the deceased

Countess Adèle had held,[111] to the leprosarium of Grand-Beaulieu. The count previously had confirmed the donation of another *scutum* on the mint of Chartres to the leprosarium by Gautier of Friaize, but retained the justice of the mint for himself.[112]

Further evidence of the count's control over the town changers is Countess Adèle's demand in 1192 that eight changers give a donation to the leprosarium.[113] Her act recalls the similar act of the count in 1147 regarding the town tavern keepers. It is significant that the changers held their tables on a street outside the cloister near the count's tower, since, in principle, everyone living and working in his part of the town was his to rule and to tax. In summary, it seems that throughout the twelfth century, the count had complete control of the money changers and the mint.

The Bishop's Claims

In the second and third decades of the thirteenth century, for the first time, documents show the bishop holding or enfeoffing major rights to the mint and the changing tables. In 1213, Lord Ursion of Fréteval, the bishop's vidame, stated in a charter that he shared the income from the mint of Chartres with the bishop.[114] The vidame was in charge of the bishop's troops, and his office was hereditary. In 1229, after Bishop Gauthier had repeatedly asked that he do so, the same Ursion confirmed that he held numerous benefits in fiefs from the bishop:

> I, Ursion de Meslay, lord of Fréteval . . . declare that the fief which I hold from him [the bishop] and which my ancestors held from the previous bishop of Chartres . . . in the city of Chartres . . . [namely] half of all the revenues, justices, fiefs . . . in the Change and changers, in the mint and the moneyers, in the justice of false moneyers, and whatever other things pertain to all these, with this added, that part which I hold of the minting, I hold entirely from the bishop of Chartres.[115]

The vidame's claim that his ancestors and he held half of the income from the mint and the changers, suggests that the office of bishop continued to hold the other half, and had done so for a long time. Therefore, the count did not hold all the rights to the mint, after all—at least, not in the twelfth and thirteenth centuries. Bishop Gauthier was simply determined to confirm these rights in 1229. The vidame was hereditary head of the bishop's armed forces,[116] and hence capable of enforcing the bishop's will. After writing the charter, the vidame asked the king to confirm its legality, which he did.[117]

The vidame stated that the bishop gave him half of the rights, but does not make clear who held the other half. This omission is not

corrected in the next record we have of the episocal minting rights, a 1312 list of grievances for arbitration between the bishop and Count Charles de Valois:

> The bishop says that the count cannot strike money, in the county of Chartres, other than in the town of Chartres; that from each one thousand, the sire Hugh of Meslay who holds the mint in fief from the bishop, ought to have sixteen livres; that certain persons ought to guard the coins, from which they draw compensation, which persons hold this right from the said sire Hugh, who holds it in an old fief from the bishop; finally, that the policing of false moneyers belongs to the said Hugh. . . . [118]

It seems here that the count had some rights and the bishop also. Here we find the amount of money that the minters must pay the Vidame Hugh of Meslay—16 livres for every 1,000 minted—was probably a contested payment. And we learn that the vidame had, in turn, enfeoffed the guarding of the coins to his vassals, while retaining the punishment of false moneyers for himself.

Not until 1389 do we find a clear statement of the history and the division of rights to the mint and changers in the document later named *Vieille Chronique*.[119] Its contents are at least partially spurious;[120] it is a political instrument, blatantly claiming canonical and episcopal rights by inventing past traditions for them. Part of what makes it suspect is its insistence on episcopal control over the mint, although the mint had been closed for seventy years.[121] The document claims that, from the beginning, the canons had half of the possessions and income of the church and the county and the bishops had the other half.[122] When the king established the count, the bishop gave him half of most of his rights, but kept the mint rights

> in money and in matters of coinage, in every type of law and custody of the mint, and in other things which we presently say: in which the count has nothing, but the bishop retains these things and from the bishop they are held solely in fief.[123]

Thus, according to the *Vieille Chronique*, the canons had one-half of the mint rights, and the bishop the other half. The document then reports the bishop's enfeoffment of his vidame, and the four guards of the mint:

> Indeed the mint and the justice on whoever holds false money is shared by the bishop with the lord Hugh of Meslay, who, when the count coins money, in each one thousand, he has sixteen livres. In the same way, four holders have guard of the mints of coins from the bishop in fief, and whatever morning they hand over the dies for stamping the

money to the coiners, they receive them again into custody, because they have certain rights and liberties. And on the part of the bishop, they are held back [the dies] in the treasury of the church, as if held in trust and twelve specie of money perforated with a certain ring, to the worth and responsibility of which the count is held to make new money.[124]

Thus, the document admits that the count does the minting at Chartres, apparently contradicting the claim in the same document that the canons and bishop hold all the rights to the mint. According to the *Vieille Chronique*, the bishop held the coin matrices in the church treasury along with the dies with which the count was required to mint new money, and so he maintained the coinage size and appearance with the use of guards whose roles became hereditary.[125] That the bishop had the dies and matrices does not accord with the count and countess's apparent right to the scutum. A Hugh of Meslay (with the same name as the person in the 1312 document), is mentioned in this 1398 document, and he likewise receives 16 livres on every 1,000 minted; there are also four guards, just as in 1312.

Unlike the document of 1312, this one claims that the bishop enfeoffed the four guards himself. It further specifies that counterfeiters were to be handed over to the guards for hanging, and names the guards:

> The guards of the aforesaid mints are Reginaldus Lambert, Petrus Beruat, Michael Breton, and heirs of the Marshall, who because of this, in the name of liberty, declines the patronage of the count and shares the patronage of the bishop.[126]

The specifics have the ring of truth, and probably were copied from an earlier document such as the 1312 list of grievances. It is reasonable that the dies and exemplars for the coins were kept under careful guard for surveillance of the coinage, since the threat of devalued coinage was a major concern—a fear that materialized into inflation and resultant economic distress culminating with the king's repurchase of the mint.[127]

To what degree the claims in the first two documents and the later enlargement of the cathedral ecclesiastics' claims to monetary rights in the *Vieille Chronique* were false probably will never be known. Cartier thought that the bishop must have held the guard of the mint and certain other rights on the changers throughout the Middle Ages.[128] Chédeville, on the other hand, thought the bishop's claims were fictitious.[129] The documents do seem to suggest that the bishop exercised some control over the mint in the early thirteenth century.[130] If the bishop originally had all of the rights to the mint, and retained some

of them when the count took it over, his rights may have been alienated through the hereditary confusion of feudal enfeoffments, so that in the early thirteenth century, when he felt the need to exercise them, he had first to establish the legality of his rights through the vidame's declaration of them.

The Evidence of the Coins

There are several reasons to think that the bishop may have had the mint in the ninth century before there ever was a count of Chartres, and that he may have retained claims to it.[131] An early coin weighing twenty-eight grains may have been minted by the bishop.[132] The center of the reverse shows a cross-topped temple surrounded by the inscription CARNOTIS CIVITAS (see plate 135, #9). It carried the inscription CARLUS REX ES around the obverse, with a cross in the center.[133] Cartier, a nineteenth-century numismatist whose work on the coins of Chartres remains the most extensive, believed the ES stood for *Episcopus*.[134] The circulation of coins of Chartres and close imitations of them beyond the realm of the count but within the extent of the bishopric has also been seen as an indication that there was an early episcopal mint.[135]

The reverse image on the coins of Chartres, which has been interpreted as a banner, provides another argument for early episcopal minting of coins. Cartier believed it must have originally been an episcopal design representing the Virgin's veil. Such an image, he thought, was undoubtedly first designed under direction of the bishop in remembrance of the defeat of the Norman invaders in 911, when Bishop Ganteleme held up the veil before the barbarian hordes, frightening them into retreat.[136] Numismatic scholars in the twentieth century do not agree with this interpretation of the coins's image; they see it as a poor copy of the profile head on early medieval coins of Tours and Chinon, which in turn were rough imitations of late antique coins.[137] However, it is possible that people living in the diocese of Chartres in the twelfth and thirteenth centuries interpreted the abstract image on the coin exactly as Cartier did.[138]

Summation

During the first part of the thirteenth century, the bishops needed to exploit every possible means to increase their expendable revenues. While the expense of building the new cathedral bore heavily on local resources, the bishops and the local nobility undertook major crusades. There was never a better time for the money merchants of Chartres to have enriched themselves by loaning out funds. It seems that their functions changed, and they were drawn into closer relationship with

the cathedral, at the time when Bishop Gauthier was borrowing heavily and was at pains to confirm and enforce his control over them.

Bishop Gauthier probably renewed his claims to the mint in part out of a concern to regain a major source of income, but also to stabilize coinage and to avoid the king's usurpation of a powerful political tool. The bishop was not concerned to pay back his debt, and thus devalued coinage was of no advantage to him in that regard.[139] The stability of the coins of Chartres was the best means available to the bishop of maintaining the mint's independence from the king.

The Offering of Coins and Precious-Metal Vessels

Coins and precious-metal vessels were the mainstay of offerings to the cathedral. The oblations, tithes, and customary payments, sometimes made in bread or wine to the church on feast days, were most frequently paid in coin.[140] Precious-metal vessels were often bequeathed to the cathedral.[141] Large coin payments due on feast days were undoubtedly presented at the Chambre des Comptes, or the Loëns, but the worshipers at a feast-day mass would have offered their small obligatory payments during the ritual of the offertory. At other times, a money box stood ready in the choir for small offerings from the faithful.[142]

The Symbolic Significance of Gold Coins

The overwhelming preponderance of gold coins relative to silver deniers depicted on the changers' tables in the windows presents an interesting problem (see color plate 3). Gold coins were scarce in Europe at the time.[143] From the eighth until the second half of the thirteenth century, coins minted for and used in daily exchange in northern Europe were silver alloy or copper, not gold.[144] Large debts were recorded in Europe in gold coins, but there is no evidence that such debts were actually paid in gold—just the opposite.[145] The scarcity and high value of gold coins at the time would have ruled out their display on open money-changing tables in the street.

However, recent research has shown that gold coins were not so scarce during the Middle Ages as once believed. The Muslim *dinar* was the best known of the gold coins to circulate in the West. The dinars were preeminent in international exchanges, because they were easier to transport and more stable in value than other coins.[146] Copies of the Muslim dinars were minted in Christian Spain beginning in the eleventh century,[147] and in the Holy Land by crusaders beginning in the twelfth century.[148] The large trade in counterfeit Muslim silver coins called *millares* manufactured in the south of France from 1200 to 1260 must have caused a considerable amount of gold coursing back into

France during the same period.[149] All these factors brought dinars back
into circulation in the West. The rate of exchange of twelve pounds of
silver for one of gold was shifting downwards in the early thirteenth
century to seven to one in some instances.[150]

Therefore, it is not surprising to find that the Magi in the twelfth-
century Infancy of Christ Window in the west facade at Chartres offer
gold coins painted to resemble Arab dinars to the Virgin and Child
(plate 137). Françoise Perrot and Michel Dhenin collaborated to pub-
lish this discovery.[151] The painting on the coins had not been noticed
by scholars, undoubtedly because the coins are barely visible from the
cathedral floor, ten meters below. Perrot examined the painting on the
coins when the window was removed for restoration in 1975. Each coin
contains a kufic inscription which can be identified with an Almoravid
coin of the first half of the twelfth century.[152] Since each of the three
Magi carries a gold coin, the window evidently illustrates Pseudo-
Matthew 16: 1–2: "Then they opened their treasures and they went to
Mary and Joseph with very rich presents. To the infant himself, each
of them offered a gold piece."[153] The same idea is illustrated in the
choir clerestory, where the foremost Magi kneels to offer a coin to the
Christ child (plate 138).

The idea that the Magi should present real gold coins to the Virgin
and Child had its counterpart in the medieval tradition of presenting
honorific payments in gold coins. Gold coins were actually made in
Europe to give customary payments prestige. Scattered medieval texts
in France mention payments in gold oboles (half-denier coins). Blan-
chet believed local mints manufactured these in the shape of local
coins, since they are referred to as gold oboles of the source town.[154]
Blanchet concluded from his examples that oboles of gold paid by vas-
sals to their lords were cens payments, confirming property rights.[155]
Chédeville enlarged on Blanchet's work, arguing that many of the gold
coins paid the papacy as a cens by abbeys and cathedrals according to
the accounts in the *Liber Censum* were similarly manufactured for
this customary payment.[156] In addition, the custom of payments in
gold coins had symbolic value, associated with biblical precedents,
such as the above-mentioned gifts of the Magi to the Christ child and
also the Queen of Sheba's gift to Solomon. Hence, gold was the quin-
tessential means of respectful oblation.

The Association of the Coin with the Virgin

In the early thirteenth century, the distinctive "banner" image on the
coins of Chartres (plate 135, #11), whatever its origin may have been,
came to be especially associated with the Virgin. The coin appears in
the early thirteenth century on small lead pendants sold to pilgrims;
in the nineteenth century some of these pendants were dredged from

the Seine (plate 139).[157] On the reverse, a large image of the coin is associated with the Virgin's veil.[158] Two relic bearers walk toward the left carrying the veil, which is encased in a gabled reliquary on a litter. A huge, simplified image of the coin of Chartres appears beneath the litter like a blazon. The obverse depicts the statue of the Virgin carried on a litter by two men who walk in the opposite direction and stare out at the viewer, as do two tiny figures who kneel at the Virgin's feet. Across the tri-lobed top of the early thirteenth-century token one can partially make out a coarse inscription: SIGNVM BEATE MARIE (plate 139).[159] The token thus evoked the ritual display of the Virgin's veil and statue on major feast days, the very occasions when most pilgrimage tokens were sold. Later tokens continued to combine the coin's image with that of the Virgin (plate 140).[160] The association of the unusual coin image with Chartres was perpetuated by its depiction on the arms of the town, still in use in the nineteenth century (plate 141).[161]

The images of the coins of Chartres on medieval pilgrimage tokens, themselves potent of miracles,[162] suggest that money donations were an integral part of the pilgrimage. The coins of Chartres symbolize the act of offering to the Virgin. Thus, this early token can be seen as a sanction of the coinage of Chartres by the Virgin herself. Accordingly, the bishop's vidame wrote, in his charter of 1229, that all the mint rights he held from the bishop were the rights of the Virgin Mary of Chartres.[163] This is in line with the traditional medieval understanding that the rights of a church belong to its patron saint.

The association of the coin with the Virgin is repeated in the imagery of the apse clerestory windows, where the coins are piled, as it were, at the entrance to the Virgin's sanctuary. The financial support for her cult implied in this arrangement and on the pilgrimage token is explicit in the image of the Virgin and Child receiving the three Magi's offerings in the cathedral glass. Bay 106 of the choir fenestration is typical (plate 138). The scene is repeated many times in the stained glass at Chartres.[164] The cult statue in the choir in the same pose thus appeared to await gifts, as the images of the Virgin and Child all over the cathedral reminded the pilgrim.[165] The money depicted piled on changers' tables at the entrance to the apse represent the Virgin's preferred offerings.

Historical Analysis of the Changer Scenes and Their Contexts

I will consider each window in turn, first describing the trade imagery based on the historical evidence of trade practice, and then considering the iconographic tradition of the trade imagery and its relationship to the traditional religious imagery above the changer scenes. Depicted with money changers are St. Peter, St. John the Baptist, St. Joseph the

Patriarch, an unidentified apostle, and St. Blaise. All these saints func-
tioned as typological representations of the bishop of Chartres—stand-
ing over his money changers.

The Money-changing Scenes

The money-changing scenes at Chartres are very similar. It seems ap-
propriate to begin in the apse clerestory, the most sacred part of the
cathedral, which is, so to speak, framed by money. At the base of the
St. Peter window, four men appear behind a money-changers' table
piled with silver and gold coins that are marked with a cross sur-
rounded by a circle, undoubtedly to simulate the coins of Chartres
(color plate 3, plates 117 and 135).[166] The two men in the center are
changers; one holds up a pair of scales, the paradigmatic tool of his
trade. The changers turn away from each other toward clients who ap-
proach from either side wearing hooded red surcoats. The client on the
left holds a money bag on the table and raises his hand in a gesture of
conversation with the changer in front of him, who holds his hand on
a pile of silver coins and gestures toward the balance. The most likely
interpretation of the scene is that this client's bag contains deniers of
another baronage, and he is exchanging the coins in his bag for some
silver coins of Chartres. The changer gestures toward the scales to sug-
gest that a proper exchange should be determined by the balance, by
measuring equal weights of the two types of coins. However, another
possible interpretation is that this client wants to buy a golden vessel,
like the one depicted on the balance.

In the right half of the scene, the money changer holding up the
balance weighs a gold vessel. The rounded, covered vessel, called a ci-
borium, is the type used at mass to hold the hosts.[167] Gold weights in
the left balance weigh more heavily than the ciborium in the right
basket.[168] That the changer has tipped the balance slightly more heav-
ily with his weights than the true weight of the ciborium suggests that
it is worth more than its weight in gold due to its workmanship, or its
purpose.[169]

In his right hand, the changer holds a green, lever-like device (or lid?)
that extends downward into a green box in which stand two large,
round, gold-colored objects. The meaning of this box is difficult to de-
termine. It probably was the box in which the changer kept his
weights. The box could also have been a verification box, into which
minters placed coins at random for testing by mint guards to assure
that the batch met with established standards.[170] Considering the care-
ful rulings about guards for the coins in the documents reviewed above,
it may very well be that the box held coins for testing, but it seems
that this operation was usually conducted in the mint, not on the
changing tables.[171] However, the guards were supposed to be present to

watch over all transactions, so we cannot even be sure that all the men are either changers or clients.

A second gold vessel, larger than the one on the scale, stands next to the box. The client on the right rests one hand on a pile of silver coins on the table in front of him and gazes at the scale. He seems intent on buying the gold vessel with his silver coins—or possibly he is buying the coins from the changer in exchange for this vessel. The client on the right gestures off to the right—outside the picture space, toward the east, where the cult image of the Virgin, patron saint of the cathedral, appeared in the center of the apse windows. His gesture suggests that he intends his purchase for her.

The principal changer scene in the window of St. John the Baptist almost exactly duplicates the money-changing imagery in the St. Peter window (plate 120). Three men stand behind a long white table looking at a balance. The man in the center who holds it up is a changer. The lower center section of the window, framed by armatures, in which the balance appears, is a modern restoration.[172] However, almost all of the rest of the scene, including the upper part of the changer's body and his extended right hand, are original, so that his hand undoubtedly did originally hold a balance.[173]

On the left, a client in a hooded red surcoat gestures toward the balance and rests his other hand on a large pile of silver coins. On the right, the changer's assistant empties gold coins from a large money bag onto the table. Either the client is buying whatever the changer was originally weighing in his balance with his silver coins, or the client is negotiating to buy the local coins with whatever was originally in the balance.

In the next register, two lateral, semicircular picture fields seem to form a single scene. On the left, a man dressed in a red cap and red cloak sits on a bench with one leg casually pulled up. He holds gloves in his right hand, indicating his noble rank,[174] and gestures with his left hand in conversation with the money changer across from him. The changer looks at the nobleman and holds his right hand on the top of a very large, fluted and footed ciborium, apparently the subject of their conversation. His left hand rests on a large pile of silver coins in front of him on the table. To the right, four gold coins appear from behind the edge of the window frame. The nobleman probably is negotiating to purchase the golden vessel with his coins but, again, we cannot be sure. He could be selling the vessel. The ambiguity of these changer scenes expresses aptly the two-way exchange they depict, which always allows for two readings.

Two scenes at the bottom of the Joseph window, in the fourth bay of the north aisle, portray money changers (plates 127 and 128).[175] On the left, a changer holds up a small scale to weigh three gold coins which balance with the small gold weights in the other basket. Beneath the

scale on the table, gold coins spill out of a large money bag. He looks at the changer next to him, who returns his gaze, pointing in the opposite direction at a pile of eleven gold coins on the table to the right.

In the scene on the right, three men appear behind the bench. A large pile of gold coins lies on the table near a seated money changer who has selected a few gold coins for close testing and piled them on the table in front of him, beside a trebucket,[176] a money-changer's tool for measuring the weight of a single coin to ascertain its fine-metal content.[177] Whoever did the recent restoration of the window has altered this little tool into an incomprehensible flare of color.[178] One can make out the trebucket in a detail of the tool in a photograph taken for Delaporte's 1926 monograph (plate 129),[179] and it can be seen more clearly in the painting of the scene also published with Delaporte's monograph (plate 130).[180]

The changer bends over, carefully examining one gold coin; he appears to indent the edge of the coin with his fingernail to judge its gold content by its softness. Before the restoration of the window, he posed the coin at the top of the trebucket. Whether the trebucket was there originally or not, this man is definitely examining the coin to ascertain its value. Next to him, another changer holds the top of a money bag from which seventeen silver coins spill out onto the table, and gestures in conversation with a client in front of him, whose attire identifies him as a merchant. The merchant returns the changer's gaze, also gesturing in conversation, while pointing at the money bag. The merchant apparently negotiates to purchase some of the gold coins from the money changer, whose assistants ascertain their value—or perhaps he is selling them gold coins. Again the antithetical composition is appropriate to the depiction of the exchange and its two possible meanings.

All we know of the window of St. Blaise comes from Pintard's description of it transcribed by Delaporte. Pintard described two scenes of money changers (plate 133):

> Panel 1. Two persons at a changing table on which there are sacks of silver; another person talks to them.

> Panel 2. Two persons at a changing table on which are many heaps of sacks of gold and silver; at the end of the table is a person dressed in a dalmatic followed by an armed man who seems to talk to one of those who is at the table.[181]

These scenes read like the ones we have already seen, with two exceptions. The larger, second panel contained images of a man in deacon's dress and an armed guard. The man in the dalmatic may have been the dean, who had charge of the fairs in the cloister, in which case the armed man would have been either a fair guard or one of the guards of the coins.

In the surviving scenes of money changers, the stained-glass artisans allowed the meaning of transactions to remain ambiguous. In each case, one is not sure whether the changers are buying or selling coins, buying or selling gold vessels. These ambiguities emphasize the useful diversity of the changers' functions. The ambiguities of exchange, and the liveliness of hand gesturing which signify bargaining for price, are important. They indicate a freedom of bargaining from which the medieval viewer would have hoped to benefit. He would have interpreted what he saw according to his own experience or need. Carefully depicted implements of measure—the scales, the trebucket, the changers' tool boxes—emphasize the changers' honesty and fairness, and by inference, their overlord's good administration of them. The deliberately depicted, unrealistic predominance of gold coins on the changers' tables was charged with suggestion of honorary donation, and that was the point of placing these stunning scenes at the entrance to the Virgin's sanctuary.

Traditional Iconographic Sources of the Imagery

The iconography of money changers was well-established in the Middle Ages, especially in the representation of two New Testament events, the Purging of the Temple and the Holy Women Buying Spices.[182] Unlike the Purging scenes, which usually depict the changers fleeing, the merchants in scenes of the Holy Women Buying Spices usually sit behind a counter laden with coins and weigh spice in a hand-held scale.[183] In Romanesque reliefs of the scene, the women usually approach from the right carrying their spice pots, and the woman in front makes the purchase. At Beaucaire, she sets money on the counter;[184] at Saint-Gilles-du-Gard, she holds out her pot to be filled (plate 142).[185] Usually the counter is solid and block-like in the Romanesque images, but some of the tables have the open-legged construction typical of medieval changers' tables, for example, at Arles (plate 143).[186] There is no bargaining for price in these images. I have not found any which depict the lively conversation between client and merchant found in the windows of Chartres.

The tradition for this aspect of the scenes at Chartres probably was copied from late Roman reliefs of money-counting that survived in France (plates 144–46).[187] These images usually show several men standing behind a counter engaged in lively conversation, indicated by their gestures. One man on a Roman relief in the Trier Landesmuseum seems to hold a coin as if to test it with his fingernail like the changer in the Joseph window (plate 144). Some of these men carry sacks of coins, or reach out to finger piles of coins on the table top, as if they were counting them, just like the men in the windows. Typically, on the reliefs, a man holding a big book is seated at one end of a desk or counter, apparently recording payments or distributions—one cannot

be sure what he is doing, taking money in or paying it out or both.[188] So, while the iconographic tradition for the representation of money changers in the stained glass at Chartres existed in Romanesque art, the narrative liveliness and ambiguity of the images at Chartres had their precedents in late Roman relief sculpture.

Related Changers Scenes in Thirteenth-Century Art

Changers also appeared in the Moralized Bibles in scenes of contemporary French life. They are important to this study because the accompanying texts consistently express disdain for the profession. Changers are said to exemplify vices and the evil desire for earthly things.[189] They are greedy, avaricious men who boast of their wealth.[190] Changers are even considered metaphors for the Babylonian captivity.[191] Hence, it is all the more surprising to see them in such an honored position in the cathedral. On the other hand, the moralizing texts encourage donation of gold and silver to the Church by declaring that charity brings eternal life, and offerings to the Church extinguish sin.[192] It is the idea of offering which justifies the scenes of changers in the apse.

Stained-glass images of minters appeared at Bourges Cathedral, and both minters and changers appeared in windows at Le Mans Cathedral. The images at Bourges have been salvaged from lost windows and reinserted in a window which is a pastiche of old and new glass.[193] Of more interest are the windows of changers in the axial chapel at Le Mans Cathedral, dated to ca. 1240. The windows depict the life and miracles of the Virgin. In their lowest registers, each window contains almost identical large pictures of money changers working (plate 147) and two tiny related scenes of minters to either side.[194] The large center scene depicts five men behind the changing table which is piled with silver coins and gold and silver goblets. Both windows contain the inscription, SCIAMBATOR DE ALONE. Alonnes was a parish belonging to the chapter of the cathedral.[195] The windows apparently represent money changers from a town which was ruled directly by the canons of the cathedral. This is similar to the situation at Chartres, where the bakers, wine sellers, and money changers in the windows seem to have been closely associated with or ruled by the canons and bishop.

The pronounced analogies between the occupational scenes and scenes of the saints' lives which occur at Chartres and at Bourges are even sharper in the Life of the Virgin window at Le Mans. There, the large square central medallions prominently display gold vessels and coins. The first square depicts the blossoming of Joseph's rod over the temple altar, and a large gold vessel beneath the altar. The second large square depicts the Virgin entering the temple followed by Joachim and Anne, who carries a pile of gold coins in her arms (plate 148). The top square depicts the Virgin in majesty, and two large golden vessels on

either side of her throne. The idea of gold offering for the temple and the Virgin appears in the center of the window above the money changers, who hold up gold vessels and display gold and silver riches on their tables. Similar analogies appear in the adjacent Miracles of the Virgin window, where the Virgin replenishes a monastic granary with golden wheat (plate 149).[196] The unmistakable suggestion is that the coins and the precious vessels on the changers' tables are the appropriate offerings for the Christian temple.

At Bourges and Le Mans, however, there are no clients negotiating as at Chartres. The money-changer scenes at Chartres show a lively interchange between the changers and their clients, but the exact nature of their transactions remains uncertain. It is this portrayal of negotiation which is unique to Chartres.

The Window of St. Peter

Finally, we look at the traditional imagery combined with the scenes of money changers in the windows. The window dedicated to St. Peter in the apse clerestory, Bay 123, illustrates money changers in the bottom register and, in ascending registers above it, three events in the life of the saint: Peter receiving the keys of the kingdom from Christ, Peter saved from prison by an angel, and Peter in bishop's attire meeting Christ at a gate to Rome (color plate 3, plates 115 and 116).[197]

The iconography of the scenes is not unusual, except for certain significant details.[198] Peter's keys are unusually large, emphasizing their significance in medieval exegesis—Peter's power to excommunicate and absolve.[199] The text of Matthew 16:18–19 which the *Traditio Clavis* illustrates was cited by theologians to justify the church's right to judge both clerics and laity.[200] It is this authority that the image of Peter's huge keys invokes. Peter's papal vestments, especially his tiara in the "Domine, Quo Vadis?" scene are also unusual.[201] They are visual manifestations of the *plenitudo potestatis* Peter received from Christ.[202] Hence the traditional iconography of the window expresses papal claims to secular as well as sacred authority. The isolation of these particular three scenes of Peter's life is unique in medieval art, so far as I know. They mark major moments when Peter's special role as the first head of the Church is manifest.

St. Peter was one of the few saints at Chartres to have his own altar. It was located in a chapel in the crypt, dedicated to St. Peter in Chains.[203] He was one of the five saints implored by name in the suffrages,[204] and the first saint named in the *Laudes Regiae*.[205] His image in sculpture and stained glass appeared in many places in the cathedral.[206] The clergy celebrated three feasts in Peter's honor: the feast of the Chair of St. Peter on February 22,[207] the feast of St. Peter in Chains on August 1,[208] and the anniversary of the martyrdom of Sts. Peter and Paul on June 29.[209]

The scenes in the apse window illustrate the events that these three feasts of St. Peter commemorate. The feast of the Chair of St. Peter celebrated the ascent of Peter to the episcopacy of Rome and Christ's presentation of the keys to him.[210] The feast of the Chains of St. Peter celebrated the saint's miraculous escape from Herod.[211] At vespers before the feast at Chartres, the clergy made a procession to the crypt and held a station at the chapel of St. Peter in Chains there.[212] The feast of Sts. Peter and Paul celebrated their martyrdom, anticipated in the scene of Christ sending Peter to be crucified.

The readings for these feasts at Chartres corresponded with the imagery of the window. The pericope book contained the apocryphal account of Peter at the gate of Rome, to be read on the feast of Sts. Peter and Paul.[213] The vigil gospel for that feast recalled Christ's prophecy of Peter's martyrdom in John 21, 18–19.[214] The festal mass epistle at the feast of Peter in Chains and the feast of Peter and Paul was the passage beginning *Misit Herodes rex*, which describes Peter's escape from Herod's prison thanks to God's intervention.[215] The ordinary specifies the festal mass gospel reading, *Venit ihesus in partes*, for all three feasts.[216] This is the incipit of the passage in Matthew 16 that describes how Christ gave the keys to Peter. Hence the window scenes of Peter stood as a constant reminder of Peter's importance, which the feasts periodically celebrated.

The line of authority from Peter to the medieval papacy was direct, and it extended from the papacy to the bishops.[217] The rite of major excommunication and its absolution specifically cite the authority of the apostles Peter and Paul as the basis of the officiant's power.[218] This image of the biblical sanction of the bishop's authority stood at the entrance to the apse directly across from the bishop's throne, where he could look at it (plate 150).[219] Furthermore, the full authority and approval of the Church through Christ and St. Peter was evoked over images of trade in coins.

The Window of St. John the Baptist

The window of St. John the Baptist in the apse clerestory, Bay 117, contains one large scene of money changers at the bottom, and, in ascending registers, three scenes from the life of St. John the Baptist: the annunciation to Zacharias, John the Baptist with the *Agnus Dei,* and the baptism of Christ (plates 118 and 119).[220] The scene just above the changers' table illustrates Luke 1:5–22, in which Gabriel tells the old priest Zacharias that he will have a son, whose name will be John.[221] In the next scene, St. John the Baptist holds up the *Agnus Dei,* recalling the moment in John 1:35–36 when John saw Jesus and declared: "Behold, the lamb of God."[222] John wears priestly robes beneath his coat made of camel hair, visually expressing the idea that he is both the last prophet of the Old Testament and the first priest of the New

Testament.[223] Two disciples dressed in monks' scapulars step toward him, as if following him in a liturgical ritual. The uppermost scene depicts Christ's baptism in the Jordan River.[224] John the Baptist now wears only his priestly vestments, and is attended by a cleric.

Like the scenes of St. Peter in the window opposite, the scenes of St. John follow traditional iconography but contain a few unusual elements. And again, as in the St. Peter window, the combination of the three scenes is unique. The unusual liturgical attire of John and his attendants emphasizes the liturgical import of the window,[225] as does the Old Testament altar at the lowest level, incensed by its priest. The altar is superseded by the priestly figure of John holding up the symbol of Christ's sacrifice and redemption. The combination evokes the Christian Eucharist.

Like St. Peter, St. John the Baptist was a prototype of the office of bishop. Von Simson in his discussion of the Maximianus throne argued that the image of the Baptist on the throne front is the embodiment of episcopal dignity. In this way the throne resembles the Chartres window. Both were built to exalt the bishop. Von Simson noted that the Baptist appears in Isaiah 49:1 and Luke 1:76 as prophet and preacher of redemption. When the Baptist said "Ecce Agnus Dei," he revealed his apostolic calling most eloquently. The Baptist embodies the bishop's authority as a teacher and his dignity as a dispenser of sacraments.[226] Accordingly, the window suggests, in its three registers, three principal sacraments of the church: ordination to the priesthood, communion by the holy wafer, and the baptism of the faithful. The window represents John specifically as the New Testament prototype of the bishop's office.

St. John the Baptist was a patron saint of the cathedral.[227] A chapel in the crypt and the baptismal font in the south aisle of the crypt were dedicated to him.[228] His image appears prominently in the cathedral.[229] He was one of five saints named in the recitation of the suffrages.[230] The clergy celebrated two feasts in honor of St. John the Baptist at Chartres, the June 24 anniversary of his birth[231] and the August 29 anniversary of his martyrdom. The June birthday feast was the more important; then the choir was decorated with tapestries. The night before at vespers the clergy formed a procession to the saint's altar in the crypt, and on the day of his feast they performed a solemn mass with special tropes.[232]

The gospel reading for the feast of his birth was the passage from Luke 1:5–22, which the window in part illustrates.[233] The blessing for this feast in the thirteenth-century Pontifical from Chartres recalls this gospel; it also refers to the *Ecce Agnus Dei* scene in the window with the prayer: "So may you be able to dress in the wool of virtues and to imitate the innocence of the lamb whom he pointed out with his finger."[234] Every time that mass was performed, the priest repeated

the words of St. John the Baptist, saying, as he elevated the host just before communion, *Ecce Agnus Dei*. And at the interval between consecration and communion, the faithful sang the "Agnus Dei" communion hymn.[235] The readings of Epiphany referred to Christ's baptism because it marked the revelation of Christ's divinity. Every baptismal ceremony recalled its biblical inception in John's baptism of Christ.[236] Like the St. Peter window opposite it, the St. John the Baptist window, by the selection of its three scenes, illustrated the liturgy.

It also extolled the bishop's office. The window and the liturgy present John as the prophet of Christ and the elect of God to whom God gave the power of the sacraments. Hence the window presents John as the prototypical Christian priest and teacher, and portrays in John the inception of the ministry carried out beneath it in the apse by the bishop. At the entrance to the sanctuary above the bishop's throne, the window expressed in clear visual terms the historical inception and precedent for his office.

The Significance of the Windows of Sts. Peter and John the Baptist

The windows of St. Peter and St. John the Baptist at either side of the apse clerestory stood as justifications of the bishop's power. Were they entirely separate in meaning, then, from the five central lancets of the apse clerestory which honor the Virgin? The windows of St. Peter and St. John have never been considered a part of that program.[237] However, the consistent idea of offering in the bottom register of the five central lancets extends outward to the money changers' tables at the bottom of the adjacent windows, whose coins were intended as offerings to the Virgin.

There are special reasons, in the case of St. John the Baptist, to see the piles of coins as offerings to the Church. In a sermon, Caesarius of Arles linked the Baptist to the tithing expected of all Christians.[238] A reading for the feast of John the Baptist's day of martyrdom stated:

> Blessed is the man who is found without stain, who does not pursue gold nor hope in money and treasure. It is he whom we will praise for he has done marvels in his life who has been tested in him and found perfect and there will be glory for him who could have transgressed and did not transgress, and could have done evil and did not. Therefore his goods are established and the assembly of the saints has proclaimed his alms.[239]

Such traditions for the giving over of tithes and alms in the name of St. John the Baptist would suggest his feast as the proper moment for payment. In the early fifteenth century, the feast of John the Baptist's martyrdom was the final accounting date for the cathedral; this may well have been the case earlier.[240]

There is a biblical passage that may be significant in relation to the combination of St. Peter with money changers. All the apostles gave up their worldly goods to follow Christ. St. Peter made reference to this fact in Acts 3: 6, when he said: "Silver and gold I have none; but what I have, I give thee in the name of Jesus Christ of Nazareth," and he healed a cripple. The notion of giving over one's wealth to the church inherent in the images of piles of coins at the entrance to the sanctuary had further resonance in the presence of St. Peter. It is, therefore, not by chance that St. Peter appears again in Bay 86 at Chartres standing atop a banking table.[241]

The windows of St. John the Baptist and St. Peter in the apse did not project their message to the broadest possible audience of the faithful, as did the five central lancets, whose blazing images are clearly visible all over the nave. The Peter and John windows stand in line with the choir clerestory windows and, like them, are very difficult to see, unless one stands in the choir.[242] They were primarily for the eyes of the chapter of canons who daily performed their offices in the choir, behind the choir screen, where they could see easily these statements of episcopal authority high overhead. The windows of Peter and John stood between the heavenly realm of the Virgin and the lineup of royalty and princes who kneel facing her at the base of the choir lancets and ride toward her in full knightly battle regalia in the choir oculi.[243] This parade of temporal power proceeds toward the Virgin on either side of the choir, and stops before types of the bishop's sacred office, St. Peter and St. John the Baptist. The superiority of the bishop's position was set out symbolically and topographically. In this larger scheme, the golden offerings for the Virgin at the entrance to her sanctuary are the oblations of kings and princes, received by the bishop on behalf of the Virgin.

The Window of Joseph the Patriarch

The window of Joseph the Patriarch in Bay 61 of the north aisle contains two scenes of money changers and twenty-seven scenes of the life of Joseph, surmounted by an image of Christ blessing (plates 121–126). The pictorial narrative of Joseph illustrates Genesis 37 through 46.[244] The story begins with Joseph dreaming that the sun, moon, and eleven stars will worship him (plate 123, panel 3). Jacob sends Joseph to join his eleven brothers tending sheep (plate 123, panels 4 and 5). The brothers, fearful that Joseph's dream prophesied that they would someday bow down to him, throw him in a well to die. But they repent, pull him up from the well (panel 6), and sell him to passing merchants (panel 7). Then they send his blood-soaked robe to Jacob, who thinks a beast killed Joseph (panel 8). The merchants sell Joseph to Potiphar, the Egyptian Pharaoh's captain (plate 124, panel 9). Joseph repels the sexual advances of Potiphar's wife (panel 10), but in her anger she ac-

cuses him of rape (panel 11), whereupon Potiphar imprisons Joseph (panels 12 and 13). In prison, Joseph interprets the dreams of Pharaoh's butler and baker (panel 16). His predictions come true, and consequently, when Pharaoh dreams strange dreams (panels 14 and 15), he summons Joseph to interpret them. Joseph explains that Pharaoh's dreams signify seven years of plenty in Egypt, followed by seven years of famine. Pharaoh appoints Joseph governor of Egypt (plate 125, panel 17), and Joseph directs the storing of grain during the years of plenty (panels 18 and 19). Famine ensues, and Jacob sends his sons to Egypt for grain (panels 20 and 21), whereupon Joseph invites them to his home and serves them a feast (panels 22 and 23). Joseph gives his brothers sacks of grain to take back to their father, but Joseph's steward discovers Joseph's cup in Benjamin's sack (panel 24), and forces Benjamin to return to Egypt. The other sons return to Jacob and tell him that Joseph rules Egypt for the Pharaoh (plate 126, panel 25). Jacob and all the tribes of Israel travel to Egypt (panels 26, 27, 28). The pictorial narrative ends with Joseph and Jacob meeting in Egypt (panel 29).[245] At the top of the window Christ appears seated in eternal Paradise between two burning candles, blessing all these temporal events.

For most of the Middle Ages, Joseph's story appears as part of a cycle of illustrations of the Old Testament. Separate narrative cycles of the life of Joseph are exceptional and are usually associated in some way with a bishop: examples predating the thirteenth century are the Maximianus throne, the Naples ambon, the Sens ivory box, and Coptic silks.[246] The throne and ambon are both church furniture for the use of the bishop, and the Sens ivory box must also have been.[247] Joseph's story was appropriate decoration for episcopal furniture because, as Meyer Schapiro has shown, Joseph had become an Old Testament prototype of the bishop.[248] French thirteenth-century stained-glass artisans elaborated the pictorial narration of Joseph's life at Chartres, Bourges, Rouen, Auxerre, Poitiers, and Troyes. None but Bourges bears a very close resemblance to the cycle at Chartres.

While the individual scenes at Chartres can be traced to previous iconographic tradition, the ensemble of twenty-seven scenes at Chartres is unique.[249] Of the thirty-six cycles in all media that I have examined, the closest are the window at Bourges and the Maximianus throne. There are two primary ways to compare the cycles: by selection of events, and by the similarity of iconography. The Maximianus throne is the closest to the Chartres window in its selection of subjects. It has only fourteen scenes to the window's twenty-six and nine of the throne's subjects are the same as those of the Chartres window.[250] But only two of these have similar iconography to the Chartres window; this indicates that they come from a different iconographic tradition. The Bourges window is closest in the proportion of scenes

composed in the same way, according to a common iconographic tradition.[251] The first six scenes in the window at Bourges are very much like those at Chartres, as is the scene further up in the window where Pharaoh awards the kneeling Joseph the governorship of Egypt by handing his scepter to Joseph. The rest of the window, however, diverges from the Chartres cycle.[252] The two criteria taken together rank the Bourges window only slightly closer to the Chartres cycle than the sixth-century throne of Maximianus,[253] although the latter resemblance has gone unnoticed, while the close resemblance between the cycle at Chartres and Bourges has been discussed in the literature.[254]

Schapiro argued that the pictorial cycle of the patriarch Joseph on the throne evoked the exegetical understanding of Joseph as a type of the bishop. He cited exegesis up to the early eighth century to make two basic points: (1) because of his holy qualities, Joseph is not only a type of Christ, but also the model of a good bishop;[255] and (2) because of his wisdom and fine administration, Joseph is a model of a high civil officer, a role which the bishop had taken on.[256] Many of the texts that Schapiro cited were by major church fathers and late classical writers whose works must also have been known to the educated clergy at Chartres.

The interpretation of Joseph as a type of the office of bishop continued to appear in the later exegetical writings of Hrabanus Maurus, who repeated almost verbatim Bede's and Isidore's ideas about Joseph that were later copied in the twelfth-century compilation of biblical commentary known as the *Glossa Ordinaria*. In the *Glossa*, the exegesis which most clearly describes Joseph as a type of the bishop concerns Pharaoh's elevation of Joseph to the governorship of Egypt:

> Joseph, who was a type of Christ, merited the wagon, and the herald proclaimed before him and Pharaoh placed him over the entire land of Egypt . . . and he received the power of preaching and judging from the father. . . . He also accepted the ring, i.e., the pontificate of faith, by which sign of salvation the souls of believers are signed, and the figure of the eternal king is imprinted on our foreheads and hearts by the sign of the cross.[257]

Thus the equation of the ring that Pharaoh gave Joseph with the ring given to a bishop on his ordination, which Schapiro found in the writing of Ambrose and Paulinus of Nola, had a wide currency in the twelfth century. The event does not appear on either the throne or the window. The window shows Joseph receiving a scepter from Pharaoh, in a thirteenth-century analogy to the institution of French royal office. The Oxford Moralized Bible also depicts this and interprets it to signify that Joseph is a type of the bishop:

> That Potiphar made Joseph overseer of his house signifies
> the prelates of the church who according to the regimen of
> the church give to churchmen the care of souls.[258]

In this case, Joseph's care of the Egyptians is likened to bishops' care
of their dioceses. In the Bible, Pharaoh says, when he appoints Joseph
governor of Egypt: "Since a god has made all this known to you, there
is no one so shrewd and intelligent as you. You shall be in charge of
my household, and all my people will depend on your every word"
(Gen. 41:39–40). Hence, it can be concluded that, in the window, Jo-
seph's good leadership and wisdom are metaphors for the bishop's lead-
ership of the diocese.

The window emphasizes the storing of grain by illustrating it twice.
Related in only two lines in the Bible (Gen. 41:48–49), it occupies two
full panels of the twenty-seven allotted the narrative, marking its spe-
cial importance in the pictorial cycle (panels 18 and 19). The window
illustrates the two verses, 49 and 48, in reverse order. In the first scene,
two men empty grain from their skirts onto the ground between them,
apparently illustrating Genesis 41:49, "He stored the grain in huge
quantities; it was like the sand of the sea." This figurative idea seems
literally illustrated here, with grain being poured out beside waves of
green at the base of the pictorial space. The green waves probably were
intended to represent the Nile River.

The ninth century exegesis of Prosper of Aquitaine helps to explain
the meaning of the two images of grain in the window. Prosper empha-
sizes the same two verses of Genesis 41: 49 and 48, paraphrasing them
in reverse order, just as the window illustrates them, which suggests
that Prosper of Aquitaine's interpretation was the source for the ar-
rangement. Commenting first on verse 49, Prosper states:

> Joseph sent his men through all Egypt and he gathered much
> grain as the sands in the sea. And our Joseph, Christ the
> Lord, sent his men through the world saying go, baptize na-
> tions in the name of the Father and the Son and the Holy
> Spirit. And a group of believers was gathered like the sands
> of the sea.[259]

Grain is a metaphor for the souls of believers. Joseph collected grain
just as Christ's apostles, the bishops in a contemporary sense, col-
lected believers. The significance of baptism as the act by which this
collection was accomplished thus explains the visual analogy in the
window between the scene of storing grain in panel 18 and the scene
of the lowering of Joseph into the well in panel 6, which simulates the
act of baptism by immersion (plates 123 and 125).

In the second scene in the window, men empty sacks of grain into
two masonry structures,[260] apparently illustrating Genesis 41:48, "Jo-
seph gathered all the food produced in Egypt during those years and

stored it in the cities, putting in each the food from the surrounding country" (panel 19, plate 125). Prosper comments on this verse:

> Joseph established granaries throughout all of Egypt, and throughout the entire world Christ the Lord consecrates churches. . . .[261]

Joseph feeding the hungry with grain signifies Christ feeding with his body the souls who starve for the word of God.[262] The *Glossa Ordinaria* partially repeats Prosper's interpretation, and, in a variation on Prosper's idea of granaries quoted from Isidore, the *Glossa* likens Joseph's gathering of the abundance of the crops to the storing up of faith in the granaries of the holy people.[263] It is no accident that the storing of grain uniquely received special emphasis in the Joseph cycle at Chartres. The window was located in the north aisle, in close proximity to the chapter's granary, the Loëns (plate 19).

Liturgical Significance of the Joseph Window at Chartres

The medieval prayer used to bless a granary appealed to that powerful and compassionate God who blessed the granaries of Joseph and who makes the earth rise with the fruit of the harvest to fill with his abundance the granary being blessed:

> All powerful and compassionate God, who blessed the granaries of Joseph, the threshing floor of Gideon, and even, what is greater, make the scattered seed of the earth rise with the fruit of the harvest, we humbly beg you that, just as grain was not lacking to the widow in response to the petition of your servant Elijah, so also may the abundance of your blessing not be lacking to this granary of your servants in response to the entreaties of our humble selves.[264]

The window draws its analogy from the blessing: just as the granaries of Egypt were filled by the providence of God under the leadership of Joseph, so are the granaries of the present church of Chartres filled by the providence of God through the leadership of the bishop. In the window, Egyptians pour huge sacks of golden grain into storage containers. The abundance of golden grain is analogous to the piles of gold coins on the changers' tables.

The Joseph window represents the Old Testament prototype for the bishop's temporal authority. Like Joseph, the bishop anticipates the people's needs, provides for them, teaches them the way to salvation. Joseph's good administration is a precedent for the bishop's administration of the diocese. His brothers, whom he forgives for their sins against him and for whom his wisdom provides sustenance, are metaphors for the canons. As in the windows of Peter and John the Baptist, the combination of a biblical prototype of the bishop of Chartres has

been combined with money changers, apparently to attest to the bishop's control and administration of them, and to suggest his expectation of the coins of offering from their tables. Here in the nave aisle, however, the bishop's care of his flock is emphasized, in a part of the cathedral where the worshipers and pilgrims would see it.

The Window of the Anonymous Apostle

In the northern nave clerestory lancet directly above the Joseph window in the aisle, three men stand behind a changers' table below a huge figure of an apostle (plates 131 and 132). The window has been heavily repaired, and may be a nineteenth-century creation entirely.[265] All the coins on the table are marked with a cross. The changer in the center empties large gold coins out of a money sack onto the table toward the client next to him, who is wearing a red cap and a red-tinged cloak and fingering the cord of his cloak in a gesture reserved to the upper class.[266] He turns to look at the changer and extends his right arm vigorously to hold his hand at the edge of the table, stopping the flow of gold coins from the changer's money bag. Five more coins, paler in color but goldish, lie in a separate pile on the table in front of the client. He apparently either buys or sells gold coins. On the right, a changer bends his head over his work. Another money bag and a large pile of silver coins splay out on the table in front of him. It is not clear from the heavily repaired glass what he is doing. Unlike the scenes in the other windows, no testing or weighing of coins occurs here. The scene lacks the dynamic antithetical composition of the other scenes.

The man wears the typical robe of the apostles in the windows, and is barefoot, but he has no attributes with which to identify him as a particular apostle. It is interesting to note the similar coordination of the aisle and clerestory subject we had seen before with the Lubinus windows, except that in this case the windows both have the same trade represented in them, but are not dedicated to the same personage.

The Lost Window of St. Blaise

The life of another prototype of the episcopal office, the sainted Bishop Blaise, appeared above money changers in Bay 12 of the south transept. In 1791, the local revolutionary government replaced the window with a wall against which was addorsed an altar for the celebration of Reason.[267] The window had contained twenty-five scenes of the story of Bishop Blaise.[268] The lessons read on his feast did not describe all the scenes in the window, which must have been derived from his legends.[269] However, the surviving legends do not entirely explain two of the hagiographic scenes. Pintard provided a sketch of the window armatures (plate 133) and described these two scenes:

Panel 12: A person coming out of a door seems to spill money before a pig; a wolf seems to run away nearby.

Panel 14: A person hits with a stick or sword an idol of gold and an idol of silver which have their hands full of gold and silver coins.[270]

The pig and wolf are part of the legend, but there is no mention in the surviving legends of a person depositing silver before the pig. Nor is there any mention that the idols in the legend were silver and gold and held silver and gold coins in their hands. I have not found these details in any other pictorial cycles of Blaise.[271] The scenes offer a moral about the wrong expenditure of money. In both cases, these coins functioned in the window as analogies to the coins on the changers' tables, which presumably should not be set before pigs or idols. Not by chance, the window was located just inside the south portal, that gave access to the cloister area where the cathedral fairs took place, and where money changers' tables were installed. On the south porch, a pillar relief expresses a similar moral injunction to that of the window: the personification of Greed fondles her money box (plate 134).

Blaise was a popular saint, to whom people appealed for healing, especially for disease of the throat, and for protection of animals. The proliferation of water blessings invoking St. Blaise in the thirteenth-century attests to the institutionalized ceremonies associated with his feast, when people brought gifts to the saint, traditionally bread and candles, and in return received blessing and sprinkling of holy water for themselves and their animals.[272] The window referred to these practices. Adjacent to the large scene of money changers in the bottom of the window, two scenes depicted Blaise with animals, and the bishop blessing a sick man accompanied by a pilgrim.[273] St. Blaise's feast was celebrated at Chartres on February 3,[274] when the bishop of Chartres blessed holy water in the name of the saint.[275] At that moment, the living bishop became a persona of the dead Bishop Blaise, reversing the window's metaphor.

The Ideology of the Images of Money

The piles of gold and silver coins on the changing tables represented wealth beyond the dreams of the peasants and most townsmen.[276] No working man could help but be intimidated by the masses of coins on the table, and by the men who dealt with them. For the upper classes who could identify with such wealth, the message lay clearly on the tables. The real tables were their last important step before entering the Virgin's sanctuary. Standing in front of the tables, they would see what their offering to the Virgin should be.

The windows with scenes of money changers in their bottom registers are dedicated to saints all of whom were types of the episcopal office, specifically the bishop of Chartres. The imagery acclaims episcopal control of the changers and the coins. The changers measure and weigh gold vessels and coins, carefully testing their value. In effect, the bishop is shown to preside over the fair exchange and good quality of the money of Chartres. The imagery implies the stability of the coins and the honest work of the changers overseen by him. The changers in the windows were probably a group of *avoués*, men who crossed over from the town to the cathedral cloister like the one changer mentioned in the inquest of 1195. They probably had tables just outside the south porch, ready to exchange foreign coins for the coins of Chartress.

The windows installed during the episcopacy of Bishop Renaud de Mouçon in the lower story set the tone. The lower-story windows of Joseph and St. Blaise show the changers with saints who exemplify the qualities of a good bishop who tends the spiritual and physical care of his people. The changers appear as a particular, important focus of the bishop's concern; the imagery urges support for the bishop's good work. But it is the two apse money-changer windows that bring the idea inherent in the lower-story changers' windows to a strident statement of power. St. Peter and St. John the Baptist are both important precedents for the episcopal office. The imagery of the St. John window emphasizes the bishop's sacramental prerogatives, and the St. Peter window stresses the bishop's right to judge men's actions which was given to him by Christ. These two prototypes of the bishop's office stand at the entry to the Virgin's sanctuary, guarding her as it were, receiving the approach of the armed knights and kings in the glass images of the choir clerestory. The windows claim episcopal supremacy. Conflicts and tensions between the bishop and the canons and between the bishop and the count in the town are resolved in the bishop's favor in the apse imagery.

Bishop Gauthier presided over the cathedral when the apse windows were installed, around 1226. Soon afterward, he would insist that his vidame confirm his right to the mint and the changers. Examples of other high ecclesiastics' concern for stable coinage best illustrate what motivated the imagery of the changers in the apse. Sometime in the first quarter of the thirteenth century, the count of Nevers, Hervé de Donzy, devalued his coins and the bishop of Auxerre protested. But he and the canons were even more outraged when the next count of Auxerre, Gui de Forez (1226–41), again devalued the coinage of their cathedral town. They appealed to the court of the archbishop of Sens, who judged against the count.[277] Another example is that of the archbishop of Bourges, who was distressed to receive the yearly payment of his pennies of Pentecost from tenants of the lord of Bourbon in devalued coinage. In a characteristic way, he arranged with that lord in 1214 to

demand payment in good coinage: the lord directed his bailiffs and provosts to announce "to his men publicly in all churches of his land"
that payment should be made in the good money of Souvigny.[278] The
bishop of Chartres, like the archbishop of Bourges and the bishop of
Auxerre, wished to receive obligatory payments and pilgrims' offerings
in stable coinage.

In each location where money changers appear in the windows, typological depictions of the bishop emphasize his functions appropriate to
that part of the building. the north aisle window, in proximity to the
granary, glorifies the bishop's good administration. The aisle and nave
windows in public areas of worship extol the bishop's evangelistic role.
The south transept window greets pilgrims entering from the cloister
fairs with the figure of a popular bishop-saint whose blessings were
dispensed by the bishop of Chartres. The apse windows spoke of episcopal superiority—to the canons and to the nobility.

The changers also metaphorically attest to the bishop's excellent character. There was a tradition which saw the work of money
changers as comparable to the weighing of souls. The early Christian
bishop Saint Gregory the Great, commenting on the horned beast of
Revelation in his *Morals on the Book of Job,* urged Christians to weigh
the quality of preachers in their hearts as money changers test the
quality of gold coins. He presented a series of analogies: the Christian
should test a man's intention like a changer tests the metal content of
a coin; he should observe if a man's character matches his pretense
like a changer observes the stamp of a coin, to be sure it is true; he
should test the perfection of the man's deeds, as a changer tests the
coin for full and proper weight.[279] In this way, the images of money
changers were moral allegories, attesting to the fine character of the
bishop whose prototypes stood over them.

The bishops' glorification of the money changers by ordering very
positive depictions of them in the cathedral windows represents a progressive attitude toward commerce and mercantile exchange. There
were divergent schools of thought regarding merchants and commerce
at the time, one a retrenchment of traditional disapproval, and the
other a growing effort to justify commerce.[280] These reactions grew out
of the contradiction between what churchmen read and what they experienced in the street. The progressiveness of the bishops is demonstrable in comparison with concurrent ecclesiastic theories about
usury and just price. By strict definition, anyone who received interest
on a loan was committing the sin of usury.[281] Prohibitions against
usury by the papacy and canon law abounded in the twelfth century.
The Third Lateran Council of 1179 excommunicated manifest usurers.[282] And yet, at Chartres such stern spiritual sanctions did not prevent episcopal glorification of a traditionally usurious trade. The bishops' progressive ideology in the windows is diametrically opposed to

the Oxford Moralized Bible's interpretation of money changers in negative terms.[283]

Related to the problem of usurious gain was the problem of just price. By medieval definition, the just price consisted of the total of material costs of production plus a reasonable wage to maintain craftsmen or merchants in their appropriate station in life.[284] However, in the thirteenth century, the attitudes toward just price diverged in ways similar to those toward usury. Conservative theologians advocated complete enforcement of the "just price" while Romanists and canonists evolved an ethic of free bargaining.[285] It is this later, more progressive notion that the window scenes project by depicting conversational bartering between clients and changers. At the same time that the scenes promote free commerce, they promote generous offering to the church.

Gold was the finest and rarest metal, the surest treasure, the greatest offering. That is the ultimate reason for the unrealistic depiction of piles of gold coins on changers' tables. Gold was the most appropriate offering for the Virgin. Joseph's need for piles of golden grain was analogous to the bishop's need for piles of gold coins to support the Virgin's church. The silver coins of Chartres were the Virgin's coins, a welcome if humble substitute.[286]

EPILOGUE

The Beginning of Artistic Materialism

An image of a medieval fair in a broken cadence of colored light bedazzled the worshiper strolling through the dark, vast cathedral. This unprecedented bazaar announced the birth of art in the service of consumer fetishism. Even as this vision of the cloister fairs in stained glass at Chartres magically elevated them to the realm of eternal glory, it operated to perpetuate the feudal system. The tradesmen and merchants saw their role as supporters of the church displayed forever in the windows. The town workers would continue to be trapped within their workshops. Most of them would continue to be alienated from possessing the desired panoply of goods and services at the cathedral fairs they helped to produce. The beauty of the windows concealed this dreary fact.

It is wrong to see in these images the beginning of middle-class freedom, or the beginning of capitalism, or the arrival of municipal organization. It is therefore equally wrong to see the windows as products of the combined authorship of troubadours, trades, and donors. In this feudal circumstance, in this backwater of economic and social development, where the cathedral bishop and chapter were tightening their grip on power, this is art in the service of clerical ideology. Not a single image would have been permitted in that cathedral without the approval of these powerful men. It is their genius which inspired the innovation of trade windows.

Where urban workers found real political power in other northern French towns at the turn of the century, they were not represented in the cathedral glass. Of course, the idea at Chartres caught hold, and

was later adopted by organized trades in other towns. The trade windows in later Gothic cathedrals represent a change of social circumstance.

Bread, Wine, and Money at Chartres

The persistence of payments in bread and wine in the twelfth and thirteenth centuries at Chartres indicated the agricultural nature of the region, but they were also, especially in the thirteenth century, exceptions to the increasingly common and generally accepted method of payment in coins. The coins represented a new social order, which separated men from their previously direct social engagement in the natural exchange of goods and services. At Chartres, it meant that the peasants were separated more and more from their lords by coin payments to intermediaries who kept accounts. The artisans and merchants in town increasingly specialized their functions, and each function was allotted its own coin worth. The coins reduced all relationships thereby to a common denominator, by which everyone's relative status could be calculated.

There is a big difference in the way the bread, wine, and coins are represented in the windows. Bread is offered to the Virgin, and wine to the altar at mass, in keeping with liturgical practices. The changers, on the other hand, simply work at their tables, negotiating exchanges. They do not appear offering money. Bread and wine were symbols of the old order of life, and of the Christian religion which gave meaning to that life. Bread and wine were the materials of the ritual communion with God. In early Christian communities, they truly were free-will offerings at mass. In thirteenth-century France, these offerings had become obligations and ritual substitutes. Only the clergy had regular, direct contact with God through mystical communion. Coins represented the new order of life, which, in a parallel development, separated people who produce from those who consume.

All three—bread, wine, and money—were important economically, but for different reasons. Bread represented the economic basis of the diocese and the essential food for the peasants' subsistence. Wine was also an important product of the land, but the majority of the vineyards were owned by ecclesiastical and lay lords, and the best wine was their privileged possession. Coins were the essential means whereby the new market economy could function for everyone.

The images of bread, wine, and coins have different kinds of relationships to the religious imagery which accompanies them. The bread scenes appear with religious imagery that invokes feasts where obligatory bread offerings were made and eulogy bread was distributed to the worshipers. Similarly, wine images appear with St. Lubinus, whose fall feast was the date for local wine presentations in cups to the canons. On the other hand, the changers appear beneath biblical models

of the bishop of Chartres, apparently envisioning in art what the bishop sought to establish in reality—control of the monetary supply.

Different levels of meaning according to the medieval system of exegesis, namely, the literal, metaphorical, and anagogical, can be discerned in the religious imagery accompanying the work scenes. These modes of thinking extended themselves selectively to different levels of society according to their literacy or lack of it. The messages of the combined imagery in the windows were adjusted in their emphases according to their placement in locations of primarily public or primarily clerical access. Joseph storing his wheat and providing for his brothers in the aisle had poignant meaning in Beauce to the illiterate peasants whose very existence depended on the wheat harvest. The claim to episcopal supremacy in the choir, on the other hand, was aimed at the canons.

Bakers, Tavern Keepers, and Changers at Chartres

The studies of bakers, tavern keepers, and money changers show that their social circumstances differed and so did their relationship to the cathedral. The bakers in the windows were probably the chapter's dependents in the cloister; the tavern keepers and wine criers were undoubtedly the canons' cloister *avoués,* if not their serfs; the money changers, on the other hand, were probably the count's vassals, whose activities the bishop sought to control. The bakers do not seem to have been in a position to accumulate capital sufficient to donate windows; but the tavern keepers in the cloister probably could have afforded to donate three windows to the cathedral and the money changers in the town could have afforded five windows—especially since the three upper-story changer windows would have been paid for by a different generation than the one that paid for the two lower-story windows. I do not know if they did donate them, and I do not think we can resolve the question in the face of a complete lack of evidence.

We are considering the very first appearance of an entirely new artistic phenomenon, and we cannot assume that the later meaning of this type of imagery was at the basis of its invention. What we do have evidence to substantiate is that local craft products were given over to churches as oblations that became obligatory over time. This practice and its liturgical ritual are enough to explain the imagery of the windows of the trades at Chartres.

The Ideology of the Bishop and Chapter

The window's ecclesiastical patrons did not just want visual models of social behavior. Their changing society mandated representation in a manner that demonstrated the place of the new urban working class in the City of God. The heretofore elite realm of donor imagery was imag-

inatively expanded to include shoemakers, bakers, and the like in order at the same time to compliment and to control them.

The churchmen also wanted glorification and justification of the commercial enterprise of the cloister and the town from which they stood to profit. They found the prototype for their innovative windows in the ancient monuments of a lost, glorious Roman civilization where artisans and merchants were important enough to be memorialized in imagery. It raised in their minds the Roman laws of commerce newly discussed in intellectual circles—laws which allowed for legitimate profit from commercial practice.

The windows project ecclesiastical ideology, not reality. The clerestory imagery in the choir and apse, created after a period when the canons tightened their stranglehold on the powers belonging to the episcopacy, claims the bishop's supremacy over the canons, which we know he did not have. Throughout the cathedral, the windows of the trades claim that the bishops and canons have allied themselves with the trades, and the trades peacefully support the cathedral. The trades represented were probably the *avoués* of the cathedral compound, not the trades of the town that rebelled against the cathedral. This was a political effort to counter temporal power in the town comparable to the king's selective alliance with certain communes to counter competing baronial power. The windows express a progressive economic ideology of free bargaining, when, in fact, the prices of such basic products as bread, wine, and money, were set by lords. The conflict and the economic contradictions were not resolved by the imagery. Eventually, the images prevailed, as their modern, fictional explanation proves. The key to the success of the future capitalist society lay within these images, in their strategic beautification of work. The cathedral's artistically expressed ideologies finally found successful reception in the twentieth century, when von Simson took them for historical fact.

The windows project the ideology of pious offering. The altar was the focal point of offering and a leitmotif of the stained glass in the cathedral. At the altar, obligatory payments of all kinds were presented in the offertory. According to the linguistic usage of medieval oblation, one thought of oneself as "offering" obligatory payments, and one thought of the altar as a payment place, and the patron saint as the recipient. This was an ideology established early in Christian liturgical practice, and it is the ideology of the trade windows.

The whole idea of offering engendered in prayer was that one gave to God what was God's. Even the coin of Chartres, with its cross on one side and its distinctive symbol on the other, came to be a symbol of the Virgin of Chartres—it was her coin. The product of work was due to her. It was given over by the peasants in wheat and wine, and by the artisans and merchants in their products or their money profits. The products of work were given over to the Virgin as firstfruits, tithes, and

all manner of feudal payments. All were handed over to the church out of respect for the Virgin and the saints, and out of fear or love of God and the clergy.

The Economic and Political Basis of Religious Imagery

The central location of bread scenes matches the central importance of bread to the economy of the diocese. The canons' desire to profit from the local commerce in wine motivated their inclusion of wine-crying scenes in the Lubinus window and the elimination of traditional, negative images of drunkenness in the Noah and Prodigal Son windows. But the secondary importance of wine to the economy is reflected in its peripheral location in the cathedral imagery. The prominence of the imagery of coins accords with the primary importance of money exchange. The bishop sought to control the local coinage for economic reasons, and sought to avoid the king's political policy of co-opting local coinage by transforming the coin of Chartres into a symbol of the special realm of the Queen of Heaven.

The invention of trade windows occurred at Chartres and Bourges, towns whose artisans and merchants had no real voice in their own governance.[1] At Chartres and Bourges, feudal oppression of communal organization was successful, undoubtedly because, in both, there were two feudal lords competing with one another.[2] It was for this reason that the first public recognition of trades in art occurred in these towns. For art is controlled by these powers, not by the "subjects" in both the social and artistic sense of the word.

At Chartres, the justification of power and its corollary, economic privilege, underlies the small-scale images of town trades bent in labor beneath enormously enlarged figures of saints in the clerestory windows, and beneath complex pictorial cycles of saints' lives in the lower-story windows. The moral ideal that those who work supported the church was inherent in this setup, and was acted out in life. That the people periodically gave over the product of their work to the church showed their proper subjugation to its leaders. Moments when payment took place were legislated to occur during liturgical feasts orchestrated by the clergy, who caused the people thus to act out their submission. And, in so doing, the people helped to maintain the cathedral's economic dominance. Then, as now, the cathedral loomed over the little town beneath it, the physical demonstration of the enormous authority of the church (plate 151).

The Image of the Heavenly Jerusalem

In the imagination of the clergy, the cathedral of Chartres was a model of the Heavenly Jerusalem on earth. The conception was acted out on Palm Sunday when the cathedral clerics went out in procession from

the cathedral to the ringing of bells, and joined the clergy of other churches in an adjacent graveyard. The procession continued across the river valley to the church of Saint-Chéron outside of town for the gospel reading and blessing of palms which, along with the chants, antiphons, and prayers, recalled the original procession of Christ into Jerusalem. On the clergy's return, it stopped at the Porte Cendreuse and intoned the Response, "Ingrediente Domino in Sanctam Civitatem," before proceeding to the cathedral for high mass.[3]

The Palm Sunday procession repeated in deliberate similitude the route of Christ in Jerusalem, and the subsequent ritual of Palm Sunday in Jerusalem, in which the assembly began on the Mount of Olives and entered the Holy City by the Valley of Cedron. Just as the Mount of Olives is separated from Jerusalem by the Valley of Cedron, so at Chartres the hill of St. Chéron is separated from the cathedral by the valley of the Eure (see map on plate 18). When the clergy of Chartres arrived back from their procession, they entered the inner gate to the cloister which they likened to the entrance to the Holy City. Hence, the cathedral was their contemporary counterpart of the temple of Jerusalem and the center of the Heavenly City.[4] The windows of the trades at Chartres were devised by churchmen to portray the ideal Christian society within this Heavenly Jerusalem.

The Tripartite Vision of Society

Inside the Gothic cathedral, the people of the city of God on earth appeared in the windows according to the medieval image of the tripartite society in which those who work provide for those who fight and pray.[5] The windows reproduce this ideal society current in theological definition. The three traditional classes—the clergy, the warriors, and the workers—appear segregated almost entirely into distinct parts of the cathedral (see plates 2 and 10). The three classes are also differentiated by what they are shown doing. The clergy usually pray, the nobility usually ride to battle. The artisans and merchants are anonymous individuals and groups who work.

The model for this visual classification was available at Chartres in the text of Bishop John of Salisbury's *Policraticus.* He was fascinated by Roman civilization. He speaks of *renovatio,* of returning to a better age. In his famous bodily image of society described in the *Policraticus,* he reinterprets the three orders by setting apart the priesthood as the soul of the body and adding urban labor to that of peasants as the body's feet.[6] The cathedral panorama matches this new literary vision of an urban tripartite order.

Although the cathedral was open to the rich and poor alike, the way one experienced this image of society varied according to one's station in life. The deeply entrenched upper classes' dislike of those who work must have caused their members some discomfort at the widespread

representation of their inferiors, but they would have understood the clerics' strategy. What of the artisans and tradesmen themselves? Each person's response, I would think, depended upon whether or not the viewer had been one of the tradesmen who rioted in the cloister and was beaten before the altar of the Virgin, and whether or not the viewer had been one of the next generation of tradesmen who were taken hostage by the king. It would have depended upon whether the viewer was a tradesmen working in the cloister or not. Time erased the memory of these differences, and the vision of the medieval religion and the devoted tradesmen of the medieval town combined to charm viewers of later centuries.

ABBREVIATIONS

AA SS	*Acta Sanctorum Martii*. Joannis Mabillon, ed. Paris, 67 volumes since 1643.
AMDC	*Archives de la Maison-Dieu de Châteaudun*. Aug. de Belfort, ed. Châteaudun, 1881.
ArchDC	Archives of the Diocese of Chartres.
BHL	*Bibliotheca hagiographica Latina antiquae et mediae aetatis*. Socii Bollandiani, eds. 2 vols. Brussels, 1898–1901; supplement 1901.
CASP	*Cartulaire de l'Abbaye de Saint-Père de Chartres*. M. Guérard, ed. 2 vols. Paris, 1840.
CdO	*Cartulaire de l'église cathédrale Sainte-Croix d'Orléans*. J. Thillier and E. Jarry, eds. Orléans, 1906.
CEH	*The Cambridge Economic History of Europe*. J. H. Clapham, ed. Vol. 2 (1st ed.), Cambridge, 1941. Vol. 3, M. M. Postan et al., eds. Cambridge, 1963.
CLGB	*Cartulaire de la léproserie du Grand-Beaulieu et du prieuré de Notre-Dame de la Bourdinière*. René Merlet and Maurice Jusselin, eds. Chartres, 1909.
CMC	*Cartulaire de l'abbaye de la Madeleine de Châteaudun*. L. Merlet and L. Jarry, eds. Châteaudun, 1896.
CND	*Cartulaire de Notre-Dame de Chartres*. E. de Lépinois and Lucien Merlet, eds. 3 vols. Chartres, 1861–65.
CSJV	*Cartulaire de Saint-Jean-en-Vallée de Chartres*. René Merlet, ed. Vol. 1. Chartres, 1906.
CSTE	*Cartulaires de Saint-Thomas d'Epernon et de Notre-Dame de Maintenon*. Auguste Moutie and Adolphe de Dion, eds. Rambouillet, 1878.
CSTT	*Cartulaire de l'Abbye de la Sainte-Trinité de Tiron*. Lucien Merlet, ed. 2 vols. Chartres, 1883.
CTV	*Cartulaire de l'abbaye cardinale de la Trinité de Vendôme*. Charles Métais, ed. 5 vols. Paris and Vendôme, 1893–1904.

CV *Chartes Vendômoises.* Charles Métais, ed. Vendôme, 1905.

CVR *Corpus vitrearum France—Recensement.* Vols. 1 and 2.
 Paris, 1978 and 1981.

DACL *Dictionnaire d'archéologie chrétienne et de liturgie.* F.
 Cabrol and H. Leclercq, eds. Paris, 1927–53.

Du Cange Du Cange, Charles Du Fresne. *Glossarium mediae et
 infimae latinitatis . . . editio nova. . . .* 10 vols. Niort,
 1883–87.

GalChr *Gallia Christiana.* Vol. 8. Paris, 1744.

GBA *Gazette des Beaux-Arts.* Paris.

JL *Jahrbuch für Liturgiewissenschaft.* Vols. 1–15. Münster,
 1921–35.

Kirschbaum *Lexikon der christlichen Ikonographie.* Engelbert
 Kirschbaum, S.J., et al., eds. 8 vols. Rome, 1968–76.

Mansi *Sacrorum Conciliorum nova et amplissima collectio.*
 Joannes Dominicus Mansi, ed. 53 volumes. Florence and
 Venice, 1758–98; rpt., Graz, 1960.

MCB *Marmoutier-Cartulaire blésois.* Charles Métais, ed.
 Chartres-Blois, 1889–91.

MCD *Cartulaire de Marmoutier pour le Dunois.* Émile Mabille,
 ed. Paris and Châteaudun, 1874.

MGH *Monumenta Germaniae Historica inde ab a. c. 500 usque ad
 a. 1500. Auctores antiquissimi.* Bruno Krusch, ed. Vol. 4, pt.
 2. Berlin, 1885.

MP *Cartulaire de Marmoutier pour le Perche.* A. Barret, ed.
 Mortagne, 1894.

OPS *Obituaires de la Province de Sens.* M. Auguste Molinier and
 M. Auguste Longnon, eds. Vol. 2. Paris, 1906.

OrdRf *Ordonnances des Rois de France de la troisième race
 recueillies par ordre chronologique.* 23 vols. Paris, 1723–
 1849.

PA *Catalogue des Actes de Philippe-Auguste.* L. Délisle, ed.
 Paris, 1856.

PG *Patrologiae cursus completus . . . Series Graeca.* Jacques Paul
 Migne, ed. Paris, 1844–64.

PL *Patrologiae cursus completus . . . Series Latina.* Jacques Paul
 Migne, ed. Paris, 1856–67.

RAC *Reallexikon für Antike und Christentum.* T. Klauser et al.,
 eds. Stuttgart, 1950.

RAPA *Recueil des Actes de Philippe Auguste roi de France.*
 Published under the direction of Elie Berger, H.-François
 Delaborde, ed. 4 vols. Paris, 1916–79.

RDK *Reallexikon zur deutschen Kunstgeschichte.* Otto Schmidt
 et al., eds. Stuttgart, 1937.

RHE	*Revue d'Histoire Ecclésiastique.* Louvain.
RN	*Revue Numismatique.* Paris.
SAELB	*Société archéologique d'Eure-et-Loir, Bulletin.* Chartres.
SAELM	*Société archéologique d'Eure-et-Loir, Mémoires.* Chartres.
SAELPV	*Société archéologique d'Eure-et-Loir, Procès Verbaux.* Chartres.
SDN	*Saint-Denis de Nogent-le-Rotrou (1031–1789); histoire et cartulaire.* Vte. de Souance and Charles Métais, eds. Vannes, 1895.
SHLSCM	*Société historique, littéraire et scientifique du Cher, Mémoires.* Bourges.
SMJ	*Cartulaire de Notre-Dame de Josaphat.* Charles Métais, ed. 2 vols. Chartres, 1911–12.
TEL	*Les Templiers en Eure-et-Loir. Histoire et Cartulaire.* Charles Métais, ed. Chartres, 1902.
Wartburg	Wartburg, Walther von. *Französisches etymologisches Wörterbuch; eine Darstellung des galloromanischen Sprachschatzes.* 21 volumes and supplement. Bonn, 1928–69.

NOTES

Introduction

1. Cecil Headlam, *The Story of Chartres*, London, 1902. Headlam published his book one year after the death of Queen Victoria. It was a romantic description of Chartres Cathedral, intended for tourists of the Victorian era.

2. French churches with extant thirteenth-century windows of the trades:

Church	Estimated date of installation	Source of date	No. of windows
Chartres	from ca. 1205	*CVR* I, 27–44	42
Bourges	from ca. 1210	*CVR* I, 170–74	11
Saint Quentin	from ca. 1220	*CVR* II, 167	2
Le Mans	from ca. 1235	*CVR* I, 246	6
Amiens	after 1220	Stoddard, 1972, 211	2
Rouen	after 1220	Perrot, 1972, 14	3
Beauvais	ca. 1240	*CVR* II, 178	1
Tours	ca. 1255	Papanicolaou, 1981, 179	1
Saint-Julien-du-Sault	ca. 1250	Lafond, 1959, 359	1

Many of these dates are unsure and debated. The dating of the windows at Chartres is discussed in Chapter 2 of this book.

3. This is my own count. For a listing of the trade windows, see Aclocque, 1917, 313–26. Her list does not include lost windows of St. Blaise and St. Lawrence known from old window-descriptions. She incorrectly identified the men working in the bottom register of the window of St. Anthony as basket sellers. They are selling fish.

4. There are 19 surviving clerestory trade windows and 23 lower-story trade windows at Chartres. Two other windows in the lower story, now lost, also contained images of tradesmen. Delaporte and Houvet, 1926 (hereafter Delaporte, 1926), vol. 1, 7, 207–10, 377–80.

Chapter One

1. "... des tableaux sur lesquels sont figurées les corporations des arts et métiers qui ont contribué, soit par leurs cotisations ou par des travaux manuels, à la construction de ce superbe édifice." Gilbert, 1824, 62.

2. Ibid., 62.

3. This summary is based on the following literature:

1681	Anquetin (quoted in Delaporte, 1926, 37, 38)
18th c.	Pintard (quoted in Delaporte, 1926, 38)
1850	Bulteau, 18–21, 184–268
1857	Lasteyrie, F., 70
1881	Lassus and Durand, vol. 2, 155, 159, 162
1887–92	Bulteau, vol. 1, 97–108, 118–27; vol. 3, 204–302
1888	Mély, 413–29
1896	Ottin, 145
1902	Headlam, 165
1904	Adams (1925 edition, 149–78)
1917	Aclocque, 313–26
1926	Lasteyrie, R., 54, 55
1926	Delaporte, passim
1931	Westlake, 54, 55
1937	Connick, 6
1937	Aubert, 7
1962	Elsen, 66
1963	Grodecki, 44–46, 173, 181
1964	Villette, 103
1968	Witzleben, 35
1969	Branner, 81
1969	Swaan, 122
1969	Brooke, 16
1970	Popesco, 17
1970	Frodl-Kraft, 114
1973	DuColombier, 16
1973	Chédeville, 453, 454
1976	Seddon, 75
1979	Villette, 123
1979	Warnke, 35–39, 55–57, 71
1981	Grodecki, Perrot et al., 27–42
1984	Grodecki and Brisac, 61, 67
1985	Kimpel and Suckale, 236–40
1987	Lévis-Godechot, 111–12

4. Bulteau, 1887, vol. 1, 99. Souchet believed the cathedral to have been Fulbert's. Souchet, 1868, vol. 2, 216ff. Also Gilbert, 1928, 8–9.

5. Bulteau, 1850, 16–20.

6. Bulteau, 1887, vol. 1, 99–103.

7. Ibid., 196–267. There was already an established tradition for the description of the scenes in the work of Anquetin, Pintard, Gilbert, and many others. See Bulteau's bibliography at the end of volume 3, 1892, xxvii–xxix.

8. Bulteau, 1887–92. Bulteau actually died before he completed the third volume, which was published posthumously by Abbé Brou. Mâle, 1983 (first

published in 1917), 5. The third volume includes descriptions of the windows, which are almost verbatim copies of the descriptions Bulteau published in 1850.

9. Aclocque, 1967 (first published in Paris in 1917), Appendix 3, 313–26.

10. Aclocque claimed that the shoemakers and weavers were already professional corporations in the twelfth century, but there is no evidence in her book to support this contention. Ibid., 13. She stated as certainty that the linen weavers formed the confraternity of St. Vincent, on the basis of the inscription in the window of Sts. Theodore and Vincent, Bay 39. However, as Delaporte remarked, there is no evidence to prove the confraternity mentioned in the inscription contained weavers, except for the representation of a weaver to the right of the inscription. Delaporte and Houvet, 1926, 320–21. Before Aclocque, the nineteenth-century scholar Adolph Lecocq searched ten years for trade statutes of medieval Chartres in libraries and archives in Chartres and Paris, finally stating that his earliest evidence was dated 1407. *SALEMPV*, 1868, 208–9.

11. Delaporte, 1926.

12. Ibid., 515.

13. Ibid., 320. Alexandre Pintard is credited with writing a manuscript entitled "Explication des Histoires peintes dans les vitrages de l'Eglise Nostre-Dame," which contained a description of the cathedral windows' content and diagrams of the armatures of each window. Ibid., 38ff. Delaporte published Pintard's diagrams and descriptions of windows, which had since disappeared, and referred to Pintard's work whenever the windows he saw were in any way different from what Pintard had seen. This is important evidence, since Pintard's original manuscript burned in the 1944 fire at the Municipal Library of Chartres. On surviving copies, all in very bad condition, see van der Meulen, 1989, #309, 131–32.

14. Von Simson, "The Palace of the Virgin," 1964, 159–82. Von Simson's book, first published in 1956, appeared in a revised edition in 1962, and a paperback edition in 1964.

15. Ibid., notes 8, 17, 22, 25, 27, 40, 50, 61, 62, 64, 65, 72.

16. Ibid., 177. Henderson and Seddon elaborated upon von Simson's claims about the economic importance of the trades signified by the windows. Henderson, 1968, 69, 72, 73; Seddon, 1976, 41.

17. Jan van der Meulen, 1974, 5–45.

18. This is a leitmotif of van der Meulen's work on Chartres. See especially van der Meulen, 1975, 509–60.

19. Chédeville, 1973. The list of primary sources in his book is important, not just as a record, but also as it indicates the large quantity of source material available for the study of Chartres and its region. Ibid., 8–25. In three major sections of the third part of his book, "Les fonctions économiques," "La bourgeoisie et les institutions urbaines," and "Le prestige de Chartres," Chédeville dramatically altered our understanding of the economic situation of Chartres in general and the trades in particular. He noted that exchange in coinage had become the general rule by the early twelfth century. Fulling mills in the later twelfth century signaled the growth of the town artisanate. Ibid., 431–525.

20. Ibid., 457. According to Chédeville, only the wool trade is known to have exported its products. It rarely appeared in distant markets, and when it did, was placed for sale in company with poorer-quality fabrics. Ibid., 448–49.

21. Ibid., 453, 454.

22. Warnke, 1976.

23. Ibid., 42–45.

24. Only Jean Favier has given a more accurate historical account in his summary of the long delay in municipal organization at Chartres. Jean Favier, John James, and Yves Flamand, *L'Univers de Chartres*, 1988, 21–22. Louis Grodecki and Catherine Brisac concern themselves primarily with style, but cite trades as window donors in the descriptions of plates 50 and 58, in *Le vitrail gothique au XIIIe siècle*, 1984. Dieter Kimpel and Robert Suckale base their comments on von Simson, whom they cite, in *Die gotische Architektur in Frankreich*, 1985. I only know of one art historian who has taken Chédeville's work on Chartres into account in his own published work: André Mussat, "Les cathédrales dans leurs cités," 1982, 9–19. Other new books with traditional treatment of the trade windows: *Les vitraux du centre et des pays de la Loire*, 1981, 25–56; Alain Erlande-Brandenburg, *Chartres*, 1986; Jean-Paul Deremble and Colette Manhes, *Les vitraux légendaires de Chartres. Des récits en images*, 1988. Deremble-Manhes cited Chédeville in her thesis, 1989, 596–633.

25. John James, *Chartres: les constructeurs*, 2 vols., Chartres, 1979–81.

26. Wolfgang Kemp, *Sermo Corporeus, Die Erzählung der mittelalterlichen Glasfenster*, Munich, 1987.

27. Nor did his later acknowledgment of the work of Chédeville and myself alter his insistence on the idea of trade-guild donation of the windows. Kemp, 1989.

28. Delaporte, 1963, 50; Delaporte, 1923, 210, 212. Similar statements can be found in the literature on Chartres which show that this notion has been carried forward uncritically:

 1913 Mâle, 154
 1947 Aubert, 7
 1948 Evans, 106
 1973 DuColombier, 16
 1976 Seddon, 40

29. For example, see the right shoemaker on Pier 6 of Piacenza Cathedral, or the figure of Music in the Swabian manuscript Cod. Poet. et philol. fol. 33, Blatt 29r. The exaggerated curve of the arms to symbolize physical effort had a long history which artists continued to use, whether consciously or not, in nineteenth-century art. See Caillebote's "Floor Scrapers." I am grateful to Philip Armstrong for making me aware of this painting.

30. There are similar repetitions of the depictions of butchers, masons, coopers, weavers, clothiers, bootmakers, leather dressers, shoemakers, porters, changers, and water carriers.

31. For example, the same scene of a wheelwright which repeats at Chartres in Bays 45 and 64 reappears in the Joseph window at Bourges. Copybooks from the Middle Ages survive and have been published. See Scheller, 1963.

32. Duby, 1978.

33. For example, a prototype for the unusual scene of carpenters debarking logs in the window of St. Julien at Chartres, Bay 45, can be found in an illustrated life St. Ludgerus, Berlin: Lib. Staatsbibl., Theol. lat. fol. 17r.

34. Compare, for example, the butcher slaying a calf in Bay 122 at Chartres, and the similar stone images of November in the labors of the month on the

west front at Chartres Cathedral and on the portal of St. Ursin at Bourges. See Webster, 1938 and, more recently, Mane, 1983.

35. On the trade imagery in the nave arcade pier reliefs of Piacenza Cathedral, see Cochetti Pratesi, 1975; on the Spanish reliefs of moneyers at Santiago de Carrión de los Condes, see Mariño, 1986, vol. 1, 499–513.

36. Compare, for example, the carved profile figure of a shoemaker in his shop on a late Roman gravestone now in Sens (Esperandieu, vol. 4, #2783) with the shoemaker in the center of the bottom register of Bay 7 at Chartres.

37. In some windows the medallions are painted, not formed by armatures. Where this is the case, figures appear to extend slightly beyond the painted frame, and sometimes appear to be standing upon it. This is true of the smiths in Bay 59, and the furriers in Bay 168. In other instances, the figures are cut off by the frame of a medallion as if a view through a window was intended. This can be seen in Bay 34, in the right medallion of the bakers at work. The man on the upper left side is cut off by the frame as if he extended behind it. In the same scene, the baker on the right extends in front of the medallion frame. This same treatment can be seen in the picture of a wheelwright and cooper in Bay 45, where the wheel extends in front of the edge of the medallion on the left, but the barrel on the right is cut off by the right edge of the medallion. Figures are depicted on one plane, but that plane is shifted in space from inside to outside of the medallion frame. By using this compositional device, the artist avoided manipulating the figures to fit into the shapes of the medallions and gave the scenes an impression of narrative realism.

38. Here is a list of the different types of organizations scholars have thought that the trades at Chartres formed when the windows were made:

1824	Gilbert	corporations	p. 62
1842	Thibaud	corporations	p. 63
1857	Lasteyrie	corps de métiers	p. 84
1887	Bulteau	corporations	p. 126
1888	Mely	corporations	p. 414
1896	Ottin	corps de métiers	p. 145
1913	Mâle	guilds and confraternities	p. 324
1926	Delaporte	corps de métiers	p. 7
1928	Gaudin	confraternities	p. 21
1938	Clemen	religious and lay corporations	p. xxxv
1940	Lefrançois-Pillon	corporations	p. 118
1962	Elsen	confraternities	p. 66
1964	Villette	religious confraternities	p. 103
1964	von Simpson	guilds	p. 167
1968	Henderson	religious brotherhoods	p. 72
1969	Swaan	corporations	p. 122
1969	Branner	guilds	p. 75
1973	DuColombier	confraternities	p. 16
1976	Seddon	guilds	p. 75
1981	Thibault	corps de métiers	p. 10
1983	Chédeville	corps de métiers	p. 119
1987	Kemp	korporationen	p. 212

39. Reinhold Kaiser has recently commented on the surge of new interest in the medieval associations of merchants and artisans into guilds. He wrote a

useful synthesis of the long and many-sided debate about their nature and origins in an article ostensibly written to review one of the new publications on the subject, *Gilden und Zünfte. Kaufmänische und gewerbliche Genossenschaften im frühen und hohen Mittelalter*, Thorbecke, 1985. Kaiser comments on the lack of French evidence in the current discussions. Kaiser, 1986, 591. See also Oexle, 1982. My own position on the nature of the origin of trade organization results from my reading of the local documents in France, which I believe verify Eberstadt's *magistériale* theory. Eberstadt, 1897.

40. Chédeville, 1973, 80, 446–80. He surveyed the documentary evidence for ateliers and artisans, and concluded that, with the exception of the wool trade after 1268, all the trades remained under the control of the count's provost, to whom the individual members of trades paid taxes in kind or coin. Chédeville, 1973, 453. He also surveyed the evidence for the operation of shops and stalls, and noted the increasing importance of town fairs all over the diocese, which attests to the growing focus of commercial activity at diverse secondary urban centers. He described the growing use of coinage and credit facilitated by religious establishments on the one hand, and Jews, changers, and usurers on the other.

41. Kaiser, 1981, 406–22. Because he read extensively concerning the demarcations and qualities of clerical and secular power in France, his judgment about the situation at Chartres carries weight. He found treatment of the northern French evidence in the collection *Gilden und Zunfte* lacking, but suggested that the situations in episcopal towns along the Rhine described therein were analogous to those of Chartres and other French towns. Both regions were, he believes, similarly unified economically and socially, and both were examples of the appropriateness of the *magistériale* theories of Eberstadt, that the artisan organizations in strongly feudal social structures had their origins in lords' institutions of trade masters, and grew diversely. Kaiser, 1986, 585–92.

42. *CLGB* #6, 3. See also Chédeville, 1973, 453, and Aclocque, 1967, 86. In 1189, Count Thibaut V added 100 more sous to the furrier's payment to the leprosarium. Arch. Nat. K 177, No. 8. Wolfgang Kemp, in denouncing my doctoral dissertation, used this document to argue that the trades had been free at Chartres for a long time, and said I did not know of this 1131 ruling, although I did publish it in my 1987 doctoral dissertation, where I argued that it proved that the trades were not free at Chartres in the twelfth century.

43. *CLGB* #24, 12.

44. Lépinois, 106, 516.

45. Métais, 1911–12, #1.

46. *CND* II, #295, 142–43.

47. Lépinois, 379–81 and 381, note 1; Aclocque, 328, note 3.

48. Aclocque, 1917, Piéces Justificatives II and III, 327–36 (from Paris, Bib. Nat. MS fr. 5382).

49. "Ne ne pevent, ne ne doivent li laneeur, li arçonneur, li tessier toillir deniers fors a leur frairies moties. Et il doit estre par reison acoillir la fraieure aus laneeurs.I.des parereurs, par le commandement dou mestre, e acoillir celle aus tessiers et aus arçonneurs .II. bourgois de la riviere." Quoted in Aclocque, 1917, 331 (from Bib. Nat. MS fr. 5382., of which it is a faithful copy, so far as I could tell on personal inspection). I believe the proper translation would

be: "And the wool-readiers, the carders, and the weavers, must not and cannot take deniers except to their own confraternities. And it must be with reason that the wool readiers' confraternity welcomes one of the finishers, by the order of the master, and that of the weavers and the carders, welcomes two *bourgeois de la rivière.*" (The *bourgeois de la rivière* were the combined woolworking trades, named for their location at Chartres along the banks of the Eure River.)

50. The following historians and art historians have assumed that the images of work in the lowest register of the trade windows commemorate window donation:

1681	Anquetin, 32 (in Delaporte and Houvet, 1926, 37–38)
17th c.	Pintard (in Delaporte, 1926, 38)
1857	Lasteyrie, F., 70ff.
1881	Lassus and Durand, vol. 2, 155, 159, 162
1887	Bulteau, 245
1896	Ottin, 145
1902	Headlam, 165
1913	Mâle, 64 (1972 ed.)
1917	Aclocque, 314ff.
1926	Delaporte, 6
1926	Lasteyrie, R., vol. 2, 174
1931	Westlake, 54, 55
1937	Connick, 6
1947	Aubert, 7
1962	Elsen, 66
1964	Villette, 103
1968	Witzleben, 35
1969	Branner, 81
1969	Swaan, 122
1969	Brooke, 16
1970	Popesco, 17
1970	Frodl-Kraft, 114
1973	DuColombier, 16
1976	Seddon, 75
1976	Lützeler, 155, 156
1984	Grodecki and Brisac, 61, 70
1987	Lévis-Godechot, 320
1988	Favier, 22

51. Delaporte 1926, 6–7. Delaporte asserts that there is no documentation of the donation of any of the windows at Chartres. Ibid., 8, and 484, note 5. However, the published necrology of Chartres lists the anniversary of Robert of Berou with an addition in parentheses "(Ille etiam dedit fenestram vitream in choro circa stallum cancellarii, in qua ipse depictus conspicitur)." *CND* III, 52. This is apparently a seventeenth-century addition, as it is noted with a 9, the key number for entries taken from a seventeenth-century compilation.

52. The window of the Infancy of Christ, Bay 1 at Saint-Denis. See Merson, 1895, 26; Grodecki, 1976, 81–92; *CVR* I, 109.

53. Abbot Suger recorded his own work in increasing the income of the abbey of Saint-Denis, collecting funds for rebuilding the abbey church, and di-

recting that effort, most importantly for the stained glass, in *Liber de rebus in administratione sua gestis*, trans. Panofsky, 1979, 144ff. (first published in 1946).

54. Bay 17, Signs of the Zodiac window, contains the inscription: COMES : TEOBALD DAT HO AD : PRECES : COMITIS TICEENSIS. According to Delaporte, the inscription indicates a donation was made by a Count Thibaut in memory of another count. Further evidence suggests that the window recalls the donation of a vineyard. Delaporte, 1926, 228–30.

Bay 53, St. Nicholas window, contains the inscription: STEPH CARDINALIS : DEDIT : ACVTREA. Delaporte translated this: "Stephanus Cardinalis dedit hanc vitream." Ibid., 367.

Bay 160, agricultural workers in a nave clerestory oculus appear accompanied by the inscription: NOVIGE / MEI DAT HAC VITREA. One cannot be sure which of the several local place names beginning with Nogent might have been intended. Ibid., 508.

Bay 157, Virgin and Child in a nave clerestory oculus accompanied by the inscription: VIRI : TURONV DED ERVT : HAS III. Bulteau translated this: "des hommes de Tours ont donné ces trois verrières." Bulteau, 1887, vol. 3, 223. See also Delaporte, 1926, 506.

55. Bay 39, Sts. Theodore and Vincent window contains a long inscription which Delaporte transcribed: (first line) TERA : A : CES / T : AVTE / L : TES : LES : MES : / / SES : QEN : CHARE : S / ONT : ACOILLI : EN : TON (second line) ERET : CE / STE : VE / RRIECENT : CIL : Q / VI : DOLI :CONFRE / RE : SAINT: VIN. Delaporte translated this inscription as follows: "Les confrères de Saint-Vincent, ceux qui donnerent cette verrière, sont accueillis en toutes les messes qu'on chantera à cet autel." Ibid., 321. On this inscription, see also Guy Villette, *La voix de Notre-Dame*, February 1958, 23–28.

56. Bay 6, window of the Good Samaritan, Delaporte, 1926, 168–70, plates XVIII–XXI; Bay 41, window of St. Stephen, Delaporte, 1926, 331–37, plates CXIX–CXXII. A similar motif of one individual holding up a window model while kneeling appeared in a lost window in Bay 124. See the reproduction of Gaignière's drawing in Delaporte, 1926, fig. 62, and pages 472–73.

57. The inscription on Bay 6 reads: SVTORES O. Delaporte believed that the O must have been an abbreviation of OBTVLERVNT. Ibid., 168.

58. A master of shoemakers is mentioned in a local document from 1210. See Chédeville, 1973, 452, and *Cartulaire de l'Eau*, no. 1.

59. The standard early work on the patron saints of French trades is that of Martin Cahier, *Caractéristiques des saints dans l'art populaire*, Paris, 1867.

60. Aclocque's documentary evidence of trade patron saints at Chartres begins in the fifteenth century. Prior to that, her only evidence is the inscription in the window of Sts. Theodore and Vincent, discussed above, which is a composite of scraps from at least two and probably three separate windows. Aclocque, 1917, 54–73. Mâle thought that the grocers gave the window of St. Nicholas, their patron saint, to the cathedral. Mâle, [1913] 1963, 323. Delaporte noted that grocers venerated St. Nicholas as patron saint in the eighteenth century, but he found no evidence that the grocers of Chartres ever venerated St. Nicholas. Delaporte, 1926, 392, and no. 2. Further, it is not clear that the tradesmen depicted in the window can properly be called grocers; they more likely are apothecaries, as Delaporte thought.

61. Delaporte, 26, 420, and plate 187.

62. Delaporte, 1926, 409, and plate CLXXIX. In this instance, he was following Mâle's observation. Mâle, 1913, 323. Later writers have also observed this analogy in the Noah window. Seddon, 1976, 75; Popesco, 1970, 56. Delaporte found similar analogies in the window of St. Sylvester, Bay 30; the window of St. Julien the Hospitaller, Bay 45; the window of St. Eustace, Bay 62; the window of St. Mary Magdalene, Bay 5; the window of St. Lubinus, Bay 63. Delaporte also thought that the same reasoning caused the juxtaposition of saint with a particular trade, even if the motivating incident or activity in the saint's life was not illustrated in the window. For example, he thought that tavern keepers donated the window of St. Lawrence, Bay 57, because as deacon St. Lawrence served wine at mass. (This was evidently not represented in the window, which is now lost and known only from an early eighteenth-century description.) Delaporte postulated similar rationales for the window of St. Martin, Bay 24; the window of Charlemagne, Bay 38; the window of St. John the Evangelist, Bay 4.

63. Mâle thought the windows demonstrated the medieval doctrine that by work man collaborates in his own redemption. Mâle, 1913, 154. Grodecki carried Mâle's idea further by commenting that due to the joining together of work scenes and sacred scenes, the workers were represented "resembling saints in paradise." Grodecki, 1958, 53.

64. See review of the documents in van der Meulen, 1976, 153–54, and James, 1982, 51–64. Further discussion of the date of this important work ensues.

65. See Delaporte, 1926, 8–10, 131–41. These are the dates he assigned: nave and aisle, 1200–1215; choir clerestory, 1215–20; ambulatory and apse chapels, 1215–35; upper story of transepts, 1230–35.

66. This disagreement as to the building's construction history can be followed in these works listed in the bibliography: Delaporte, 1959; Frankl, 1957, 1961, 1963; Grodecki, 1949, 1951, 1958; Van der Meulen, 1965, 1967.

67. Van der Meulen, 1967, 152–70. Van der Meulen argued that the only terminus to be established from knowledge of a particular donor is the approximate terminus post quem, or date after which it would be reasonable to suppose that the person depicted was influential enough to have either donated the window or to have been honored by a portrayal. His most successful demonstration is his analysis of information about individual donors, which shows a sequence that would jump erratically from one part of the building to another if it were read in a chronological manner. Moreover, some windows are known to have been moved. Hence neither donor identity nor relative building chronology can be used to securely date windows.

68. James, 1977; English ed. 1981. He illustrated his theory with hypothetical drawings of the yearly progress in construction of the building.

69. Lautier, 1990, 40–42.

70. James, 1981, vol. 1, 10.

71. On the dates when templates for the windows could have been made, ibid., vol. 2, 496–97.

72. On the vaulting of the aisles, ibid., vol. 1, 276–77; on the vaulting of the ambulatory and its chapels, ibid., 282–85.

73. On the nave vault, ibid., vol. 2, 520–21; choir and apse vault, ibid., 526–27.

74. *CVR* II, 1981, 25–45.

75. Van der Meulen reviewed James's work in *The Catholic Historical Review* of 1984, 83–89. He also annotated its entry in his bibliography on Chartres, 1989, 671–73.

76. It was almost unprecedented for the prestigious Société archéologique d'Eure-et-Loir to publish a foreigner's study of the cathedral. Jean Villette has referred to James as an authority in subsequent articles, most importantly in his article of 1988 discussed below.

77. Deremble-Manhes, September 1988, 11–16, and Villette, 1988, 4–10. See also Deremble-Manhes on the early date of the window of St. Margaret in the same journal, December 1988.

78. Compare Villette, 1988, 9 and 10, with James, 1981, 496–97.

79. Deremble-Manhes, September 1988, 11–16.

80. Spiegel dated the *Gesta* additions of Le Breton to 1215–20 and the *Phillipidos* to 1218/1220–26. Spiegel, 1978, 63–68. She had studied the chronicle tradition of St. Denis.

81. Baldwin, 1986, 397, regarding the *Gesta Philippi* additions of Le Breton.

82. Of course, windows have been added and changed over time. For example, these windows were probably added around 1250: Bay 88, Delaporte, 1926, 427; Bay 35, ibid., 301–2. See also Meredith Lillich's dating of the addition of thirteenth-century grisaille windows. Lillich, 1972, 1152–59.

83. On Bishop Renaud de Mouçon and Bishop Gauthier, see *Gallia Christiana*, vol. 8, cols. 1152–59.

Chapter Two

1. "Le décor sculpté, les vitraux traduisent une idéologie dominante qui n'est pas que religieuse mais nous informent aussi des accents particuliers qui lui sont donnés, écos indirects de rapports sociaux et des tensions qu'on y peut déceler." Mussat, 1982, 9.

2. These are the best known but not the only histories of Chartres:

Rouillard	1609 (exists only in manuscript form)
Sablon	1671 (republished in the seventeenth, eighteenth, and nineteenth centuries)
Pintard	1708 (exists only in manuscript form—author died in 1708)
Challine	1918 (posthumous—Challine died in 1678)
Chévard	1800–1802
Doyen	1786
Ozeray	1834–36
Lépinois	1854–58
Bulteau	1887
Souchet	1867–76 (posthumous—Souchet died in 1654)
Headlam	1922
Delaporte	1951
Chédeville	1973

Jan van der Meulen's critical bibliography published in 1989 contains a comprehensive bibliography on the history of Chartres up to 1260. Van der Meulen, 1989, 402–37. He had previously published a bibliography on the pre-Gothic cathedral of Chartres in 1976 in *Mediaevalia*, vol. 2, 223–84. Reinhold Kaiser's major new work on the bishop's power in French towns cogently reviews and

reinterprets much of the previous historical work on Chartres. Kaiser, 1981, 406–22.

3. See especially von Simson, 1964, 167, 178; and Henderson, 1968, 69–73.

4. Chédeville, 1973, 268; Lépinois, [1854] 1976, 175–180; Souchet, 1869, vol. 3, 125–46.

5. This extended to the smallest matters between the lesser clergy. For example, when the bishop ruled in 1180 that the head sacristan had the right to the presentations received by a priest outside the choir and in the crypt, we suspect that this right had been challenged. *CND* I, #97, 1180–83, 205–6.

6. *CND* I, #96, 1181–83, 203–5.

7. *CND* II, #246, 1224, 103. The bishop was also involved in disputes with his officers over rights: for example, with his archdeacons, *CND* II, #244, 1223, 101–2; and with his vidame, *CND* II, #327, 1258, 167–68.

8. "We strictly prohibit by this document anyone presuming to diminish or disturb the rights of the archdeaneries . . . or alienate other things or the churches or the presentations of them . . ." *CND* I, #129, 1195, 249–50.

9. *CND* II, #237, 1221, 95–96.

10. *CND* I, #124, 1195, 245–46.

11. The customs would be valid if recalled by a majority of canons or even by the unchallenged testimony of three or four canons. *CND* I, #125, 1195, 246.

12. The customs were issued by the dean of the chapter of Sens between 1191 and 1200. *CND* II, #144, ca. 1200, 3–6; and with slight variation, *GalChr* XIII, #73, 1191, cols. 344–346.

13. *CND* II, #144, 4.

14. Ibid., 6.

15. Papal documents supporting the chapter's claims to rights and privileges in the twelfth and early thirteenth centuries, six of them dating to 1195:

Pope confirms rights of chapter

CND I	#47	pp. 139–41	1133
	67	168	1160
	86	188–90	1171
	99	208–9	1183
	100	209	1183
	124	245–46	1195
	125	246	1195

Pope supports extension of rights and protection of status

CND I	#105	pp. 213–14	1186
	126	246–47	1195
	127	247–48	1195
	128	248–49	1195
	129	249–50	1195
II	277	126–27	1233

16. *CND* I, cxiv–cxx. On the episcopal powers of the chapter, which included the rights to procuration at parishes normally a bishop's prerogative,

see Amiet, 1923. The bishop, however, continued to use his right to excommunicate and interdict against his enemies. *CND* I, cxxvj, and note 7, 209, 246, 247; *CND* II, 126, 127, 203, 226.

17. *CND* I, lxvj. This oath confirms Kaiser's analysis of the bishop's position at Chartres. Kaiser, 1981, 422.

18. Ibid. Unfortunately, I have not found the text of any of these oaths. The bishop also swore an oath to his metropolitan, the archbishop of Sens. Lot and Fawtier, 1962, vol. 3, 163. Amiet, 1923, 213–14.

19. *CND* II, 280–283, of the *Polypticon* of 1300. On the other hand, the bishop nominated the canons and the chapter dignitaries to their offices and the chapter passed on his nominations. One can see that a system of checks and balances had developed between the cathedral personnel. Part of this oath probably was written shortly after Bishop Renaud's death, since it refers to his fond memory and to the elimination of the four provostships which occurred before the fire of 1194.

20. *CND* II, 283.

21. The chapter was supposed to invite the count's bailiff and provost to come to hear this oath taken in the canons' meeting chamber. Ibid.

22. *CND* II, #313, 1254, 54–156. On the manumission of the chapter's serfs, see *CND* I, clxxj. The chapter also required its mayors to make an oath in the chapter every other year. Ibid., xcix, note 5. On the oath of the chapter provost to the chapter (ca. 1070), the oath of the lord of Gallardon to the chapter (ca. 1100), and the oath of the canons to Gervais, lord of Chateauneuf-en-Thimerais (ca. 1121), see Merlet and Clerval, 1893, 187–98.

23. The entire oath is printed in Souchet, vol. I, 1866, 547–50. The oath was taken before the dean of the chapter, or a substitute presiding dignitary, and in the presence of the relics of saints. Ibid., 547. Lecocq said the oath was taken "entre ses mains," presumably by the serf placing his hands between the hands of the dean. Therefore, both homage and fealty were enacted by the serf, who then became a vassal of the dean and chapter. This raises the question of the personal status of the chapter's *avoués*, which seems, from the scant evidence concerning them, to have been servile. On the acts necessary to consummate a contract of vassalage, see Jacques le Goff, 1980, 237–88.

24. *CND*, 1232, #275, 124–25. The canons had long sought to guard their local prerogatives. In 1190, Pope Clement III on their behalf prohibited other religious communities from establishing a chapel in the town or its suburbs without prior consent of the chapter. Lépinois [1854] 1976, 119.

25. *CND* II, #272, 1231, 122–23.

26. *CND* I, cxxviij.

27. Chédeville came to this conclusion. Chédeville, 1973, 495, 493–504.

28. On the establishment of the counts of Chartres, see Werner, 1980, 265–72; Chédeville, 1973, 252; Boussard, 1962, 308–10; Cartier, *RN* 10, 1845, 27–29.

29. The document, called the *Vieille Chronique*, dated to 1389, is published in *CND* I, 1–66.

30. Kaiser, 1981, 420–22. For a plan of the town, see Chédeville, 1973, 421. The bishop and count shared the *menues coutumes* in the town. *CND* I, lxiv–lxv. The bishop's receipts from these taxes, recorded in 1280, appear in the *Cartulaire*. *CND* II, 211–18. The bishop originally had the *comitatus* before the count was set up as the secular lord. See review of the literature on this

subject in Kaiser, 1981, 413–15. According to the *Vielle Chronique* (1389), the bishop originally had the *comitatus* in the town but gave half of his city rights as landlord to the count when he appointed him. The whole idea of the division of power described in this document is questionable. *CND* I, vij, and 1–66. It was written long after the historical events it recounts and clearly was wrong about many; for example, the king surely established the count. The *Vielle Chronique* remains, however, the only medieval explanation of the division of powers. This still causes confusion; for example, Kaiser recognizes its inaccuracy, and yet repeats the idea that the bishop set up the count. Kaiser, 1981, 422. A mark of the inferior position of the bishop in relation to the count was the count's violent seizure of the bishop's property on his death, a practice the count renounced in 1102. On the other hand, episcopal justice was second only to the king's at Chartres, without passing through the count's court. *CND* I, lxv–lxvj.

31. *CND* I, cxxvj–cxxvij. For a plan and description of the contents of the cloister, see Nicot, 1976, 4–16.

32. After Count Thibaut V's death in 1190, the county was divided between two heirs. The widowed Countess Adèle ruled over Chartres and engaged in protracted disputes with the canons over the *avoués* from 1192 to 1194. Her eldest son, Louis, ruled in Blois and died on crusade in 1205. His widow, Countess Catherine, then ruled Chartres. Like her mother-in-law before her, she became involved in a dispute with the canons over the cloister *avoués*, which led to the cloister riot of 1210. Count Louis's son, Thibaut VI, succeeded him, but went almost immediately on crusade; he finally returned with the leprosy he contracted fighting in Spain and died in the Leprosarium at Chartres in 1218. The last of the male line, he divided his domain between his two aunts, the daughters of Thibaut V, Marguerite and Isabelle. Countess Isabelle, the younger daughter, then ruled Chartres. She was quickly married to Count Jean d'Oisy, and they ruled together until 1249, when the rule passed on to the countess' daughter, Mahaut. On the history of the counts, see Lépinois, [1854] 1976, vol. 1, pp. 115–63; Cartier, *RN* 10, 1845, 1–23.

33. According to Kaiser's analysis, the count was the landlord of the town, and the bishop and chapter were his feudal tenants. Kaiser, 1981, 416–17. The bishop granted a fief of land and rights to his hereditary vidame, and the count similarly enfeoffed a viscount. Further divisions of power occurred in this feudal manner, and disputes over boundaries of jurisdiction arose accordingly.

34. *CND* I, #47, 1133, 139–41; *CND* I, #67, 1160–81, 168; *CND* I, #86, 1171, 188–90; *CND* I, # 96, 1181–3, 203–5.

35. On the adopted serfs, see especially *CND* I, cxxix–cxxx; Lépinois, [1854] 1976, 116–19; Blondel, 1903, 26–27; Chédeville, 1973, 491–509; Kaiser, 1981, 420.

36. *CND* I, 229–243. For example, *factus serviens*, and *de burgensia transivit ad servicium* . . . , ibid., 231. The condition of servitude of the chapter's *homo et femina de corpore* is not entirely clear. See Chédeville, 1973, 376–78.

37. *CND* II, #350, 1271, 188–92.

38. Blondel, 1903, 26. See, for example, Schneider's discussion of the *avouerie* of Toul. Schneider, 1963.

39. This repeated sequence of events is amply attested to in the deposition of 119–95. *CND* I, #121, 229–43. The count's most active officer in these affairs and in the city administration was his provost. He was a local burgher

appointed for a two-year term to levy the count's taxes and exercise the count's justice, administer the town and its police. Blondel, 1903, 21–22.

40. Witnesses frequently describe these events in the 1194–95 deposition. *CND*, I, #121, 229–43.

41. *CND* I, #120, 227–28.

42. "Les Miracles de Notre-Dame de Chartres," ed. Thomas, 1881, 505–50.

43. *CND* I, #121, 229–43.

44. The identity of many trades represented in the windows is disputed, but allowing for reasonable doubt, one can say it seems possible that these trades or their products appear in the following windows: barrel makers, Bays 45 and 64; changers, Bays 61, 117, 123, 164; woodworker, Bays 45, 64, 77, 78; shield makers, Bay 4; ironworker, Bay 4. There are no scenes of potters making pots, but there are certainly pots in several scenes of artisans and shops. See for example the water carriers in Bay 5. Similarly, there are no scenes of fullers of wool, but there are two windows which illustrate wool for sale, Bays 37 and 118, and three which illustrate weavers, Bays 39, 43, and 170.

45. "Canonicis ejusdem ecclesie libere liceat burgenses Carnotenses qui ad eorum domesticum servicium transierunt, preter servos principis Carnotensis, recipere et tueri, eadem libertate et immunitate cum ipsis canonicis gaudentes, una cum rebus et familiis suis, relicta tamen omni negociatione et usura, hoc excepto quod, in tempore messis, annonam, et, tempore vindemiarum, vinum, pro voluntate sua, emere possunt et vendere, sicut et canonici, et de velleribus ovium suarum pannos facere et eos sine consuetudine laicali vendere, ad quorum perfectionem si quid defuerit et aliunde fuerit comparatum eis, sine solutione teleonei, id facere licebit. De omnibus nutrituris suis et earum proventibus facere possunt sub eadem libertate. . . ." *CND* I, #123, 1195, 244–45.

46. Wine sellers appear in Bay 63. The men with goblets of wine in Bay 172 may or may not be wine sellers; the same is true of the men with goblets who appeared in the lost window of Bay 57. These windows will be discussed in Chapter 4.

47. *CND* II, 142, 143 and note 1. These butchers were independent of those of the count.

48. The *Polypticon* of 1300 lists the enormous amount of wheat the chapter expected to be delivered to its Loëns granary at that time. Much of this wheat was assigned for making the "bread of Loëns" which was distributed to the canons daily. *CND* II, 287–402. We know the chapter had its own oven in the cloister. *CND* I, #101, 209–10.

49. The bishop had his own tradesmen to whom he granted small fiefs and prescribed victuals for their sustenance. See for example, *CND* II, #222, 1215, on the fief of the bishop's carpenter. The editors of the *Cartulaire* state, without reference, "il avait même le droit d'avouer, c'est-à-dire de retenir à son service et de faire passer sous son loi un homme du Comte pris dans chaque corps de métier." *CND* I, lxv.

50. *CND* I, #128, 1195, 248–49. In this document, the pope also urged the chapter to repress the already existing commune at Etampes. See also *CND* I, #126, 1195, 246–47.

51. In the king's letter of November 1210, he states "we want all who were in the counsel and aid of the breaking in of the home of the dean of Chartres and the cloister of Chartres, both men belonging to the bodily service of this

chapter and others. . . ." This is the only document that admits the chapter's servants also took part in the 1210 riot. *PA*, #1153, 251.

52. Souchet, vol. I, 547.

53. *PA* II, #967, 1207, 9–10; *CND* II, #177, 1195, 36–37.

54. The bishop, the archdeacon, and other dignitaries convened by the archbishop of Sens in February 1210 confirmed the dean's sentence. *CND* II, #193, 1210, 47–48. In this document, the archbishop of Sens sustained in his court the punishment of the countess' marshall previously determined by the dean's court.

55. "Contigit in urbe Carnotensi, anno ab incarnatione Domini millesimo CXX, mense octobri, die quadam dominica, post prandium, quod vulgi pars maxima in Willelmum decanum ejusque familiam violenter insurgere et domum ipsius, que in claustro Beate-Marie sita est, violare presumpserit, eo scilicet quod unus ex memorati decani servientibus ausus fuerat in eodem claustro, sicut dicebatur, cuidam rustico de villa, servo scilicet Comtisse, minis duntaxat et convitiis injuriam intulisse. Cumque ministri Comitisse qui civibus preerant universis, marescallus videlicet et prepositus, requisiti fuissent a Capitulo, etiam ex parte Regis, quatinus furiosam vulgi multitudinem a claustro repellerent, vel eorum furorem pro tradita sibi potestate comprimerent, noluerunt, sed impellere potius populum quam repellere, et augere furorem magis quam comprimere conti sunt, misso etiam per urbem precone qui per vicos et plateas clamabat quantinus universi cum armis ad domum decani diruendam irruerent. . . . Sane decanus, ut primum furentis populi rabiem vidit increscere, ad ecclesiam confugit . . . multi ex eadem sacrilega multitudine vulnerati sunt, quorum nonnulli morte non immerita corruerunt. . . . Depredatio enim illa noctis tempore candellis accensis, facta est. . . ." *CND* II, #203, 1210, 56–57.

56. The excommunication of sinners, criminals, and relapsed heretics at Chartres took the form of a special anathema, which is published in Merlet and Clerval, 1893, pp. 231–38.

57. "Verum sacrilegi non ideo compuncti sunt, sed illorum amplius indurata sunt corda. Quindena siquidem die a sacrilegio perpetrato, dum sacredotum unus, sicut statutum fuerat, memorate maledictionis verba proferret, calmor vulgi astantis altus et irrisonus in eadem ecclesia subsecutus est. Unde Dominus, magis ad iracundiam provocatus, suam non distulit ultionem; qui, proxime noctis tempore, anathematis sententiam, quam ministri ejus verbo tenus tulerant sacerdotes, per angelum exterminatorem, ut credimus, executioni mandavit. Ignis enim succensus est in furore suo, qui a vico quodam inferiore secus ripam Audure incipiens, in urbem ascendit et omnium fere sacrilegorum domos usque ad claustrum Beate-Marie, non tam mirabili quam miraculoso incendio . . . Decanus etenim et universi fere cum eo canonici, ipsa hebdomada post commissum sacrilegium, Philippi, Francorum regis illustrissimi . . . In sequenti namque hebdomada, peregrinationis causa, Carnotensem visitavit ecclesiam. . . ." *CND* II, #203, 1210, 58–59. This remarkable intransigence stands in direct refutation of Otto von Simson's claims.

58. *PA* #1142, October 1210, 238, and *PA*, #1235, October 1210, 516.

59. *CND* II, #203, 1210, 59–61.

60. "Decrevit itaque Rex eosdem malefactores . . . ter mille librarum parisiensis monete solutione muletandos; de qua scilicet summa quingentas libras episcopo dari precepit, Capitulo autem mille et quingentas libras, ita tamen

quod, de eadem summa Capitulo assignata, decanus, pro injuria sibi specialiter irrogata, sexaginta libras haberet; tertiam vero partem pene pretaxate fisco suo censuit inferendam. Decrevit preterea Rex quod sepedicti malefactores et eorum complices, de quibus Capitulum nominatim et expresse querimoniam fecerat, die quadam solenni, ad processionem ecclesie, in conspectu totius populi, nudi apparerent, virgas portantes in manibus, quibus, finita processione, ante altare beatissime Virginis Marie, flagellati, Deo et eidem gloriose Virgini pene corporali satisfactionem exhiberent." *CND* II, #203, 1210, 61–62.

61. Every year, on the second Sunday of October, anniversary of the "sacrilege," the people of Chartres came in crowds to the cathedral to attend a ceremony of expiation at the altar of the Virgin and to express to the canons their respect and obedience. L. Merlet, 1860, 184.

62. *CND* II, #218, 1215, 77–78. There was a moment of apparent reconciliation in 1218 when Thibaut gave the chapter 7 livres 10s. on his weighing station at Chartres. *CND* II, #231, 1218, 91.

63. *CND* II, #294, 1249, 140–42. The executors of the Countess Isabelle's estate delivered 500 livres to the chapter in 1249 in payment of the damages caused the chapter and its serfs. *CND* II, #298, 1249, 145.

64. The bishop of Orleans did as requested but then tried to make peace between the countess and the chapter. *CND* II, #305, 1252, 148–49. The Countess Mathilde, daughter of Countess Isabelle, had taken over the county of Chartres.

65. *CND* II, #316, 1254, 157–59; *CND* II, #317, 1255, 160; on the details of the jurisdictional dispute, see Lépinois, [1854] 1976, vol. I, 139–40. At the same time, a major conflict was underway at Marmoutier between Count Jean de Châtillon and the monks. The pope sent a legate to try to settle the disputes but problems continued, and broke out into open conflict in 1256. Finally, the king paid the count of Blois 300 livres to give up his claims. Métais, *MCB*, 249–58, 265–66, 271–73.

66. Colinus was a brother of one of the canons, Hugh of Chavernay. The Cantor Lepine wanted to punish the murderers of the two *avoués* severely, and according to Lépinois, Chavernay, whose family were town burghers, had taken the murderers as *avoués* to protect them. Lépinois [1854] 1976, 139–41, and note 102. See also *CND* II, #324, 1257, 165–66.

67. *CND* II, 1254, #315, 156–57; *GC* VIII, # 96, 1254, col. 367; *GC* VIII, #98, 1256, col. 368; *GC* VIII, #99, 1256, col. 368–69. Chédeville, 1973, 84.

68. The canon was expelled from the chapter, and two other accomplices were jailed indefinitely. *CND* II, #317, 1255, 160–61; *GC* VIII, #97, 1255, cols. 367–68.

69. Chédeville, 1973, 498 and note 148.

70. Lépinois, [1854] 1976, 142. According to Lecocq, the canons finally decided to pay the count because of his obstinancy and despite their conviction that enclosing the cloister was their right. Lecocq, 1858, *SAELM* I, 131. Obviously, the count knew that the canons were very frightened and that he could profit from the townspeople's clerical animosity. Pope Alexander III granted the chapter permission to close the cloister. *CND* II, #324, 1257, 165–66.

71. Lépinois, [1854] 1976, 143.

72. Jan van der Meulen, 1974, 5–45.

73. Ibid., 16, 30–31. The sacristy bridge connected to stairs leading down to the cellars and crypt. See James, 1981, 95–98, photos 97 and 98, and note 37.

74. Van der Meulen, 1974, 5.

75. Ibid., 8–22. See illustrations 11, 13, 15, 37, 38, 39, 41. The two buttresses contain staircases within them that connect to the doors, and also to the crypt. Ibid., 18, 19. On the stairs in the eastern buttresses, see James, 1981, 202–4, and note 26.

76. I think that these stairways could have permitted both escape from attack on the ground floor and counterattack from above. John James in personal conversation disagreed with me. For photographs and descriptions, see James, 1981, vol. 1, chap. 4, notes 4, 5, 7, 8, 44, and photographs 54, 56, 68.

77. The eight stairways appear clearly in Félibien's plan, reproduced in Bulteau, 1887, vol. I, 134–35. In addition, there are four doors at the ground level at the end of the transepts that lead into tunnels at the crypt level. James, 1981, 104, and note 57.

78. John James comments that with the exception of the cathedral of Reims, Chartres has the most commodious and numerous group of stairs in northern France, and they all rise unbroken from floor to roof. He believes the stairs were intended only for workers. James, 1981, 53, note 1. James has found only one other instance of doors going nowhere, at Braine. Ibid., 204, and note 29.

79. See above, 35, and notes 107 and 108. The fullest information on the cloister remains Lecocq, 1858, 125–58. See also Nicot, 1976, 4–16.

80. Lecocq, 1858, 131–32.

81. Ibid., 132. See also Jusselin, *SAELM* 16, 1923–36, 275–88.

82. It is particularly surprising that Dieter Kimpel and Robert Suckale have not referred to Chédeville's study in their treatment of Chartres. Kimpel and Suckale, 1985. I am aware of only one scholarly study of Chartres which refers to the substantive political and economic information in Chédeville's 1973 study, namely, that of a West German historian, Kaiser, 1981.

83. Complete Latin text published by Thomas, 1881, 505–50. Thomas dates the text to approximately 1210. Ibid., 506. On the history of the text, and differing opinions as to its date, see Kunstmann, 1973, 2–12.

84. The lost fresco from the Hôtel Dieu illustrated in plate 20 may have commemorated this event, and suggests that the canons hid the veil there, although the *Miracles* text claims it was hidden in the cathedral crypt.

85. Thomas, 1881, 511. Their pledge was necessary, of course, since the main burden was inevitably theirs. However, they could not have contributed all of their income, since they would have had to retain some for the sustenance of their households and for the rebuilding of their houses. On a comparison of the obligations of other chapters, see Branner, 1961, 26–28. John James calculates that the first few years of work at Chartres were very slow, and probably did not cost a great deal. James, 1981, 109–10 and note 75. Both the canons' willingness to obligate their revenues and the slow rate of work in the first few years after the fire must be seen in relation to reports of bad crops and famine from 1195 to 1199 in northern France. Alexander, 1976, 75–76.

86. The miracles on the one hand proclaim the efficacy of the Virgin and her relics to produce miracles, thus encouraging pilgrims to visit her shrine, and on the other hand encourage pilgrims to bring offerings to the Virgin of Chartres by relating the example of others. The text is full of sermon-like urging such as the following excerpt from Miracle 16: "It seemed . . . that just as nobody who sets his hand to the plow and looks back is suited for the kingdom of God, so nobody who puts his hand in his pocket to give alms and greedily

pulls it back out . . . is fit for the kingdom of God." Many stories propose a similar moral on the importance of visiting the Virgin's shrine for the forgiveness of sins, as in the case of the sinning weaver in Miracle 16 who was told by her priest to visit the cathedral every year for the rest of her life as a penance.

87. *CND* I, lxxxvij. Chédeville, 1973, 516, notes the mid-twelfth century precedent at Saint-Père for the revitalization of building funds through the "discovery" of a miraculously surviving relic.

88. Chédeville, 1973, 510–12, and fig. 26.

89. James, 1972, 58.

90. Warnke also believes the 1210 fine set by the king must have been intended to boost reconstruction funding. Warnke, 1979, 55.

91. The title of Warnke's book, *Bau und Uberbau*, leads one to expect a materialist analysis, but Warnke surprisingly fails to discuss this combination of economic hardship and social unrest.

92. See miracles 1, 5, and 10 in Thomas, 1881, 508–23; also Bulteau, 1887, vol. 1, 124–26.

93. Bay 9, Delaporte, 1926, plate XXX.

94. Thomas, 1881, Miracle 16, 528–31; Bulteau, 1887, vol., 1, 115–17. On the many such money-raising trips with relics in France, see Heliot and Chastang, 1964, 789–822. In the late twelfth and early thirteenth century, most of the ecclesiastics on money-raising trips for the benefit of French cathedrals and abbeys did not carry relics. Ibid., 793–94, 798.

95. Benson, 1968, 170–73. The bishopric of Chartres was "effectively royal" by the reign of Louis VII.

96. Ibid., 365–67.

97. *CND* II, #177, 1207, 36–37 (cf. *RAPA* 3, #967, 9, and *PA* #1021, 235).

98. *PA* 1183, #409, 98; *PA* 1203, #800, 181–82; *CND* II, 1203, #164, 25; *CND* II, 1225, #249, 105–6.

99. *PA* 1193, #409, 98; *PA* 1207, #1020, 234; *RAPA* 3, 1212, #1389, 315; *RAPA* 3, 1213, #1278, 400–402; *RAPA* 1229, #270, 120–22.

100. Beauhaire, 1892, 4.

101. Baldwin, 1981, 331 and note 77.

102. Bishop Renaud de Mouçon (1183–1219), formerly treasurer of the abbey of St. Martin at Tours, was of the house of Bar, a nephew by his mother of Count Thibaut V (the brother-in-law of King Louis VII), and nephew of Archbishop William Blanches-Mains of Reims. Lépinois, [1854] 1976, 106, 113; *GC* 8, col. 1152. On Bishop Gauthier's relationship to Queen Blanche, see Lépinois, [1854] 1976, 133.

103. Renaud de Mouçon brought reinforcements to the Albigensian crusade in 1210. Lépinois, [1854] 1976, 125. However, Philip Augustus had not taken a great interest in this campaign. His son, Louis VIII, was dedicated to the cause. Bishop Gauthier accompanied Louis VIII on his fatal crusade to the south of France in 1226. Bishop Gauthier also accompanied Queen Blanche on her war in Brittany in 1231. Ibid., 132–33.

104. Beauhaire, 1892, 4.

105. For a review of the kings' rights over the church in France, see Fawtier and Lot, vol. 3, 1962, 243–56. In 1226, Louis VIII took over Perche, considerably diminishing the noble domains in the area of Chartres. In 1234, Louis IX

bought the suzerainty of the counties of Chartres, Blois, and Sancerre from Count Thibaut of Champagne for 40,000 livres of Tours. Count Jean de Chatillon united Chartres and Blois for the last time; on his death in 1279, his daughter took over the county of Chartres. She ceded Chartres to King Philippe le Bel for 3,000 livres in 1283. The king gave this fief to his brother, Charles de Valois, whose successor, Philippe de Valois, became king of France in 1328, thus uniting the region of Chartres permanently to the royal domain. Lépinois, [1854] 1976, 41–184; Chédeville, 1973, 32–43.

106. King Philip Augustus donated 200 livres on the occasion of his visit to view damage from the 1210 riot. *CND* II, #203, 59. Bulteau tried to write an account of the cathedral's financing which showed the kings' financial support, but he simply lacked the facts to make it convincing. Bulteau, 1887, vol. 1, 119–21.

107. *GC*, vol. 8, cols. 1152–59.

108. For the best review of the bishop's domain, see *CND* I, lxvij–lxix. Von Simson seems to have misunderstood Lépinois and Merlet's calculation of the bishop's income in "silver" to mean the metal rather than the coins naturally figured in livres. See Von Simson, [1956] 1964, 175, note 60. The bishop had a number of powerful local barons as vassals who expressed their position of subservience by carrying the bishop into the city on his inaugural entrance, seated on his *sedia gestatoria. CND* I, lxvi–lxvij.

109. It is interesting that apparently a rival to Bishop Renaud was once elected, but never consecrated. *GC* VIII, col. 1152.

110. James, 1972, 59. Bishop Renaud de Mouçon led an army on the Albigensian crusade in 1210. Chédeville, 1973, 328.

111. On the static income of the bishop, see Luchaire, 1909, 146. His estimates of the bishop's income probably are drawn from those by Lépinois and Merlet in *CND* I, lxix. The bishop did not receive any church offerings. The bishop's revenues from his lands in 1300 are listed in *CND* II, 239ff.

112. The increasing inflation of the period would have caused this effect; in addition, long-distance trade made available increasing amounts of luxury goods with which to embellish courtly life.

113. Chédeville, 1973, 279 and note 193; Lépinois, [1854] 1976, 115, note 2.

114. Amiet, 1922, 17; *CND* II, #150, 12–14; *CND* #219, 78, and note 1.

115. *CND* II, #228, 1234, 127–29.

116. Wolff, 1982, 660.

117. Chédeville, 1973, 439, 457.

118. Grodecki attempted to calculate the cost of stained-glass windows at St. Denis under Abbot Suger. He found an undated entry in a document at Limoges concerning a window costing 23 livres, and a record from Soissons ca. 1215 of the king's donation of 30 livres parisis for a choir window. Grodecki, 1976, 27 and note 19.

119. Recorded wages I have found in local documents from the building period were made primarily in daily rations of food. In England, where records are more extensively preserved, an unskilled laborer in the later thirteenth century could expect around one or two deniers daily. Peter Spufford, *Money and Its Use in Medieval Europe* (Cambridge, 1988, 235); Christopher Dyer, *Standards of Living in the Later Middle Ages* (Cambridge, 1989, 215).

120. Warnke, 1976, passim.

121. Chédeville, 1973, 77.

122. On the secular canons, see Fawtier and Lot, 1962, vol. 3, 188–92.

123. Amiet, 1922, 3–5. Chédeville, 1973, 491–92. There is an interesting insistence in the early literature on the high nobility and intellectual training of the canons. This is especially surprising in Blondel, whose work is otherwise based on the documents. Blondel, 1903, 30–31.

124. On the chapter, see Chédeville, 1973, 509; Amiet, 1922, passim; CND I, lxx–cxxxvi. The chapter also had the largest number of dignitaries of the northern French cathedrals, 17 as compared to 8 at Paris, 15 at Orleans, 13 at Bayeux, 6 at Noyon. Amiet, 1922, 44.

125. Bad weather did cause poor harvests in the Paris basin around St. Denis in 1194, 1196, and 1197. Alexander, 1987, 368–70.

126. CND I, #86, 1171, 188–90. The canons had already begun the long process of taking over the provosts' rights in 1171–72 with the appropriation of half of the provosts' rights to the church presentations in their districts. CND I, cx. On the history and alleged misuses of the chapter's four provosts, see ibid., xcii–c.

127. This is borne out repeatedly in local documents by the heated debate over rights to administer justice at all levels.

128. Chédeville, 1973, 514. This led to a new, larger share of lands for each of the seventy-two prebends. Reapportionment took place according to the *Polypticon* of 1300 every nine to twelve years, the highest dignitaries receiving first choice of two prebends, the rest of the canons only one. All were required to return a portion of their revenues to the common fund maintained at the chapter's granary, the Löens. In turn, the canons received daily distributions from the granary of bread and wine for their use and the use of their families. CND I, c–cii; CND II, 279–80, 283–87. See also Amiet, 1922, 180–200; 214–18. The presentations went to the individual prebends and the collation of benefices were made in chapter by a majority of votes. CND I, cx.

129. Obit of the former bishop, William Blanches-Mains, CND III, 169. The canons still recognized the importance of this event in their induction oath recorded in 1300 saying, "Moreover I swear in good faith that I will faithfully observe in accordance with my ability and at my own expense if necessary whatever others do concerning the chapter, even if everyone, which may it not happen, should withdraw from this custom made by the Reverend Father Renauld of good memory, Bishop of Chartres, in the counsel and approbation of Master Melioris, then legate of the apostolic see, concerning the four ancient provostships. . . ." CND III, 281–82.

130. The most active effort to regain tithes occurred in the early thirteenth century at Chartres. Chédeville, 1973, 326. Tithes in theory were intended to be presented to the parish priests and to serve to sustain them, but were usually taken over at least in part by a higher authority. CND I, cxj.

131. CND III, 1–226. For further evidence of increasing donations for anniversary celebrations, see CND I, 67–263; II, 1–172 (to 1260).

132. Martin Warnke points out that relics opened up superregional resources for large building enterprises and at the same time sanctified the site where they were kept and legitimized their ecclesiastical keepers. Warnke also sees the relics as the means whereby donors attained satisfaction for their donation.

The "discovery" of relics functions to legitimize a building project and inspire donations at Chartres twice, first at Saint-Père and later at the cathedral in 1194. The fire of 1194 is seen in the *Miracles* as the punishment of God, and the discovery of the relic's miraculous survival as an example of God's deliverance. Only after this sign did the people and the clergy undertake to rebuild. Warnke interprets this to show that medieval men recognized the economic value of relics. Warnke, 1978, 70–72.

133. This is amply evidenced in the *Miracles* text.

134. John James's attempt to determine expenses in terms of present-day methods and costs of construction remains entirely hypothetical. The quarry at Berchères-les-Pierres lay only 12 kilometers from the cathedral site, providing relatively inexpensive access to excellent-quality stone. James, 1972, 47–65.

135. John James estimates that 1,284 churches survive in the Paris basin that were built between 1140 and 1240, and that must be only a fraction of the original number, since so many churches have since been destroyed or rebuilt. James, 1982, 15–18.

136. Chédeville concluded that economic stagnation occurred between 1220 and 1230. Chédeville, 1973, 528. Chédeville states, relative to the effect of the cathedral building on the economy: "It is then incontestable that, on a purely economic basis, the cathedral cost much more to the region than it brought back to the town." Ibid., 524.

137. Chédeville, 1973, 514; *CND* I, lxix.

138. Chédeville, 1973, 184, 298, 514; *CND* II, 390–96. Chédeville noted that Otto von Simson incorrectly listed the Dean's thirteenth-century income at 2,300 livres based on an eighteenth-century record. Chédeville, 1973, 514, note 50.

139. Chédeville, 1973, 185 and 193.

140. Bulteau, vol. 1, 82.

141. The bishop usually nominated the dignitaries at Chartres, but sometimes the king intervened in these nominations. Amiet, 1922, 21–29. By 1300, however, the chapter had managed to exclude the bishop from appointment of the master of the works. *CND* II, 280. According to Jusselin, this dignitary held, uniquely at Chartres, a privileged and hereditary position of responsibility for the accomplishment of work on the fabric. Jusselin, 1921, 231–55.

Chapter Three

1. *PL* 202, col. 1046.

2. Bulteau, 1887, vol. 3, 217, 270; Aclocque, 1917, 513; Delaporte, 1926, 296–97, 466–67; Villette, (1964), 103, 105, 106; *CVR* 2, 1981 27, 36, 42; Weber, 1984, 1.

3. The window of the patron saint, the Virgin Mary: Delaporte, 1926, vol. 1, 467, plates CCXXIV–CCXXVIII; Bulteau, 1892, vol. 3, 216; Villette, 1964, 105; Lasteyrie, 1857, 63; Aclocque, 1917, 313. Lépinois thought the men in the apse must be wool workers or dyers carrying balls of yarn because, he reasoned, the local bakers were too poor to have donated windows. Lépinois, [1854] 1976, 219 and note 2. *CVR* 2, 1981, 36; Weber, 1984, 4.

4. The window of Moses and Isaiah: Delaporte, 1926, 466, plates CCXXIV and CCXXV; Bulteau, 1892, vol. 3, 217; Lee, 1976, 75; Villette, 1964, 105; Lasteyrie, 1857, 63; Aclocque, 1917, 313; *CVR* 2, 1981, 36; Weber, 1984, 4.

5. The head painted onto the lump of dough in the baker's arms in the left panel, plate 32, is a later addition.

6. The window of St. James: Lasteyrie identified the worker as a pastry cook. Lasteyrie, 1857, 69; Bulteau thought the window represented a pastry cook and two boys carrying a bread basket, Bulteau, vol. 3, 1872, 241; Aclocque, 1917, called the workers in the St. James window *boulangers-pâtissiers*, 313; Delaporte thought that the bakers and pastry makers were one in the thirteenth century, Delaporte, 1926, 415, plate CLXXXIV; Lépinois, unlike for the windows of the choir, here identifies the workers as *talemeliers-oubliers* and *pâtissiers*, Lépinois, 1854, 221,; Villette thinks a pastry cook appears in one nave window, presumably the St. James window, 1964, 106; Aclocque, 1917, 313; *CVR* 2, 1981, 42, calls the men bakers and a pastry maker; Weber, 1984, 4, thinks the bakers and pastry makers combined to donate the window.

7. The window of St. Peter: Bulteau said the window was donated by pastry cooks, Bulteau, vol. 3, 1872, 241; Delaporte says it was without doubt offered at the same time as the adjacent window by the same donors, the bakers. Delaporte, 1926, 416, plate CLXXXIV; Villette, 1964, 106; Lasteyrie, 1857, 69; Aclocque, 1917, 313; *CVR* 2, 1981, 42. Weber noticed that the purchaser seems to wear a sling for carrying bread like that, already full of loaves, worn by the man in the window of the Apostles who purchases bread. Weber, 1984, 4.

8. For a review of the scholarly literature on the trumeau, see Cummins, 1980. For the subsequent additions to the scholarly discussion of the trumeau socle, see Villette, *Notre-Dame de Chartres*, September 1982, 7–10, and Weber, 1984, 6–8.

9. The understanding of the socle figures which prevails in the literature can be traced back to the writing of Vincent Sablon of 1671, which was republished many times. Sablon describes the figure as Pierre Mauclerc distributing bread. Sablon, 1835 (first published in 1671), 23. The idea that this basket of bread is intended for charitable distribution appears repeated in every subsequent scholarly discussion of the basket. Bulteau, 1850, 102; Sauerländer, 1972, 113; van der Meulen, 1965, 120–21; Delaporte, 1959, 104; Claussen, 1975, 13.

10. Jacques Weber has posited a consistent meaning for these baskets different from my own but more in keeping with the traditional trade-donation idea used to explain the trade windows. He thinks the kneeling man was the head of the confraternity of bakers at Chartres. Weber, 1984, 1–10.

11. Katzenellenbogen, 1959, 79–100.

12. Delaporte, 1953, 25, 39, and unnumbered page with plan at the end of the book.

13. See Chédeville, 1973, 190–200.

14. On the rising consumption of bread as a dietary staple in the eleventh and twelfth centuries, see Duby, 1974, 187–89. Winter grains (*hibernagium, hiemales*) consisting of wheat and rye were milled and baked into bread. Spring oats were primarily for horses, with some use as gruel, another staple of the medieval diet. Chédeville, 1973, 190–97. Montandon, a historian of French bread, notes that medieval loaves in Paris were made of these varieties of grains, revealed in a Parisian bread-testing in 1418. Montandon, 1979, 22–23.

15. Chédeville, 1973, 192 and note 156.

16. Vast chapter receipts of grains are recorded in the *Polypticon* of 1300. *CND* II, 279–429.

17. Chédeville found the first mention of the Löens in 1106. Chédeville, 1973, 455, note 168; see also Clerval and Merlet, 1893, 149; *CND* II, 405–6.

18. Ergot disease was especially associated with rye bread. See Montandon, 1979, 48.

19. In the fourteenth century, the hospital was called the *Sanctus-locus-Forcium* after the well of the martyrs in the crypt, and ergot was called *ardentes* or *ignis Beate-Marie*. The ill were said to be cured through the grace of God and his mother during a nine-day stay in the hospital. *CND* I, 58.

20. Montandon, 1979, 48–49.

21. The nature of the different taxes and customary payments satisfied by bread payments is not clear in every instance, due to changes in both practice and linguistic usage, and alienations of sacred payments to secular lords and vice versa.

22. There were two distinguishable types of cens, one a recognition of a lord's ownership of property used by a social dependent, and the other levied by lords on their serfs yearly by the head, and hence referred to as *capitation*. Jubainville, 1861, vol. 3, 281. At Chartres, Merlet distinguished three types, the first mentioned above called the *menu cens*, the second the *capitation*, and a third, the *supercensus* by which vassals paid to free themselves of some service or paid to gain some concession or privilege. This situation probably explains the extraordinarily large cens of 69 deniers six sous paid the Leprosarium for the cens of seven bread stalls by the count's tower. *CLGB* #312, 1237, 119–32. L. Merlet, 1901, 182. The cens were usually very small payments which, however, represented the powerful and lucrative right to jurisdiction, so that their gift in documents frequently represents a much greater transfer of potential income than the small amount recorded for the cens. Chédeville, 1973, 468–69.

23. *CASP* II, #47, 1108, 439; *SMJ* I, #304, ca. 1200, 349; *CMC*, #64, 1210, 69; *CND* II, #214, 1213–28, 73–74; *CLGB*, #257, 1228, 98–99; *CND* II, #349, 1270, 187–88; *CSTT*, 376, 1250. These payments might be called *oblites* or *oblations*, further confusing the categorization of feudal dues. Chédeville, 1973, 345. Hence, one is not sure how to categorize the *oblites* payments of loaves, along with chickens and oats, which hospites at Bonville paid to the Leprosarium at Christmas. *CLGB*, #312, 1237, 128.

24. The payment was made in little loaves called *oublié* or *oblivia*. *CASP*, vol. II, 847. This bread was also referred to as *oblation, oblitis,* or *obliviones*. It was synonymous with cens, and therefore was a small sum paid by a dependent to his lord in recognition of his dependency or the privilege he held from the lord. It was, in other words, a symbolic payment, no matter what the payor's status might be in the social ladder, to show recognition that the property he used belonged to a lord. Sometimes the word *oubliés* referred also to similar obligation paid in grains or chickens. Ibid., vol. I, clvij. *Hôtes* paid *oblitae* yearly or more rarely *oblationes*, frequently represented by two loaves, two chickens, two deniers, and two setiers of oats for their small tenures of land of one arpent or less. Chédeville, 1973, 345. Lépinois and Merlet claimed the tax originated with the oblations of bread made for the mass which, by a substi-

tution, indicated a tax of bread that vassals paid lords on designated days. The payments were gradually converted into a revenue in money or grains, calculated by arpent. *CND* I, 154, no. 1. See also *CND* I, ccviij.

25. At Chartres, bread sellers paid the bishop one denarius a day on markets days and sellers of a special bread called *summa* paid similarly one obole.

26. On *fournage* tax, see *CND* I, ccxij and no. 4. The bakers who used the furnace of St. John near the church of St. Maurice paid the bishop 3 *pictas* a week. *CND* II, #368, 1280, 211–18.

27. Tithes of bread appear in local documents of the eleventh, twelfth, and thirteenth centuries. See *SDN*, #21, 1080, 73–76; *CSTT* I, #9, 1115, 21; *CSTT,* I, #63, 83, and II, #377, 1250; *CND* II, #385, 239–45; *CND* II, *Polypticon*, 1300, 303, 360. For a comprehensive explanation of medieval French tithes, see Viard, 1912, especially 1–32. According to Viard, the grain tithes were sometimes paid in bread, the idea being that the natural product was transformed by work. Viard, 1912, 64. On the tithes at Chartres in particular, see Lucien Merlet, *SAELM* XII, 1901, 184–88; also *CASP* I, cxvj–cxviij. In the eleventh century, most laity gave monasteries and cathedral chapters ownership of churches but kept the tithes. Duby, 1974, 223. The small tithes, augmented by the oblation of deniers, candles, and bread, often constituted the salary of the priests. See *CND* I, cciij and below, concerning the *altarium*.

28. Bread sellers in Bourges paid the king two denarii's worth of bread a week. Giry, 1885, 3, item 11. Bourges bakers also paid the king 6 sous per year for their stall. Boyer, 1914, *SHLSCM*, vol. 28, 116. Parisian bakers paid three types of taxes on their commerce: *hauban, tonleiu,* and *coutume.* They paid tonlieu or sales tax weekly in two parts: on Wednesday, they paid one small bread or demie, and Saturday two demie to the king, who ceded his rights to a knight. The bishop of Paris received these taxes from the bakers every third week. The Saturday payment had changed to one denier by 1258 when the Parisian statutes were recorded by Etienne de Boileau. The coutume payments bakers made at that time were: 10 deniers on Christmas, 22 on Easter, and 5 deniers one obole on St. John's day, for a total of 37 d. 1 o. Lespinasse and Bonnardot, 1879, xx–xxi. These payments were probably made in bread earlier, and show the prevalent custom of paying bread on these particular feasts. The same can be said for the Parisian bakers' payment of 25 d. at Christmas on the occasion of their installation after apprenticeship. Ibid., xxi. On bread taxes in other parts of Europe, see Zylbergeld, 1982, 263–304; Tits-Dieuaide, 1982, 453–94; Falck, 1974, 103–12.

29. Thomas Bisson discusses these first Capetian money taxes, which are called the *tallia panis et vini* in the documents. See Bisson, 1979, 29–31, 35–40.

30. The right to *gîte, past,* or *procuration* appears frequently in the local charters (variously referred to as *pastus, gestum, parata, procuratio, herbergagium, corrodium*), but it is sometimes difficult to determine if the right included simply lodging or provisions or both. The right was frequently changed to a money payment or abandoned entirely in the thirteenth century, but, as with so many other customary payments in Beauce, the payment of bread frequently persisted. For a general discussion, see Merlet, 1901, 204–5. For an example of bread procuration, see *CND* II, #146, 1201, 709.

31. Small meals served to the canons and clerks on long liturgical processions through the town and its suburbs at the monasteries of St. Martin and St. Chéron were eventually transmuted to money payments. On the meals at St. Martin, see *CND* I, #89, 1176, 195–96; and on the meals at St. Chéron, see *CND* II, #282, 1241, 131. However, the dean was still responsible in 1300 for serving participants in the matins liturgy of St. Piat with bread, wine, and *pastillos* behind the altar. *CND* II, *Polypticon*, 1300, 300.

32. For a description of the canonical distributions at Chartres, see Amiet, 1922, 214–17; *CND* I, cvij–cix.

33. A particular payment corresponded to every religious act of canonical life, including payments for participation in the five daily masses. According to the *Vieille Chronique,* the canons assisting at the second or main mass of the day received three loaves and two additional loaves for assistance at the mass of the dead celebrated each day. *CND* I, 58. The editors of the *Cartulaire* wrote that the main mass distribution to the assisting canons was three loaves and sometimes a cup of wine. At the mass of the Virgin, the canons received three loaves again; the dean, subdean, and priests received one loaf each at both masses. *CND* I, cviij, no. 2. See also Amiet, 1922, 216 and note 216. According to Amiet, bread of Löens was distributed to canons emerging from Matins celebrations. Ibid., 215. The bread distributions evidentally took place at the chapter's granary, the Löens: "et ad quamcumque horam accedat apud Carnotum, ipse percipit in Loenio duos panes et vi den., si tunc peccunia in Loenio distribuatur." *CND* II, 299. On the rules covering distributions, see *CND* II, *Polypticon*, 1300, 298–99 and *CND* I, ciii–cix. By 1367, the amount of loaves had decreased: the canons received three loaves daily when residing in the town if they assisted at matins, anniversary masses, and the main mass. According to Souchet, these distributions stopped in December of that year, for unknown reasons, and were changed to distributions of wheat. Souchet, vol. 3, 226, 227. However, in 1374, a local baker contracted to make the bread of Löens. Lépinois, 1854, 369, no. 4. Similar distributions of bread took place at Notre-Dame in Paris. Guérard, 1850, vol. 1, CLXII–CLXV. At Orléans, the bishop installed bread distributions to the canons who attended certain services in 1245 to stimulate the canons' zeal to take part in the services. *CdO*, #284, 1245, 368–69.

34. For example, see *CASP* II, #167, 1130, 383. High-status vassals performing *corvés* for the abbey of Saint-Père received bread and wine during their work. *CASP* I, #5, 1102, 231; *CASP* II, #137, 1265, 711–12.

35. On the fief of the bishop's carpenter, *CND* II, #222, 1215, 84; the fief of the bishop's janitor, *CND* II, #201, 1210, 53–54; the fief of the bishop's *clausarius, CND* II, #259, 1226, 114–15; the bishop's payments to the clerks and lay servants of the choir, *CND* II, #372, 1282, 225–26.

36. *PL* 202, cols. 929–1046; see also *Dictionnaire de Théologie Catholoque,* vol. 12, pt. 1, cols. 1898–99.

37. Lépinois, [1854] 1976, vol. 1, 111–13, and note 1, 113.

38. Henisch, 1976, 79–80.

39. Our first evidence of a bakers' trade organization appears in a document dated 1291, in which the count ruled concerning the bakers' community with words suggesting they had been constituted for some time previously: "[In]

The mandate of our court concerning the discord that was amongst us on the one hand and the community of bakers of Chartres on the other regarding the legal method of choosing their master and presenting him, it was promised by the judgment of the court that the community was and had been for a long time in the legal practice of choosing their master." Boutaric, I, #803, 442. Toward the end of the thirteenth century, a bread hall was built on land of the count where bread was sold. This apparently coincided with or followed close upon the bakers' incorporation. Lépinois, 1854, p. 329. This changing status is evident in the late thirteenth century. At Chateaudun, a baker and his wife sold property worth 20 livres in 1296. *CMC*, #2204, 1296, 222–223.

40. The count of Blois and Chartres gave monks of the abbey of Sainte-Trinité at Tiron seven bakers in 1121. *CSTT* I, #45, 64. The monks still had six of them, presumably descendants, in the mid-thirteenth century. *CSTT* II, 159. The vidame of Chartres gave the monks of Saint-Père of Chartres two bakers prior to his departure on the Albigensian crusade in 1226. *CASP* II, #101, 684.

41. This is not the case with town bakers in the royal domain. The king granted the bakers of Pontoise a monopoly on selling bread in exchange for one modius of wine in 1162. Fagniez, 1898, #114, 89.

42. On the growth of mills and ovens installed by lords and their oppressive economic effect, see Duby, 1974, 187–88. Duby notes evidence of enforced mill and oven use, which appears also at Chartres.

43. The basic study of the medieval taxes at Chartres remains that of Merlet, 1901, 184–88.

44. The *Polypticon* lists receipts from each canonical prebend, many of which specified payment for the bread of Löens. See for example *CND* II, 296.

45. On the *chambrier*, see *CND* I, lxxxj. We don't know when the Löens was rebuilt. According to John James's analysis of the construction, it was built around 1221 (personal conversation). However, the chapter had a cellar already in the early twelfth century, in a house given to the chapter in the eleventh century, approximately in the same location (*ante Portam Novam*). Merlet and Clerval, 1893, 149, and Chédeville, 1973, 455, no. 168.

46. Loaves were awarded according to participation in the daily rites. *CND* I, lxxxj.

47. Lépinois, 1854, 369. I have found evidence of the following ovens in the town and its suburbs:

1. The oven in the cloister called *Böel*; a knight gave 20 sous annual rent from this oven to the abbey of the Madeleine at Chateaudun. *CMC*, #77, 1217, 82–85.

2. Another oven, location unknown, called *Nivelon* was the property of the vidame's family, who gave 6 sous income from the oven to the Leprosarium. *CLGB* #224, 1222, 87.

3. There was another oven in the cloister, which belonged to the Alms House. *CND* I, #101, 1183, 209–10.

4. The Leprosarium had an oven. *CND* II, 217.

5 and 6. The bishop and chapter had their own ovens. *CND* II, 416, 418.

48. Numerous references occur in the *Polypticon*. See for example, *CND* II, 296, 357.

49. See the papal confirmation of Matins assignments: *CND* I, #63, 1156, 163.

50. Measures of wheat based on Löens measure appear in charters from an early date, testifying to the chapter's granary. See *CASP* II, #62, 1119, 312–13; Chédeville, 1973, 455 and note 168.

51. According the *Polypticon* of 1300, there were ovens near the Porta Nova and Porta Epars whose owners paid taxes yearly to the chapter. In addition, the bishop and canons had their own ovens. *CND* II, 409, 410, 416, 418, 419.

52. In his study of medieval bread, Desportes unfortunately does not attempt to differentiate the wide variety of breads mentioned in medieval documents. Desportes, 1987.

53. Throughout this study I have used the edition of the *Livre des Métiers* edited by René de Lespinasse and François Bonnardot, Paris, 1879. The bakers' statutes appear on 1–15 and the editors' analysis of the statutes in their introduction, xix–xxvi. For previous but similar analysis, see Fagniez, 1877, 173–74. See also Le Grand d'Aussy, vol. 2., 240–68.

54. On the three sizes of ordinary loaves in Paris, see Lespinasse and Bonnardot, 1879, xxii. On the persistence of the adjustment of bread size to the set prices, ibid., 9, #XXIII, and no. 2, 9–10. The bread worth one denier was called *denerata panis* in Bourges. Boyer, *SHLSCM*, vol. 28, 1914, 116.

55. Lespinasse and Bonnardot, 1879, xxii. The *echaudées* were so-named because to make them rise people put them in hot water. St. Louis prohibited bakers from baking on feast days and Sundays, except *echaudées* for the poor. Le Grand d'Aussy, vol. 2, 1782, 262. Elsewhere in France, *oubliés* were distributed on certain days to the clerks and canons and often formed part of the tax required of vassals called *droit d'oubliage*. At Pentecost, special loaves called *nieules* were made. Ibid. 264–68; also Martin Saint-Léon, 1922, 200.

56. A charter of 1201 stipulated the procuration right of a provost to be one bread or one denarius. *CND* II, #146, 1201, 7–9. Similarly, in the Vendôme, an abbey's rights include a payment from its *hôtes* at Christmas of one bread or one denarius. *CV*, #95, ca. 1160, 122–23. On the *mediani*, see *CSJV*, #128, 1196, 64.

57. On *panis consuetudinales*, see *CSJV*, cxxx–cxxxj. The first mention of *gastel* I have found in documents from the region of Chartres dates to 1469. *CASP*, #165, 734–35.

58. *CASP* II, #133, 1140, 642–43. According to Guérard, *alberon* was bread made from top-quality wheat, also called *alberon*. *CASP* I, ccxj. White loaves were also called *panis candidus*, or *michia alba*. Ibid., ccx.

59. On tortelli, see *CASP* vol. I, cxxx–cxxxj; also *CND* I, 157, no. 1. In Bourges in 1100, the bakers paid the vicar one *tertellus* at Christmas. Boyer, 1914, *SHLSCM*, vol. 28, 116. See also Du Cange, vol. 8, 134.

60. On *canistrum* and *canistrellos*, see *CND* I, #89, 1176, 195–96, and no. 1; *CND* II, #282, 1241, 131. Probably of the same type is the *chenestellis* in *CSJV* I, #226, 1227, 110.

61. On the *echaudées* at St. Chéron, see *CND* II, #282, 131.

62. *CASP* II, 847; I, clvij. Each year at Chartres, colonists (*hôtes*) paid *oubliés* to their ecclesiastical or secular lords, frequently represented by two loaves, two chickens, two deniers, and two setiers of oats, for their small tenures of land. See Chédeville, 1973, 345, and *CND* II, #214, 1213, 73–74.

63. *CASP* I, ccx; *CND* II, #201, 1210, 53–54; *CND* II, #222, 1215, 84; *CASP* II, #140, 1265, 714.

64. According to Guérard, the oblations were offerings of all kinds that the faithful made at churches during mass or other times, usually during the collect recited after the offertory. *CASP* I, cxxviij. A most trenchant discussion of the meaning of *oblationes* in the medieval records is that of Georg Schreiber, 1913. Schreiber found abundant evidence of offerings in medieval documents used in the sense of duty payment, such as the *decimas offerre*, and similarly, evidence that *oblationes* were in fact obligatory payments. See especially ibid., 17–34. Devailly found the same phenomenon at Bourges, where offerings carried by the faithful to altars on the occasion of certain grand liturgical feasts and the taxes paid in the same way were combined and became obligatory. Devailly, 1973, 247. Oblations were sometimes secular payments to lords, probably due to alienation of church rights. See, for example, *MCB* #74, 1213 and *CND* II, #220, 1215, 79–83.

65. *CSJV*, #333, 1195, 162–63. Sometimes, the Christmas bread offerings were presented the day after Christmas.

66. *CASP* II, #86, 1213, 676–77.

67. *CASP* II, #133, 1142–58, 157–59; *SMJ* II, #267, 1176, 313.

68. *CND* I, cciij; *CV* #184, 1210, 219–22.

69. *SDN* #21, 1080, 73–74; *CSTT* I, #9, 1115, 21; ibid., #63, 1125, 83; *CND* I, #65, 1157, 164–66.

70. *CSTT* I, #63, 1125, 83.

71. Jungmann, 1950, vol. 2, 14; Schreiber, 1913, 13ff.

72. The record of the customary bread payments does not always designate the nature of the custom they satisfy. See, for example, the loaves due to the church of Chandai called "customary loaves" due at Nativity, Easter, and Ascension. *CASP* II, #133, 1142, 618–20. Definitions in local studies of the composition of the *altarium* vary. According to the editors of the cathedral *cartulaire*, the *altarium* included the small tithes and oblations of bread, wine, and candles. *CND* I, 165, no. 5. See bread and candles in *CND* I, #56, 1149, 154–55; bread and denarii in *CSJV*, #333, 1258, 162–63. Bread along with deniers and candles was also associated with death rites (*sepultura*) and death memorials, in both cases due the priest as payment for special liturgical services. See Schreiber's discussion of this. Schreiber, 1948, 266–72. See also *CASP* I, cxxx–cxxxj, and *CASP* I, #71, 1080, 196–97.

73. Schreiber, 1948, 266–67.

74. *CASP* I, #200, 1055, 199; *CASP* II, #23, 1118, 638–39.

75. Durandus states that "in some places, the parishioners offer the day of Christmas loaves called *panes calendarious* because of what one reads in Leviticus 22: 'You offer two loaves to your priest for his own use and you will call this day a day very solemn and very holy.'" Durandus, *Rational*, 1854, II, chap. 30, xl.

76. One finds no mention of free-will bread presentations. Schreiber notes that the clause "si offeretur" suggests free-will offering of a donation in Luray in the Oise (*Burricum*) which he posits later became an obligatory payment to the clerical office. The obligatory nature of such customs was established by the fourth Lateran Council with the institution of *laudabilis consuetudo* under Innocent III and later reinforced through French synodal statutes in the thirteenth century. Schreiber, 1948, 253.

77. Disputes over bread receipts at local churches: *CASP* II, #132, ca. 1101–29, 617–18; *CASP* II, #133, 1142–48, 618–20; *CND* I, #56, 1149–55, 154–55; *CND* I, #65, 1157, 164–66; Schreiber, 1948, 249–50 and note 147 regarding dispute in 1165 over bread presentations at Crespière; *CND* I, #130, 1195, 250–51; *CSTE* #11, 1225, p. 152. *SDN*, #123, 1229, 248–49; The first suggestion I have found that this bread borne to churches on feast days was transmuted into money occurs at the priory of St. Hilarius in 1236. *CASP* II, #110, 1236, 688–90. This seems to happen earlier with cens payments: *CND* II, #212, 1213, 73–74.

78. *CASP* II, #86, 1213, 676–77.

79. *CND* I, #130, 1195, 250–51.

80. Amiet, 1923, 224. The *Pouillé* of the thirteenth century showed the canons as a whole had seventy-two parish churches. See also *CND* I, cix. In 1300, the canons still received two-thirds of the bread tithe from Opharvilla (Aufferville). *CND* II, *Polypticon*, 360. Similarly, the canons received two-thirds of the bread tithe from Villarcellus (Villarceaux). Ibid., 303.

81. They first received half of the provosts' presentations in a reform in 1171–72. *CND* I, #86, 1171–72, 188–90 and cx. In 1193, the entire income of the provostships reverted to the canons in an even broader reform. *CND* I, #119, 225–27 and cx.

82. In 1176, Bishop Geoffrey de Lèves gave the abbey of Josaphat parts of all the oblations of the four principal feasts at the church of St. Piat, namely, at Christmas, Easter, St. Piat's day, and All Saints. *SMJ* I, #267, 1176, 313. According to Guérard, when lords abandoned their right to offerings, returning them to the church, they sometimes reserved all or part of the offering of the great feasts, which would have included the bread offerings made on those days. *CASP* I, cxxviij–cxxix. The bishop and canons continued to receive part of the parish offerings at Illiers in 1157. *CND* I, #65, 1157, 164–66. Under pressure of church reform, lay lords abandoned their claims to parish rights, increasing the parish incomes. For example, *CSTT* I, #63, ca. 1125, 83, in which a lord returned a bread tithe to an abbey. Devailly followed this phenomenon in the charters from Berry. He found that the offerings carried by the faithful to altars on the occasion of major feasts and the charges which had replaced presents given by the parishioners for administration of the sacraments had fallen into the hands of ecclesiastic and lay lords. *GD*, 247.

83. The bishop gave two parts of the oblations on the four principal feasts at the church of St. Piat to the abbey of Josaphat in 1176, apparently retaining the third part. *SMJ* I, #267, 1176, 313. According to the list of customary payments due the bishop from his tenants by territory, recorded in 1300, the bishop received 71 loaves at Christmas, 16 from his tenants at Basochia, 30 from his tenants at Mondonville and 22 from his tenants at Disconfectura; the tenants at La Chapelle-du-Thieulin paid the bishop 25 loaves on the feast day of St. Denis. *CND* II, #385, 1300, 239–45. By this date, many such customary payments had been transmuted to coinage, so the amount of taxes paid in bread in the early thirteenth century to the bishop was probably much greater.

84. Parishioners were ordinarily bound to their own parish. Dobiache-Rojdestvensky, 1911, 87. At the time of fairs, a conflict of interest might arise between fair attendance elsewhere and Sunday mass at the parish. At Trequier, this was resolved by one member of each family attending mass; those who went to the fair without first attending mass paid a fine to the priest. Ibid., 89.

85. According to Jungmann, since the eleventh century, it was customary to hold the offertory procession on specified feast days, when it was regarded as obligatory. Jungmann, 1951–55, vol. 2, 22. In his introduction to the cartulaire of Notre-Dame in Paris, Guérard discussed the ceremony of offering, but gave no dated reference. He stated that all participated except catechumens, penitents, and those who could not communicate. Other than what was necessary for the priests' communion and what was destined for eulogies, one offered also all sorts of presents which were later disposed of at the bishop's house. The bishop received the offering walking amongst ranks of the faithful. Guérard, *Cartulaire de l'église Notre-Dame de Paris*, vol. 1, xiv.

86. Jungmann, 1951–55, vol. 1, 71, 84; vol. 2, 8, n. 35.

87. Ibid., vol. 2, 14. See also Eisenhöfer, 1961, 297 and Corblet, vol. 1, 122. Evidence of this offering of bread and other products occurs in the charters. See, for example, the charter from Nogent-le-Rotrou: "presbiterium scilicet et omnia ad altare pertinentia, cum offerenda panis et vini, lini, et canabi, et candele et omnia quecumque offerri debentur ad altare." *SDN*, #55, 1080, 131; *CND* I, #65, 1157, 164–66; *CASP* II, #86, 1213, ca. 676–77.

88. Jungmann, 1951–55, vol. 2, 14.

89. Georg Schreiber, "Mittelalterliche Segnungen und Abgaben. Brotweihe, Eulogie, und Brotdenar," 1948, 213–82.

90. Or *denarious panis benedicti*, ibid., 250, note 147. From his evidence, Schreiber concluded that the bread blessing was a parish right. Ibid., 255. An example that Schreiber missed occurs in a charter dated 1203 concerning the bread offering received in the chapel of the Hôtel Dieu at Nogent. "De pane benedicto sic ordinaverunt: non faciemus panem benedictum de aliquo pane oblato, nisi tantum modo de pane quo vescimur." *SDN*, #108, 1203, 210. Bread blessing was common in the whole area of Rouen as well, but Schreiber found no diocesan evidence of the manner of its liturgical presentation at Chartres or Rouen. Schreiber, 1948, 250, 252.

91. Ibid., 253. The pennies paid for the blessing of bread were assigned to the priory's chaplain.

92. Ibid., 252.

93. "Les sous-diacres et les acolytes recoivent les offrandes qu'on apporte à l'évêque, pour montrer qu'il ne doit pas administrer de ses mains, mais par celles des autres, les biens du temps." Durandus, *Rational*, 1854, chaps. 30, 37, vol. 2, 195.

94. Schreiber, 1948, pp. 244–58.

95. Eulogy, or *eulogia*, literally means blessing. The word had many meanings over time. Du Cange, vol. 3, 332–33. Bread called *eulogia* was often used as a gift or tribute, and by extension also referred to all Christian gifts. From the early Christian period, eulogy bread functioned as a meal which was blessed but not considered the true sacramental bread, and hence was a sort of substitute for communion. On its early Christian usage, and its continuing usage in the eastern church see Galavaris, 1970, 109–66, and Corblet, vol. 1, 216, 221. The identification of eulogy bread with blessed bread is made in the twelfth century by Honorius of Autun: "Statutum est ut panis post Missam benediceretur, et populo pro benedictione communionis partiretur; hoc et eulogia dicebatur." *Gemma Animae*, lib. 1, cap. 67, quoted in Du Cange, vol. 6,

131, s.v. "panis benedictus" (*PL* 172, col. 565). Schreiber correctly notes that the linguistic usage of the word *eulogia* shifts in the High Middle Ages, and in its place one finds generally the *panis benedicti*. Schreiber, 1948, 241–43. On eulogy bread, see also Franz, 1960, vol. 1, 247ff; *Lexikon für Theologie und Kirche*, vol. 3, cols. 1180–81; Browe, 1940, 185–200; *DACL*, vol. 5, pt. 1, cols. 733–34; Du Cange, vol. 3, 332–33, s.v. 2. and 3. "eulogiae."

96. On the change to unleavened wafers, see Jungmann, 1951–55, vol. 1, 84. On early evidence of the practice, see Du Cange, vol. 3, 332–33.

97. According to Jungmann, the custom of eulogy was so closely associated with communion as a substitute for the benefit of noncommunicants, that when the change to unleavened bread was made, eulogy at first took the form of hosts; but since the twelfth century a distinction was made between the form of eulogy loaves and communion wafers. Jungmann, 1951–55, vol. 2, 454. Eulogies were broken and distributed in fragments, from which came the name *panis fractus* for eulogy bread. Janssens, 1891, 28–41.

98. Jungmann, 1951–55, vol. 2, 360–62.

99. Eulogy was distributed on Maundy Thursday with a special ceremony. Browe, 1940, 191–92; *PL* 186, col. 1141. Jacob de Vitry (died 1240) thought eulogy should be omitted from the Easter services. Browe, 1940, 190.

100. Browe, 1940, 36.

101. Schreiber discusses the longevity of the custom in France. He sought to establish the continuity between present-day bread presentations on Sundays in France and medieval practices. Schreiber, 1948, 262–72. See also Franz, 1960, vol. 1, 255; Jungmann, 1951–55, vol. 2, 452; Janssens, 1891, 40. The practice of bread presentation and distribution on Sundays continues in the Beauce region of France. Marcel-Robillard, vol. 1, 1965, 76–79. This was confirmed to me by residents of Chartres in 1980. One can also still see bread offerings left by the altar in parish churches in France.

102. Franz, 1960, vol. 1, 229–78, esp. 260–63, 268, 274.

103. The earliest blessing of bread is from Gregory the Great's sacramentary. Janssens, 1891, 28. It is exactly the same as that in the Pontifical of Chartres.

104. The Chartres Pontifical, made for the bishop before 1236, includes this bread blessing: "Benedic Domine creaturam istam (dictio panis) panis sicut benedixisti quinque pane in deserto, ut omnes gustantes ex eo accipiant tam corporis quam anime sanitatem." Orléans, Bib. Mun. MS Lat. 144, fol. 143v.

105. Browe, 1940, 191. Distribution of eulogy bread is generally said to have occurred at the close of mass. Jungmann, 1951–55, vol. 2, 453; Franz, 1960, vol. 1, 247–63; Browe, 1940, 185–200; Janssens, 1891, 31–32.

106. There is very little evidence of the cathedral's charity. Charity was evidently distributed during some processions, since there is special mention in the ordinary on one procession not to do so. Delaporte, 1953, 98.

107. Andrieu, 1940b, Liber Secundus, XXIV, #3–10, 538–39.

108. The festive oblation and blessed bread in the charters were presented to the parish priest but frequently divided between him and the church lord. See discussion in Schreiber, 1948, 268–72. Schreiber differentiated between offerings made to the hands of the priests, and those made to the altar, the former to be retained by the priest, while the latter was subject to outside claims. Ibid., 269–70.

109. In 1300, the resident canons received two loaves and 6 deniers as distributions daily. The nature of this bread is not stated; hence, it could easily have been presentation bread collected in the cathedral and given back to the canons. This would be in keeping with the notion of *altarium* belonging to the presiding priest. *CND* II, *Polypticon*, 298–99.

110. Blaise, 1975, 135; Du Cange, vol. 2, 90. See also the mention of "artificiales panes quos canistrellos vocant" in a charter from Chartres dated 1176. A footnote explains that this bread had the form of a *canistrum*, the container in which one conserved eulogies or blessed bread. *CND* I, #89, 1176, 196 and n. 1. The basket is also called *chenestelli* in a local document. *CSJV* #226, 1227, and 110, note 1.

111. No one else has noticed that Christ's blessing can be seen to be directed toward the bread at his feet. According to Tom Cummins's reading of the literature on the trumeau, the two parts of the trumeau, the Beau Dieu and the socle, are always discussed separately in the literature. Cummins, 1980, 86.

112. Weber interpreted the scene as a bread sale; the figure with breads in a sling buys from the seated pair whom he identifies as a baker and his wife. He sees them by their attire as similar in rank to the couples depicted as shoemaker-pilgrims in Bays 74 and 121. Weber, 1984, 6. However, the woman's attire in the socle is definitely that of the upper class, and could not, I contend, have been a lowly baker's wife.

113. This was first suggested by Vincent Sablon in 1671, undoubtedly following a long tradition based on the heraldry in the south transept clerestory. Sablon, [1671] 1835, 23. On these clerestory windows, see Villette, 1982, 74–10. See also Gilbert, 1824, 41, and Delaporte, 1926, 429–37, plates CXCVI–CCIV.

114. Van der Meulen, 1965, 120; 1967, 154 and n. 18.

115. Villette, 1982, 7–10. The man with a sling in the apostles' chapel window also wears a flowered headband, casting doubt on Villette's interpretation. Weber pointed out the frequency of flowered headbands on artisans, illustrating as evidence a shoemaker in Bay 7. Weber, 1984, 8–9.

116. Weber, 1984, 10.

117. The center figure, which Villette believes to be Count Louis, wears different clothing from that of the kneeling figure above him, so that Villette's identification of the lower socle figure is unconvincing.

118. *CND* III, 89–90; *OPS* II, 58–59.

119. Weber sees a strong similarity between the simple robe and single belt-cord of the kneeling man in the socle and the garments of men he identifies as heads of shoemakers' confraternities in several windows in the cathedral. He even notes a flowered headband, similar to the one on the kneeling man in the socle, depicted on the head of a shoemaker in the window of St. Stephen. He notes that the nobility in the windows usually are identifiable by their blazon, and usually wear armor and a *surcot* or sleeveless tunic. Weber, 1984, 10.

120. Michler, 1989, 117–31.

121. Gilbert, 1824, 41; Bulteau, 1887–92, vol. 2, 292; Duvergie, 1914, 86; Mâle, 1948, 105; Delaporte, 1959, 104; Sauerländer, 1970, 432. In his 1975 publication, Peter Claussen made the first and only attempt so far to justify this assumption. He cited the historical record of almsgiving to the poor on the porches of three German cathedrals as indication of a generalized medieval

practice that was institutionalized on the south porch of Chartres, evidenced by the portal sculpture. His evidence is from the fifteenth century. Claussen, 1975, 13.

122. This apparently refers to the feeding of the poor at the cathedral's alms house. *CND* III, Necrologium, 89–90. The money for the refectory of the Hôtel Dieu does not prove, as Van der Meulen suggests, that distribution of bread to the poor is pictured on the socle.

123. On the window of Sts. Anthony and Paul, see Delaporte, 1926, 212, and plates XXXVI–XXXIX. On the window of St. Thomas, ibid., 360, and plates CXXXVI–CXXXIX.

124. Tilmann Buddensieg, in an article about the Bâle altarpiece, states that the trumeau of Chartres is the first Gothic example of Christ trampling the lion and dragon, illustrating Psalm 90 (91). He declares that there are two figures at Christ's feet, Pierre of Dreux and Anne of Bretagne, whom he compares to the royal figures kneeling at the feet of Christ in the altarpiece. Buddensieg, 1957, 152–53, and n. 58.

125. Houvet, 1919, plate 33.

126. Buddensieg, 1957, 140–44. For a comprehensive discussion of the tradition of the imagery of Psalm 90, see Verdier, 1982, 35–106.

127. Quoniam in me speravit, liberabo eum;
Protegam eum, quoniam cognovit nomen meum.
Clamabit ad me, et ego exaudiam eum;
Cum ipso sum in tribulatione;
Eripiam eum, et glorificabo eum.
Longitudine dierum replebo eum,
Et ostendam illi salutare meum.
Psalm 90 (91), 14–16

128. Orléans, Bib. Mun., MS 144, fol. 71r This image in the Pontifical was first called to my attention by Tom Cummins, who wrote his master's thesis on the trumeau of the south portal at Chartres.

129. See the twelfth-century sacramentary from Chartres now in Paris, Bib. Nat. MS lat. 1096, fols. 80r–80v; also Jungmann, 1951–55, vol. 2, 46–49, 52.

130. On the identity of the figures under the apostles on the south porch, see Sauerländer, 1972, 112–13.

131. Henderson, 1968, 134.

132. Villette, 1982, 8.

133. On the litanies, see Delaporte, 1953, 197–98, and Paris, Bib. Nat. MS lat. 1096, fols. 63v–65r; on the mass, see ibid., fols. 72r–74r; on the Feast of All Saints, see ibid., fol. 95v, and Delaporte, 1953, 184–86. See also the apostles, martyrs, and confessors invoked in the Prayer for the Holy Land at the Cathedral, ibid., 197–98, and in the Laudes Regiae, ibid., 242–44.

134. *CASP* II, #133, 1142–58, 618–20; *CND* I, #65, 1157, 164–66; *SMJ* I, #267, 1176, 313; *CASP* II, #86, 1213, 676–77; *CSTE,* #11, 1225, 152; *CASP,* II, #110, 1236, 688–90.

135. Villette thought that this man was a baker who had just come from tending an oven. Villette, 1964, 105. This could be correct, but I doubt the bread itself is a single baker's offering. He may simply be a porter.

136. *PL* 202, col. 1046.

137. Amiet, 1922, 144–48.

138. On the mid-thirteenth-century stone *jubé* at Chartres, see Mallion, 1964.

139. Giuseppe Wilpert, 1929–36, text vol. 2, 343–47, plates LIII, CLXIII, CLXIV, CCXX; Engemann, 1973, pl. 57. It is not always clear whether the Agape or the Last Supper was represented.

140. Espérandieu, vol. 10, #7535, 175–76.

141. London, British Museum, MS. Cottonianus Julius A.VI, Winchester School (see Webster, 1970, 53–55, and catalogue no. 33, 134–35 and plates 17–18); and London, British Museum, MS Cottonianus Tiberius B.V. (see Webster, 1970, 53–55, and catalogue no. 34, 135–36, and plates 19–20).

142. The Miracles of the Virgin window, Bay 9, retains only the lower portion of its original glass. Pintard's description of the whole window is our only evidence of its lost contents. Delaporte, 1926, 194.

143. Ritter, 1926, 41 and plate V.

144. The scene occurs in the first window of St. Austremoine in an ambulatory chapel at the cathedral of Clermont-Ferrand. Ranquet described the window scene: "In the assembly before the platform, women have on bonnets so characteristic of the thirteenth century. The scene takes place not far from the shore of the Allier. Lumberjacks who were cutting wood across the river came to him, and one who was touched by his teaching comes forward humbly with hands joined to ask the saint to bless him and give him eulogies. The saint consents and blesses the man while handing the convert sanctified bread." Ranquet, 1932, 53. The windows must date well after the beginning of construction of the new cathedral in 1248, and hence certainly postdate the windows at Chartres. Ibid., 4. The pictorial narrative derives from the saint's legend. *Beatus pontifex Austemonius juxta flaveris flumen praedicaeret, AA SS* I, 51.

145. In other gospel accounts of the moment, Jesus' words are more abbreviated: "Take this. This is my body" (Mark 14: 22); "Take and eat this. This is my body" (Matt. 26: 26).

146. On Distinctions in general, see Rouse and Rouse, 1974, 27–37; also Rouse, 1976, 115–47.

147. Rouse, 1976, 118.

148. Published from a fifteenth-century copy in *PL* 210, cols. 687–1012. See also Wilmart, 1940, 338.

149. On Pseudo-Germanus, see Galavaris, 1970, 182–83.

150. *Liber de Panibus,* caps. 7, 21, *PL* 202, cols. 959, 1017–22.

151. There are four surviving Moralized Bibles made in Paris in the early thirteenth century. According to Robert Branner, the two now preserved in Vienna are the earliest: Vienna Österreichische Nationalbibliothek (hereafter ÖNB) 1179 in Latin and ÖNB 2554 in French. The third is in Latin in three volumes, preserved primarily in the Cathedral of Toledo, with the last eight folia in the Pierpont Morgan Library, Morgan 240. The fourth is called the Oxford Bible. It now exists in four volumes, but only the first volume is in Oxford, Bodleian 270b; the second volume is in Paris, Bib. Nat. lat. 11560; and the third and fourth volumes are in London, Brit. Mus. Harley 1526 and 1527. Branner, 1977, 22–65. Branner dates the Vienna Bibles between ca. 1212 and ca. 1225; the Toledo Bible 1220s to ca. 1235; and the Oxford Bible ca. 1235–45. Ibid. 48, 64–65. I have not yet been able to see the volumes in Spain, but I have looked at the other three. Two have been published. Reiner Haussherr

published a facsimile edition of the Codex Vindobonensis 2554 (Haussherr, 1973). Alexandre Laborde published a black and white facsimile of the Oxford Bible in his earlier study of the Moralized Bibles. Laborde, 1911–27.

152. "Il i vient Moyses et ses peuples et prenent un pain et li mettent en un for et puis le truient" (Lev. 2:4). "Ce qe li pains fu mis el for par le commandemant Deu senefie qe iesu criz fue mis el ventre a le pucele par le commandemant del père del ciel et par annuncement del angle" Vienna Bib. Nat. MS Fr. 2554, fol. 27. The same idea is contained in the Oxford Bible, Bodl. 270b, fol. 59v and in the Vienna Bib. Nat. Lat. 1179, fol. 14.

153. "Il i vient li peuples et prenent le pain qe il orent trait del for et sien font offrande a Deu sur un autel de pierre" (Lev. 2:9). "Le pains qi fu el for et fu offert a Deu senefie iesu criz qi fu el ventre a la pucele et fu offert a père del ciel ou temple qant symeon le receut." Vienna Bib. Nat. MS Fr. 2554, fol. 27.

154. *Liber de Panibus,* cap. 26, *PL* 202, cols. 1040, 1044. See also Kirschbaum, vol. 4, col. 423.

155. Forsyth, 1972, 52–59.

156. See the illustration of a fresco in the catacomb of Sts. Pietro and Marcellino, illustrated in Ihm, 1960, plate XV, 1; also J. Wilpert, 1903, pl. 60.

157. The two capitals at the porch to the north of the cathedral at Le Puy show a figure approaching a seated Virgin with a bread offering. I do not know of any publication of these capitals.

158. Forsyth, 1972.

159. On the medieval theological writings about Mary as the Seat of Wisdom, see ibid., 24–26.

160. Katzenellenbogen argues that the twelfth century understood the Eucharist to be the *corpus verum.* Katzenellenbogen, [1959] 1964, 12–14. See also Lubac, 1949, passim.

161. Gifts were presented to the *Sainte Chasse,* which contained the Virgin's tunic, and to the statue, *Notre-Dame-sous-terre.* Forsyth, 1972, 109–10.

162. Ibid., 8, 9.

163. Ibid., 105–11; Delaporte, 1955, 6–32; Mâle, [1922] 1978, 282–85. For a review of all the cathedral images of the Magi presenting their gifts, see Lemarié, 1986, 4–13.

164. Delaporte, 1955, 36–39.

165. In the account of the miracles of the Blessed Virgin of Chartres, pilgrims are described crowding around the main altar, on which the new statue was placed. A. Thomas, 1881, 512. In the Miracles of the Virgin window, Bay 9, pilgrims appear rushing toward the thirteenth-century altar of the Virgin bearing gifts. Delaporte, 1926, 189–92, pls. XXIX–XXXI.

166. Ihm, 1960, 67–68.

167. The idea of transubstantiation developed in the West from the eleventh century, but was not ecumenically promulgated as dogma until the Fourth Lateran Council in 1215. *Catholic Encyclopaedia,* vol. 5, 579. On the medieval understanding of the *corpus verum* in the eucharistic bread, see Lubac, 1949.

168. On the iconographic tradition of the multiplication of the loaves, see Kirschbaum, vol. 1, cols. 326–30, s.v. "Brotvermehrung"; on the special tradition of Christ enthroned above loaves on a lost fresco in the Roman catacombs, see *DACL,* vol. 13, pt. 1, col. 447, fig. 9362.

169. On the series of biblical events which anticipate the bread of the Eucharist, see Daniélou, 1963, 142–61.

170. Bread presentations at Christmas: *CASP* II, #133, 1142, 618–20; *CV,* #94 and #95, ca. 1160, 120–23; *SMJ* I, #267, 1176, 313; *SMJ* I, #304, 1200, 349; *CND* II, #146, 1201, 7–9; *CASP* II, #86, 1213, 676–77; *CLGB* #312, 1237, 128; *CSJV,* #333, 1258, 162–63; *CND* II, #385, 1300, 239–45.

171. *CND* II, #385, 1300, 239–45.

172. The visit of the Magi described in Matthew 2:1–12 was the standard gospel reading for Epiphany. Frere, 1934, 30, 237. The multiplication of the loaves, that is, the story of the feeding of five thousand with five loaves and two fishes, appears in Matthew 14:13–21, Mark 6:32–44, and Luke 9:10–17. The account in Matthew 14:15–21 was a standard gospel reading during the week in February after epiphany. Frere, 1934, 33, 328. The account in Mark 6:34–46 was also read during the week in February after Epiphany. Ibid., 33, 241.

173. The miracle at Cana was thought to have occurred thirty-one years after the adoration of the Magi on the same day, January 6. The baptism of Christ was thought to have occurred thirty years after the adoration, also on January 6. Hence the first three manifestations of God to man were celebrated on Epiphany, and the feast was first referred to as Theophany. Roger Adams, 1982, 34, and n. 63, gives medieval sources for this concurrence.

174. *CASP* II, #133, 1142–58, 618–20.

175. Bread presentations at the Purification: ibid.; *CND* I, #65, 1157, 164–66; *MCB,* #170, 1163, 159–60.

176. Parishioners must go to the cathedral for Ascension Day, and also the purification of women. *CND* I, #130, 1195, pp. 250–51.

177. Browe, 1940, 197.

178. The seal had on its reverse the Annunciation, combining two images that are in the window. *CND* I, 135, note 3; *TEL* 188.

179. Delaporte, 1926, 466, and plates CCXXIV and CCXXV. On Moses' horns, see Mellinkoff, 1970, 67–68, and fig. 62.

180. Mary emerges from the burning bush in a relief on the east portal of the north porch at Chartres beneath the figure of Mary in the Visitation. Adams, 1982, 32. On Moses and the burning bush, see Réau, vol. 2, pt. 1, 185–86; *LCI* I, 510–11; Kirschbaum, vol. 3, cols. 282–97.

181. Réau, vol. 2, pt. 1, 187–88. For example, see the mural of Christ and the four beasts accompanied by the burning bush in the apse of Berghausen. Demus, 1970, plates 266 and 267. See also stained-glass images of Moses before the burning bush at Cappenburg Castle (Grodecki, 1977, 152) and in the Laon apse, Bay 2, ca. 1210–15.

182. Grodecki, 1977, 152, 153.

183. Madeline Caviness dated the surviving windows in the typological series to 1179–80, some forty years before the window at Chartres. Caviness, 1977, 154, 168.

184. *CVR* I, Bay 2, 163.

185. Delaporte observed that the alternating predomination of red and blue in the lancets is symmetrical, but the divisions and medallions within the five lancets are not symmetrically arranged. Delaporte, 1926, 132.

186. Clermont and Weber expanded on the work of Delaporte. Clermont and Weber, 1982, 4–9. See also Faucheux, 1990; Grodecki, 1963, p. 150; Delaporte, 1926, 132, 464–70; Bulteau, 1887–92, vol. 3, 216–18.

187. Isaiah's most famous prophecy of the Virgin, "And there shall come

forth a rod out of the root of Jesse" (Isa. 11:1–5) was the lesson for the sixth feria of Advent in December. *Liber Comitis* Advent reading for feria VI: *Egredietur virga . . . renum elcius.* Frere, 1935, 19. It was also read at Christmas, as was Isaiah 9:6–7; Isaiah 7:14 was read during Advent. Ibid., 106.

188. Book of Numbers 17:1–10. See *Oxford Dictionary of the Christian Church*, 1978, 1. Three stages of vegetable life as simultaneously visible according to the biblical text: blossoms, buds, and fruit. The window shows only two stages: Aaron holds a white rod terminating in three buds; a golden chalice rests atop the buds, from which grows a white branch topped by leaves and red blossoms.

189. Aurenhammer, 1959, 5, s.v. "Aarons Stabwunder," 6, s.v. "Aaronstab"; *RDK* vol. 1, cols. 9–11. In the Oxford Moralized Bible, Numbers 17:8–9 is illustrated. Aaron's blossoming rod is juxtaposed with a Nativity scene in which a midwife holds up the newborn Jesus. The accompanying text explains that Aaron's rod signifies St. Mary, the virgin who gave birth to Christ. Oxford Bodl. 11560, fol. 79v.

190. See, for example, the west lancet of the Tree of Jesse from the twelfth century at Chartres. Delaporte, vol. 1, 147 and plates I–III.

191. Jeremiah 1, 11. See Réau, vol. 2, pt. 1, 371; Kirschbaum, vol. 2, cols. 387–92.

192. Heimann, 1968, 89–102.

193. Ibid., 92 and note 104.

194. Ibid., 92 and note 108.

195. Since we have no documentary evidence to explain the scene, speculation about the identity of the man called Gaufridus cannot be confirmed. (See Delaporte, 1926, 468–69, plates CCXXV, CCXXVI, CCXXIX.) He would appear to be a tradesman with a stocking-maker's banner, suggestively placed opposite the scene of Moses removing stocking-like shoes. I have found no documentary evidence of trade banners in the thirteenth century at Chartres.

196. Ibid., 470, plates CCXXX–CCXXXIII.

197. Heimann, 1968, 96–97 and plate 41a.

198. Ibid., 464–66, plates CCXXII–CCXXIII.

199. Schiller, 1971, vol. 1, 34.

200. See the 1268 statutes of the wool workers published in Aclocque, 1917, 327–36. The wool of Chartres is described as "dras tainz, raiez et bloef et piars. . . ." Ibid., 329.

201. *Liber de Panibus,* cap. 7, *PL* 202, cols. 958–66.

202. The *Glossa Ordinaria* compares the five loaves which Christ multiplied, as described in Matthew 14:17–19, to the five books of Moses. *PL* 113, col. 136.

203. Vienna, *ÖNB* 2554, fol. 24v.

204. Hrabanus Maurus, *Allegoriae in univerram sacram scriptaram, PL* 112, col. 1020.

205. "Panis noster Christus est virga deradice Jesse, et flos." *Glossa Ordinara,* lib. Isaiae, cap. 4, *PL* 113, col. 1240.

206. Vienna, *ÖNB* 1179, fol. 140r.

207. Réau, vol. 2, pt. 1, 402.

208. *Liber de Panibus,* caps. 9, 10, cols. 969, 974.

209. Ibid. caps. 9, 20, cols. 969, 1013.

210. Ibid., caps. 6, 20, cols. 955, 1013.

211. Ibid., cap. 7, col. 960.

212. Ibid., cap. 5, *PL* 202, col. 951.

213. Ibid., cap. 18, col. 1004.

214. Delaporte, 1926, Bay 34, 296–301, and plates XCII–XCV. Bulteau, 1887–92, vol. 3, 270–71. Nine panels were removed in the Revolutionary period and replaced by a wall. The removed panels were inserted in other windows; Bulteau observed some of them in 1850. The window was restored in 1872 by Coffetier and Steinheil, who reincorporated one of the removed panels, panel 2. They did not follow the late seventeenth-century descriptions of the window by Pintard in designing the six panels that they replaced with new glass, and they did not put the old panels back in proper order. Lorin reinserted two more alienated panels in 1921, panels 1 and 3, and reordered some of the misordered panels. Delaporte, 1926, 296–97. The ambulatory chapel of the apostles also contains three other large historiated windows dedicated to St. Paul, St. Andrew, and Sts. Simon and Jude; the fifth window in the chapel is grisaille.

215. Delaporte, 1926, 212 and 360.

216. On medieval merchant's attire, see Norris, 1927, vol. 2, fig. 233, 170.

217. The pose of his arms in a ubiquitous one in medieval images of work, repeatedly used to portray intense physical labor. See for example the shoemakers in Bays 6 and 41, or the leather workers in Bays 24, 25, and 167.

218. Delaporte wondered if this was a repair. Delaporte, 1926, 297. The style is clearly later than that of the rest of the scene.

219. Nash, 1968, vol. 2, 330.

220. Espérandieu, vol. 6, #5268, 439–60; Zahn, 1976, 20, plates 18 and 19; Schindler, 1980, 50, and fig. 7.

221. The illustration of the Vocation of the Apostles is rare in medieval art. See Kirschbaum, vol. 1, cols. 165–67, s.v. "Apostel II"; Réau, vol. 2, pt. 2, 311–13; Schiller, 1971–72, vol. 1, 155–56. The closest examples to the window are found in Greek manuscripts: Paris gr. 74, fol. 8; Paris, gr. 510; Homilies of Gregory Nazianzus, Cod. Laur. VI 23 and fol. 426v, fol. 87v. On Pentecost iconography, see Schiller, 1966–80, vol. 4, pt. 1, 18–25; Réau, vol. 2, pt. 2, 591–96; *DACL* vol. 14, pt. 1, cols. 260–74; Kirschbaum, vol. 3, cols. 415–23.

222. Kirschbaum, vol. 1, col. 152, s.v. "Apostel I. Apostelgruppen u. reihen."

223. Vienna, ÖNB 2554, fol. 24r.

224. *PL* 202, cols. 967–72.

225. According to Delaporte, Judas holds a purse and turns to depart. It is more likely, however, that Judas is holding the bread which Jesus has given him to identify him as his betrayer, described in John 13:21–27. (The Last Supper appears in all four gospels: Matthew 26:20–30; Mark 14:17–25, Luke 22:14–23, and John 13:18–30.) Schiller discusses the iconographic variations of the scene in medieval art. Judas frequently appears in the Last Supper holding a loaf and thrusting his hand into a dish, as in the Ingeburg Psalter, fol. 23r. In the psalter, Jesus holds up both the cup and the bread, instituting the Eucharist, while at the same time the identity of the traitor is made clear by Judas's actions. Schiller, 1966–80, vol. 2, 24ff., and pl. 87. The window image is close in concept to the psalter illustration, but follows the iconographic tradition of the scene established in Ottonian manuscript illumination. (See, for

example, the Golden Gospels of Henry III, Escorial, Cod. Vetrinas 17, fol. 52.)
On the iconography of the Last Supper, see also Kirschbaum, vol. 1, cols. 10–18.

226. The iconography of the scene has its precedent in English manuscript illumination, such as the Missal of Robert of Jumièges, 1006–1023, Rouen, Bibl. Mun., MS Y 6, 274. See Schiller, 1966–80, vol. 3, 141, 157–58; Réau, vol. 2, pt. 2, 582–90; Schapiro, 1943, 135–52. See also Réau, vol. 2, pt. 2, 582; Kirschbaum, vol. 2, col. 268.

227. Vienna, "ÖNB 2554, fol. 28r.

228. Vienna, ÖNB 1179, fol. 45v.

229. Similar scenes appear at the tops of Bays 17 and 52 at Chartres, where Christ is seated on an altar between candles, and blessing with his right hand. However, in these scenes, he holds a book, not a globe.

230. For discussion and bibliography, see von den Brincken, 1985, 99–100.

231. The globe Christ holds is upside-down in Bays 6, 37, and 40 also. Delaporte calls it the globe of the world. Delaporte, 1926, 313, 331. This might simply be an incorrect reinstallation of the panels after World Wars I and II, when the windows were removed for safekeeping. There is no indication that I know of in the medieval period that the world upside-down held special significance as it did later. Cocchiara, 1981. The globe appears upside-down in other medieval images: Vienna ÖNB 1179, fol. 171v. On the globe as an imperial symbol of power, see Schiller, 1966–80, vol. 3, p. 176.

232. Vienna, ÖNB 1179, fol. 165v, and 2554, fol. 48v.

233. Christ appears in Paradise at the summit of many of the lower-story windows at Chartres: Bays 10, 17, 21, 24, 40, 49, 52, 58, and 59. In five of these, Bays 10, 24, 40, 49, and 58, he holds up a globe. Jan van der Meulen published a careful study of two similar images in the clerestory oculi at Chartres. He demonstrated that one was a late, misunderstood copy of the other, its medieval counterpart. The medieval original shows Christ as Creator of the world, seated on a bench between the sun and moon. He holds a globe divided horizontally into three zones signifying the heavens, dry land, and sea. In the Apostles' window, the scene is quite different. Van der Meulen, 1966, 82–100.

234. Delaporte, 1926, 434–35.

235. Schapiro, [1954] 1977, 306–27.

236. Delaporte, 1953, 226–39.

237. The lists of names of the apostles after the death of Judas varies. The disciple Nathaniel was identified with Bartholomew by the twelfth century. Miller and Miller, 1973, 62, s.v. "Bartholomew." See also *DACL* vol. 1, pt. 2, col. 2631.

238. Delaporte, 1953, 25, 39. The thirteenth-century ordinary specifically states that processions at vespers went to the apostles' altar in the apostles' chapel before the feasts of Sts. Philip and James the Less on May 1, St. Bartholomew on August 24, and Sts. Simon and Jude on October 28. Ibid., 53, 56, 62. Although the thirteenth-century ordinary does not specify it, this was undoubtedly also the destination of the vesper processions before the feasts of St. John the Evangelist on December 27, St. Matthew on September 21, St. Andrew on November 30, and St. Thomas on December 21. Ibid., 42, 63, 64, 78, 80–85.

239. Ibid., 25, 168, 54.

240. Ibid., 108, 261–64. The Washing of the Feet took place on Maundy Thursday. Kantorowicz, 1956, 205. Hence the depiction of the feet-washing adds to the emphasis on Maundy Thursday in the window.

241. Andrieu, 1940, Liber Secundus, XXIV, 538–39.

242. See above, note 55.

243. Pentecost: CASP II, #145, 1101–29, 360; CSJV, #333, 1258, 162–63. Ascension: II, #133, 1142–58, 618–20; II, #86, 1213, 676–77; CSJV, 33, 1258, 162–63.

244. Weber believes these to be the earliest of the bread scenes, but the dating he relies on has been refuted, since the lower story was built before the upper one. Weber, 1984, and James, [1977] 1981.

245. This was apparently a tool used for making tarts and pastries. One can still see such tools preserved in the bread museum on the outskirts of Paris.

246. Several French scholars have identified this as a *moule à gaufres*, a sort of waffle pan. Lasteyrie, 1853–57, vol. 1, 69; Delaporte, 1926, 415; Villette, 1964, 106.

247. On *tortelli*, see *CND* I, #58, 1149–55, 157.

248. Both these windows are obviously heavily repaired. I have not been able to get permission to climb on the roof to observe the glass in the north nave clerestory. It is entirely possible that the bread images are copies of the other scenes. Some of the nineteenth and early twentieth century stained-glass ateliers were extremely accomplished at copying thirteenth-century style and simulating the ravages of time. What argues against this is the repaired look of the scenes, as if parts are probably still original, and parts clumsily repaired.

249. Cahier and Martin, 1841–44, 272–76, plate XV.

250. The Corpus Vitrearum census dates the Bourges window of St. John the Evangelist to 1210–15. *CVR* II, 1981, Bay #22, 174. The same publication dates the Apostles' window in the ambulatory at Chartres to 1210–25. Ibid., 27.

251. Faint traces of marking similar to those on the loaves in the window of the Apostles at Chartres can still be seen. The scene depicts a man removing a loaf from an oven with a long wooden peel. A large basket full of small, somewhat flat, white loaves sits beside him. It is different in appearance from the *canistrum* at Chartres. Another man with a basket and peel appears in the background, apparently awaiting his turn at the oven. A similar scene appears in the choir clerestory at Le Mans. It has its precedent in late Roman and Gallo-Roman reliefs.

252. Raguin, 1982, 153. Raguin considers the cycle to have been created by the "Genesis Atelier." Ibid., 41. On the story of Mary of Egypt, see Jacobus de Voragine, *The Golden Legend*, trans. Ryan and Ripperger, 1969, 228–30.

253. In the lowest register of four lancets in the upper southern choir clerestory at Le Mans, men measure grain, prepare loaves, bake them in an oven, and set them out on a stall table for sale. Window #212. See Mussat, 1981, 184. See also Bouton, 1962, 634–35. Bouton discusses the bakers at Le Mans, but his sources are from the fourteenth and fifteenth centuries. Ibid., 544–46.

254. Delaporte, 1926, 415, plate CLXXXIV.

255. Bay 74, Delaporte, 1926, 420, plate CLXXXVII.

256. Delaporte, 1953, 54, 166. On St. James, see also Réau, vol. 3, pt. 2, 690–702; Kirschbaum, vol. 7, cols. 23–39.

257. Bays 37, 74, 106, and 133. Delaporte, 1926, 307–13, 420, 446–48, and 484–85. A fresco depiction of St. James appears in the chapel of St. Clement in the crypt. Deschamps and Thibout, 1963, 35, plate XII–1.

258. Delaporte, 1926, 416 and plate CLXXXIV. On St. Peter holding the keys, see Carr, 1978a, 60–68.

259. Delaporte, 1926, 416 and late CLXXXV.

260. His image appeared in column statues at all three entrances, and in stained glass in Bays 86 and 123. Delaporte, 1926, 426 and 471–72.

261. Delaporte, 1953, 14, 31, 54, 55, 66, 150, 161, 168.

262. *PL*, 202, cap. 10, cols. 972–77.

263. Ibid., caps. 11, 27, cols. 977, 1046.

264. A. Thomas, 1881, 514–17.

265. On these prohibitions in Paris, see Lespinasse and Bonnardot, 1879, 8, n. 23.

Chapter Four

1. Car le parole et le renon
 Des bons vins avoit entendu
 Qui a Chartres erent vendu,
 Clers, seins, nes et delicïeus. . . .
 Si que tantout com il vint la,
 Tot droit an la taverne ala.
 In Kunstman, 1973, 157.

2. Delaporte, 1926, 405–8, and plates CLXXV–CLXXVIII. The window is dated to 1205–15 in the Corpus Vitrearum, and assigned a new number. *CVR* II, Bay 45, 34. I am indebted to Anne Pascaud-Grandboulan, who under difficult circumstances patiently analyzed for me the condition of the glass in this window and in the oculus dedicated to St. Lubinus. Despite numerous repairs over the centuries, the windows seem to retain a great deal of original glass and their original iconography. More scientific analysis of the window's condition must await publication of observations made during its removal for cleaning.

3. On the oculus of Lubinus, Bay 172, see Delaporte, 1926, Bay 172, 516–17, and plate CCLXXIV; *CVR* II, Bay 139, 42, dated to 1205–15; Aclocque, 1917, 314; Bulteau, 1887–92, vol. 3, 1892, 220. On the imagery of Lubinus, see also van der Meulen, 1974b, cols. 412–14.

4. There are two scenes of vineyard workers in two windows of the south ambulatory, which I believe are concerned with the donation of vineyards, and do not depict any wine-drinking. A vintner's window in Le Mans Cathedral shows both vineyard workers and men tasting the wine, but it dates much later in the thirteenth century. Accordingly, the imagery in this latter instance can be argued with contemporary documentation to indicate window donation.

5. On the St. Lawrence window, see Delaporte, 1926, 377–80, plates CXLVIII–CXLIX; Bulteau, 1887–92, vol. 3, 253; *CVR* II, 33, Bay 33.

6. Bay 139 represents Sts. Philip and Jude above a kneeling cleric before an altar with a huge chalice on it. Delaporte, 1926, 491, and plate CCXLVIII; Bulteau, 1887–92, vol. 3, 226–27, Bay 24; *CVR* II, 39, Bay 117.

Bay 140 represents Sts. Anthony and Philip. Delaporte, 1926, 491, and plate CCXLIX; Bulteau, 1887–92, vol. 3, 226, Bay 23; *CVR* II, 39, Bay 117.

Bay 141 is an oculus above the two previously described windows which repeats the image of the kneeling cleric at the bases of those windows. Delaporte, 1926, 492, plate CCLIII; Bulteau, 1887–92, vol. 3, 226, Bay 24; *CVR* II, 39, Bay 117.

Bay 142 represents Sts. Thomas and Jude. Delaporte, 1926, 492, plate CCLI; Bulteau, 1887–92, vol. 3, 226, Bay 22; *CVR* II, 39, Bay 119.

Bay 143 represents Sts. Thomas and Barnaby. Delaporte, 1926, 492, plate CCLII; Bulteau, 1887–92, vol. 3, 225, Bay 21; *CVR* II, 39, Bay 119. On these four very similar lancets, see also Van der Meulen and Hohmeyer, 1984, 81–82, and plates XVIII–XXI; Van der Meulen, 1966, 82 and note 2; Grodecki, 1978, 52–61; Grodecki, 1948, 130–34.

7. Delaporte, 1926, 431–36, plate CIC.

8. Ibid., 438 and plate CCVI.

9. Scholars concur that tavern keepers donated the windows:

1888	de Mély, 420
1892	Bulteau, vol. 3, 220, 245–46
1922	Headlam, 171
1917	Aclocque, 313–14
1926	Delaporte and Houvet, 405–6, 517
1930	Houvet, 31
1962	Von Simson, 166–67
1963	Grodecki, 181
1964	Villette, 109–10
1970	Popesco, 56–57
1976	Seddon, 75
1984	Grodecki and Brisac, 61
1986	DeCosse, 107
1987	Kemp, 242
1988	Deremble and Manhes, 119

10. Delaporte, 1926, 491–92; Bulteau, 1887–92, vol. 3, 225–27.

11. Derembles-Manhes' thesis on the windows includes a section on the Lubinus window at Chartres, in which she notes the work of Chédeville in commenting on the dedication of a priory to St. Lubin in the vineyards near Chartres, and wonders if the woman at the base of the window has a *banvin* payment in her purse. She does not develop these arguments. Derembles-Manhes, 1989, 596–633. Stylistic affinities between the windows of St. Lubinus, St. Nicholas, and Noah at Chartres were noted by Delaporte and affirmed by Grodecki and Brisac. Delaporte, 1926, 131; Grodecki and Brisac, 1984, 62. Grodecki also associated the Lubinus window's style with that of the Good Samaritan window at Bourges. Grodecki, 1975, p. 343. See also Hayward and Cahn, 1982, 162–64; Aubert et al., 1958, 129.

12. DeCosse's article was unfortunately without footnotes or bibliography. DeCosse, 1986, 107–9.

13. Kemp, 1987, 242–61.

14. Kemp subsequently published an article in which he acknowledged he had not known about my dissertation, and—much more surprisingly—he had

not known about the monograph of André Chédeville of 1973 when he wrote his book. The article was supposed to make up for these omissions. But in the article Kemp reiterated his reception theory and his treatment of the Lubinus window from his book, reserving his refutation of my work to a footnote and never commenting on the monumental study of Chédeville. Kemp, 1989, 242–61.

15. She tantalizingly noticed that the window appropriately combined the saint with wine, since the priory of St. Lubinus near Chartres was located in vineyards, but only hazarded a guess that the little secular images might relate to the *banvin* tax discussed by Chédeville. Deremble-Manhes, 1989, 596–633.

16. Deremble-Manhes, 1988, 119, and 188.

17. The reader will note that I have commented on Wolfgang Kemp's publications in Chapter 1.

18. A. Thomas, 1881, 525; Kunstmann, "Jehan le Marchant," 1973, 157.

19. Chédeville, 1973, 232.

20. Ibid., 223, 224, and note 366.

21. The local documents also frequently refer to small vineyards, of less than one acre, cultivated by men in addition to their regular occupations. Ibid., 226–28.

22. On the numerous small vineyards in the vicinity of Chartres between one-fourth and three arpents in size, see Chédeville, 1973, 236. Some charters evidence the principal occupation of small-vineyard owners: *CLGB*, #312, 1237, 128–29.

23. Ibid., 232–33.

24. In addition to the bishop's vineyards, some monastic vineyards are known from the Carolingian period. Chédeville, 1973, 232–33 and n. 449. Old vineyards were large, twenty-five to thirty acres, and were enclosed and guarded. Ibid., 224.

25. Ibid., 224.

26. The 1300 *Polypticon* of Chartres lists prebend vineyard holdings and receipts from the diocese and payments the chapter received in the town and its outskirts, including numerous wine payments, and numerous donations. *CND* II, 287–429. Donations of vineyards appear repeatedly in the necrology. *CND* III, 24, 43, 81, 97. See also Chédeville, 1973, 232.

27. Amiet, 1922, 112–18.

28. Chédeville, 1973, 227. According to Duby, this was the best way for lords to profit from their vineyards. Duby, [1962] 1981, 140.

29. Tenants worked under a wide variety of conditions. See *CND* I, ccxxix–ccxxxi. Also Chédeville, 1973, 227–29.

30. This historical section is primarily indebted to André Chédeville's excellent study of wine production and commerce at Chartres, summarized in his chapter "Une culture privilégié: la vigne," Chédeville, 1973, 222–37. Chédeville asserts that the local wines were mediocre, and were destined to satisfy local needs, since there were no navigable water routes to provide for extraregional trade. Chédeville, 1973, 236.

31. Guérard found evidence that the daily ration for workers was one *miche* of bread and one-half to one liter of wine. *CASP* I, clxxxvj.

32. *CASP* II, #137, 1265, 711–72.

33. The bishop's doorkeeper received a half-*setier* of wine daily, *CND* II, #201, 1210, 53–54; the bishop's carpenter received a half-*setier* of wine daily also. Ibid., #222, ca. 1215, 84. The bishop also paid the lay servants of the choir breads and a half-*setier* of wine daily. Ibid., #372, ca. 1282, 225–26.

34. On the canons' daily wine distributions, see *CND* I. p. cviij, n. 1, and *CND* II, *Polypticon*, 405. For a summary of such distributions that the canons received, which were a sort of salary, supplementing the income from their prebends, see Amiet, 1922, 214–18.

35. *CND* I, #89, 195–96; *CSJV* #226, 1227, 110; *CND* II, #282, 1241, 131; *CND* II, *Polypticon*, p. 300.

36. On monks' wine-drinking, see Chédeville, 1973, 232; monks rarely drank wine in the early twelfth century at Saint-Père, *CASP* II, #32, 1101–29, 290. Later in the thirteenth century, the monks drank wine without water. *CLGB*, #359, 1264, 154–56. Their daily portions of wine were so appreciated by them that they were punished by deprivation of it. Ibid., and *CSJV*, #356, 1263, 175–78. In the early fourteenth century, the bishop confirmed that their daily rations should be increased. Ibid., #387, 1304, 172–73.

37. On the population, see Wolff, 1982, 660. On the bishop's *banvin* income, see *CND* II, #385, ca. 1300, 239–345. The bishop received 3 sous per muid of tax, totaling 80 livres yearly, equal to 1,600 sous (20 sous = 1 livre), drawn on 533.3 muids (1,600 divided by 3). There were 6 barrels in each muid, so the total number of barrels taxed was 3,199.9 (6 times 533.3), or 116,792.7 liters (219 liters = 1 muid, so multiply 219 times 533.3). On the measures of Chartres, see *CASP* I, vol. 1, clxxv–clxxxj.

38. Chédeville, 1973, 233.

39., Ibid., 231–32.

40. *CND* I, ccxxx.

41. This seems to have been true of the new vines planted in the suburbs of Chartres. Chédeville, 1973, 228.

42. This can be inferred from records like that concerning new-wine payments in September. *CND* II, *Polypticon*, 423. See also Chédeville, 1973, 230.

43. The labors of the month appear at Chartres in a window of the south ambulatory, twice on the north portal of the west front, and on the west bay vault of the north porch. See Bulteau, 1882, 197–224.

44. Chédeville, 1973, 230. On the numerous references to local presses, ibid., note 429. Lords sometimes provided unfermented grape juice, or must, for their household staff to drink. *CND* II, #222, 1215, 84.

45. Chédeville, 1973, 231.

46. On wine taxes at Chartres, see Lucien Merlet, 1901, especially 184, 194–95. On the *foragium*, see *CSTE* #40, 1245, 41–42; on the *jalage*, see *CND* II, #337, 1260, 177 and n. 1.

47. Large vineyards were farmed out in tiny parcels to tenant farmers: *CND* II, #248, 1225, 104–5; *CLGB*, #312, 1237, 121–23. Two contracts between the chapter and its tenant farmers further reveal taxes levied against wine production: *CND* I, ccxxx–ccxxxj; *CND* II, #248, 1225, 104–5.

48. Examples of charters stipulating wine pressed by foot: *CND* II, #207, 1212, 67, note 1; *CLGB*, #251, 1228, 95–96. The most dramatic evidence of the persistence of this preference is the charter of 1256, in which a traditional money payment was changed to payment in wine. *CLGB*, #342, 1256, 144–45.

49. On the king's conservation of coinage tax, see Bisson, 1979, 29–44. See also *OrdRf*, #11, 1137, 188; *CdO*, #54, 1143–44, 106–7; *CdO*, #152, 1209, 235–36.

50. Chédeville, 1973, 231–32; *CND* I, ccxxx.

51. *CLGB*, #8, 1193, 188; *CND* II, *Polypticon*, 423.

52. On the right of lords to hold monopoly sales of wine during *bans* in their fiefs, over which they held high justice, see Chénon, 1903, 254–55; Boyer, 1918–19, 33.

53. The tavern keeper announced each day the price of the wine to be sold, as well as selling it himself. Lucien Merlet, 1901, 194.

54. Chédeville, 1973, 233, 234, n. 459. According to Chédeville, the history of *banvin* at Chartres is not well known because the counts rarely gave rents on it, but kept the right to themselves. He found it cited in the regional charters for the first time in the beginning of the twelfth century. CASP II, #5, 1101–29, 473. This right of lords was not abolished until 1789. Franklin, 1887, ser. 1, vol. 2, 25. For comparative evidence at Bourges, see Chénon, 1903, 253–67; Boyer, 1918–19, 33, 34.

55. Chédeville, 1973, 233–34. The lords of Brou, near Chartres, held *banvin* four times a year, at All Saints, Christmas, the beginning of Lent, and three weeks at Easter. *CASP* II, #5, 1101–29, 473. See also *CMC*, #78, 1219, 85–86; *AMDC*, #140, 1228, 95–96. Wine-selling monopolies during the medieval period were generally exercised elsewhere at the end of the summer, when it was necessary to empty the barrels before the next harvest. Chédeville, 1973, 233.

56. In 1170, Count Thibault gave Saint-Chéron 10 livres of rent on his *bans* of Easter and Pentecost, not positively but likely at Chartres. Chédeville, 1973, 233, n. 453. In 1193, Countess Adèle and her son, Count Louis, gave the leprosarium 40s rent on the ban of Pentecost at Chartres. *CLGB*, #154, 1193, 62.

57. Lépinois, 1976, vol. 1, 506.

58. Chédeville, 1973, 233.

59. At least that seems to me to be the logical outcome of the change to a *banvin* tax. We don't know how much of the year taverns stayed open. It is clear the tavern keepers were not independent, as in Paris. Chartres was a relative backwater, where older modes of economic relations held on.

60. *CND* I, 20; *CND* III, Necrologium, 47.

61. For this reason, one of the towers of the new town wall was named "Courte-Pinte." Chédeville, 1973, 233 and n. 45. On wine measurements at Chartres, see *CASP* I, clxxviij–clxxxvj.

62. Lespinasse and Bonnardot, 1879, 21, and note 2. Criers surveyed preparation of the wine in the tavern and tasted it, then received a pitcher and *hanap* and went out on the street. Franklin, 1887, ser. 1, vol. 1, 4–30.

63. Boyer, 1918–19, 40–46.

64. *CASP* II, #5, 1101–29, 472–74; *CLGB*, #9, 1135, 4; #24, 1147, 12.

65. Chédeville, 1973, 235 and n. 465.

66. This is clear in Miracle 13 of the *Miracles of Notre-Dame de Chartres*, ca. 1210, which describes a pilgrim stopping at a tavern in Chartres to drink wine. A. Thomas, 1881, 524–26.

67. "Ego Teobaudus, Blesensis comes, presentibus et eorum sequatibus notum fieri volo quod tabernarii Carnotenses quendam pastum omnes insimul comedere solebant semel in anno, et quoniam hoc ad ingluviem pertinere videbatur, rogando eos monui ut ab hoc desisterent et triginta solidos ad refecti-

onem leprosorum fratrum Belli Loci annuatim darent; qui peticioni mee diligenter adquieverunt, et se reddituros ad festum Omnium Sanctorum uno quoque anno spoponderunt, magistro eorum ab aliis illos XXX solidos accipiente et fratribus Belli Loci reddente. Hoc autem laudavi et concessi quoniam de me officia sua tenebant et per manum meam tenendum institui, et ne aliqua in posterum fratribus Belli Loci super hac re calumpnia oriretur, hanc cartulam fieri et sigilli mei auctoritate confirmari precepi." *CLGB*, #24, 1147, 12. The same count had his own tavern at Blois, and appointed a tavern keeper who kept a record of the receipts. Bourgeois, 1892, vol. 1. xxiv, and no. 1. On the exceptional situation in Paris, where burghers were able to sell the wine of their vineyards from an early date in taverns, and the highly complicated control of the wine trade there, see Fourquin, 1964, 108–10.

68. Lépinois, 1976, 512; Coornaert, 1968, 59.

69. ". . . from the crying of wine." *CLGB*, #64, 1163, 29–31.

70. According to Merlet, tavern keepers received a revenue paid by their lord's tenant farmers called *criagium, levagium doliorum*, or *criage*. He cites charters from 1184 and 1207. Lucien Merlet, 1901, 194 and note 5.

71. "Ego Esabella comtissa Carnotensi et Domina Ambosie notum facio omnibus presentes litteras inspecturis quod ego considerans et attendens fidele servicium quod Diselaiz Marescallus meus Johannes Collirubei michi semper exhibuit. Eidem Johanni et heredibus suis dedi et concessi magisteriam tabernarii mee Carnotensis et Curratorie de vino deforis in perpetuum possidendam vere hereditario cuius totalis iusticia eiusdem tabernarie eiusdem Curratorie. Excepta tamen maiori iusticia quam michi retinui in eadem tabernarii et in eadem Curratoria. Insuper duos modios vini quos Tabernii mei de Carnotensis michi debebant et reddebant annuatim in Pascha eidem Johanni et heredibus suis similiter vere hereditario habendos concessi. Super hoc autem Johannem in hominem ligium suscepi et ipse et heredibus ipsius michi et heredibus meis super hoc ipso ligium similiter exibebunt ad quinque solidos servicii quotiens advenietur. . . ." Chartres, Archives Municipal J 123 (dated 1220, April).

72. The chapter ruled in 1320 that the count's two officers assigned to collect his wine tax (*banvin*) from the sellers of wine in a house on the cloister should return this tax to a wine crier named Guiard de la Porte. Lépinois, 1976, vol. 1, 512, n. 5. This sounds as if the chapter was taxing its own wine sellers, which would have been the ordinary thing for it to do. The crier's name is intriguing. One wonders if criers had to serve time guarding gates as a *guet*, which would explain why the crier at the gate in the Lubinus window carried a stick. Guard duty was not required of criers in Paris, but it was required of other trades.

73. *CND* I, #123, 244–45, 1195. We know that the canons sold off excess stores in 1300. *CND* II, 297, and *CND* I, cvj.

74. On small holdings of vineyards, see Chédeville, 1973, 236–37.

75. This is amply evidenced in the charters. See the *Cartulaire* editors' comments in *CND* I, ccxxviij–ccxxxj.

76. Pope Alexander, addressing the bishop, dean, and chapter of Chartres in a bull dated between 1160 and 1181, confirmed the liberty of the cloister, its houses and domestic retinues and the immunity of the cloister from any secular power, which he said had been enjoyed continuously from the time of Bishop Ivo of Chartres. *CND* I, #67, 1160–81, 168. See also, ibid., #96, 1181–

83, regarding some provisions deemed appropriate to this liberty; also ibid., #86, 1171–72, 188–90; ibid., cxxx. The *Vielle Chronique* of 1389 states the matter clearly: "in the land of the chapter the count and the bishop receive nothing, . . . the chapter and the canons have every type of jurisdiction high, medium, and low and by their own laws in that place they levy and collect as the count and the bishop do in their land." *CND* I, 49.

77. *CASP* II, #81, 1208, 673–74.

78. Chédeville, 1973, 458; *CND* I, lxxviij.

79. According to Lépinois, the chapter ruled in 1327 that the wine criers should be chased out of the nave of the church, along with merchants of spiced wine, the sellers of candles, merry-makers, and children playing ball. Lépinois, vol. 1, 1976, 181. The original chapter records were destroyed in 1944, but a seventeenth-century copy of the ruling survives, and is quoted in Chédeville, 1973, 235, n. 470.

80. Lépinois, 1976, 512 and n. 5; Aclocque, 1917, 253.

81. Axton and Stevens, 1971, 135. Here is the French version from Axton, 1974, 135:

> Le vin aforé de nouvel
> A plain lot et a plain tonnel,
> Sade, bevant, et plain et gros,
> Rampant comme escureus en bos,
> Sans nul mors de pourri ne d'aigre;
> Seur lie court et sec et maigre,
> Cler con larme de pecheour,
> Croupant sur langue a lecheour;
> Autre gent n'en doivent gouster.

Axton thought the images of the cry might have been a convention in advertising wine, because he found them recurring in two later Anglo-Norman formulas. Ibid.

82. The sale of wine on certain days in the portals of basilicas and in church precincts is known to have occurred in the early Middle Ages. See Fournier and Fournier, 1859, vol, 1 195. One suspects the casks surrounded by candles in the nave of the cathedral of Le Mans on the occasion of the translation of the body of St. Julian to the new church in 1254 were there for a nonsacramental celebration. Busson and Ledru, 1902, 491.

83. The *menues dimes* included wine. Lucien Merlet, 1901, 184. For the receipt and transfer of wine tithes: *CLGB*, #15, 1140, 6; *CLGB*, #20, 1146, 9–10; *CLGB*, #40, 1154, 18; *CND* II, #220, 1215, 79–83; *CSTE*, #7, 1222, 145; *CLGB*, #312, 1237, 127.

84. On firstfruits payments, see Lucien Merlet, 1901, 184.

85. *CND* I, #65, 1157, 164–66; *CND* II, *Polypticon.* 338.

86. *CND* I, #73, 1165–81, 174–75; *CV*, #115, 1212, 234; *MCD*, #221, 1212, 203; *CASP* II, #86, 1213, 676–77.

87. In 1208, a knight provided for a chapel with five modii of wine pressed by foot, along with grain and money. *CSJV*, #158, 1208, 77–78.

88. *SMJ* I, #110, 1140, 141–42; *CSJV*, #112, 1185, 58; *CSJV*, #216, 1225, 105–6.

89. *Polypticon* of 1300, *CND* II, 287–429.

90. Chédeville, 1973, 229. For description of *terceau*, see Lucien Merlet, 1901, 194. An *arpent* is a unit of land equal to about 0.85 acre.

91. *CND* II, #248, 1225, 104–5. The old French words for some of these payments are obscure. Tenants paid 3 deniers per quarter-arpent for *minotis* and *cuppis*. *Cuppa* was a tax charged for the measuring of wine. Wartburg II, 2, 1554. *Minotis* was probably also a measure of farm products (Latin *minagium?*). Lucien Merlet, 1901, 193. Tenants also paid the chapter *gands* and *vents*. These were seignorial taxes imposed on property, and often paid in natural products. Ibid., 183. The *charroi* was a *corvée*, or free labor service specifically, the delivering of the harvest to the lord's grange or cellar. See ibid., 214–15. The tenants' contract states: "He [the tenant] will pay half of the *charroi* of the harvest." Thus, the word seems to have changed to mean the work to be accomplished. *CND* II, #248, 1225, 104.

92. *CND* II, #220, 1215, p. 81, note 1.

93. *CND* II, *Polypticon*, 423.

94. Examples of wine tithes due the chapter: *CND* II, #274, 1232, 124, wine tithes assigned to Matins; *CSJV*, #333, 1258, 162–63, concerning controversy over continuance of practice; *CND* II, *Polypticon*, 338, chapters' fourth of tithe from Jouy includes wine tithe paid in cups of wine pressed by foot (discussed in Viard 1912, 64); *CND* II, #263, 1226, 116, n. 1, chapter receives more wine tithes; *CTV*, 178, on tithes from the Vendômoise. In 1249, the chapter bought a wine tithe from Bleury from a layman. *CND* I, 116, note 1.

95. The chapter had seventy-two parishes. *CND* I, cix. The canons also received the *altarium* from their farms, which payments were assigned to Matins. *CND* I, #73, 1161, 174–75.

96. On the continued presentation of wine to churches, see Honorius of Autun, *Gemma animae*, lib. 1, cap. 27, *PL* 172, col. 553; Schreiber, 1948, 308, nos. 130, 131; Métais, 1899, 151. On the change to the wafer, see Jungmann, 1951–55, vol. 2, 31–37, 385; Corblet, 1885–86, vol. 1, 223–24, 613–19.

97. On the continuance of offering wine to the altar as part of a customary payment, see Schreiber, 1948, 308 and note 130, where he mentions the practice at a priory in the diocese of Chartres recorded in 1180; also 248, 276, 309, 311, 312.

98. Jungmann, 1951–55, vol. 2, 14, 22.

99. Corblet, 1885–86, vol. 1, 219.

100. Ibid., 199. The bishop supplied clerks of the choir with three sextarii of good wine for communion at Easter. *CND* II, #370, 1280, 221–24.

101. The Fourth Lateran Council ruled that people should attend mass at least once a year, at Easter. Jungmann, 1951–55, vol. 2, 361–65.

102. This usually occurred at the end of mass. Ibid., 385.

103. Ibid., 411–19; Corblet, 1885–86, vol. 2, 242; Browe, 1940, 185–200.

104. Browe, 1941, 51.

105. Jungmann, 1951–55, vol. 2, 413.

106. Up to the twelfth century, children and infants were given consecrated wine at a baptismal communion; thereafter, they received blessed wine of ablution instead. Browe, 1940, 129–42; Jungmann, 1951–55, vol. 2, 385 and n. 81.

107. Browe, 1940, 187. It was also called blessed wine. Ibid., note 91.

108. I have devised my own numeration of the panels in the aisle window, a system that follows the order in which I believe the window was meant to be

seen. The reader also can consult Delaporte's monograph for a description of the pictorial narrative in the window. Delaporte, 1926, pp. 405–8, and plates CLXXV–CLXXVIII. There is a great deal of repair glass in panel 1, but it has been added in pieces over the centuries and does not seem to have altered the iconography.

109. "Voici d'abord une taverne; un cerceau, sans doute une enseigne, est pendu à une perche. Le patron est sorti; il presente une coupe de vin à un client qui s'est assis en plein air." Ibid., 405.

110. In the play, Auberon enters a tavern, remarking: "Ah! Saint Benoît, laissez-moi recontrer souvent votre anneau d'abondance!" Henry, 1962, 71. Richard Axton described his impression of the tavern as follows: "the tavern is most clearly outlined in the dialogue: its seems to be a porch-like house opening on to the place; it has a doorway at the back through which wine is brought to the tables and dicing board; on the roof is a barrel-hoop sign." Axton, 1974, 134.

111. The February 1415 ordinance regarding rules of functions, rights, and duties of the officers of Paris, Chapter III, article 16, states that criers could offer services only to tavern keepers having a shop open on the street with a hoop for a sign. Franklin, 1887, ser. 1, vol. 2, 36.

112. On a tradesman's *cotte*, see Norris, 1927, vol. 2, fig. 145, 112; on the merchant's attire, ibid., fig. 233, 170.

113. Apprentices in Paris carried a baton on which a notch was marked with the completion of each of four years. This is one possible explanation for the stick. Lespinasse and Bonnardot, 1879, xxi.

114. Coonart, the crier of the *échevins* of the city, tells another crier whom he meets to put down his pot of wine and his stick: "Fuis, crétin, renonce à ton imposture, car tu cries bien trop faiblement! Mets bas le pot et la baguette!" Henry, 1962, 99.

115. No. 2. "Quiconques est Crieur à Paris, il convient qu'il doinst au prevost des Marcheans et aus eschevins de la Marchandise, ou a leur conmendement, seurté de LX s. et I d.; et seur cele seurte, li doit livrer li Taverniers son hanap." P. 21.

No. 5. "Quiconques est Crieur à Paris, il puet aler en la quele taverne que il voudra et crier le vin, por tant que il y ait vin a broche, se en la taverne n'a Crieur." P. 22.

No. 12. "Le Crierres doit crier chascun jour II foiz . . ." P. 23.

No. 14. ". . . li Crieur tout ensemble doivent crier le vin le Roi, au mein et au soir, par les quarrefours de Paris; et les doivent li mestre des Crieur(s) mener. . . ." Lespinasse and Bonnardot, 1879, 23–24. On the date of the statutes, ibid., p. xvl. For a résumé of the statutes in modern French, see Levasseur, 1900, 274–75; Fourquin, 1964, 108.

116. Boyer, 1918–19, 39–45.

117. Coornaert, 1968, 193. The criers in Paris were at liberty to choose the tavern they would cry wine for each day, and tavern keepers were obliged to accept the first offer of service. Lespinasse and Bonnardot, 1879, 22, no. 5. In *Le Jeu de Saint-Nicolas*, the crier Coonart claims to have worked at his trade for over sixty years and is startled to find another crier, whom he calls an imposter, working in his territory. Henry, 1962, 99.

118. This occurs in *Le Jeu de Saint-Nicolas*, when the tavern keeper, standing on the front step of the tavern, calls out: "Ici, c'est un plaisir de déjeuner,

ici! Vous y trouverez pain chaud et harengs chauds et vin d'Auxerre à plein tonneau." Ibid., 71. Boyer notes that the practice appears in medieval plays. Boyer, 1918–19, 46.

119. Her costume marks her as a woman of high rank who would not ordinarily be in public with a moneybag. My identification of the merchant's cushion as a travelling bag is less secure, since I have found no other representation of such a bag.

120. Wine criers usually worked one tavern a day. Franklin, 1906, 237. King Louis VII set the number of criers at Bourges at twelve in 1141, one for each tavern. Boyer, 1918–19, 42–44. Thus the four pairs of men crying wine may mean that there were four taverns in the cloister.

121. On the plan and history of the cloister, see Nicot, 1976, 4–16.

122. See the Oxford Moralized Bible, Brit. Mus. Harley 1527, fol. 23r.

123. Bay No. 45, Delaporte, 1926, 350–53, plate CXXXII, and fig. 40, panel 8.

124. For thirteenth century examples, see Rouen Cathedral, St. Julien the Hospitaler window, Bay 45. Ritter, 1926, plate 10, b7, and 43. Also St. Julian-du-Sault, St. Nicholas window, Bay 9. Rheims, 1926, 155–56.

125. Another similar thirteenth-century example in fresco appears in the Novalesa Abbey nave. The sick person sits up to receive the wafer, and a brother grieves with his hand to his cheek.

126. The manuscript burned up in the nineteenth century. Lefèbvre des Noëttes, 1931, vol. 1, 121–25 and vol. 2, plate 151. Lefèbvre des Noëttes wrote a study of the historical development of the harness, horseshoes, and equipage of horses for different uses from ancient to modern times. His plate volume contains extensive reproductions of evidence in medieval art, including many examples of the changing method of hitching horses to carts and driving them.

127. Delaporte, 1926, 335, and fig. 37, panel 14, and plate CXX; ibid., 306, and fig. 32, panels 19, 20, and plate XCVII. Another example appears in the window of St. Sylvester, Bay 30, where the sainted Pope Sylvester and Emperor Constantine ride in a horse-drawn chariot guided in this case by a man on foot. See ibid., 277, fig. 28, panel 26, and plate LXXXIII, text vol. 277, fig. 28, panel 26. The driver's position on the horse, rather than driving the horse from the cart, seems to signify respect due the barrel of wine intended for the sacrament, as opposed to the driver sitting on top of the barrel in the Miracles of the Virgin window (Bay 9). In the latter case, the driver directs the people who are pulling the cart, and the wine is intended to serve as nourishment for the workers constructing the cathedral, following the tradition of the previous "Cult of Carts." Ibid., plate vol. I, plate XXXI, text vol. 190–91, fig. 14, panel 7.

128. Working-class attire generally is the same, so that one cannot derive any special status or occupation from this man's clothes. He wears a *cotte*, which appears slightly longer than those worn by the tavern keepers, but the painter may have effected the folds of swooping drapery to cover the man's thigh. He wears a bonnet (*coiffe*) which was worn by men of all ranks, but differentiated according to class by the quality of its fabric—not distinguishable here. On the *coiffe*, see Viollet-le-Duc, 1872, 176–77.

129. We do not have evidence of the timing of the harvest in the thirteenth century in the way that we have it in later documents. It is inferred from rec-

ords like that concerning new wine payments in September. *CND* II, *Polypticon*, 423. See also Chédeville, 1973, 230 and n. 426.

130. Cathedral documents show that the canons most frequently stipulated wine payments to them be made in the best quality of wine. *CND* I, ccxxx.

131. Since we do not know when the window was made or when the cellar was built, this can only be suggestive. According to John James's analyses, the cellar was built around 1221, and the window could have been installed in the aisle any time after 1205 (personal communication). However, the chapter had a cellar already in the early twelfth century, in a house given to the chapter in the eleventh century, apparently in approximately the same location ("ante Portam Novam"). See Clerval and Merlet, 1893, 149, and Chédeville, 1973, 455, n. 168.

132. "Prope claustrum, ex parte Porte-Nove, habet Capitulum quoddam atrium pulcherrimum cum magno porprision, clausum muris lapideis magnis et altis, quod vocatur Loenium . . . Et ibidem est pulcherrimum cellarium lapideum cum multis pulcherrimis tonnis, in quibus solebat reponi vinum omnium vinearum clausi Capituli et omnium aliarum vinearum Capituli. . . ." *CND* II, *Polypticon*, 405.

133. The *Polypticon* of 1300 describes the cellar with superlatives of admiration. *CND* II, 405–6. Merlet, speaking of thirteenth-century wine cellars in the region, comments that the Löens' relative grandeur (36 × 16 × 9.50 meters) equals the enormity of the chapter's revenues. René Merlet, 1896a, 363.

134. Most authors, although mistakenly, identify the man in the cave as a tavern keeper. Bulteau, 1887–92, vol. 3, 246; Aclocque, 1917, 314; Delaporte, 1926, 405; Villette, 1946, 110. Identification of the man in Panel 3 as a tavern keeper is obviously mistaken. He is tonsured, and wears a long ecclesiastical robe. Therefore, other scholars identify him as St. Lubinus, who had charge of a monastic storeroom before he became bishop of Chartres. Gilbert, 1824, 78; Lasteyrie, 1855–57, vol. 1, 70, n. 1; Popesco, 1970, 57. The window has had many repairs over the centuries, and it is apparent that this man has been repainted, but, as is usual in these cases, he probably was repainted with the same features that he had originally.

135. Webster, 1970, 66–72. Of all the French twelfth-century examples Webster considered, only one September illustration does not concern the grape harvest. Ibid., 177.

136. Clerval and Merlet published an edited copy of most of the manuscript which still survives in the Bibliothèque Municipale at Chartres. Clerval and Merlet, 1893, 9–21. The Chartres version almost exactly duplicates that in the Calendar of St. Mesmin. On the Calendar of St. Mesmin, now in the Vatican Library, MS Reg. lat. 1263, see catalogue no. 31 in Webster, 1970, pp. 133–34, and plate 15. The labors in this calendar are appropriate to a southern climate, as opposed to their adaptation in France, where customarily September crushes grapes and October fattens hogs. Ibid., pp. 50–52.

137. Clerval and Merlet, 1893, 17–19. It may be more than coincidental that the same scenes appear in the Noah window and the Lubinus window next to it: at the bottom of the Noah window, a man posed in just the same way raises his mallet to secure a hoop on a wine barrel, and above, one of Noah's sons picks grapes in a similar pose.

138. *CASP* I, clxxxj–clxxxiv.

139. The special liturgy for this feast has been published. See Delaporte, 1953, 246–50. Like the legend of St. Lubinus from which it was created, it emphasizes the saint's miracles. See also ibid., 57, 177. Delaporte published an article on the two feasts of St. Lubinus. Delaporte, 1925, 123–27.

140. *CND* II, #367, 1280, 207–8: "Item, pro quolibet festo demiduplici, debent II cereos ad Ascensionem, ad festum beati Johannis-Baptiste, ad festum beate Marie Magdalene, ad festum beati Leobini in septembri, ad festum sancti Piati, ad festum sancti Nicolai, ad Circoncisionem Domini, ad Epiphaniam. De omnibus istis cereis qui tradentur matriculariis pro sabbatis, pro festis duplicibus, semi-duplicibus, pro candelabro, tenentur matricularii clerici reddere espicopo et capicerio torciones quilibet sabbato.

"In vigilia sancti Piati, a primis vesperis usque post complectorium diei festi, tenentur ponere ante capsam sancti Piati unum cereum de processione vel unum alium magnum cereum; similter in festis duobus sancti Leobini; similiter in festo sancti Caletrici; similiter in festo sancti Turiani; similiter in festo sancte Tecle; similiter in festo sancti Tugdualis: ad Anuntiationem vero, coram letrino, unum cereum quod ardet a primis vesperis usque ad crastinum post complectorium."

141. Delaporte, 1953, 53, 57, 64, 192, 193.

142. Van der Meulen argues that the head-reliquary of St. Lubinus, known to have been in the cathedral in the thirteenth century, was kept in a treasury in the choir. Van der Meulen, 1975, 76–79. However, the first evidence of the Lubinus chapel in the choir dates to 1519. Ibid., 74 and n. 338.

143. Evidence of St. Lubinus's body in the church in the twelfth century strengthens van der Meulen's argument. In a letter written 1177–79, the then bishop of Chartres, John of Salisbury, recounts the miraculous healing performed by St. Lubinus's body in the cathedral. Letter no. 325 in Millor and Brooke, 1979, 802–7. Van der Meulen's claim that *capsa* in the liturgical documents of Chartres referred to the body shrine is verified by the use of the word in the same way in a thirteenth-century document from Le Mans to indicate a shrine for a saint's body. Busson and Ledru, 1902, 482.

144. Delaporte said that we don't know that there were three altars in the choir in the thirteenth century (the earliest evidence of them is from a description by Pintard), but Delaporte believed that it must have been so. Delaporte, 1953, 24. Van der Meulen has argued for the existence of the third altar. Van der Meulen, 1975, 75, n. 348;

145. Corblet, 1885–86, vol. 2, 178–83.

146. Candles otherwise stood on the floor, except when the deacon took them to the pulpit for the gospel reading. Ibid., 146–47.

147. According to Jungmann, the prayer should be said by the priest *inclinatus ante altar*, as it still is done, to indicate a spirit of humility. There was a long tradition for the gesture of offering to be accompanied by bowing of the head. The prayer changed in many details from place to place, and was sometimes followed by a series of other offertory prayers, but the formula for the *Suscipe* prayer remains, in its pattern of contents, similar. Jungmann, 1951–55, vol. 2, 46–49, 52.

148. "Suscipe sancta trinitas hanc oblationem quam tibi offero in memoriam incarnationis nativitatis passionis resurrectionis ascensionis domini nostri Jesu Christi et in honorem omnium sanctorum tuorum qui tibi placuerunt ab initio mundi et eorum quorum hodie festa celebrantur et quorum hic nomina

quorum reliquie habentur ut illis proficiat ad honorem novis autem ad salutem ut illis omnis pro nobis autem ad salutem ut illis omnis pro nobis intercedere dignentur in coelis quorum memoriam facium in terris. Per eumdem Christum Dominum nostrum." Paris Bib. nat. MS lat. 1096, fols. 80r–80v.

149. Tirot, 1985, 33–35. The scene of mass is almost unique at Chartres. There are few other representations of the liturgical performance of mass in the windows. Other scenes of altars abound and usually represent either devotion or donation.

150. The rubric for the *Orate fratres* prayer in the *ordo missal* of Innocent III directs the officiant to turn to the people (*versus ad populum*). *PL* 217, col. 768. According to Jungmann, this prayer is unchanged and fixed in all medieval oblation rites. The priest turns to those present to ask them to pray for him. He speaks in a hushed voice so that the prayer appears to form part of the canon. The prayer occurs when the presentation of the gifts at the altar is completed and the priest is about to present them to God. Jungmann, 1951–55, vol. 2, 82.

151. From a twelfth-century sacramentary of Chartres: "Orate fratres pro me ad domini ut meum et vestrum in conspectu eius fiat acceptum sacrificium." Paris Bib. nat. MS lat. 1096, fol. 80v.

152. Jungmann, 1951–55, vol. 2, 85–90.

153. "Suscipiat dominis sacrificium de manibus tuis ad tuam et nostram salutem et omnium et animarum omnium fidelium defunctorum. Amen." Paris. Bib. nat. MS lat. 1096, fol., 80v.

154. Altars with chalices upon them, indicating mass, represented in the windows of Chartres:

Bay 28	St. Remy kneeling before altar with chalice and cross on it.
Bay 38	Mass of St. Gilles, before altar with chalice.
Bay 60	St. Nicholas's episcopal ordination, before altar with chalice.
Bay 63	St. Lubinus's episcopal ordination, before altar with chalice.
Bay 100	Priest stands praying before altar with chalice.
Bay 139–43	Priest kneels before altar with large chalice on it.

155. Scenes of altar without a chalice upon it:

Bay 9	Statue of Virgin and Child on altar, ecclesiastic kneeling.
Bay 16	Joachim and Anne carry offerings to temple, high priest removes lamb from altar.
Bay 26	Layman kneels before altar with statue of Virgin and Child on it.
Bay 27	St. Nicholas kneels before altar with cross, cloth on it.
Bay 28	Two scenes of canons kneeling before altars with statues of Virgin and Child on them.
Bay 36	Two scenes of clerics kneeling before altars, one with statue of Virgin and Child on it, one with statue of Christ on it.
Bay 38	Relics deposited on altar with cross.
Bay 40	Cleric kneels before altar with statue of Virgin and Child.
Bay 89	Priest kneels before altar with cross.
Bay 99	Priest stands before altar praying.

Bay 103	Priest stands before altar with cross.
Bay 127	Count kneels before altar with cross.
Bay 133	Canon kneels before altar with seal.
Bay 152	Count kneels before altar with cross.

156. On the elevation of the host during mass, see Browe, 1929, 20–66; and Jungmann, 1951–55, vol. 2, 206ff. According to Jungmann, a charter of 1399 at Chartres required the ringing of one of the bells suspended above the choir so that attention of the people could be called to the *levatio sacramenti*. Ibid., 131, n. 22.

157. Jungmann, 1951–55, vol. 2, 207.

158. Delaporte, 1906, 224, plate X.

159. Jungmann, 1951–55, vol. 2, 115–38.

160. Scenes of work believed to commemorate window donation usually appear in the lowest register, while in the aisle window of Lubinus these images invade the center and upper reaches of the window. Inclusion of figures in window borders is unusual at Chartres; as a rule, borders are floriated or patterned.

161. The pilgrim is identifiable by his stick, the moneybag hanging around his neck, and his white garb. See pilgrim's dress in Bay 133 of the cathedral, Delaporte, 1926, pl. CCXL. The saint was best known for his healing power, and this pilgrim, who walks with a cane, may have been seeking a miraculous cure at the saint's altar. Of the thirteen miracles Lubinus performs in his legend, eight are healing miracles. Of the eleven miracles mentioned in his liturgy, seven are healing miracles. On his liturgy, see Delaporte, 1953, 245–50. The subject of a relief on the south portal of Chartres Cathedral (illustrated in Van der Meulen, 1974b, col. 414), must refer to the miraculous healing described in Chapter 23 of the legend. A large thirteenth-century painted wood statue of St. Lubinus in Brittany was worshiped along with a group of statues of healing saints at a chapel near Moncontour. Gruyer, 1923, 15, 51. The richly robed man wears a red *gardcorp* that extends nearly to the bottom of his long, green *cotte*, indicating a man of high social standing. Norris, 1927, vol. 2, 171.

162. *CND* II, 423 of the *Polypticon*: "the chapter has . . . in a certain clos situated toward St. Lubinus in the Vineyard that is called *Clausum-Medium*, one barrel. The total wine from all the aforesaid vineyards (equals) 3 modii, 1 and ½ barrels. Which *tercoleum* is called the *tercoleum* of St. Catherine, and it is received for matins and some of the same is received in cups to discharge the debt. Item, and in the above-mentioned places the chapter has around 20 sous of cens on the feast of St. Lubinus in September called the cens of St. Lubinus which cens belongs to Matins." A 1786 record of vineyard tenants paying fourteen pots of new wine per quarter-arpent of vineyard to the chapter refers to a practice known to have been of "ancient" origin. Hence the fourteen goblets in the window may represent the thirteenth-century expression of this custom. Lépinois, 1976, vol. 1, 503–4. For another example of wine tithe paid to the chapter in cups, see *CND* II, *Polypticon*, 338. There were other social customs in France involving the presentation of wine in church. At Rouen Cathedral before the Revolution, new wine was blessed on September 14, and it was used for the mass of the day. Corblet, 1885–86, vol, 1, 197. Franz writes of the adaptation of the Germanic custom of love-drinks in honor of saints' celebrations, especially local saints. Franz, vol, 1, 1960, 289. Ewers of wine

were presented at Rouen masses for the dead. Corblet, 1885–86, vol, 1, 224. Three of four canons carried hosts and chalices of wine to the altar at solemn obits for bishops at Sens. Ibid., p. 225. Wine was customarily offered at the consecration of bishops, and was associated with festival masses of ordination and canonization. Andrieu 1938, 137, 151ff.; Andrieu, 1940a, 349, 364ff.; Jungmann, 1951–55, vol. 2, 13, and n. 67.

163. Schapiro, [1954] 1977, fig. 3. According to Schapiro, the format derives certainly from a Beatus manuscript such as that from Saint Sever (Paris, Bib. nat. MS lat. 8878, fols. 121c–22) in which the elders all hold up cups, but sit in a circle around the vision of Christ. However, in its format and variety of objects that the elders hold, the Auxerre page seems closest to the page illustrating the Worship of the Lamb in the German copy of the Liber Floridus of Lambert of St. Omer, dated to the twelfth century (Wolfenbüttel, Herzog August Bibliothek, cod. Guelf. Gud. lat. 2, fol. 11r) illustrated in Van der Meer, 1978, plate 88.

164. Bay 95, Delaporte, 1926, 434, and fig. 56, plate CIC. There are two other traditions which the format of the Lubinus window resembles. The border recalls the ladder of virtue, such as the Heavenly Ladder of John Climacus in the East. The late sixth-century treatise of John Climacus described the prescribed spiritual exercises for monks as rungs of a ladder to Heaven. Each step must be achieved by shunning a vice and attaining a virtue, so the monk increasingly overame worldliness until he reached the uppermost rung's virtues of faith, hope, and charity. Martin, 1954, 5–9. Martin surmises that the image must have been known in the West before the thirteenth century because he believes it is reflected in the *Hortes Deliciarum* of Herrad of Landsberg, late twelfth century. Ibid., 6, 19.

A second tradition which the format of the Lubinus window resembles is the "Scala Humilitatis" of St. Benedict in the West. In a Swabian manuscript dated to between 1138 and 1147, St. Benedict himself is framed on one side by the "Scala Humilitatis," and on the other side by Jacob's Ladder. Stuttgart, Landesbibliothek, Cod. hist. 415, fol. 87v. It dates between 1138 and 1147. Katzenellenbogen, 1964, 25.

165. Oxford Moralized Bible, Bodl. 270b, fol. 57v.

166. Both Charity and Patience hold chalices in the border of the window of the Infancy of Christ at the cathedral of Lyons. Bégule, 1880, 131–38, figs. 30 and 46.

167. Delaporte, 1926, 405–8; *CVR* II, Bay 45, 34; Kirschbaum, vol. 7, cols. 412–14.

168. The published texts are almost identical. *MGH*, 73–82; *AA SS*, vol. 14, 349–54; *Acta Sanctorum Ordinis S. Benedicti*, 1935, vol. 1, 123–28; *PL*, vol. 88, cols. 549–62. *BHL*, vol. 2, #4847, lists two other full publications of the legend that have not been available for this study: Labbe, Bibl. MSS II, 528–88 and *Fortunati Opera*, ed. Luchi, II, 140–53. Labbe published the legend for the first time in 1657 based on the manuscripts collected by André du Chesne. Luchi's edition was republished by Migne. For the manuscript sources and history of publication of the legend, see *MGH*, XXVIII–XXIX. There are minor variations in wording and omissions in all four texts consulted that do not alter appreciably the meaning of the text. The only major difference in the texts is found in *MGH*, chapters III and IV, in which the elsewhere unidentified monastery where St. Avitus was abbot and where St. Lubinus visited is specified as

Saint-Mesmin at Micy. The *MGH* version of the legend was drawn primarily from Bib. nat. lat. 5280, a thirteenth-century collection of hagiographical texts. *MGH*, XXVIII and *Catalogus codicum*, 1889, vol. 1, 489.

169. The text is most frequently credited to Bishop Fortunatus of Poitiers (530–609) due to the similarity of its style and some of its content to the life of St. Avitus by the same author (*BHL*, vol. 2, 721). Poncelet reviewed the past literature concerning the date and the author of the original legend. He reasoned that the life of St. Lubinus was written after that of St. Avitus and in its present state must belong to the mid-ninth century. Other authors, most recently van der Meulen, believe the life of St. Lubinus was written shortly after his death by his successor to the bishopric of Chartres, Caletricus. Poncelet, 1905, 25–31; van der Meulen, 1974b, col. 412.

170. *MGH*, XXVIII.

171. Bulteau and Delaporte believed that all the center panels refer to the tavern keepers of Chartres who, they assumed, donated the windows. Delaporte further commented that the panels in the central axis of the window might be called "a poem to the glory of wine." Bulteau, 1887–92, vol. 3, 246; Delaporte, 1926, 405.

172. Neither Bulteau nor Delaporte could explain these panels. The saint's life as it is described in the legend begins just above them in the window. Bulteau, 1887–92, vol. 3, 245; Delaporte, 1926, 406.

173. The boy kneeling in the far left of the right-hand side of the panel might be Lubinus as a young acolyte. This would appropriately precede his life as a shepherd in the next panel. Ibid., 406.

174. Furthermore, Lubinus is shown with sheep instead of cattle, as the text describes. Delaporte conjectured that the reason for the discrepancy was that the artist knew the legend only from an abbreviated text lacking certain details. According to Delaporte, this is most likely because all the manuscripts he consulted contained the word *boves* not *oves*. Ibid., 406, n. 4.

175. The monastery is identified by Bulteau as that located at Noailles near Poitiers. Bulteau, 1887–92, vol. 3, 245.

176. Bulteau and Delaporte identified this man as a tavern keeper; the identification must be mistaken, since the man is tonsured. Bulteau, 1887–92, vol. 3, 246; Delaporte, 1926, 405. However, Popesco thought, as had Lasteyrie before him, that the scenes depicted Lubinus when he was a storekeeper. Popesco, 1970, 57; Lasteyrie, 1857, 70, n. 1. The head of the man appears to be made of repair glass, so it may have not always been tonsured as it is now.

177. In panel 12, Lubinus appears bowing his head before an abbot who blesses him. Behind Lubinus, a cruet appears on a small table.

178. Bulteau and Delaporte also identified this double panel scene with the miracle in Chapter 22. However, neither of them mentioned the depiction of the objects in mid-air nor the unexplained white posts. Bulteau, 1887–92, vol. 3, 245–46; Delaporte, 1926, 408. The white posts appear to be original glass, but the falling stones are probably repair glass.

179. Bulteau thought that the figure of Christ signified "the wine that germinates virgins." Bulteau, 1887–92, vol. 3, 246. Delaporte saw the Christ figure as receiving the homage of the donors and presiding over the events of the saint's life. Delaporte, 1926, 405–6.

180. Delaporte, 1953, 246–50.

181. Text: Chapter 1, youth; chapters 2–12, monastic life; chapters 15–27, life as bishop. Window: youth, panels 8, 9, 10, 11; monastic life, panels 12, 13, 14, 15, 16, 18; life as bishop, panels 17, 19, 20, 21. The legend does explain most of the pictorial cycle: window scenes explained by text of legend: 5, 8, 9, 10, 11, 12, 16, 17, 18, 20, 21; scenes related generally to text: 3, 4, 13, 14, 15, 19, scenes not explained by text: 1, 2, 6, 7.

182. Travel in the text: chapters 1, 2, 4, 6, 8, 10, 13, 15, 17, 18, 19, 22, 23; travel in the window: panels 8, 9, 12, 14, 15, 16, 19.

183. This metaphorical arrangement has been noted by other scholars, including DeCosse, 1984, and C. and J. P. Deremble, 1989.

184. *DACL*, 1953, vol. 3, cols. 1024, 1025. Bulteau, 1887–92, vol. 1, 227.

185. *GalChr*, vol. 8, col. 1209.

186. Delaporte, 1953: St. Lubinus, 57, 177; St. Anne, 54–55, 234; St. Nicholas, 63, 239; St. Ambrose, 231, n. 1; St. Piat, 58, 237; St. Mary Magdalene, 234. On the feasts of St. Lubinus at Chartres, see Delaporte, 1925, 123–27.

187. Kirschbaum, vol. 7, col. 413.

188. Jan van der Meulen has brought to light the importance of the cult of St. Lubinus at Chartres in his study of the eastern crypt of the cathedral. Van der Meulen, 1975, especially 70–79.

189. On the choir chapel of Lubinus, see *CND* I, 59ff.; Kirschbaum, vol. 7, col. 413.

190. Bay 11, Delaporte, 1926, 206–7. According to Pintard, the window contained images of St. Michael, a church, St. Lubin, a chapel, and St. Martin.

191. The subject of the relief on the south portal of Chartres Cathedral must refer to the miraculous healing described in Chapter 23 of the legend. Kirschbaum, vol. 7, col. 414.

192. Lubin's healing miracles predominate in the legend. Of the thirteen miracles Lubinus performs in the legend, eight are healing miracles. A large, thirteenth-century painted wood statue of St. Lubinus in Brittany was worshiped at a chapel near Moncontour along with a number of other almost life-sized statues of healing saints. Gruyer, 1923, 15, 51.

193. The Chartrain liturgy of the saint that survives, the office of the saint for his feast on September 16, was published by Delaporte in an appendix to his publication of the thirteenth-century Ordinary of Chartres. It seems certain that the author of the office based his composition on the legend, as Delaporte thought. Of the eleven miracles mentioned in the liturgy, seven are healing miracles. See Delaporte, 1953, 245–50.

194. Lépinois, 1976, vol. 1., 269–71. Saint-Lubin-des-Vignes fell into the hands of the counts of Chartres in the tenth century. In the eleventh century it was given over to the abbey of Saint-Père at Chartres. The priory's possessions were enlarged by donations in the twelfth century. Dion noted that towns which grew in the midst of vineyards frequently were named with the suffix of "les-Vignes," and he cited Saint-Lubin-des-Vignes as an example. Dion, 1959, 41 and n. 102.

195. This procession left from Notre-Dame and went by way of Saint Michael's to Saint Martin's and returned by Saint-Lubin-des-Vignes and Saint Saturnin and Saint Faith to Notre-Dame. Delaporte, 1953, 50, 125, 126.

196. *CND* III, *Polypticon*, 423.

197. Delaporte's treatment is brief. He mentions that the window was repaired by Coffetier in 1874. Aclocque thought that the men on either side of the saint were pewterers, and Delaporte thought this was possible, or equally, that they could be tavern keepers. Aclocque, 1917, 314; Delaporte, 1926, 516, and plate CCLXXIV. See also Bulteau, 1887–92, vol. 3, 220.

198. According to Corblet, the bishop received the mass offerings either himself in company with the archdeacon and a priest at the chancel, or by way of a deacon collecting the offering in the nave. Corblet, 1885–86, vol. 1, 220. Tithes were officially paid to the bishop. The Synod of Paris ruled in 1197 that "no cleric or regular clergy receive tithe from the hand of the layman except through the hand of the bishop." Mansi, vol. 22, col. 681, no. 14. According to Durandus, the thirteenth-century bishop of Mende who had previously been a member of the chapter of Chartres, subdeacons and acolytes brought offerings to the bishop. Durandus, 1854, vol. 2, 195.

199. Hans Jantzen noticed and described this effect: "The coloured light softens the sinewy lines of the architectural framework until it merges into a physically solid structure, in which architecture and coloured light make the containing sides of the lofty nave into a luminous wall . . . the enclosing walls appear diaphanous, intangible, luminous, like the golden background in medieval painting." Jantzen, 1962, 70–71.

200. Schnitzler, 1962.

201. In the south nave clerestory: Bay 67, a sainted bishop or possibly an abbot with two monks, Delaporte, 1926, 415; Bay 73, Bishop Solenne and two saints, ibid., 419; Bay 79, Bishop St. Augustine with two angels, ibid., 423–24; Bay 82, Bishop St. Gregory the Great with two lambs, ibid., 423; Bay 85, Bishop St. Hilaire and two praying figures, ibid., 426. In the north nave clerestory: Bay 175, a sainted bishop with two suppliant figures, ibid., 518; Bay 172, Bishop St. Lubinus with two wine offerers, ibid., 516–17; and Bay 169, Bishop St. Thomas of Canterbury with two praying figures, ibid., 514.

202. The oculi of the nave clerestory were added to the cathedral several years after the aisle window, and they seem to have been thematically planned as a group. Two other oculi are very similar: the Virgin flanked by suppliant figures and Christ flanked by adoring angels. The Virgin oculus is in Bay 157, Delaporte, 1926, 506; and Christ in Bay 70, ibid., 416. Another oculus depicts Bishop Jerome in the act of writing his translation of the Bible. He, too, sits frontally and reaches out towards either side to the Hebraic Bible and his Latin translation. Bay 76, ibid., 421. Only three of the fourteen oculi are at variance. Bay 160, a group of laborers with a cart, ibid., 508; Bay 161, St. George unattended, ibid., 508–9; Bay 166, the Virgin surrounded with the seven gifts of the Holy Spirit, ibid., 512–13.

203. Ibid., 377–80.

204. Delaporte, 1926, 377–78.

205. Ibid., 379. Events of the saint's life which are recognizable from Pintard's descriptions and his plan of the window show that the window was meant to be read from the top downwards.

206. Ibid., 377–78.

207. Ibid., 379.

208. Moreover, the scenes seem to have been shifted out of chronological sequence. Delaporte, 1926, 377–78.

209. Bay 171, ibid., 516.

210. Ibid., 380; *CND* II, #331, 1259, 169–72. The extra border of twenty-one angels around the window may have been inserted there to coordinate with the dedication of the altar.

211. The apostles are identified by inscriptions at their feet (from left to right): Sts. Thomas, Barnabus, Jude, Thomas, Philip, Andrew, Philip, and Jude. Three apostles appear twice, and the paired images of two apostles in each lancet are exactly alike. For this reason their authenticity is suspect. Bulteau explains the repetitions as an economy measure, but notes the windows have unusual colors and transparency. Delaporte, 1926, 139–40; Bulteau, 1887–92, vol. 3, 226. Roger Gaignière's late-seventeenth-century color sketches show one standing figure in each lancet, where today two appear. Van der Meulen and Hohmeyer, 1984, 81–82 (compare plates XVII and XVIII).

212. For the state of research on this problem, see Adams, 1987.

213. Delaporte, 1926, 438.

214. Corblet, 1885–86, vol. 2, 174.

215. Jungmann, 1951–55, vol. 1, 297, vol. 2, 210ff., 292, 294, 376ff., 457.

216. *CND* I, lxxxviij; II, #290, 1247, 137, n. 2.

217. Réau, vol. 1, 237; Braun, 1973, 140–41. There is a description of the practice of collecting small wine contributions by B. Guérard, 1850, vol. 1, xiv. See also Corblet, 1885–86, vol. 2, 240. He describes the manner by which communion was distributed to the faithful in a huge chalice with a straw. Corblet also published a series of articles on medieval sacred utensils surviving in European churches, the third of which concerned chalices large and small. Corblet, 1885, 53–64.

218. Braun, 1973, 141.

219. The gift included six silver goblets, as if the vase and goblets formed a set of utensils that would have been ideal for the distribution of ablution wine. *CND* I, cvj, n. 3.

220. See Delaporte's description of the practice in Appendix VIII to his publication of the thirteenth-century Ordinary, entitled "La concélébration de Jeudi Saint." Delaporte, 1953, 261–64.

221. Jungmann, 1951–55, vol. 2, 360–61.

222. For example, at Besançon. Franz, 1960, vol. 1, 259.

223. Ibid., 260ff.

224. Réau, vol. 2, pt. 2, 364; Kirschbaum, vol. 2, col. 300; Schiller, 1971, vol. 1, 162–64.

225. Réau, vol. 2, pt. 2, 362–66. See, for example, the early Christian wooden door of Santa Sabina in Rome, and the Tree Sarcophagus in the Lapidary Museum of Arles.

226. Miracle IV, A. Thomas, 1881, 515–17.

227. ". . . vinum sapore suavissimum, colore subtilissimum." Ibid., 516.

228. ". . . laudant omnes saporis dulcedinem, colorem singuli admirantur." Ibid., 517.

229. Grodecki, 1963, 181.

230. White, 1978, 188ff.

231. Mansi, vol. 22, col. 1003, can. 15. *De arcenda ebrietate clericorum.*

232. Dozer, 1980, 323.

233. Ibid., 307.

234. "Ce que li prestre mauves entendirent a mangier et devorer les delicioses chars senefie cels qi hantent les tavernes et les bordeaus et entendent a devorer les delicioses chars del munde." Vienna ÖNB 2554, fol. 35.

235. "Haec est inebrietas qua obliviscimur precepta dei et qua humanum gentis plenum est vitii et peccatis." Paris Bib. nat. lat. 11560, fol. 139. Other similar images and interpretations of taverns in the Oxford Moralized Bible: ibid., fols. 45 and 175, and Oxford, Bodl. Lib. 270b, fol. 20.

236. Brit. Lib. Harley 1527, fol. 34v.

237. Dozer, 1980, esp. 155ff., 161, 248.

238. ". . . non statim cum socio ad ecclesiam voluit proficisci, sed audiens quod Carnoti vina purissima et liquidissima venderentur more solito tabernam intravit, . . ." Thomas ed., 1881, 13, Miracle, 525.

239. Car le parole et le renon
Des bons vins avoit entendu
Qui a Chartres erent vendu,
Clers, seins, nes et delicïeus.
De boivre estoit plus curïeus
Et de hanas de vin voier,
Donne se poëit ennoier,
Que de vertu voiar n'aprendre;
Car trop avoit la bouche tendre
De bons vins et de bons morsiaus,
Don si ventrë estoit vessiaus,
Si que tantout com il vint la,
Tot droit en la taverne ala,
Si com touz jours fere soloit,
Por ce que les bon vins voloit
Boivre a leisir et essaier.

Kunstmann, 1973, Miracle 20, 157–58. Kunstmann dates this French version to 1252–62. Ibid., 6.

240. Bay 64, Delaporte, 1926, plates CLXXIX–CLXXXII.

241. Brit. Lib. MS Cott. Claudius BIV, fol. 17v.

242. Gaillard, 1944, plate VI. On the Salerno Antependium, see Goldschmidt, 1914–26, vol. 4, plates XLII–XLVIII.

243. Bettini, 1944, plate LIX. Early theologians had considerable difficulty explaining away Noah's drunkenness and nakedness. Allen, 1963, 73. However, it was featured even in short cycles of Noah's life, for example, the doors of Monreale (Salvini, 1962, 239, fig. 102), and the Oxford Moralized Bible (Oxford 270, fol. 10r).

224. Bay 58, Delaporte, 1926, plate vol. II, plate CL. See in contrast the Prodigal Son window at Bourges, or the illustration in the Oxford Moralized Bible, Brit. Lib. MS Harley 1527, fol. 34v.

245. Normally, the life of a saint would have been placed in a window near to his or her relics. Popesco, 1970, 56. On the location of the saint's relics, see van der Meulen, 1975, 76–79.

Chapter Five

1. Noonan, 1957, 11–20; Baldwin, 1959a, 12–16; Baldwin, 1959b, 287–99; Baldwin, 1970, vol. 1, 261–71.

2. Delaporte, 1926, 471–72, plates CCXXX, CCXXXI, CCXXXIV. *CVR* II, Bay 135, 42.

3. Delaporte, 1926, 463–64, plates CCXXII, CCXXIII. *CVR* II, Bay 41, 33.

4. Delaporte, 1926, 395–98, plates CLXII–CLXVI, color plates XIV–XVI. The window was inadvertently excluded from *CVR* II.

5. Delaporte, 1926, 511–12, plate CCLXVIII. *CVR* II, Bay 106, 36.

6. Delaporte, 1926, 207–10. *CVR* II, Bay 32, 32–33.

7. Bulteau, 1887–92, vol, 3, 221, 217–18, 249; Aclocque, 1917, 313–14, 325–26; Delaporte, 1926, 209, 395, 463, 471, 511–12; Villette, 1964, 116.

8. Pepin and Charlemagne minted coins of Chartres (plate 98, #4–6). Charles the Bald issued the first royal coin, whose design approximated the later coin of Chartres, in that the reverse had a large center cross inside a circle of pearls surrounded by CARNOTIS CIVITAS (plate 98, #7). This cross remained characteristic of the reverse of all the coins in the diocese, and undoubtedly the coins in the cathedral's windows were deliberately marked with a cross because of this. Charles the Bald's coin had, on its obverse, an inscription around the outside separated from the center by a circle of pearls like the later coin. But the inscription read GRATIA DI REX and the center contained the king's monogram. Similar coins were issued by Eudes (887–97) (see plate 98, #8). Lépinois, [1854] 1976, vol. 1, 406–7. See also *RN* vol. 10, 41–50.

9. The first known stipulation of the coin of Chartres occurs in a letter of Bishop Fulbert, ca. 1019, and mentions of the coins appear in documents through the course of the eleventh century. Chédeville, 1973, 432, n. 10.

10. By the beginning of the thirteenth century, eighty lords had the right to strike money in France. Vigreux, 1934, 17 and note 3.

11. Spufford, 1984, 355–95.

12. Chédeville, 1973, 436–37.

13. Ibid., 437.

14. Ibid., 437.

15. The change to royal money, however, occurred slowly in the fourteenth century. Ibid., 437–38.

16. Money was part of the fruits of dominion, like the lord's possession of a local mill. The only restraints on the lord's use of his money were moral obligation and self-interest. Typical financial needs that caused lords to devalue coins to raise money were wars, crusades, daughters' dowries. Babelon, 1909, 28–41.

17. Vigreux, 1934, 18.

18. On early devaluations, see Fournial, 1970, 69; on the twelfth century, see Grierson, 1976, 111.

19. The proportion of silver to alloy in the Middle Ages is expressed in deniers: 12 d. corresponded to fine silver (1,000). During the twelfth century a coin of 6 deniers had devalued approximately 6/12 of fine, or 0,500 fine in northern France. Fournial, 1970, 21. On the devaluation of the parisis, see Dumas, 1982, 39; Fournial, 1970, 68–69.

20. Dumas and Barrandon, 1982.

21. Bisson, 1979, 38–39. The parisis remained stable in the reigns of Louis VII and Philip Augustus. Fournial, 1970, 69.

22. *SMJ* I, #292, 1196, 338; *CND* I, #141, 1198, 261–62; *CND* I, #147, 1201, 9–10; *TEL*, #47, 1206, 57–58; *CSJV*, #154, 1207, 75.

23. On effects of monetary devaluation in the Middle Ages, see Marc Bloch, 1953, 145–58; Laurent, 1933, passim.

24. Payment was made on the feast of All Saints every third year. Bisson, 1979, 29–31, 36.

25. The tax was also known in Paris as the *tallia panis et vini*. Ibid., 36.

26. Ibid., 39.

27. Ibid., 37.

28. Ibid., passim.

29. Cartier, *RN* 10, 1845, 41–50.

30. Ibid., 284; Chédeville, 1983, 82–83.

31. Subsequent confirmations of the coins of Champagne were issued in 1208 and 1214. Bisson, 1979, 130. On the history of the minting of coins in Champagne, see also Arbois de Jubainville, 1861–65, vol. 4, pt. 2, chap. 10, "Monnaie," 759–88.

32. Bisson, 1979, 126–27. The following is a partial translation of the text Bisson reprinted on 126, 127, note 5, from Bernier's *Histoire de Blois . . .* , Paris, 1682: "Count Thibaut, Seneschal of France, and Countess Alix, for the love of God and for the souls of their ancestors, have conceded the holding of weapons and horses by the men of this land. . . . They also granted that they would not make the coin worth less and that they would not take the *cornagium* (money tax applied to horned beasts) any more. Therefore, we entrust the divine power that whoever dares to violate the sacred *permagina* and that which has been sanctified or to weaken it any more, should be struck with eternal malediction and the implacable wrath of the vengeance of God."

33. On the probable date of the ruling, see Bisson, 1979, 127, and n. 1. Bisson says extreme dates for this are the marriage and the death of Thibaut V. He believes it should be assigned an early date due to the preexistence of a related inscription, and the similar confirmation of the coinage in Champagne in 1165 (see ibid., 130–33). According to Bisson, Count Thibaut V was moved by high-minded morality. This is the ideology of his monumental pledge; I believe the cause of his action lay in economic self-interest.

34. Dumas, 1982, 541–74.

35. On the illusory nature of the king's promises, see Dieudonné, 1909, 105. The royal policy actually began with Louis VII, who first attempted to create a nonfeudal coinage in France and closed feudal mints that fell into his hands. *CEH*, vol. 3, 1963, 583–84. According to Vigreux, eighty lords had the right to strike money in France in the beginning of the thirteenth century. Vigreux, 1934, 17 and note 3.

36. Dumas, 1982, 542–45. Diverse coinages had circulated in Picardy, a land of communes and powerful bishops. The king allowed the "black" money (inferior in alloy by the addition of copper that turned black) of Laon and Noyon to circulate in reduced parity with the parisis. The uniquely profitable mint of Ponthieu continued but altered its coins to match the parisis.

37. Dumas, 1982, 546. Charter published in Saulcy, 117–18.

38. *CEH*, vol. 3, 584.

39. Fournial, 1970, 70. Philip Augustus eventually minted both the tournois and the parisis in all his royal ateliers. On Rennes, see Dieudonné, 1923, lxxxii.

40. Philip Augustus established his two royal coins by 1223. Louis VIII and Louis IX did not strike the parisis at all, but struck the tournois in all the royal mints: Bourges, Carcassone, le Bois-Sainte-Marie, Macon after 1239, Paris, Saint-Antonin, Sommières, and Tours. Fournial, 1970, 70.

41. See Dumas's maps 1 and 2 of the coinages in France before and after Philip Augustus' consolidation. Dumas, 1982, following 572.

42. On Chartres, see Bisson, 1979, 128–232. On anonymous coins of Chartres, see Cartier, *RN* 10, 1845, 41–50, and plate 2.

43. Dhenin, 1978, 156. The coins of Chartres, Châteaudun, Blois, and Vendôme circulated freely in the region of Chartres and beyond into Evreux at this time. Chédeville, 1973, 435.

44. The coins are illustrated in Lépinois, 1976, vol. 1, opposite 405, nos. 11 and 12; and in *RN* 14, plate VII. See also Dhenin, 1978, 156. The coin of Blois originally carried a crowned, profile head on its reverse. It shifted to the abstract, banner-like image of Chartres sometime in the twelfth century. Cartier proposes that these coins date after the ca. 1164 ruling inscribed on the portal, because from these coins onward, he claims, the real value of the coins of Bois was conserved. *RN* 11, 1846, 40. For Cartier's treatment of the coins of Blois, see Cartier, *RN* 10, 1845, 112–41, plates 6–7. Châteaudun's coin is a variant of the coins of Chartres from its appearance in the mid-eleventh century, but is most like the coins of Chartres in the first quarter of the thirteenth century. Cartier, *RN* 10, 1845, 291, 295–96. On the coins of Châteaudun, see Cartier, *RN* 10, 1845, 275–80, 283–303, and plates 15–16; Engel and Serrure, 1964, vol. 2, 398–400. On the coins of Perche, see Cartier, *RN* 10, 1845, 281–83, 303–7, plate 17. The coins of Perche show the abstract, banner-like insignia of Chartres reversed like a mirror image, possibly copied after a particular issue of Châteaudun's coins. Ibid., 305. The coin of Vendôme, originally like the coin of Blois, with a crowned profile head, in mid-eleventh century, shifted toward Châteaudun's coin and the orbit of Chartres very early. Cartier, *RN* 10, 1845, 217. On the coins of Vendôme, see Cartier, *RN* 10, 1845, 196–226, and plates 10–11. Engel and Serrure, 1964, vol. 2, 397–98.

45. Chédeville, 1973, 435. See Chédeville's coinage map, ibid., 46. Dhenin, 1978, 156.

46. *Revue Numismatique*, vol. 9, plate XIII.

47. Vendôme's coins change first, with the minting of types simulating the image of the royal coin of Tours during the reign of Count Jean III (1207–18). Cartier, *RN* 10, 1845, 221. Châteaudun coins similarly alter during the reign of Vicomté Geoffroy IV (1215–35). Ibid., 297. The coins of Blois alter first to more exactly simulate the chartrain and then the tourain, during the reign of Count Jean de Châtillon (1241–69). Engel and Serrure, 1964, vol. 2, 395–96. Devailly found the turning point to be around 1215 in the Cher, when the tournois usage began to dramatically increase and the circulation of the parisis and the local monies dropped off. See his graph, Devailly, 1973, 574.

48. The first evidence Chédeville found of a changer was in a charter of 1070. Chédeville, 1973, 476, and no. 285; *CASP* I, 203. I am most indebted for the information in this section to Chédeville's chapter entitled "Juif, changeurs et usuriers," Chédeville, 1973, 474–80. That the occupations were hereditary at

Chartres is borne out in local documents not only by the apparent dynastic names but also in bequests of rights. See *CASP* II, #107, 338. The counts of Chartres and Blois allowed the occupation to be hereditary at Bois as well. Soyer and Trouillard, 1903–7, #22, 1211, 81–83, #31, 1214 or 1215, 100–102.

49. Chédeville, 1973, 476–77.

50. Vigreux, 1934, 24–25.

51. Chédeville, 1973, 475.

52. Souchet, vol. 2, 1866–73, 508.

53. ". . . cambitores Carnotenses, amore Dei et pro remedio anime boni viri mei comitis Teobaldi, redditum suum de canbio de diebus dominicis ecclesie de Burdinaria et fratribus ibi Deo famulantibus dederunt et perpetuo possidendum concesserunt. . . ." *CLGB*, #6, 1192, 187–88.

54. The changers did not pledge the income from their tables; rather, each pledged a different amount of money or grain from other property that he held. Ibid., 188.

55. *CND* I, 50–51. According to Chevalier, the number of changers in French towns grew dramatically from the mid-thirteenth century up until the mid-fourteenth century, the number clearly depending on the size of the population, not the commercial activity. He gives some figures: Tours had 23 changers in 1344, Chartres 39 at the end of the fourteenth century, Toulouse 80 in 1337. He does not give population estimates, but argues that these changers were not bankers. Since all they did, according to him, was to change coins, their numbers were logically based on the population. Chevalier, 1973, 153–60.

56. For an excellent and thorough account of the work of minting coins and the control of coins in the medieval period, see Dumas, 1986. See also Chevalier, 1973, 154–55; Bigwood, 1921, 422–37. For an early Christian description of a changer's task, see that of Gregory the Great, 1850 edition, 611.

57. Luchaire, 1892a, 271.

58. Vigreux, 1934, 1, 23–26.

59. The king set the rate between the parisis and tournois. While the king had the right to set these values, it was limited by the commercial value of precious metal. Ibid., 17.

60. This is, at least, the documented practice of changers elsewhere, for example, in Burgundy. See Lièvre, 1929, 26–27.

61. Mention of a goldsmith's house on what was late the Rue du Petit Change in a conspectus to the charters of 1070–80 (*CASP* I, 24) causes Chédeville to speculate that changers were first recruited from men with experience in precious metals: minters and goldsmiths. Chédeville, 1973, 476 and n. 293. The street is mentioned in 1183. See Aclocque, 1917, 184, re: Arch. Nat. K177.

62. This is stated in a royal ordinance of 1311. *OrdRf*, vol. 1, 481–82.

63. According to Lopez, they charged a commission of 8.33 percent, or one denier per sous. Lopez, 1953, 21.

64. Chédeville, 1973, 154.

65. On the hereditary nature of the trade at Chartres, see Chédeville, 1973, 476–80. The overhead for a money changer was low, at least according to the purchase of eleven tables in Clermont in 1288 for 6 livres, 5 sous, 6 deniers (with a tent, a carpet, a safety box which served for a seat, a leather purse, two scales, and a standard of measure all thrown into the bargain). Boudet, 1911, 184.

66. We cannot be sure how much they paid in taxes, but it seems clear they paid the count a fairly large amount for their *scutum* in the twelfth century. The *scutum* the changers paid the count yearly is not ever precisely set forth in the charters. The count transferred differing amounts from this payment in the twelfth century: 100s. in 1123, (*SMJ* I, #12, 1123, 24–25); 20s. in 1197 from 2 scuta (Arch. Nat. S 3292, no. 48). In the thirteenth century, the changers' payments are no longer referred to as *scuta*; rather, the payments seem to be considered as rents: 60s. from change in 1220 (Arch. Nat. K 177, no. 216); 12 livres (240s.) from two tables in 1237 (*CLGB*, #312, 1237, 126), a very large sum for the rent of two tables, suggesting the high profitability of the trade.

67. Eventually changers were forced to do this. Vigreux, 1934, 24.

68. Minters usually directed a shop of workmen. Lopez, 1953, 18; and Fournial, 1970, 13. Unfortunately, we have no knowledge whatsoever of the division of labor in the mints at Chartres. Medieval coins were pennies of silver alloy, struck by hand from clipped pieces of hand-pounded metal sheeting. The lower die was stationary, and the worker held the upper die, consisting of an iron bar, in one hand. He placed the piece of sheet metal on the stationary die, positioned the iron bar with the upper die in its end over the piece of metal, and struck the top of it with a mallet (see plate 26). Singer, 1956, vol. 2, 490, and fig. 451 of a twelfth-century moneyer carved on a capital at Saint-Georges de Bocherville, Normandy. For a more detailed account of the medieval fabrication of coins, see Blanchet and Dieudonné, 1916, vol. 2, 21–29. For a description of the personnel involved in the fabrication of coins in the royal atelier in Paris, see Saulcy, 1879, XII–XIV.

69. They also minted some half-deniers called *oboles*. On the coins of Chartres, see Cartier, *RN* 10, 1845, 41–50, and plate 2; Dhenin, 1978, 154–58.

70. On the *seignioriage* and *brassage*, see Lièvre, 1929, 10. The seignioriage apparently varied dramatically. In Melgueil in 1174 the seignioriage amounted to 8 percent, and in Genoa in 1141 it was at least 25 percent. Ibid., no. 22. The vidame of Chartres received 16 livres on every 1,000 livres struck in 1312, but it is not clear whether this represented a *seignioriage*. *CND* I, 50, n. 1. See also Lépinois, 1976, vol. 1, 537. In addition, in the late fourteenth century, the vidame and three other knights received a cens from the thirty-nine change tables of 34 deniers and 1 obole annually. *CND* I, 51.

71. For example, Frankish moneyers under Pepin the Short gained their share of the profits by retaining one of every twenty-two deniers they made. Lopez, 1953, 16–18. Because the relative cost of manufacture diminished as volume increased, the amount of minters' profit varied according to the volume of production; if fewer coins were struck, the rate was raised, and vice-versa. Ibid., 18.

72. Vigreux, 1934, 19–20. They clipped recalled coins, which could bring considerable profit also. Ibid., 27.

73. Ibid., 18–22.

74. Since silver and gold were in short supply in Western Europe, and in fact coins themselves as well, it would stand to reason that the decision as to whether to sell foreign coins, reprocess them into native ones, or fashion silver objects or bullion for sale would be based on market conditions. The shortage of coins made it possible to receive a discount on prices by paying cash. Chédeville, 1973, 460; Vigreux, 1934, 28–29. On discounts for cash payments, see

Boudet, 1911, 19–20. Chevalier, who asked himself how changers became opulent, proposed an interesting theory. He suggested that the flight of silver to the East was the cause for the reintroduction of gold coins in the West in the thirteenth century, and postulated that the conduit of silver to the East was operated by merchants of Cahors who bought from changers and sold to eastern middlemen. Chevalier, 1973, 155–59. However, according to Chédeville, there is no documentation of Cahorsins in Chartres until the second half of the thirteenth century. Chédeville, 1973, 479–80.

75. In Paris, the combination of the two professions was made convenient by the proximity of their shops on either side of the *Grand Pont.* Franklin, 1906, 139.

76. I have purposely selected dated examples from the Necrology. Other, more stunning, undated examples of goldsmith works donated to the cathedral could be cited from the Necrology and from unpublished materials. For example, in 1220, the archdean of Vendôme, Pierre de Bordeaux, gave a statue of the Virgin with two attending angels all covered with silver. Delaporte, 1955, 41, and n. 5, and Archives Départementales d'Eure-et-Loir, Series G, 403, document 4.

77. *CND* III, Necrologium, 135.

78. Ibid., 106.

79. Ibid., 160–62.

80. Chédeville, 1973, 478–79.

81. Lopez and Raymond, 1955, 212. "Expansion of the exchange business into money lending and deposit banking is a frequent and almost unavoidable process. . . . [I]n an age when relatively few private individuals had much cash at hand and when even a count might be unable at short notice to pay six livres, the moneyers were almost the only ones who were in a position to lend money. To [their own] liquid assets they may have added bullions and coins which private individuals and institutions may have placed for safekeeping in the well-guarded coffers which must have existed in every mint house. If they used the deposits in their business they were in fact deposit bankers, no matter how modest and elementary their operations may have been. This in turn would help us to explain their close connections with merchants and with high lay and ecclesiastic officials." Lopez, 1953, 22–23. However, Lopez did most of his research on Italian commerce, and the opposite opinion about the changers in French towns, including Chartres, was hazarded by Chevalier in 1973. He thought that all the changers did at Chartres was change money, presumably before he had seen Chédeville's work. Chevalier, 1973, 154. According to Bigwood, the incipient transformation of money changing to banking appeared at the taking of deposits in Flanders; his first evidence dates to 1246 in Liège. Bigwood, 1921, 430.

82. Chédeville, 1973, 476–77. Prosperous changers appear in documents already in the eleventh century: *CASP* I, ca. 1070, 24; *CASP* II, #25, n.d., 284–85, ca. 1101.

83. *CASP* II, #107, 1101, 338.

84. Now he left two arpents of vineyard, half of a grange, other properties and 100 sous to Saint-Père, plus 400 sous to other local monasteries. Ibid., #53, 1116–24, 306–7.

85. *CLGB,* #219, 1221, 85.

86. Many family members of changers joined monastic institutions. Chéde-ville, 1973, 476–77. By far the highest-known ranks attained by money mer-chants at Chartres in the twelfth and thirteenth centuries are represented by the Theobaldus Monetarius whom King Louis commanded to protect the ca-thedral and its men (1225), and Guillelmus de Moneta, squire (1283). See *CND* II, #249, 1225, 105–6 and *SMJ* II, #510, 1283, 152–53.

87. *CLGB*, #239, 1225, 92.

88. Chédeville, 1973, 492.

89. In 1283, Guillaume de La Monnaie was decorated with the title of *ecuyer*. Ibid., 478.

90. Remarkable social mobility was achieved by changers in other French towns. On Beauvais changers who formed powerful aristocratic families with prerogatives of wealth and political clout, see Labande, 1892, 57, 58, 69ff., 113, 116; on aristocracy of changers in Normandy, see Musset, 1959, 285–99. See also Chédeville, 1973, 155.

91. Lopez comments on the decline of moneyers: "as the economic and po-litical tide began to turn, the moneyers had to take sides. Some of them cast their lot with the religious reformers and occupied leading positions in the emerging communes. Others forsook their origins to merge with the diehard feudal nobility." Lopez, 1953, 1.

92. Chédeville, 1973, 477–78.

93. Actual loans of coins, however, first appear in the local documents in 1227 (*mortuum pignus*), and were usually in small amounts. Contracts gener-ally stipulated natural goods to avoid accusation of usury, but rents, the major means of borrowing, were almost always in species from the end of the twelfth century. Chédeville, 1973, 464–66.

94. Souchet, 1866–73, vol. 1, 547–50.

95. Chédeville, 1973, 460–68.

96. *CND* III, Necrologium, 17. A monetarius left 50s. for his anniversary. The entry is from a necrology that the editors date 1276 or later. A goldsmith in another undated entry left the cathedral some property in the cloister. Ibid., 52. This entry is from a necrology that the editors date before 1120.

97. One minter witnessed the charter of 1181, *CND* I, #98, 207; and six changers witnessed the charter of 1183, *CND* I, #101, 209–11.

98. Chédeville, 1973, 492.

99. *CND* I, #121, 1194–95, 238.

100. *CND* II, #246, 1224, 103.

101. Branner, 1969, 98–99.

102. Du Cange, vol. 5, 350–51.

103. The charter further states that the *mercerii* owed their dues to the chap-ter and "whoever should be elected to the deanship might not lay claim to them, but that they might remain without hindrance, as heretofore, in the possession of the chapter." *CND* II, #246, 1224, 103. The dean had the right of policing the cloister during fairs, but this charter was written on the occasion of the election of a new dean, setting aside part of a disputed profit as belonging to the chapter. On the dean's jurisdiction of the cloister during fairs, see *CND* I, lxxviij, and n. 4.

104. The pilgrims' tokens are known from the early thirteenth century. Le-cocq, 1876, 194–242. The earliest clear record of their sale in the cloister, how-

ever, is much later. Lecocq, 1858, 147. It seems likely that changers' stalls were set up temporarily in the cloister during the cathedral fairs, since we have evidence of this occurring elsewhere. Lièvre, 1929, 22–24.

105. *CND* II, #249, 1225, 105–6. The king was the guardian of the cathedral and of most cathedrals under his protection. This finds expression in his *gîte* and in his justice of last resort. Didier, 1927, 85–91; 304–7.

106. Lépinois, 1976, vol. 1, 122ff.

107. *CND* II, #278, 1234, 127–29. The count of Champagne, in a parallel need for cash, built up a debt of 10,500 livres by 1224, borrowed from the "Jews of the King," and had mortgaged the gold from the altar and the cross of the cathedral of Troyes for an additional 2,000 livres. By 1229, he owed 23,340 livres or two-thirds of his yearly revenue. Arbois de Jubainville, 1861–65, vol. 4, pt. 2, 836–42.

108. Lépinois, 1976, vol. 1, 407. The first coin with a count's name on it was an obole which still contained King Raoul's monogram, but had inscribed around it TETBALDIS C. I. This type was changed by Count Thibaut I's successor, Eudes I, to the anonymous coin of Chartres which endured to the end of the local mint. Dhenin, 1978, 155. Dumas-Dubourg, 1971, 196–97.

109. Lopez, 1953, 4, 11–12.

110. Chédeville, 1973, 435, and note 22.

111. *CLGB*, #119, 1183, 49.

112. *CLGB*, #50, 1160, 23.

113. *CLGB*, #6, 1192, 187–88.

114. *MCB*, #80, 1213. This may be why a vidame at the end of the twelfth century had as his seal three besants like the three besants on the coin of Chartres. René Merlet, 1896c, 84, n. 1.

115. "Ego Ursio de Melleyo, dominus Fractivallis . . . immo de jure et consuetudine regni Francorum . . . feodum quod ab ipso teneo et antecessores mei ab episcopis Carnotensibus predecessoribus suis tenuerunt . . . declaro . . . in civitate Carnotensi. . . . Item medietatem omnium reddituum, justiciarum, feodorum . . . in Cambio et cambitoribus, in Moneta et monetariis, in justicia falsariorum et quarumlibet aliarum rerum ad hec omnia pertinentium, hoc addito quod partem illam quam habeo de monetagio teneo totam ab episcopo Carnotensi." *CND* II, #270, 1229, 120–21.

116. According to Luchaire, a vidame was a lay person, a lord whose position was hereditary, who held a fief to guard the possessions of the bishop, to represent the bishop at the tribunal of the count, to lead the bishop's troops, and to guard the episcopal mansion after the bishop's death. The seigneurie of the vidame usually comprised a house near the episcopal palace, a territorial domain in the town and in the country. The vidame had a right to certain taxes raised on the inhabitants of the city. Luchaire, 1892a, 288–89. See also René Merlet, 1896c, 81–91, on the vidames of Chartres. According to Merlet, the title of vidame extended to all the members of the entitled person's family. Ibid., 85. Unfortunately, he does not give any information about Urseo de Meslay, who wrote the 1229 charter.

117. Louis IX confirmed this by letters dated from Melun in August 1229. *CND* II, 122, n. 1.

118. "L'Evêque dit que le Comte ne peut battre moinnaie, en la comté de Chartres, que dans le seule ville de Chartres; que, de chaque millier, le sire

Hugues de Meslay qui tient la monnaie en fief de l'Evêque, doit avoir seize livres; que certaines personnes doivent garder les coins, d'ou elles retirent émolument, lesquelles personnes tiennent ce droit dudit sire Hugues, en arrière-fief de l'Evêque; enfin, que la police des faux monnayeurs appartient au dit Hugues, . . ." Lépinois, 1976, vol. 1, 537.

119. The *Vieille Chronique* is reproduced in its entirety in *CND* I, 1–66. For a description of its contents, see ibid., 1, n. 1.

120. See Sanfaçon, 1988, 399.

121. After 1304, Count Charles minted royal coins. Cartier, *RN* 10, 1845, 36. The king purchased the mint, and closed it permanently, in 1319. Ibid., 39–40; Grierson, 1976, 217.

122. This is also historically unsound, because the cathedral documents claim episcopal office at Chartres began in the first century A.D., and bishops are verified in documents from the fifth century, whereas the legendary beginnings of the chapter date to the reign of Bishop Lubinus in mid-sixth century. Lépinois 1976, vol. 1, 422–23; Challine, 1918 (written before 1678), 236–37, 410.

123. ". . . in moneta omnimodam justiciam et custodiam cuneorum, et aliis que consequenter dicimus; in quibus comes nichil habet, sed episcopus ea retinuit et ab episcopo solo tenentur in feudum." *CND* I, 50.

124. "Moneta enim et justicia cujuscumque false monete tenentur ab episcopo per medium domini Hugonis de Mellayo, qui, quando comes facit monetam, in quolibet miliario habet sexdecim libras. Item quatuor tenentes ab episcopo in feudum habent custodiam cuneorum monete, et quolibet mane illos tradunt percucientibus et sero recipiunt iterum in custodia, et propter hoc habent certas libertates et jura. Et ex parte episcopi reservate sunt et in thesauro ecclesie, tanquam in sequestro posite, in quodam anulo perforate, duodecim pecie monete, ad quarum instar et aleamentum comes tenetur facere monetem novam." Ibid.

125. On the guards of mints, see Dumas, 1986, 486–87.

126. "Custodes vero dictorum cuneorum sunt Raginaldus *Lambert*, Petrus *Beruat*, Michael *Breton*, et heredes dicti *le Mareschal*, qui, propter hoc, nomine libertatis, forum comitis declinant et forum episcopi sorciuntur." *CND* I, 50.

127. On the devaluations of the coin by Charles de Valois, see Cartier, *RN* 10, 1845, 36–39.

128. Cartier concluded that the bishop had maintained rights over the mint and ceded them to a vassal, perhaps to avoid direct altercation with the count. Ibid., 35–36.

129. Chédeville, 1973, 435.

130. A possibly similar situation occurred in 1265 between the archbishop of Narbonne and the vicomté and consuls there. The archbishop, after a heated dispute, struck coins without the vicomté's and consuls' agreement. Bisson, 1973, 55–56.

131. We know that the kings did transfer the royal right of minting to bishops in the late Carolingian period, especially where the bishop held local temporal authority. The bishop was the territorial lord at Chartres in the ninth century, and hence probably did receive minting rights until the king established a secular lord over the region. On the number of bishops minting coins

in the medieval period, see Fournial, 1970, 178–80. He lists forty-six bishops and archbishops who minted coins.

132. *RN* 14, 1849, plate VII, #9, 248–85. The weight of deniers generally diminished throughout the Middle Ages. The weight of the early coins of Chartres serves to date them approximately to the late Carolingian era. Cartier, *RN* 10, 1845, 41–42. For the average weight of the deniers of Charlemagne, see Fournial, 1970, 61. He lists the average theoretical weight of 1,852 grams, which equals 28.58 grains.

133. On the Chartres coin with a reverse image of a temple, see also Lépi-nois, 1976, vol. 1, 404. Unlike Cartier, he attributes the coin to the reign of Charles the Simple (897–923), but agrees with Cartier that ES probably stood for Episcopus (ibid. p. 407). Gariel says the coin was issued by King Raoul. Gariel, 1883–84, vol. 2, 302.

134. Cartier, *RN* 14, 1849, 284. M. E. Cartier's work on the coins of Chartres appeared in issues of the *Revue Numismatique* in the mid-nineteenth century under the title "Recherches sur les monnaies au type chartrain." *RN*, 9, 1844, 405–28, plates XII, XIII; *RN*, vol. 10, 1845, 26–51, 112–41, 196–226, 275–308, 360–95, plates II, VI, VII, X, XI, XV, XVI, XVII, XIX, XX; *RN*, 11, 1846, 28–55, 107–33, plates II, III, IV, VII, VIII, IX; *RN*, 14, 1849, 248–95, plates VII, VIII. Cartier later suggests that the ES might rather be FS, indicating Bishop Fulbert of Chartres. *RN* 14, 1849, 254, 255.

135. The counts of Vendôme frequently were at war with the counts of Blois and Chartres. Yet Vendôme was part of the diocese of Chartres, the local counts were vassals of the bishop of Chartres, and the coins of Vendôme closely resembled the *chartrain*. Cartier, *RN* 10, 1845, 196–207. Chédeville, however, disagrees with Cartier. He sees the extent of the minting of the coin to finally conform to the count's domain, not the bishop's. Chédeville, 1973, 433–34. He admits that Vendôme poses a contradiction to his contention. Ibid., 434, n. 19.

136. Cartier, 1860, 37. Harreaux proposed in 1876 that the image represented a Sanskrit letter of unknown origin. Harreaux, 1876, 243–47; Merlet in 1891 claimed the image developed from a disintegration of King Raoul's monogram. René Merlet, 1896b, 111–21. Engel argued in 1894 that the type was a degeneration of "chinonaise" head from the time of Eudes I. Engel and Serrure, [1894] 1964, vol. 2, 395.

137. Dhenin, 1978, 154–55, worked out the lineage of the image on the chartrain. He convincingly argued for its derivation from profile heads on local coins, based on the transitional coin found in the Treasure of Fécamp. The *tête chartrain* head on the obverse of the coin of Chartres is considered a notorious example of the medieval disintegration of profile heads, which become more and more unreadable. *CEH* vol. 3, 1963, 581.

138. The image is turned 90 degrees onto its side, proving that the remembrance of a face is lost. It is this view of the abstract image that appears like a banner, and may have been understood that way by the thirteenth century, when it appears on pilgrimage tokens in this way.

139. According to Chédeville, he probably was not expected to pay back most of the debt. Chédeville, 1973, 462, note 206.

140. Money payments became the rule by 1110–20, later than in other regions. Chédeville, 1973, 432–33.

141. For example, the very large gold chalice bequeathed by Simon de Mont-fort, or the silver chalice weighing one marc given by a sacristan, or the silver basin weighing three marcs given by a canon. *CND* III, Necrologium, 185, 188, 220.

142. The money box is mentioned in one of the miracles of 1210. A. Thomas, 1881, 512.

143. For a review of the reasons for the drain of gold from the West to the East during the Middle Ages, despite some trade which returned gold coins to the West, primarily the slave trade, and the difficulty of knowing the effect of the crusades on the balance of silver and gold exchanges between the East and West, see *CEH* vol. 2, 161–63. Watson later states that the crusades continued the gold drain from the West. Watson, 1967, 7. On exchange rates between gold and silver, see ibid., 5.

144. *CEH* vol. 2, p. 164; see *CEH* vol. 3, "Coinage and Currency," 576–602, for a basic review of medieval coins.

145. Lavagne, 1981, 21.

146. Cipolla, 1956, 26.

147. Watson, 1967, 7.

148. Ibid., 10.

149. Ibid., 11–12, 14.

150. Watson found one reference to an exchange of 7.5 silver to gold in France at the end of the twelfth century. Watson, 1967, 23. At the same time, he found evidence of a similar shift in Tunisia or Sicily, where around 1200 the rate was 6 to 4. Ibid., 27.

151. Perrot and Dhenin, 1985, 641–45.

152. The coin closely resembles Almoravid exemplars. The inscription painted on the coin is a mirror image of the actual coin, and although the kufic is not correct, it is close enough to be deciphered. The center contains, in three lines, the motto: "There is no God but Allah." The outer circle contains a verse from the Koran. Ibid., 644.

153. Ibid., 642.

154. See Blanchet, 155, 147–51. For example, the counts of Toulouse paid to the altar of the patron saint of the abbey of St. Pierre at Moissac one gold obole yearly. Ibid., 147.

155. Ibid., 151. Monneret de Villard found mentions of gold denarii in char-ters from various parts of Europe, dating from the eighth through the twelfth centuries. See Monneret de Villard, 1919, 125–28.

156. Chédeville, 1977, 413–43. Chédeville found that gold became a means for ecclesiastic institutions to express their gratitude to generous donors in the Romanesque period, but the gifts of gratitude were seldom in coinage. The last such gold present he found in the region was made in 1115. He asserts that such gifts did continue until the end of the twelfth century, but usually silver was given instead, worked into vases and cups. Chédeville, 1974, 307.

157. A nineteenth-century antiquarian named Arthur Forgeais found tokens in the Seine which originated from many pilgrimage sites. Forgeais, 1858. On the work of Forgeais, see Lecocq, 1876, 202–4, with bibliography on 204, n. 2. For a full discussion of the pilgrimage tokens of Chartres, see ibid., 194–242. The first documentation of the sale of these lead pilgrims' tokens is much later. Lecocq cites and quotes sixteenth-century contracts between the chapter

and individuals who gained the monopoly for sales of lead pilgrims' tokens during the fairs of the Virgin. Ibid., 208–9; Lecocq, 1858, 147–49.

158. Lecocq, 1876, 214 and fig. 3. Lecocq compares the reverse image to the fresco demolished in the nineteenth century, over a doorway leading to Roman cellars under the Hôtel-Dieu. It depicted two men, who Lecocq believes were guards of the cathedral treasury. Ibid., 216–27 and fig. 4 (see Plate 20).

159. Ibid., 1876, 214, and fig. 2.

160. Ibid., 217–23.

161. Lecocq, 1860, 33–47.

162. St. Louis is said to have always worn a lead image of the Virgin in his hair or on his hat. Ibid., 212. The power of protecting the wearer was attributed to the tokens worn as talismans.

163. CND II, #270, 1229, 121.

164. On the many images of the Virgin and Child in the cathedral glass, see Delaporte, 1955, 95–96.

165. On the images of the Virgin with the Magi at Chartres, Delaporte, 1955, 86; on the original cult statue in the crypt, see Forsyth, 1972, 105–11, and Delaporte, 1955, 6–32; on the new thirteenth-century cult statue in the choir on the main altar, see ibid., 35–40.

166. On the window, see Delaporte, 1926, 471; Gilbert, 1824, 69. On the resemblance to the coins of Chartres, notice how the circle on the coins in the window simulates the actual ring of tiny pearls separating the inner cross from the outer inscription on the coins.

167. An example of a thirteenth-century gilt ciborium is in the treasury of Saint-Maurice Abbey.

168. Weights were made in bronze or in lead, and in a wide variety of shapes. See Lavagne, 1981, 21; Machabey, 1959, 326–37; Sheppard and Musham, 1923, figs. 9, 10, 12.

169. The image portrays graphically what Abbot Suger had inscribed on the cast and gilded doors of the new west front at St. Denis: "Marvel not at the gold and the expense, but at the craftsmanship of the work." Panofsky, 1979, 47.

170. M. Dhenin of the Cabinet des Médailles in Paris suggested the first possibility to me. Changers' wood boxes, carefully compartmentalized to hold a balance and a set of weights, survive from the late Roman period and the sixteenth century. Sheppard and Musham, 1923, figs. 1, 3, 9–10, 12. I have found no references to medieval boxes of money weights and balances, but it is likely that changers used them in the Middle Ages. The image of the box in this window looks original, as does the glass. As to verification boxes, they too are difficult to find in medieval sources. The earliest reference that I have found for these boxes is from the early fifteenth century. RN ser. 4, vol. 13, 1909, cxi–cxii. According to Fournial, similar boxes were used twice during minting in the Middle Ages, first as just described, and second, when at the end of a minting issue, the guards themselves placed coins at random into a box to submit to an assayer. Fournial, 1970, 18–19. See also Lièvre, 1929, 11, and Colin, 1858–59, 59–60.

171. Dumas, 1986, 486–87.

172. Delaporte, 1926, 463; Gilbert, 1824, 70.

173. I examined this window from the exterior with M. Petit of Thivars, a stained-glass artisan whose knowledge of ancient glass Mme Françoise Perrot

had commended to me. M. Petit assisted me in charting the repairs in work scenes in the apse clerestory. The face of the client on the left is a repair, but his hair is original, as is his body, with the exception of central sections of his torso. His hands are original, and the greater part of the silver coins in front of him are original. The changer scene opposite this in the window of St. Peter is in an extraordinarily good state of preservation.

174. Wealthy clients hold gloves in other trades scenes at Chartres. See the cloth merchant's customer on the bottom left of the St. James window in the ambulatory, Bay 37. Delaporte, 1926, plate CI.

175. Ibid., 395; Gilbert, 1824, 79.

176. In assaying money, sometimes a touchstone (*pierre de touche*) was used. These were little pieces of gold of different alloys, also called *touchaux*, flat pieces of gold with *titre* marked on them. One struck the gold coin to be tested on the touchstones, and whichever touchstone was the closest in softness and color indicated the quality of the gold coin. Hence these little gold pieces could be touchstones against which the gold coin to be tested was struck for comparison. Boizard, 1892, 181.

177. This trebucket presents a similar dilemma to that of the changers' balance box in the window of St. Peter. The trebucket in the window appears to be original glass, but trebuckets only survive from the eighteenth century and after. Sheppard and Musham, 1923, figs. 46, 50, 51, 52. Hucher found an ordinance of 1325 in which a money trebucket (*trabucare monetam*) is specified for verification of money weight. He believed that the instrument in the changers' window at Le Mans is a trebucket, and identifies a similar instrument in a window fragment from Bourges. Hucher, n.d., 3–7. On the Le Mans trebucket, see also Feldhaus, 1931, 264–65; Lopez, 1953, 18, n. 25.

178. This change may have been due to the disbelief on the part of technical advisors as to the authenticity of the trebucket, since I was told in 1980 by some of the curators of the Cabinet des Médailles in Paris that there is no evidence of them in the Middle Ages.

179. Delaporte, 1926, plate CLXII. Delaporte thought it was a scale. Ibid., 395.

180. Ibid., color plate XV.

181. Ibid., 208–9.

182. For example, Gospel Book of Echternach, fol. 53r; Gospel Book of Matilda, Morgan Library 492, fol. 84r.

183. For example, the reliefs at Beaucaire and Arles in Provence, also many Romanesque capitals and archivolts, the tympanum of Condrieu, and the right side of the portal of San Isidoro at Leon. Stoddard, 1972, 75.

184. In Beaucaire, at the church of Notre-Dame-des-Pommiers, exterior south frieze.

185. On St. Gilles, see Hamann-MacLean, 1955, 168–69, and Stoddard, 1973.

186. In Arles, at the church of St. Trophîme, cloister gallery, north side, first pier.

187. Typical are reliefs at Trier. Schindler, 1980, figs. 140, 341. There are no images of minting at Chartres, like the ones Beatriz Mariño has published on the portal of Santiago de Carrión de los Condes. Mariño, 1986, 499–513.

188. On this issue, see the excellent analysis and accompanying bibliography in Drinkwater, 1981, 215–33.

189. Paris Bib. nat. Lat. 11560, fol. 54r.

190. Brit. Mus. Harley 1527, fol. 25r.

191. Paris Bib. nat. Lat. 11560, fol. 7v.

192. Oxford Bodl. 270b, fols. 212r and 222r.

193. One of two panels is readable: two men work on either side of a device, apparently testing the size and weight of coins. On the Bourges window, see Cahier and Martin, 1841–44, plate XXVIII, "Usages civils A"; also *CVR* II, Bay 34, 175.

194. One of the two scenes is a modern copy. On the Le Mans windows, see Mussat, 1981, 109–11. See also E. Hucher, n.d., 1–5, and *CVR*, II, 246–47.

195. Mussat, 1981, 110.

196. The Virgin appears filling a monastic granary with wheat, shown as little golden discs, in a visual analogy to the coins on the changers' table below. Ibid., color plate, 105.

197. Delaporte, 1926, 471–72, plates CCXXX, CCXXXI, CXXXIV.

198. The traditional nature of these images is apparent in the work of Carolyn Kinder Carr, who wrote her dissertation on certain aspects of the iconography of St. Peter in medieval art in Western Europe. Carr discussed the *Traditio Clavis* imagery at length. Carr, 1978a, 60–68. On the medieval representation of Peter escaping Herod's prison, see ibid., 140–44; on the "Domine, Quo Vadis" iconographic tradition, see ibid., 158–60.

199. Réau, 1955–59, vol. 3, pt. 3, 1083.

200. Carr, 1978a, 54. Carr traced the development of the literary tradition regarding St. Peter's keys. Ibid., 54–60. The image of Peter with the keys to the kingdom was already important in fifth-century Rome, when he stood on the triumphal arches of the basilicas visibly supporting the claims of the pope to political power. *DACL*, vol. 3, pt. 2, col. 1860. Carr sees the image of Peter in the Quo Vadis scene as the historical moment when the papacy was instituted. Carr, 1978a, 159–60.

201. According to Innocent III, the tiara was a sign of the temporal power when the pope wore it outside of the church. Carolyn Carr found that the representations of Peter as supreme pontiff dated primarily to the twelfth and thirteenth centuries, and were relatively rare. Carr 1978a, 30–34; Carr, 1978b, 1167–68. Peter also wears the tiara on the north porch of Chartres.

202. Carr, 1978a, 34.

203. There were five altars in the lower church mentioned in the thirteenth-century ordinary: the altars of Sts. Savinien and Potentien, St. John the Baptist, St. Denis, St. Christopher, and St. Peter in Chains. *CND* II, #290, 1247, 137, n. 2.

204. Delaporte, 1953, 65, 199.

205. Ibid., 242.

206. Peter also appears in two upper-story lancets in the cathedral: Bay 69 in the south nave clerestory and Bay 86 in the west wall of the south transept clerestory. Delaporte, 1926, 416 and 426. Peter is one of the twelve apostles in the lintel of the Royal Portal on the west front, and one of the column statues of the central portal of the south porch, and appears as a column statue on the outermost flank of the center entrance to the north porch, opposite his Old Testament counterpart, Melchizedek, and next to St. John the Baptist.

207. Delaporte, 1953, 14, 150. See also *DACL* vol. 14, pt. 1, cols. 976–80.

208. Delaporte, 1953, 55, 168. See also *DACL* vol. 14, pt. 1, cols. 980–81.

209. Delaporte, 1953, 14, 31, 54, 66, 161. See also *DACL* vol. 14, pt. 1, cols. 974–76.

210. O'Connor, 1969, 42.

211. *DACL* vol. 14, pt. 1, cols. 980–81; *DACL* vol. 3, pt. 1, cols. 3–19.

212. Delaporte, 1953, 55.

213. Delaporte published a French translation of an excerpt of the Latin text in the twelfth-century lectionary of Chartres that has since burned. Delaporte, 1926, 471–72. For a discussion on the sources for the legend of Peter's martyrdom in Rome, see O'Connor, 1969, 65ff., esp. 67, and n. 56; and Réau vol. 3, pt. 3, 1095–96.

214. Frere, 1934, 247, and in the Standard Gospel Series, ibid. 45, no. 160. On the night before the feast of Sts. Peter and Paul, the chapter made a procession to the monastery of Saint-Père and reiterated the vesper service it had already performed in the cathedral, and on the festal day the chapter again went to Saint-Père to take part in the mass there. Delaporte, 1953, 54. The liturgy holds a curious precedent for the association of St. Peter with silver and gold coins. The reading for the *laudes* of Peter's martyrdom in the thirteenth-century Ordinary includes the antiphon *Petrus et Johannes . . .* from Acts 3:1–10. Ibid., 161. The biblical passage relates that Peter and John went to the temple at the hour of prayer, and at the entrance met a cripple who asked them for charity. Peter responded, "I have no silver or gold; but what I have I give you: in the name of Jesus Christ of Nazareth, walk." The *Liber Comitis* used the same biblical passage for the epistle of the same feast, and it was probably also used in this way at Chartres, since the Ordinary omits many things. Frere, 1935, 14, 109.

215. Delaporte 1953, 161 and 168.

216. Ibid., 150, 161, and 168.

217. Cross and Livingstone, 1974, 76, s.v. "Apostolic Succession."

218. The ordo for a major excommunication in the Pontifical of Durandus states: "idcirco, auctoritate Dei omnipotentis, patris et filii et spiritus sancti, et beatorum apostolorum Petri et Pauli et omnium sanctorum, exigente ipsius contumacia, ipsum excommunico. . . ." Andrieu, 1940b, 610. Concerning the absolution for a major excommunication, the officiant said: "Auctoritate Dei omnipotentis et beatorum apostolorum Petri et Pauli et ecclesie sancte sue et ea qua fungor, absolvo te a vinculo talis excommunicationis, quo ex tali causa ligatus eras." Andrieu, 1940a, 611.

219. The bishop's throne stood on the south side of the choir when the first secure indication of its placement appears. Plate 150 was taken from the chart of the choir in Bulteau, 1887–92, vol. 3, 83–86.

220. Delaporte, 1926, 463–64, plates CCXXI, CCXXIII.

221. On the annunciation to Zacharias, see Koehler, 1952, 48–57.

222. The next day John was standing with two of his disciples when Jesus passed by, and he repeated the idea: "There is the Lamb of God." John 1: 35–36.

223. The implication of John's priestly robes on the front of the Maximianus throne was explained by John Chrysostom, who wrote in a homily that John

was not only a prophet but also a priest when he exercised the sacerdotal function of baptism. Mâle, 1951, 55. On the medieval notion of John the Baptist as the herald of Christ, see the *Glossa Ordinaria*, lib. genesis, cap. 41, *PL* 113, col. 170; Hrabanus Maurus, *Commentario in Genesim*, lib. 4, cap. 4, *PL* 107, col. 635; Isidore, *Quaestiones in Vetus testamentum*, concerning Genesis, *PL* 83, col. 274. Because John was considered the first priest of the New Testament, the annunciation to Zacharias of the future birth of John the Baptist became the traditional picture beginning the New Testament cycle in the East from the fifth century and the West from the sixth century. Kirschbaum, vol. 7, col. 178.

224. Matthew 3: 16–17; Mark 1: 9–11; and John 1: 21–22.

225. Mâle, 1951, 55–56. The Baptism usually includes St. John, Christ, and two attendant angels. Réau, vol. 2, pt. 2. 295–304.

226. In a sermon in the sixth century, Bishop Chrysologus of Ravenna related St. John's life to his office of bishop. Schapiro, [1952] 1979, 35–36. Von Simson discussed the image of John the Baptist on the front of the Maximianus throne in Ravenna as the embodiment of episcopal dignity. Von Simson, 1948, 65–66.

227. *CND* I, #97, 1180–83, 205, n. 2.

228. Delaporte, 1953, 54; Delaporte, 1932, 132–36.

229. The image of John the Baptist appears in other locations in the twelfth- and thirteenth-century cathedral glass and stone decoration: Bay #104, Delaporte, 1926, 444, and plate CCX; Bay #9, ibid., plate XXIX; statue of St. John the Baptist on the north porch; and in various narrative cycles, such as the Infancy of Christ window, ibid., 153, and plate V.

230. Delaporte, 1953, 65, 199.

231. Ibid., 54, 160. For the feasts of John the Baptist, see *DACL* 7, pt. 2, cols. 2171–74.

232. Delaporte, 1953, 54, 56, 67, 173, 220.

233. *Fuit in diebus Herodis regis.* . . . Frere, 1934, 44, 242.

234. Orléans, Bib. Mun. MS 144, fol. 30v.

235. Jungmann, 1951–55, vol. 2, 332–35.

236. The standard readings were Matthew 3:13–17 (Christ's baptism), Frere, 1934, 237; John 1:29–34 (John's prophecy of Christ's imminent appearance), ibid., 245; and Matthew 12:9–13, 15 (Jesus says John is the first among those born of women), ibid., 238. One of the Psalm readings for Epiphany was *Fluenta Iordanis retro conversa*, again referring to Christ's baptism. *RAC* vol. 5, col. 899.

237. Faucheux thought they were a sort of link between the Old and New Testaments at either end of the apse. Faucheux, 1990, 11.

238. Caesarius of Arles, 1978, sermon 33, 168–81.

239. From the Bobbio Missal, 1920 edition, 98.

240. Lucien Merlet, 1889, 35–94.

241. Delaporte, 1926, 426, and plate CXCIII.

242. The choir screen extended only across the west end of the choir, but the upper spaces between the pillars around the choir were usually closed off by tapestries, and the lower space was definitely closed off by the choir stalls. The spaces between the pillars of the apse were apparently closed off by furniture and an elaborate raised reliquary for bodies called the *capsa*. One still has to

actually walk into the choir in order to gain a view of the whole length of the choir windows.

243. Françoise Perrot has recently hazarded a hypothesis that these clerestory knights and kings were the result of an organized collective donation of those involved in the Albigensian crusade around 1218–23. Perrot, 1987, 109–29.

244. Bulteau described the scenes based on the story of Joseph in Genesis 37–46, but did not specify the precise biblical text that the scenes illustrate. Delaporte, 1926, 395–98. The story of Joseph in the Bible continues to his death in Genesis 50.

245. Horizontal iron armatures divide the tall lancet window into four registers, within which four squares defined by armatures set diagonally rise up the lancet, one on top of another. This geometric arrangement is very different from that of the Lubinus window, for example, in which a double meaning was intended for the large, central, superimposed medallions. The Joseph window's format is designed for a continuous pictorial narrative.

246. Fabre, 1921–22, 193–211. There seems to have been a hiatus of interest in the Joseph cycle from the seventh to the eleventh centuries, but the large number of cycles in the twelfth and thirteenth centuries attest to renewed popularity of the story. Ibid., 204. Rupprecht identified three early Christian traditions for the cycle, characterized by the Octateuch, the Vienna Genesis, and the Cotton Genesis. Rupprecht, 1969, 166.

247. For the literature on the Maximianus throne, see Volbach, 1976, 94, and Matthews, 1980, 35–56; on the ambon in the cathedral of Santa Restituta in Naples, see Bertaux, 1903, 775–78, plate XXXIV; on the Sens ivory box, see Goldschmidt and Weitzmann, 1930–34, vol. 1, 64–67, plates LXXII–LXXV; for literature on the Coptic silks, see Matthews, 1980, 37, note 9. Ioli Kalavrezou pointed out to me that while we know that the silk medallions were used to decorate clothing, we do not know who wore them or the significance that they conveyed to the wearer.

248. Schapiro, [1952] 1979, 35–47.

249. I created a data-processing system for the study of the pictorial cycles of Joseph the Patriarch which was published twice, in 1984 and 1988.

250. The cycles closest to that of Chartres in selection of scenes:

Cycle	Date by century	No. of scenes	No. of subjects like Chartres	% of subjects like Chartres
1 Maximianus throne	6th	14	9	64.2
2 Bourges window	13th	18	11	61.1
3 Naples marble ambon	13th	15	9	60.0
4 Salisbury sculpture	13th	23	12	52.1
5 Psalter of St. Louis	13th	24	11	45.8
6 Auxerre reliefs	13th	22	10	45.4

251. Iconographic resemblances of scenes in other cycles to those at Chartres:

Cycle	Date by century	No. of scenes	No. of subjects like Chartres	% of subjects like Chartres
1 Bourges window	13th	18	5	27.7
2 Vienna Psalter	13th	30	8	26.6
3 Sens ivory box	11th	24	4	16.6
3 Rouen windows	13th	48	8	16.6
3 Psalter of St. Louis	13th	24	4	16.6
4 Maximianus throne	6th	14	2	14.2
5 Salisbury sculpture	13th	23	3	13.0

252. The first three scenes in the window at Bourges are very much like those at Chartres: Joseph's dream begins the cycle, and on either side in the next register Jacob sends Joseph to Sicham and Joseph's brothers see him approach. The next three scenes are alike in subject, but different in iconography. The window at Bourges ends with Joseph taking Benjamin by the hand to his palace, unlike the ending at Chartres. It has a different format, with three tiny center scenes whose narrative meaning is not clear. It has only sixteen panels, and crowds two events into two of these.

253. The two criteria taken together rank the cycles closest to that at Chartres as follows:

Cycle	Date by century	No. of scenes	% of same subjects	% of same iconography	Total
Bourges window	13th	18	61.1	27.7	88.8%
Maximianus throne	6th	14	64.2	14.2	78.4%
Naples marble ambon	13th	15	60.0	6.6	66.6%
Salisbury sculpture	13th	23	52.1	13.0	65.0%
Psalter of St. Louis	13th	24	45.8	16.6	62.4%

254. Grodecki, 1975, 339–59; Haselhorst, 1974, 159–69; Grodecki 1948a, 87–111; Quievreux, 1942, 255–75.

255. Schapiro, [1952] 1979, 35–37. Most convincing for his argument is the text by Ambrose entitled "De Officiis Ministrorum" (PL 16, cols. 23–184), instructions written by Bishop Ambrose to the priests of his diocese, using Joseph as an example for them of good qualities for a spiritual and temporal leader. Schapiro, 1979, 36; no. 13 (p. 44) cites cols. 56, 116–18, 122–27. See also Rupprecht, 1969, 163. Daniélou used Joseph as an example of how biblical typology was preserved in the liturgy. Daniélou, 1963, 141–61.

256. Schapiro's citations of Eusebius, Philo, and Cassiodorus especially support the idea of Joseph as a type of the good political leader and administrator. Jane Timken Matthews has recently shown that the inversion of biblical events on the throne of Maximianus may result from reference to Philo. Matthews, 1980, 35–56. See Philo, 1935, 138–271. Also Rupprecht, 1969. For a brief survey of exegesis on Joseph, see Argyle, 1956, 199–201.

257. "Joseph, qui typum Christi gerebat, currum meruit, et praeco praeconavit ante eum,-et constituit eum Pharao super universam terram Egypti . . . et accepit potestatem praedicandi et judicandi a Patre . . . Accepit quoque annulum, id est, pontificatum fidei, quo credentium animae salutis signo signantur, frontibussque et cordibus nostris per signum crucis figura aeterni regis im-

primitur." *Glossa ordinaria,* lib. Genesis, cap. 41, *PL* 113, col. 170, regarding Genesis 41:41. See also Hrabanus Maurus, *Commentarii in Genesim,* lib. 4, cap. 3–4, *PL* 107, cols. 634–63; Bede, *In Pentateuchum commentarii,* Genesis, cap. 41, *PL* 91, cols. 268–69.

258. "Potiphar qui constituit Joseph prepositum domus sue prelatos ecclesie significat qui ecclesiasticis viris regimen ecclesie et curam tradunt animarum." Oxford Moralized Bible, Bodl. 270b, fol. 24.

259. "Misit Joseph suos per totam Aegyptum, et collegit frumentum multum quasi arenam maris. Et noster Joseph Christus Dominus misit suos per mundum, dicens: 'Ite, baptizate gentes in nomine Patris, et Filii, et Spiritus sancti.' Et collectus est credentium numerus sine numero, quasi arena maris." Prosper of Aquitaine, *Liber de promissionibus et praedicationibus Dei,* pt. 1, cap. 29, *PL* 51, col. 756. On the *Glossa's* similar interpretation, see *PL* 113, col. 170. A similar scene appears in the Joseph window at Rouen. Ritter, 1926, 44 and plate 16. Madeline Caviness, in a talk presented at the SUNY Binghamton conference in 1985, explained the scene at Chartres as an illustration of the apocryphal account that Joseph ordered chaff cast into the Nile to alert his father that there was grain in Egypt. Pamela Blum previously had described the scene in the Salisbury Chapter House spandrels cycle of Joseph (dated shortly after 1280) as a depiction of this apocryphal event. Blum's only sources for the apocryphal story were its later depiction in the Queen Mary's Psalter, and her suspicion that it was contained in a lost folio of the mid-thirteenth-century paraphrase of the Joseph story, *Iacob and Iosep* (Oxford Bodl. 652), the remainder of which explains other nonbiblical imagery in the spandrels. Blum, 1969, 18, 25. No early thirteenth-century documentation of the story has come to light, and it seems less persuasive an explanation for the scene in the Chartres and Rouen windows than the biblical passage. With either explanation, however, my observation about the emphasis on the storing of an abundance of grain in the window at Chartres remains valid.

260. The scene adorses the figures of antiquity who were usually confronted, for example, in the tenth-century copy of the Diptyque of Flavius Magnus of 518 now in the Cabinet des Médailles in Paris.

261. "Constituit Joseph horrea per universam Aegyptum, et per totum mundum Christus Dominus consecravit ecclesias. . . ." Prosper of Aquitaine, *Liber de promissionibus et praedicationibus Dei,* pt. 1, cap. 29, *PL* 51, col. 756.

262. "In hac fame positis, noster Joseph Christus Dominus ex horreis suis nobis divinam sui corporis annonam administrat, quam gustantes videmus quam suavis est Dominus." Ibid.

263. *PL* 113, col. 171.

264. "Omnipotens et misericors deus, qui benedixisti horrea ioseph, aream gedeonis, et adhuc quod maius est iacta terrae semina surgere facis cum fenore messis, te humiliter quaesumus, ut sicut ad petitionem famuli tui heliae non defuit uiduae farina, ita ad nostrae paruitatis suffragia huic orreo famulorum tuorum non desit benedictionis tuae abundantia." See Deshusses, 1982, no. 4298, 241–42, and Franz, 1960, vol. 1, 643–44, where the wording is somewhat different.

265. Little is written about this window. See Delaporte, 1926, 105, 511–12; Gilbert's description of the changers scenes in 1824 is uncharacteristically brief: "Trois personnes qui comptent de l'argent sur une table; ce sont vrai-

semblablement des changeurs." Gilbert, 1824, 64. I examined the window ex-
terior myself from the roof, and found that the exterior of the glass is mostly
encrusted with a reddish-gray patina which I think might be a deliberate mod-
ern simulation of aging. The individual pieces of glass are of an unusual
rounded cut, larger than usual. The style of the figures is not consistent with
that of the other trade scenes, and the imagery shows some confusion caused
by replaced pieces. All of these observations together suggest a major repair. It
is known that the window underwent extensive repair in the atelier of Coffe-
tier in the nineteenth century. However, Mme Anne Granboulon, looking with
binoculars, did not find the exterior suspicious, nor did she find the style ex-
traordinary for the thirteenth century. Mme Granboulon has done considerable
research on medieval glass, and was for a time in charge of the Bibliothèque et
Documentation of the Centre International du Vitrail at Chartres. She exam-
ined the exterior of windows on the north aisle and north clerestory with bi-
noculars in my company in October 1983 and helped me to chart the repairs
in work scenes there.

266. This gesture of upper-class men and women appears in many windows
at Chartres: see for example Delaporte, plate vol. II, plates CI, XCVIII, CXV,
CXXV, CXXXIII, CXXXV.

267. Ibid., 207. The window was opened up again in the nineteenth century,
and now holds a modern glass window dedicated to St. Fulbert donated by
American architects.

268. Delaporte, 1926, 207–10.

269. Ibid., 1926, 209. On the legends of St. Blaise, see *BHL*, vol. I, 204–5,
nos. 1370–80. *AA SS*, vol. 3, 336–53.

270. Panel 12: "Une personne sortant d'une porte semble répandre de l'ar-
gent devant un porc; un Loup paroist s'enfuir tout proche.

Panel 14: "Une personne abbat à coups de bâton ou d'Epée une Idole d'or et
une Idole d'argent qui ont les mains plaines de pièces d'or et d'argent." Dela-
porte, 1926, 209.

271. On the pictorial cycles of Blaise and his cult, see Réau, vol. 3, pt. 1,
227–33; and Kirschbaum, vol. 5, cols. 416–19; Aurenhammer, 1959, 384–90,
s.v. "Blasius."

272. See Franz, 1960, vol. 1, 202–3, 271–72, 452–53, 458–59; vol. 2, 10, 17,
129, 416. See also Honorius of Autun, *Gemma animae*, lib. 3. cap. 25, *PL* 172,
col. 649.

273. Panels 1 and 4 described by Pintard, and numbered on Pintard's diagram
of the window. Delaporte, 1926, 208.

274. Delaporte, 1953, 145, 150.

275. On the blessing used, see Franz, 1906, vol. 1, 203.

276. One finds the same combination of coins and golden vessels on the
changers' tables in the Moralized Bibles.

277. Bisson, 1979, 143.

278. Ibid., 159. Similar concerns can be construed at Le Mans as well, where
the money changers in the choir appear at their tables below enormous pic-
tures of sainted bishops.

279. St. Gregory the Great, 1850, 611.

280. Lester K. Little wrote a summary of the two separate trends of thought
on money and its commercial uses. At the end of the twelfth century, needs of

business and government for a credit system were increasingly in conflict with rigid anticommercial morality. Little, 1978.

281. On usury, see Noonan, 1957.

282. The Third Lateran Council declared usury to be condemned by both the Old and New Testaments, excommunicated and denied Christian burial to manifest usurers, and prohibited reception of offerings made by them. Ibid., 19.

283. Changers in the Oxford Bible: Oxford. Bodl. 270b, fols. 4, 20, 70, 90; Paris Bib. Nat. lat. 11560, fols. 7, 54, 72, 76, 138, 167; Brit. Mus. Harley 1527, fols. 21, 25, 56, 111. A typical negative commentary to the image of money changers is that accompanying Jesus' statement: "The foxes have holes and the birds nests, but the son of man has nowhere to lay his head" (Matt. 8: 19–20). The commentary: "The foxes signify the greedy lying in wait in temporal things, the birds those who boast in the wealth and pomp of the world. The lord who came to preach poverty and humility shuns the society of these." Brit. Mus. Harley 1427, fol. 25.

284. On the just price, see Baldwin, 1959b, and K. S. Cahn, 1969.

285. Conservative theologians concentrated in Paris around Peter the Chanter. See Baldwin, 1970. On the justification of free bargaining, see Cahn, 1969, 23–25; Baldwin, 1959, 21; Ibanes, 1967, 25, 40; Baldwin, 1970, 267–8; McGovern, 1970, 217–53.

286. This differentiation was accentuated by the gold and silver apostle statues that once stood high on alternating piers in the nave and the choir. In the nave, where the people gathered, the statues were sheathed in silver; in the choir, the Virgin's sanctuary, the apostle statues were sheathed in gold. David, 1989, 14.

Epilogue

1. On the early communal organizations in France, see Luchaire, 1892a; Petit-Dutaillis, 1947; Vermeesch, 1966.

2. On the situation at Bourges, see Raynal, 1844–47, vol. 2; Monjaidet, 1936–37; Devailly, 1973. On the so-called communal organization at Bourges, actually a reserve army, see Vermeesch, 1966.

3. Delaporte, 1953, 44–45.

4. The idea must have had an early medieval conception, since the Porte Cendreuse and the abbey of Saint-Chéron came into being then. According to legend, the abbey of Saint-Chéron was founded in the sixth century. In the seventh century, King Clother III generously endowed the abbey, for healing one of his sons. Lépinois, 1976, vol. 1, 282–83. The Porte Cendreuse was part of the ninth-century wall of Chartres. It was demolished in 1504. Buisson and Bellier de la Chavignèrie, 1860, 19.

5. Duby, 1978.

6. Ibid., 263–68. See Cary J. Nederman's 1990 translation of John of Salisbury's *Policraticus*, 125ff.

BIBLIOGRAPHY

Abel, W. *Crises agraires en Europe (XIII–XX s.)*. Paris, 1974.

Aclocque, Geneviève. *Les corporations, l'industrie et le commerce à Chartres du XIe siècle à la revolution*. Paris, [1917], 1967.

Adams, Henry. *Mont-Saint-Michel and Chartres*. New York, [1904], 1926.

Adams, Roger J. *The Eastern Portal of the North Transept at Chartres. "Christocentric" Rather Than "Mariological."* Kultstätten der gallisch-fränkischen kirche 2, Frankfurt-am-Main and Bern, 1982.

———. "The Chartres Clerestory Apostle Windows: An Iconographic Aberration?" *Gesta*, vol. 26, 1987, 141–50.

Alexandre, Pierre. *Le climat au moyen âge en Belgique et dans les régions voisines (Rhénanie, Nord de la France)*. Louvain, 1976.

———. *Le climat en Europe au moyen âge*. Paris, 1987.

Allemang, G. "Leobin." *Lexikon für Theologie und Kirche*, vol. 6, col. 958. Freiburg, 1961.

Allen, Don Cameron. *The Legend of Noah*. Urbana, 1963.

Amiet, Louis. *Essai sur l'organization du Chapitre Cathédrale de Chartres du XIe au XVIIIe siècle*. Chartres, 1922.

———. "La juridiction privilégiée spirituelle du chapitre cathédrale de Chartres." *Revue historique de droit français et étranger*, 1923, 210–71.

Andrieu, Michel. *Le Pontifical romain au moyen-âge*. Vol. 1, *Le Pontifical romain du XIIe siècle*. Studi e testi 86. Vatican, 1938.

———. *Le Pontifical romain au moyen-âge*. Vol. 2, *Le Pontifical de la curie romaine au XIIIe siècle*. Studi e testi 87. Vatican, 1940a.

———. *Le Pontifical romain au moyen-âge*. Vol. 3, *Le Pontifical de Guillaume Durand*. Studi e testi 88. Vatican, 1940b.

Argyle, A. W., Jr. "The Patriarch in Patristic Teaching." *The Expository Times*, vol. 67, 1956, 199–201.

Auber, Abbé. *Histoire de la cathédrale de Poitiers*. Vol. 1. Poitiers and Paris, 1849.

Aubert, Marcel. *French Cathedral Windows of the 12th and 13th Centuries.* New York, [1937] 1939.

Aubert, Marcel, et al. *Le vitrail français.* Paris, 1958.

Aurenhammer, Hans. *Lexikon der christlichen Ikonographie.* Vol. 1. Vienna, 1959.

Axton, Richard. *European Drama of the Early Middle Ages.* London, 1974.

Axton, Richard, and John Stevens, trans. *Medieval French Plays.* Oxford, 1971.

Babelon, E. "La théorie féodale de monnaie." *Académie des inscriptions et belles-lettres,* vol. 38, 1, 1909, 279–347.

Baldwin, John W. *The Government of Philip Augustus.* Berkeley, 1986.

———. "The Medieval Merchant before the Bar of Canon Law." *Papers of the Michigan Academy of Science, Arts, and Letters,* vol. 44, 1959a, 287–99.

———. *The Medieval Theories of the Just Price: Romanists, Canonists and Theologians in the Twelfth and Thirteenth Centuries.* Philadelphia, 1959b.

———. *Masters, Princes, and Merchants: The Social Views of Peter the Chanter and His Circle.* 2 vols. Princeton, 1970.

———. "La décennie decisive: les années 1190–1203 dans le règne de Philippe Auguste." *Revue historique,* vol. 266, 1981, 311–37.

Barasch, Moshe. *Gestures of Despair in Medieval and Early Renaissance Art.* New York, 1976.

Barthélemy, Anatole de. "Monnaie." *Histoire des ducs et des comtes de Champagne,* Henry d'Arbois de Jubainville, ed. Paris, 1859–65, vol. 4, pt. 2, 772ff.

———. "Essaie sur la monnaie parisis." *Société de l'histoire de Paris et de l'Ile-de-France, Mémoires,* vol. 2, 1876, 142–71.

Barthélemy, H. de. "Origines de la monnaie tournois." *Revue Numismatique,* ser. 4, vol. 1, 1897, 153–62.

Beauhaire, Joseph. *Chronologie des évêques, des curés, des vicaires, et des autres prêtres de ce diocèse depuis les temps les plus reculés jusqu'à nos jours.* Châteaudun and Paris, 1892.

Bedos, B., "Les sceau du chapitre de Notre-Dame de Chartres, témoin d'une antique tradition mariale." *Club française de la médaille,* 1979, 132–35.

Bégule, Lucien. *Monographie de la cathédrale de Lyon.* Lyon, 1880.

Benson, Robert L. *The Bishop Elect; a Study in Medieval Ecclesiastical Office.* Princeton, 1968.

Bertaux, Émile. *L'art dans l'Italie méridionale.* Vol. 3, Paris, 1903.

Bettini, Sergio. *Mosaici antichi di San Marco a Venezia.* Bergamo, 1944.

Biblia Sacra iuxta Vulgatam Clementinam. 5th ed., Alberto Colunga, O.P., and Laurentio Turrado, eds. Madrid, 1977.

Bigwood, Georges. *Le régime juridique et économique du commerce de l'argent dans la Belgique du moyen âge.* Académie Royale de Belgique, classe des lettres et des sciences morales et politiques, 2d series, vol. 14. Brussels, 1921.

Bisson, Thomas N. *Conservation of Coinage. Monetary Exploitation and Its Restraint in France, Catalonia, and Aragon (c. AD 1000–c. 1225).* Oxford, 1979.

Blaise, Albert. *Lexicon Latinitatis Medii Aevi.* Corpus Christianorum Continuatio mediaevalis. Turnholt, 1975.

Blanchet, Adrien. "Le denier et l'obole d'or. Redevances médiévales." *Receuil de Travaux offert à M. Clovis Brunel.* Vol. 1. Paris, 1955, 147–51.

Blanchet, Adrien, and A. Dieudonné. *Manuel de numismatique française,* vol. 2, Paris, 1916; vol. 4, Paris, 1936.

Bloch, Marc. "Le problème de l'or au moyen âge." *Annales d'histoire écomique et sociale,* vol. 5, 1933, 1–34.

———. "Mutation monetaire dans l'ancienne France, Part 1." *Annales d'histoire économique et sociale,* vol. 8, 1953, 145–58.

Blondel, André. *Essai sur les institutions municipales de Chartres.* Chartres, 1903.

Blum, Pamela Z. "The Middle English Romance 'Iacob and Iosep' and the Joseph Cycle of the Salisbury Chapel House." *Gesta,* vol. 8, 1969, 18–34.

Blumenkranz, Bernhard. *Le juif médiéval au miroir de l'art chrétien.* Paris, 1966.

Boizard, Jean. *Traité des Monoyes de leurs circonstances et dépendances.* Paris, 1892.

Bonneau, G. "Description des verrières de la cathédrale d'Auxerre." *Bulletin de la société des sciences historiques et naturelles de l'Yonne* (Auxerre), vol. 39, 1885, 296–348.

Boudet, Marcellin. "Etude sur les sociétés marchandes et financières au Moyen âge: Les Gayte et les Chauchat de Clermont." *Revue d'Auvergne,* vol. 28, 1911, 1–20, 145–86, 239–70, 379–429; vol. 29, 1912, 42–64, 116–41, 261–81; vol. 30, 1913, 102–44.

Bourgeois, Alfred. *Les Métiers de Blois.* Vol. 1. Blois, 1892.

Boussard, Jacques. "L'origine des familles seigneuriales dans la région de la Loire moyenne." *Cahiers de civilisation médiévale Xe–Xii siècles,* vol. 5, 1962, 303–22.

Boutaric, E. *Actes du Parlement de Paris.* Vol. 1. Paris, 1863–67.

Bouton, André. *Le Maine: Histoire économique et sociale des origines au XIVe siècle.* Le Mans, 1962.

Boyer, Hippolyte. "Histoire des corporations and confréries d'arts et métiers de Bourges: La vigne et le vin." *SHLSCM,* 4th ser. (Bourges), vol. 30, 1917, 145–70; vol. 31, 1918–19, 1–107.

Branner, Robert. "Historical Aspects of the Reconstruction of Reims Cathedral, 1210–1241." *Speculum,* vol. 36, 1961, 23–37.

———. *La cathédrale de Bourges et sa place dans l'architecture gothique.* Paris, 1962.

———. *Chartres Cathedral.* London, 1969.

———. *Manuscript Painting in Paris during the Reign of Saint Louis: A Study of Styles.* Berkeley, 1977.

Braun, Joseph. *Die liturgische Gewandung im Occident und Orient nach Ursprung und Entwicklung, Verwendung, und Symbolik.* Freiburg im Breisgau, 1907.

———. *Der christliche Altar in seiner geschichtlichen Entwicklung.* 2 vols. Munich, 1924.

———. *Das christliche Altargerät in seinem Sein und in seiner Entwicklung.* Rpr., Hildesheim and New York, 1973.

Brincken, Anna-Dorothee von den. "Mundus figura rotunda." *Ornamenta Ecclesiae* (Cologne), vol. 1, 1985, 98–106.

Brooke, Christopher. "The Cathedral in Medieval Society." *The Gothic Cathedral.* London, 1969, 13–20.

Browe, Peter. "Die Elevation in der Messe." *JL*, vol. 9, 1929, 20–66.

———. *Die Pflichtkommunion im Mittelalter.* Münster, 1940.

———. "Mittelalterliche Kommunionriten. Kapital 5. Die Ablution." *JL*, vol. 15, 1941, 48–57.

Brown, Elizabeth A. R. *The Oxford Collection of the Drawings of Roger de Gaignières and the Royal Tombs of Saint Denis.* Transactions of the American Philosophical Society, vol. 78, part 5, 1988.

———. "Taxation and Morality in the 13th and 14th Centuries; Conscience and Political Power and the Kings of France." *French Historical Studies*, vol. 8, 1973, 1–28.

Buck-Morss, Susan. "Walter Benjamin, Revolutionary Writer." *The New Left Review*, no. 128, July–Aguust, 1981, 50–75.

Buddensieg, Tilmann. "Die Basler Altartafel Heinrichs II." *Wallraf-Richartz-Jahrbuch*, vol. 19, 1957, 133–92.

Buisson, P., and P. Bellier de la Chavignèrie. *Tableau de la ville de Chartres en 1750.* Chartres, 1860.

Bulteau, Marcel J. *Description de la cathédrale de Chartres.* Chartres and Paris, 1850.

———. "Etude iconographique sur les calendriers figurés de la cathédrale de Chartres." *SAELM*, vol. 7, 1882, 197–224.

———. *Monographie de la cathédrale de Chartres.* 3 vols. Chartres, 1887–92.

Burford, A. *Craftsman in Greek and Roman Society.* London, 1972.

Busson, G., and A. Ledru. *Actus Pontificum Cenomannis in Urbe Degentium.* Le Mans, 1902.

Caesarius of Arles. *Sermons au Peuple*, Marie-José Delâge, ed. Vol. 2, Sources chrétiennes 243. Paris, 1978.

Cahier, Charles, *Caractéristiques des saints dans l'art populaire.* Paris, 1867.

Cahier, Charles, and Arthur Martin. *Monographie de la cathédrale de Bourges.* 2 vols. Paris, 1841–44.

Cahn, Kenneth S. "The Roman and Frankish Roots of the Just Price of Medieval Canon Law." *Studies in Mediaeval and Renaissance History*, vol. 6, 1969, 3–52.

Cahn, Walter. *Romanesque Bible Illumination.* Ithaca, 1982.

Caron, Émile. *Monnaies féodales françaises.* Paris, 1882.

Carr, Carolyn Kinder. "Aspects of the Iconography of Saint Peter in Medieval Art of Western Europe to the Early Thirteenth Century." Ph.D. diss., Case Western Reserve University, 1978a.

———. "Aspects of the Iconography of Saint Peter in Medieval Art of Western Europe to the Early Thirteenth Century." *Dissertation Abstracts*, vol. 39, #3, 1978b. 1167–68.

Cartier, E. "Dernières observations sur les monnaies au type chartrain." *RN* 14, 1849, 248–95.

———. "Recherches sur les monnaies au type chartrain," *RN* 9, 1844, 405–28, and pls. XII, XIII; *RN* 10, 1845, 26–51, 112–41, 196–226, 275–308, 360–95, pls. II, VI, VII, X, XI, XV, XVI, XVII, XIX, XX; *RN* 11, 1846, 28–55, and pls. II–IV; *RN* 14, 1849, 248–95 and pls. VII–VIII.

Catalogus codicum hagiographicorum latinorum . . . in Bibliotheca Nation-

ali Parisiensi. Ed. Bollandistes. vols. 1 and 3. Brussels and Paris, 1889, 1893.

Caviness, Madeline Harrison. *The Early Stained Glass of Canterbury Cathedral, circa 1175–1220.* Princeton, 1977.

Cecchelli, C. *La cattedra di Masimiano.* Rome, 1936–44.

Challine, Charles. *Recherches sur Chartres, Transcrites et annotées par un arrière-neveu de l'auteur.* Roger Durand ed. Chartres, 1918 (written before 1678).

Chédeville, André. *Chartres et ses campagnes. (XIe–XIIIe s.).* Paris, 1973.

———. "Le rôle de la monnaie et l'apparition du credit dans les pays de l'ouest de la France (XIe–XIIIe siècles)." *Cahiers de civilisation médiévale,* vol. 17, 1974, 308–25.

———. "Recherches sur la circulation de l'or en Europe occidentale du Xe à la fin du XIIe siècle, d'après les cens dus au Saint-Siège." *Le moyen âge,* vol. 83, 1977, 413–43.

———, ed. *Histoire de Chartres et du pays chartrain.* Toulouse, 1983.

Chénon, M. Émile. "Etude sur les droits seigneuriaux relatifs aux vignes et au vin, d'après les chartes et coutumes du Berry," ("Notes archéologiques et historiques sur le Bas-Berry"). *Société des Antiquaires du Centre, Mémoires* (Blois), vol. 27, 1903, 240–91.

Chevalier, Bernard. "Les changeurs en France dans la première moitié du XIVe siècle." *Économie et sociétés au moyen âge, Mélanges offerts à Edouard Perroy.* Paris, 1973, 153–60.

Chévard, Vincent. *Histoire de Chartres et de l'ancien pays chartrain, avec une description statistique du département d'Eure-et-Loir.* 2 vols. Chartres, 1800–1802.

Cipolla, Carlo. *Money, Prices, and Civilization in the Mediterranean World, Fifth to Seventeenth-Century.* Princeton, 1956.

Claussen, Peter C. *Chartres Studien zu Vorgeschichte, Funktion und Skulptur der Vorhallen.* Forschungen zur Kunstgeschichte und christlichen Archäologie, 9. Wiesbaden, 1975.

———. "Goldschmiede des Mittelalters." *Zeitschrift des deutschen Vereins für Kunstwissenschaft,* vol. 32, 1978, 46–86.

Clemen, Paul. *Gothic Cathedrals,* Oxford, [1937] 1938.

Clermont, O., and J. Weber. "Le programme iconographique des cinq verrières de l'abside de la cathédrale." *Notre-Dame de Chartres,* vol. 51, 1982, 4–9.

Clerval, Jules Alexandre. *La famille Chardonnel et les vitraux de la chapelle du Pilier.* Chartres, 1889.

Clerval, René, and l'Abbé Merlet. *Un manuscrit chartrain au XIe siècle.* Chartres, 1893.

Cocchiara, Giuseppe. *Il mondo alla rovescia.* Universale scientifica 218/219, Turin, 1981.

Cochetti Pratesi, Lorenza. "La decorazione plastica della cattedral de Piacenza. *Il Duomo di Piacenza 1122–1972.* Atti del Convegno di Studi Storici. Piacenza, 1975, 53–71.

Colin, Martin. "Les boîtes de changeurs à Genève et Berne (XVIIe–XVIIIe s.)." *Schweizerische Numismatische Rundschau.* Vol. 39. Bern, 1858–59.

Connick, Charles J. *Adventures in Light and Color.* New York, 1937.

Coornaert, Émile. *Les corporations au France avant 1789.* Paris, 1968.

Corblet, Jules. *Histoire dogmatique, liturgique et archéologique du sacrement de l'Eucharistie.* 2 vols. Paris, 1885–86.

———. "Des vases et des ustensiles eucharistiques." *Revue de l'art chrétien,* vol. 28, 1885, 53–64.

Cousins, C. E. "Tavern bills in the Jeu de Saint-Nicholas." *Zeitschrift für romanische Philologie,* vol. 56, 1936, 85–93.

Crapelet, G. A. *Proverbes et Dictons Populaires avec les Dits du Mercier et des Marchands, et les Crieries de Paris aux XIIIe et XIVe siècles.* Paris, 1831.

Cross, F. L., and E. A. Livingstone, eds. *The Oxford Dictionary of the Christian Church.* London, 1974.

Cuissard, Ch., ed. *Les chartes originales de l'ancien Hôtel Dieu d'Orléans.* Société archéologique et historique de l'Orléanais, Mémoires, vol. 28. Orléans, 1904.

Cummins, Tom. "The Trumeau of the South Porch at Chartres: The Origin of Its Interpretation and Its Reification." Master's thesis, UCLA, 1980.

Daniélou, Jean. *The Bible and the Liturgy.* Notre Dame, 1961.

———. "La typologie biblique traditionelle dans la liturgie du Moyen âge." *Settimane di Studio del Centro Italiano di Studi sull' Alto Medioevo,* Spoleto, vol. 10, 1963, 141–61.

David, A. "Les apôtres de la cathédrale de Chartres." *Notre-Dame de Chartres.* June, 1989, 14–16.

De Roover, Raymond. *Money, Banking, and Credit in Mediaeval Bruges.* Cambridge, 1948.

Deck, S. "Les marchands de Rouen sous les ducs." *Annales de Normandie,* vol. 6, 1956, 245–54.

DeCosse, Carole M. "The St. Lubin Window of Chartres Cathedral," M.A. thesis, Tufts University, February 1984.

———. "The Wine Merchants' Window of Chartres Cathedral." *American Wine Society Journal,* vol. 18, no. 4, 1986, 107–9.

Delaporte, Yves. *Le voile de Notre-Dame.* Chartres, 1927.

———. "Les manuscrits enluminés de la Bibliothèque de Chartres." *Le Cinquantinaire de la SAELM* (Chartres), vol. 2. 1906, 165–362.

———. "Les deux fêtes chartrains de Saint Lubin." *La Voix de Notre-Dame de Chartres,* Sup. March, 1925, 127ff.

———. "Les anciens fonts baptismaux de la crypte de Notre-Dame de Chartres." *La Voix de Notre-Dame de Chartres,* Sup. March, 1932, 132–36.

———. "Chartres." *Dictionnaire d'histoire et de géographie ecclésiastiques,* vol. 12. Paris, 1951, 544–74.

———. *Les trois Notre-Dame de la cathédrale de Chartres.* Chartres, 1955.

———. *L'Ordinaire chartrain du XIIIe siècle.* Chartres, 1953.

———. "Remarques sur la chronologie de la cathédrale de Chartres." *SAELM,* vol. 2, 1959, 299–320.

Delaporte, Yves, and Etienne Houvet. *Les vitraux de la cathédrale de Chartres.* 4 vols. Chartres, 1926.

Demus, Otto. *Romanesque Mural Painting.* London, 1970.

Deremble, Jean Paul and Colette. "Le vitrail de saint Lubin. Histoire et légende." *Notre-Dame de Chartres,* September, 1989, 14–17.

Deremble, Jean Paul, and Colette Manhes. *Les vitraux légendaires de Chartres. Des récits en images.* Paris, 1988.

Deremble-Manhes, Colette. "De quand date la verriére de sainte Marguerite." *Notre-Dame de Chartres*. Chartres, December, 1988, 16–18.

———. "Guillaume le Breton et la chronologie de Notre-Dame de Chartres." *Notre-Dame de Chartres* (Chartres), September, 1988, 11–16.

———. "Etude iconographique des verrières basses de la cathédrale de Chartres." Doctoral thesis, Ecole des Hautes Etudes en Sciences Sociales. Paris, 1989.

Deschamps, Paul, and Marc Thibout. *La peinture murale en France au début de l'époque gothique*. Paris, 1963.

Deshusses, Jean. *Le sacramentaire Gregorien*. Vol. 3. Spicilegium Friburgense, vol. 28. Fribourg, 1982.

Desportes, Françoise. *Le pain au moyen âge*. Paris, 1987.

Deuchler, Florens, ed. *The Year 1200. A Background Survey*. 2 vols. New York, 1970.

Devailly, Guy. *Le Berry du Xe siècle au milieu du XIIIe. Etude politique, religieuse, sociale, et économique*. Paris, 1973.

Dhenin, Michel. "Un denier de Chartres au type anépigrophe à la tête." *Le Club Française de la Médaille*, vol. 58, 1978, 154–58.

Dictionnaire de Théologie Catholique. Paris, 1903–50.

Didier, Noël. *La garde des églises au XIIIe siècle*. Paris, 1927.

———. "Metropoles et vignobles en Gaule romaine. L'exemple bourguignon." *Annales d'histoire économique et sociale*, vol. 7, 1952, 1–11.

Dieudonné, Adolphe Edmond. "Le théorie de la monnaie à l'époque féodale et royale d'après deux livres nouveaux." *RN*, ser. 4, vol. 13, 1909, 90–109.

———. *Les monnaies capétiennes ou royales françaises*, section 1. Paris, 1923.

———. "Changes et monnaies au Moyen âge." *Revue Deux Mondes*, 1927, 929–37.

———. "Les lois générales de la numismatique féodale." *RN*, ser. 4, vol. 36, 1933, 155–70.

Didron, Adolphe. *Christian Iconography*. 2 vols. New York [1851] 1965.

Dion, Roger. *Histoire de la vigne et du vin en France des origines au XIe siècle*. Paris, 1959.

Dobiache-Rojdestvensky, Olga. *La vie paroissiale en France au XIIe s. d'après les actes épiscopaux*. Paris, 1911.

Doyen, Guillaume. *Histoire de la ville de Chartres, du pays chartrain et de la Beauce*. Chartres, 1786.

Dozer, Jane Blythe. "The Tavern: Discovery of the Secular Locus in Medieval French Drama." Ph.D. diss., UCLA, 1980.

Duby, Georges. *The Early Growth of the European Economy: Warriors and Peasants from the Seventh to the Twelfth Century*, trans. H. B. Clarke. Ithaca, 1974.

———. *The Three Orders: Feudal Society Imagined*, trans. Arthur Goldhammer, Chicago, 1978.

———. *Rural Economy and Country Life in the Medieval West*, trans. Cynthia Postan. Columbia, S.C. [1962] 1981.

DuColombier, Pierre. *Les chantiers des cathédrales. Ouvriers, architectes, sculpteurs*. Paris, 1973.

Dumas, Françoise. "La monnaie dans le royaume au temps de Philippe Auguste." *La France de Philippe Auguste. Le Temps des mutations*. Paris, 1982.

———. "Monnayâge et monnayeurs." *Artistes, artisans et production artistique au moyen âge.* Vol. 1. Paris, 1986, 483–98.

Dumas, Françoise, and Jean-Noël Barrandon. *Le titre et le poids de fin des monnaies sous le règne de Philippe Auguste (1180–1223).* Cahiers Ernest-Babelon I. Paris, 1982.

Dumas-Dubourg, F. *Le trésor de Fécamp et le monnayâge en Francie occidentale pendant la second moitié du Xe s.* Paris, 1971.

Dumézil, G. *Mythe et epopée. I. L'idéologie des trois fonctions dans les epopées des peuples indo-européens.* Paris, 1968.

Duplessy, Jean. "La circulation des monnaies Arabes en Europe Occidentale du VIIIe au XIIIe siècle." *RN,* ser. 5, vol. 18, 1956, 101–63.

Durandus, Guillaume. *Rational ou Manuel des divins offices,* trans. M. Charles Barthélemy. Paris, 1854.

Duvergie, J. *Les sculptures des porches et portails de la cathédrale de Chartres.* Chartres, 1914.

Eberstadt, Rudolph. *Magisterium und Fraternitas. Eine verwaltungsgeschichtliche Darstellung der Entstehung des Zunftwesens.* Leipzig, 1897.

———. *Der Ursprung des Zunftwesens und die ältere Handwerkerverbändene des Mittelalters.* Munich, 1915.

Eisenhöfer, Ludwig, and Joseph Lechner. *The Liturgy of the Roman Rite.* H. E. Winstone ed. Freiburg and Edinburgh-London, 1961.

Elbern, Victor Heinrich. *Der eucharistische Kelch im frühen Mittelalter. Teil 2. Ikonographie und Symbolik.* Zeitschrift des deutschen Vereins für Kunstwissenschaft, vol. 3. Berlin, 1963.

Elsen, Albert E. *Purposes of Art.* New York, 1962.

Engel, Arthur, and Raymond Serrure. *Traité de numismatique du moyen âge.* 3 vols. Rpr., Bologna [1894] 1964.

Engemann, Josef. *Untersuchungen zur Sepulkralsymbolik der späteren römischen Kaiserzeit.* Jahrbuch für Antike und Christentum, Ergünzungsband. Munster, 1973.

Erlande-Brandenburg, Alain. *La cathédrale.* Paris, 1989.

———. *Chartres.* Paris, 1986.

Espérandieu, Émile. *Recueil General des bas-reliefs de la Gaule romaine.* 14 volumes. Paris, 1907–55.

Evans, Joan. *Art in Medieval France.* Oxford, 1948.

Fabre, Pierre. "Le développement de l'histoire de Joseph dans la littérature et dans l'art au cours des douze premières siècles." *Mélanges d'archéologie et d'histoire,* vol. 39, 1921–22, 193–211.

Fagniez, Gustave. *Etudes d'industrie et la classe industrielle à Paris au XIIIe et au XIVe siècle.* Paris, 1877.

———. *Documents relatifs à l'histoire de l'industrie et du commerce en France.* Paris, 1898–1919.

Falck, Ludwig. "Das Bernbrot, eine mittelalterliche Bäckerabgabe in Strassburg, Worms, und Mainz." *Historischer Verein für Hessen in Verbindung mit der Technischen Hochschule Darmstadt, (Archiv für hessische Geschichte und Altertumskunde),* vol. 32, 1974, 103–12.

Falk, Ilse. "Studien zu Andrea Pisano." Diss., University of Zurich. Hamburg, 1940. (Iconographical survey of John the Baptist, pp. 104ff.)

Faral, Edmond. *Courtois d'Arras, jeu du XIIIe siècle.* Paris, 1911.

Faucheux, P. "Les vitraux de l'abside du choeur." *Notre-Dame de Chartres*, April 1990, 10–13.

Favier, Jean, John James, and Yves Flamand. *L'Univers de Chartres*. Paris, 1988.

Fawtier, Robert, and Ferdinand Lot. *Histoire des institutions françaises au Moyen âge*. 3 vols. Paris, 1957–1962.

Feldhaus, Franz M. *Die Technik der Antike und des Mittelalters*. Leipzig, 1931.

Ferguson, Carra. "The Iconography of the Facade of Saint-Gilles-du-Gard." Ph.D. diss., University of Pittsburgh, 1975.

Ferre, P. "A propos du vitrail de la Redemption. Les figurées bibliques de la Passion interpretées par les Pères de l'Eglise." *Notre-Dame de Chartres*. Chartres, March 1986, 11–18.

Forgeais, Arthur. *Notice sur des plombs historiés trouvés dans la Seine*. Paris, 1858.

Forsyth, Ilene H. *The Throne of Wisdom: Wood Sculptures of the Madonna in Romanesque France*. Princeton, 1972.

Foulet, Lucien. "Les scènes de taverne et les comptes du tavernier dans le *Jeu de Saint Nicolas* de Jean Bodel." *Romania* (Paris), vol. 68, 1944–45, 422–38.

Foulon, C. "Les comptes du tavernier dans le *Jeu de Saint Nicolas*," *Romania* (Paris), vol. 68, 1944–45, 438–43.

Fournial, Etienne. *Histoire monétaire de l'occident mediéval*. Paris, 1970.

Fournier, Francisque-Michel, and Edouard Fournier. *Le livre d'or des métiers. Histoire des hôtelleries, cabarets, courtilles, et des anciennes communautes et confréries d'hôteliers, de taverniers, de marchands de vins, etc.* Vol. 1. Paris, 1859.

Fourquin, Guy. *Les campagnes de la région Parisienne à la fin du moyen âge*. Paris, 1964.

Frank, Gr. "Wine reckonings in Bodel's *Jeu de Saint Nicolas*." *Modern Language Notes*, vol. 50, 1935, 9–13.

Frankl, Paul. "The Chronology of Chartres Cathedral." *Art Bulletin* (New York), vol. 39, 1957, 33–47.

———. "Reconsiderations on the Chronology of Chartres Cathedral." *Art Bulletin* (New York), vol. 43, 1961, 51–58.

———. "The Chronology of the Stained Glass in Chartres Cathedral." *Art Bulletin* (New York), vol. 45, 1963, 301–22.

Franklin, Alfred. *Les corporations ouvrières de Paris du XIIe au XVIIIe siècle. Histoire, statuts, armories, d'après des documents. . . .* Paris, 1884.

———. *La vie privée d'autrefois*. Ser. 1, vols. 1 and 2. Paris, 1887.

———. *Dictionnaire historique des arts, métiers et professions exercés dans Paris depuis le treizième siècle*. Paris and Leipzig, 1906.

Franz, Adolph. *Die kirchichen Benediktionen im Mittelalter*. 2 vols. Rpr., Graz, 1960.

Frere, Walter Howard. *Studies in Early Roman Liturgy. II. The Roman Gospel-Lectionary*. Alcuin Club Collections 30. London, 1934.

———. *Studies in Early Roman Liturgy. III. The Roman Epistle-Lectionary*. Alcuin Club Collections 32. London, 1935.

Friend, A. M. "The Portraits of the Evangelists in Greek and Latin Manuscripts." *Art Studies*. Cambridge, 1927, 115–45.

Frodl-Kraft, Eva. *Die Glasmalerei; Entwicklung, Technik, Eigenart.* Vienna and Munich, 1970.

Gaborit-Chopin, Danielle. *Ivoires du Moyen âge.* Fribourg, 1978.

Gaillard, Georges. *The Frescoes of Saint-Savin.* New York, 1944.

Galavaris, Georges. *Bread and the Liturgy; the Symbolism of Early Christian and Byzantine Bread Stamps.* Madison, 1970.

Ganshof, F. L. *Feudalism.* New York, 1961.

Gariel, E. *Les monnaies royales de France sous la race Carolingienne.* 2 vols. Strasbourg, 1883–84. Rpr. in 1 vol., 1980.

Garrucci, Raffaele. *Storia dell'arte cristiana.* 6 vols. Prato, 1872–81.

Gaudémet, Jean. *La collation par le Roi de France des benefices vacants en regale des origines à la fin du XIVe siècle.* Paris, 1962.

Gaudin, F. *Le vitrail du XIIe au XVIIIe siècle en France.* Paris, 1928.

Gautier, Léon. *Etudes historiques pour la defense de l'Eglise.* Paris, 1864.

Gerstinger, H. *Die Wiener Genesis.* Vienna, 1931.

Gilbert, Antoine Pierre Marie. *Description historique de l'église cathédrale de Notre-Dame de Chartres.* Chartres, 1824.

Giry, A., ed. *Documents sur les relations de la royauté avec les villes en France de 1180 à 1314.* Paris, 1885.

Godfrey, F. M. *Christ and the Apostles.* London and New York, 1957.

Goldschmidt, Adolph. *Die Elfengeinskulpturen.* 4 vols. Berlin 1914–26.

Goldschmidt, Adolph, and Kurt Weitzmann. *Die byzantinischen Elfenbein-skulpturen des X–XIII Jahrhunderts.* 2 vols. Berlin, 1930–34.

Gollub, Siegfried. "Funde und Ausgrabungen im Bezirk Trier." *Kurtrierisches Jahrbuch,* vol. 14, 1974, 213–47.

Gouron, A. "La science juridique française aux XIe et XIIe siècles: Diffusion du droit de Justinien et influences canonique jusqu'à Gratien." *Ius Romanum Medii Aevi.* Part I, 4, d and e. Mediolani, 1978.

Grabar, A. *L'art de la fin de l'antiquité et du Moyen âge.* Paris, 1968.

———. *Christian Iconography; a Study of Its Origins.* Princeton, 1968.

Le Grand d'Aussy, Pierre Jean. *Histoire de la vie privée des français depuis l'origine de la nation jusqu'à nos jours.* Vol. 2, pt. 1. Paris, 1782.

Gregoire, R. "La communion de moine prêtre à la messe d'après les coutumes monastique." *Sacris Erudiri,* vol. 18, 1967–68, 524–49.

Gregory the Great. *Morals on the Book of Job.* Vol. 3, pt. 2. Oxford, 1850.

Grierson, Philip. *Coins and Medals. A Select Bibliography.* London, 1954.

———. "Le sou d'or d'Uzés." *Le Moyen âge.* Vol. 60, 1954, 293–309.

———. *Monnaies du Moyen âge.* Fribourg, 1976.

Grivot, Denis, and George Zarnecki. *Gislebertus, Sculptor of Autun.* New York, 1961.

Grodecki, Louis. "A Stained Glass Atelier of the Thirteenth Century. A Study of Windows in the Cathedrals of Bourges, Chartres, and Poitiers." *Journal of the Warburg and Courtauld Institutes,* vol. 11, 1948a, 87–111.

———. *Les vitraux des églises de France.* Paris, 1948b.

———. "Le vitrail et l'architecture au XIIe et au XIIIe siècles." *GBA,* vol. 36–37, 1949, 5–24.

———. "The Transept Portals of Chartres Cathedral." *Art Bulletin,* vol. 33, 1951, 156–64.

————. "Les vitraux de la cathédrale de Poitiers." *Congrès archéologique de France*, vol. 109, 1952, 138–63.

————. *Les vitraux de France du XIe au XVI siècle*. Paris, 1953.

————. "Chronologie de la cathédrale de Chartres." *Bulletin monumental* (Paris), vol. 116, 1958a, 91–119.

————. *Chartres*. Paris, 1963.

————. "Le Maître de Saint-Eustache de la Cathédrale de Chartres." *Gedenkschrift Ernst Gall*, Margarete Kühn and Louis Grodecki, eds. Munich, 1965, 171–94.

————. "Le Maître du Bon Samaritain de la Cathédrale de Bourges." *The Year 1200: A Symposium*. New York, 1975, 339–59.

————. *Les vitraux de Saint-Denis. Etude sur le vitrail au XIIe siècle*. Corpus Vitrearum Medii Aevi. Paris, 1976.

Grodecki, Louis, and Catherine Brisac. *Le vitrail gothique au XIIIe siècle*. Fribourg, 1984.

————. *Le vitrail romane*. Fribourg, 1977.

Grodecki, Louis, et al. *Les vitraux du centre et des pays de la Loire*. Corpus Vitrearum Recensement des vitraux Anciens de la France, vol. 2. Paris, 1981.

Guérard, M. *Cartulaire de l'église Notre-Dame de Paris*. Vol. 1. Paris, 1850.

Guilhiermoz, P. "Note sur les poids du Moyen âge." *Bibliothèque de l'école des Chartes* (Paris), vol. 67, 1906, 161–233.

————. "Remarques diverses sur les poids et mesures du Moyen âge." *Bibliothèque de l'école de Chartes*, vol. 80, 1919, 5–100.

Gruyer, Paul. *Les saints brétons*. Paris, 1923.

Hamann-MacLean, Richard. *St. Gilles*. Berlin, 1955.

————. *Die Monumentalmalerei in Serbien und Makedonien vom 11 bis zum frühen 14 Jahrhundert*. 3 vols. Giessen, 1963.

Harmand, Auguste. "Notice historique sur la léproserie de la ville de Troyes." *Société d'agriculture des sciences, arts, et belles-lettres du département de l'Aube, Mémoires*, vol. 14, 1848, 429–680.

Harreaux, M. "Recherches sur le sens du type chartrain dans les monnaies locales." *SAELM*, vol. 6, 1876, 243–47.

Haselhorst, Kurt. *Die hochgotischen Glasfenster der Kathedrale von Bourges*. Munich, 1974 (Inaugural Dissertation: Ludwig-Maximilians-Universität, Munich).

Haussherr, Reiner. "Beobachtungen an den Illustrationen zum Buche Genesis in der Bible moralisée." *Kunstchronik*, vol. 19, 1966, 313–14.

————. *Bible Moralisée Faksimile-Ausgabe im Originalformat des Codex Vindobonensis 2554 der Osterreichischen Nationalbibliothek*. 2 vols. Graz, 1973.

————. "Eine Warnung vor dem Studium von zivilem und kanonischem Recht in der Bible Moralisée." *Frühmittelalterliche Studien*, vol. 9, 1975, 390–404.

Hayward, Jane. "The Lost Noah Window from Poitiers." *Gesta*, vol. 20, 1981, 129–39.

Hayward, Jane, and Walter Cahn. *Radiance and Reflection: Medieval Art from the Raymond Pitcairn Collection*. New York, 1982.

Headlam, Cecil. *The Story of Chartres*. London, [1902] 1922.

Heimann, Adelheid. "The Capital Frieze and Pilasters of the Portail Royal, Chartres." *JWCI*, vol. 31, 1968, 73–102.

Héliot, Pierre. "Chronologie de la basilique de Saint-Quentin." *Bulletin Monumental* (Paris), vol. 117, 1959, 7–50.

Héliot, Pierre, and M.-L. Chastang. "Quêtes et voyâges de reliques au profit des églises françaises." *RHE*, vol. 59, 1964, 789–822.

Henderson, George. "The Sources of the Genesis Cycle at Saint-Savin-sur-Gartempe." *British Archaeological Association*, ser. 3, nos. 25–26, 1962–63, 11–26.

———. *Chartres*. Harmondsworth, 1968.

Henisch, Bridget Ann. *Fast and Feast: Food in Medieval Society*. University Park and London, 1976.

Henry, Albert, ed. and trans. *Le Jeu de Saint Nicolas de Jehan Bodel*. Brussels and Paris, 1962.

Herrad of Landsberg. *Hortus Deliciarum of Herrad von Landsberg*, ed. Rosalie Green et al. 2 vols. London, 1979.

Hesseling, D.-C. *Miniatures de l'octateuque Grec de Smyrna*. Leyde, 1909.

Holt, Elizabeth G. *A Documentary History of Art*. Vol. 1: *The Middle âges and the Renaissance*. New York, 1957.

Houvet, Etienne. *Cathédrale de Chartres. Portail occidental ou royal XIIe siècle*. Chelles, 1919.

———. *Cathedrale de Chartres; Portail nord XIIIe siècle*. Chelles, 1919.

———. *Cathedrale de Chartres; Portail sud XIIIe siècle*. Chelles, 1919.

———. *Monographie de la cathédrale de Chartres*. Chartres, 1930.

———. *Chartres Cathedral*. N.d.

Hucher, Eugene. *Calques des vitraux peints de la cathédrale de Mans*. Le Mans, 1864.

———. "Explication des virtraux dits des monnayeurs." *Mélanges archéologiques. Moyen âge 2*, n.d., 1–5.

Huvelin, Paul. *Essaie historique sur le droit des marches et des foires*. Paris, 1897.

Ibanes, Jean. *La doctrine de l'église et les réalités économiques au XIIIe siècle: l'interet, les prix et la monnaie*. Paris, 1967.

Ihm, Christa. *Die Programme der christlichen Apsismalerei vom vierten Jahrhundert bis zur Mitte des achten Jahrhunderts*. Forschungen zur Kunstgeschichte und christlichen Archäologie 4. Wiesbaden, 1960.

Innitzler, Th. *Johannes der Täufer nach der heiligen Schrift und der Tradition dargestellt*. Vienna, 1908.

Jacobus de Voragine: The Golden Legend, trans. Granger Ryan and Helmut Ripperger. New York, London, and Toronto, 1969.

James, John. *Chartres: les constructeurs*. 2 vols. Chartres, 1977–81.

———. *The Contractors of Chartres*. 2 vols. Wyong, 1981.

———. *Chartres: The Masons Who Built a Legend*. London and Boston, 1982.

———. "What Price the Cathedrals?" *Transactions of the Ancient Monuments Society*, vol. 19, 1972, 47–65.

James, Margery Kirkbride. *Studies in the Medieval Wine Trade*. Oxford, 1971.

James, Montague R. *The Apocryphal New Testament*. Oxford, 1926.

Janssens, D. L. "Les Eulogies." *Revue Benedictine*, vol. 7, 1890, 515–20; vol. 8, 1891, 28–41.

Jantzen, Hans. *High Gothic: The Classic Cathedrals of Chartres, Reims, Amiens.* Trans. James Palmes. London, 1962.

Jossier, Anesine-Ferdinand. *Monographie des vitraux de St.-Urbain de Troyes.* Troyes, 1912.

Jubainville, H. d'Arbois de. *Histoire des ducs et des comtes de Champagne.* Vol. 3 and vol. 4, pt. 2. Paris, 1861–65.

Jungmann, Josef A. *Die lateinischen Bussriten in ihrer geschichtlichen Entwicklung.* Innsbruck, 1932.

———. *The Mass of the Roman Rite: Its Origins and Development (Missarum Sollemnia).* Trans. Rev. Francis A. Brunner, C.S.S.R. 2 vols. New York, 1951–55.

Jusselin, Maurice. "La mâitrise de l'oeuvre à Notre-Dame de Chartres." *SAELM,* vol. 15, 1915–22, 233ff.

———. "Les Fortifications de Chartres." *SAELM,* vol. 16, 1923–36, 256–93.

———. "La chapelle Saint-Serge-et-Saint-Bacche on Saint-Nicolas-au-cloître à Chartres." *Bulletin Monumental,* vol. 99, 1940, 133–55.

Kaiser, Reinhold. *Bischofsherrschaft zwischen Königtum und Fürstenmacht.* Bonn, 1981.

———. "Guildes et métiers au moyen âge." *Francia,* 1986, 585–92.

———. "Teloneum Episcopi. Du tonleiu royal au tonleiu épiscopal dans les *civitates* de la Gaule (VIe–XIIe siècles)," *Histoire comparé de l'administration (IVe–XVIIIe siècles). Actes du XIVe colloque historique franco-allemand. Tours, 1977.* Munich, 1980, 469–85.

Kaiser-Guyot, M.-Th., and R. Kaiser. *Documentation numismatique de la France médiévale. Collections de monnaies et sources de l'histoire monétaire.* Munich, 1982.

Kantorowicz, Ernst H. "The Baptism of the Apostles." *Dumbarton Oaks Papers,* nos. 9–10, 1956, 203–51.

Katzenellenbogen, Adolf. "The Separation of the Apostles." *Gazette des Beaux-Arts,* ser. 6, vol. 35, 1949, 81–98.

———. *The Sculptural Programs of Chartres Cathedral: Christ, Mary, Ecclesia.* Baltimore, [1959] 1964.

———. *Allegories of the Virtues and Vices in Medieval Art.* New York, 1964.

Kemp, Wolfgang. "Les cris de Chartres: Rezeptionsästhetische und andere Überlegungen zu zwei Fenstern der Kathedrale von Chartres," ed. Clemens Fruh, Raphael Rosenberg, and Hans-Peter Rosinski. *Kunstgeschichte Aber Wie?* Berlin, 1989, 189–220.

———. *Sermo Corporeus. Die Erzählung der mittelalterlichen Glasfenster.* Munich, 1987.

Kimpel, Dieter, and Robert Suckale. *Die gotische Architektur in Frankreich 1130–1270.* Munich, 1985.

Kircher, Karl. *Die sakrale Bedeutung des Weines im Altertum.* Giessen, 1910.

Kisch, Bruno. *Scales and Weights: A Historical Outline.* New Haven and London, 1965.

Koehler, Wilhelm. "An Illustrated Evangelistary of the Ada School and Its Model." *Journal of the Warburg and Courtauld Institute,* vol. 15, 1952, 48–66.

Krusch, Bruno, ed. "Vita S. Leobini." *MGH,* sec. 1, vol. 4, pt. 2, 1885, xxviii-xxix, 73–82.

Kunstmann, Pierre. "Jean le Marchant. Miracles de Notre-Dame de Chartres." *SAELM*, vol. 26, 1973.

Labande, L. H. *Histoire de Beauvais et de ses institutions communales jusqu'au commencement du XV s.* Beauvais, 1892.

Laborde, Alexandre. *La Bible Moralisée illustré.* 5 vols. Paris, 1911–27.

Lafond, Jean. "Vitraux." *La cathédrale de Rouen*, ed. Armand Loisel. Paris, n.d., 110–23.

———. "Saint-Julien-du-Sault, les vitraux." *Congrès archéologique de France*, vol. 116, Paris, 1958, 365–69.

Lafond, Jean, ed. *Le vitrail français.* Paris, 1948.

Langlois, Ernest. "Les manuscrits des Miracles de Notre-Dame de Chartres." *Revue Mabillon*, vol. 2, 1906, 62–82.

Langlois, Marcel. *Catalogue des manuscrits et pièces de la société archéologique d'Eure-et-Loir.* Chartres, 1856–1903.

Lassus, J. B., and Paul Durand. *Monographie de la cathédrale de Chartres.* 2 vols. Paris, 1842 and 1881.

Lasteyrie, Ferdinand de. *Histoire de la peinture sur verre d'après ses monuments en France.* 2 vols. Paris, 1855–57.

Lasteyrie, R. de. *L'architecture religieuse en France à l'époque gothique.* 2 vols. Paris, 1926–27.

Laurent, Henri. *La loi de Gresham au Moyen âge.* Brussels, 1933.

Lautier, Claudine. "Les peintres-verriers des bas-côtés de la cathédrale de Chartres." *Bulletin Monumental*, vol. 148, 1990, 7–45.

Lavagne, F.-G. *Balanciers étalonneurs. Leurs marques—leurs poinçons.* Montpellier, 1981.

Lecocq, A. "Historique du cloître Notre-Dame de Chartres." *SAELM*, vol. 1, 1858, 125–58.

———. "Note de M. Lecocq sur la statuts de la corporations d'arts et métiers de la ville de Chartres." *SAELPV*, vol. 3, 1868, 208–10.

———. "Notice historique sur les armoiries de la ville de Chartres." *SAELM*, vol. 2, 1860, 33–47.

———. "Recherches sur les enseignes de pèlerinages et les chemisettes de Notre-Dame-de-Chartres." *SAELM*, vol. 6, 1876, 194–242.

Ledru, A., and G. Fleury. *La cathédrale Saint-Julien du Mans, ses évêques, son architecture, son mobilier.* Mamers, 1900.

Lefèbvre des Noëttes, Ct. *L'Attelâge, le cheval de selle à travers les âges.* 2 vols. Paris, 1921.

Lefrançois-Pillon, Louise. *Maîtres d'oeuvre et tailleurs de pierre des cathédrales.* Paris, 1940.

Le Grand d'Aussy, Pierre Jean B. *Histoire de la vie privée des français.* Vol. 2. Paris, 1882.

Lemarié, J. "L'adoration des mâges à la cathédrale." *Notre-Dame de Chartres*, December 1986, 4–13.

Leo the Great. *Leo the Great, Gregory the Great*, Charles Lett Feltoe, ed. and trans. A Select Library of Nicene and Post-Nicene Fathers, vol. 12. Grand Rapids, 1956.

Lépinois, E. de. *Histoire de Chartres.* 2 vols. Brussels, [1854] 1976.

Lespinasse, René de, and François Bonnardot, eds. *Les métiers et corporations de la Ville de Paris: XIIIe siècle. Le livre des métiers d'Etienne Boileau.* Paris, 1879.

Levasseur, E. *Histoire de classes ouvrieres et de l'industrie dans France avant 1789*. 2d ed. Vol. 1. Paris, 1900.

Lévis-Godechot, Nicole. *Chartres-révélée par sa sculpture et ses vitraux*. La Pierre-qui-Vire, 1987.

Lexikon für Theologie und Kirche. Freiburg-im-Breisgau, 1957–65.

Lièvre, L. *La monnaie et le change en Bourgogne sous les ducs de Valois*. Dijon, 1929.

Lillich, Meredith. "Gothic Glaziers: Monks, Jews, Taxpayers, Bretons, Women." *Journal of Glass Studies*, vol. 27, 1985, 72–92.

———. "A Redating of the Thirteenth-Century Grisaille Windows of Chartres Cathedral." *Gesta*, 11, 1972, 11–18.

Little, Lester K. "Pride Goes before Avarice: Social Change and the Vices in Latin Christendom." *The American Historical Review*, vol. 76, 1971, 16–49.

———. *Religious Poverty and the Profit Economy in Medieval Europe*. Ithaca, 1978.

Lopez, Robert Sabatino. "Continuita e adattamento, un millennio di storia delle associazioni de monetreri nell'Europa meridionale." *Studi in onore di Gino Luzzatto*. Vol. 2, Milan, 1950, 74–117.

———. "Economie et architecture médiévales. Cela aurait-il tué ceci?" *Annales économies, sociétés, civilisations*, vol. 7, 1952, 433–38.

———. "An Aristocracy of Money in the Early Middle Ages." *Speculum*, vol. 28, 1953, 1–43.

Lopez, Robert Sabatino, and Irving W. Raymond. *Medieval Trade in the Mediterranean World*. Record of Civilization, Sources and Studies 52. New York, 1955.

Lowe, E. A., ed. *The Bobbio Missal*. London, 1920.

Lubac, H. de. *Corpus Mysticum*. 2d ed. Paris, 1949.

Luchaire, Achille. *Etudes sur les actes de Louis VII*. Paris, 1885.

———. *Manuel des institutions françaises. Periode des Capétiens directs*. Paris, 1892a.

———. *La société française au temps de Philippe-Auguste*. Paris, 1892b.

———. *Social France at the Time of Philip Augustus*, New York, 1912.

Lützeler, von Heinrich. "Ist die Kathdrale von Chartres soziologisch erklärbar?" *Zeitschrift für Aesthetik und Allgemeine*, vol. 21, 1976, 145–59.

Machabey, Armand. "La metrologie dans les musées de provence et sa contribution à l'histoire des poides et mesures depuis le 13e siècle." Doctoral thesis, Sorbonne, 1959.

MacKinney, Loren. *Medical Illustrations in Medieval Manuscripts*. Berkeley, 1965.

Mâle, Emile. "Le type de Saint Jean-Baptiste dans l'art et ses divers aspects." *Revue des Deux Mondes*, vol. 3, 1951, 53–61.

———. *Les saints compagnons du Christ*. Paris, 1958.

———. *The Gothic Image. Religious Art in France of the Thirteenth Century*. Trans. D. Nussey. New York, [1913] 1972.

———. *Religious Art in France: The Twelfth Century*. Ed. Harry Buber, trans. Marthiel Mathews. Bollingen Series 90. Princeton, [1922] 1978.

———. *Notre-Dame de Chartres*. Paris, [1917] 1983.

Mallion, Jean. *Chartres: Le jubé de la cathédrale*. Chartres, 1964.

Mane, Perrine. *Calendriers et Techniques Agricoles (France-Italie, XIIe–XIII siècles)*. Paris, 1983.

Marcel-Robbillard, Charles. *Le folklore de la Beauce.* Vol. 1. *Moulins et Meuniers du pays Beauceron.* Paris, 1965.

———. *Le folklore de la Beauce.* Vol. 2. *Vignes et Vigerons de pays chartrains.* Paris, 1966.

Mariño, Beatriz. "Testimnoios iconográficos de la acuñación de moneda en la Edad Media." *Artistes, Artisans et production artistique au moyen âge.* Vol. 1. Paris, 1986, 499–513.

Martin, John Rupert. *The Illustration of the Heavenly Ladder of John Climacus.* Princeton, 1954.

Martin Saint-Leon, Etienne. *Histoire des corporations de métiers depuis leur origines.* Paris, 1922.

Matthews, Jane Timken. "Reflections of Philo Judaeus in the Septuagint Illustrations of the Joseph Story." *Byzantine Studies,* vol. 7, 1980, 35–56.

Mayer, Gilbert. *Lexique des oeuvres d'Adam de la Halle.* Paris, 1940.

McGovern, John F. "The Rise of New Economic Attitudes—Economic Humanism, Economic Nationalism—During the Later Middle Ages and the Renaissance, A.D. 1200–1550." *Traditio,* vol. 26, 1970, 217–53.

Mellinkoff, Ruth. *The Horned Moses in Medieval Art and Thought.* California Studies in the History of Art 14. Berkeley, 1970.

Mély, Fernand de. "Etude iconographique sur les vitraux de treizième siècle de la cathédrale de Chartres." *Revue de l'art Chrétien* (Paris) vol. 38, 1888, 413–28.

———. "Vitraux de Beauce du XIIIe s. en Amérique." *Revue de l'Art,* vol. 40, 1921, 153–58.

Merk, K. J. *Abriss einer liturgiegeschichtlichen Darstellung des Mess-Stipendiums.* Stuttgart, 1928.

Merlet, Lucien. *Robert de Gallardon, scenes de la vie féodale du XIII siècle.* Chartres, 1860.

———. "Compte de l'oeuvre de la cathédrale de Chartres en 1415–1416." *Bulletin archéologique du comité des travaux historiques et scientifiques* (Paris) 1889, 35–94.

———. "Redevances au pays chartrain durant le Moyen âge." *SAELM,* vol. 12, 1901, 181–229.

Merlet, René. "Cellier du XIIIe siècle de l'ancien hôtel des seigneurs de Tachainville." *SAELM,* vol. 10, 1896a, 357–70.

———. *Origine des monnaies féodales au type chartrain.* Chartres, 1891 (republished in *SAELM,* vol. 10, 1896b, 111–21).

———. "Les vidames de Chartres au XIIIe siècle et le vitrail de Sainte Marguerite." *SAELM,* vol. 10, 1896c, 81–91.

Merlet, René, and Lucien Merlet. *Dignitaires de l'église Notre-Dame de Chartres. Listes chronologiques.* Chartres, 1900.

Merson, Olivier. *Les vitraux.* Paris, 1895.

Métais, Ch. *Pieces détaches pour servir à l'histoire du Diocèse de Chartres.* Vol. 1. Chartres, 1899.

———. "Le crosse et le tombeau de Regnaud de Mouçon (1183–1217)." *Revue de l'art chrétien,* 1911, 211ff.

Métais, Ch., ed. *Cartulaire de l'abbaye de Notre-Dame de l'Eau.* Chartres, 1911–12.

Meyers, Wilhelm, Alfons Hilka, and Otto Schumann. *Carmina Burana.* Vol. I, pts. 1, 3. Heidelberg, 1970.

Michler, Jürgen, "La cathédrale Notre-Dame de Chartres: reconstitution de la polychromie originale de l'intérieur." *BM*, 1989, vol. 147, 117–31.

Miller, Madeleine S., and Jane L. Miller. *The New Harper's Bible Dictionary.* New York, 1973.

Millor, W. J., and C. N. L. Brooke. eds. *The Letters of John of Salisbury.* Vol. 2, 1163–80. Oxford, 1979.

Monjaidet, R. *Recherches sur les institutions municipales de Bourges au Moyen âge."* Société des Antiquaires du Centre, Mémoires, vol. 47, 1936–37, 28–36.

Monneret de Villard, Ugo. "L monetazione nell'Italia Barbarica." *Rivista italiana di Numismatica*, vol. 32, 1919, 125–38.

Montandon, Jacques. *Le bon pain des provinces de France.* Lausanne, 1979.

Moore, P. S. *The Works of Peter of Poitiers.* Notre-Dame, 1936.

Morath, G. *Die Maximianskathedra in Ravenna.* Freiburg im Breisgau, 1940.

Moutié, A., and A. de Dion, eds. *Cartulaires de Saint-Thomas d'Epernon et de Notre-Dame de Maintenon, prieurés dependant de l'abbaye de Marmoutier.* Rambouillet, 1878.

Mussat, André. "Les cathédrales dans leur cités." *Revue de l'art*, vol. 55, 1982, 9–19.

Mussat, André, et al. *La cathédrale du Mans.* Paris, 1981.

Musset, L. "A-t-il existé en Normandie au XI siècle une aristocracie d'argent?" *Annales de Normandie*, 9, 1959, 285–99.

Nash, Ernest. *Pictorial Dictionary of Ancient Rome.* 2 vols. New York, 1968.

Nerzic, Chantal. *La sculpture en Gaule romaine.* Paris, 1989.

Netzer, Nancy D. "A Stylistic Analysis of the Chartres Cathedral Nave Stained Glass Windows." Master's thesis, Tufts University, 1976.

Neuss, W. *Das Buch Ezekiel in Theologie und Kunst bis zum Ende des 12 Jahrhunderts.* Munster, 1912.

Nickl, G. *Der Anteil des Volkes an der Messliturgie im Frankenreiche.* 1930.

Nicot, G. "Le cloître Notre-Dame de Chartres." *Notre Dame de Chartres*, no. 27, June 1976, 4–16.

Noonan, John T., Jr. *The Scholastic Analysis of Usury.* Cambridge, Mass., 1957.

Norris, Herbert. *Costume and Fashion.* Vol. 2, 1066–1485. London, 1927.

———. *Church Vestments: Their Origin and Development.* New York, 1950.

O'Connor, Daniel W. *Peter in Rome. The Literary, Liturgical, and Archaeological Evidence.* New York, London [1960] 1969.

Oexle, Otto Gerhard von. "Die mittelalterliche Zunft als Forschungsproblem. Ein Beitrag zur Wissenschaftsgeschichte der Moderne." *Blatter für Deutsche Landesgeschichte*, vol. 118, 1982, 1–44.

Ottin, L. *Le vitrail: son historie, ses manifestations à travers les âges et les peuples.* Paris, 1896.

Ozeray, M.-J.-Fr. *Histoire générale, civile et religieuse de la cité des Carnutes, et du Pays Chartrain, vulgairement appele la Beauce . . . jusqu'à l'année 1697. . . .* Vol. 1. Chartres, 1834.

Pacaut, Marcel. *Louis VIII et son royaume.* Paris, 1964.

Panofsky, Erwin, ed. and trans. *Abbot Suger on the Abbey Church of St.-Denis and Its Art Treasures.* Princeton, [1946] 1979.

Papanicolaou, Linda Morey. "Stained Glass Windows of the Choir of the Cathedral of Tours." Ph.D. diss., New York University, 1979.

———. "The Iconography of the Genesis Window of the Cathedral of Tours." *Gesta*, vol. 20, 1981, 179–89.

Pellicer, Bru. "Le sou d'or et le sou-monnaie." *Société française de numismatique, Bulletin*, vol. 34, no. 7, 1979, 565–67.

Perrot, Françoise. *Le vitrail à Rouen*. Paris, 1972.

———. "Le vitrail, le croisade et la Champagne: réflexion sur les fenêtres hautes du choeur à la cathédrale de Chartres." *Les Champenois et la croisade*, ed. Yvonne Bellenger et Danielle Quéruel. Paris, 1989.

Perrot, Françoise, and Michel Dhenin. "L'or des Rois Mâges: vitrail de la cathédrale de Chartres (XIIe s.)." *Bulletin de la société française de numismatique*, no. 5, 1985, 641–45.

Petit-Dutaillis, Charles Edmond. *Les communes françaises, caractères et évolution des origines au XVIIIe siècle*. Paris, 1947.

Philo. *On Joseph*. F. H. Colson, trans. Loeb Classical Library, vol. 6. London and Cambridge, Mass., 1935, 138–271.

Plus, R. *Jean-Baptiste dans l'art*. Paris, 1937.

Poncelet, Albert. "Les saints de Micy." *Analecta Bollandiana* (Brussels), vol. 24, 1905, 5–104.

Popesco, Paul. *La cathédrale de Chartres, Chefs-d'oeuvre du Vitrail européen*. Paris, 1970.

Porée, Charles. *La cathédrale de Auxerre*. Paris, 1926.

Postan, M. M., and E. E. Rich, eds. *Trade and Industry in the Middle Ages*. Cambridge, 1962.

Prou, M. "Esquisse de la politique monétaire des rois de France du Xe au XIII siècle." *Entre Camarades*. N.d. 77–80.

Quantin, M. "Note sur une trouvaille de monnaies du Moyen-âge." *Société des sciences historiques et naturelle de l'Yonne, Bulletin*, vol. 39, 1885, 226–33.

Quarré, Robert. *La cathédrale de Chartres*. Paris, 1927.

Quiévreux, François. "Les vitraux du XIIIe siècle de l'abside de la cathédrale de Bourges." *Bulletin Monumental*, vol. 101, 1942, 255–75.

———. *Les Paraboles*. Paris, 1946.

Raguin, Virginia. "The Genesis Workshop of the Cathedral of Auxerre and Its Parisian Inspiration." *Gesta*, vol. 12, 1974, 27–38.

———. *Stained Glass in Thirteenth-Century Burgundy*. Princeton, 1982.

Ranquet, H. du. *Les vitraux de la cathédrale de Clermont-Ferrand, XIIe, XIIIe, XIVe, et XV siècles*. Clermont, 1932.

Raymond, Irving Woodworth. *The Teaching of the Early Church on the Use of Wine and Strong Drink*. New York, 1927.

Raynal, L. *L'histoire du Berry*. 4 vols. Bourges, 1844–47.

Razy, E. *Saint Jean-Baptiste, sa vie, son culte, et sa legende*. Paris, 1880.

Réau, Louis. *Iconographie de l'art Chrétien*. 3 vols. Paris, 1955–59.

Rheims, Gabrielle. "L'Eglise de Saint-Juien-du-Sault et ses verrières." *GBA*, vol. 2, 1926, 139–62.

Ritter, Georges. *Les vitraux de la cathédrale de Rouen (XIIIe–XVIe siècles)*. Cognac, 1926.

Rivet, Dom. "La vie de S. Lubin, Evêque de Chartres." *Histoire littéraire de la France*. Vol. 3. Paris, 1735, 357–58.

Rouse, Richard H. "La diffusion en Occident au XIIIe siècle des outils de travail

facilitant l'accès aux textes autoritatifs." *Revue des études Islamiques*, vol. 44, 1976, 115–47.

Rouse, Richard H., and Mary A. Rouse. "Biblical Distinctions in the Thirteenth Century." *Archives d'Histoire Doctrinale et Littéraire du Moyen âge* (Paris), Vol. 41. 1974, 27–37.

Rudolph, Conrad. *Artistic Change at St-Denis: Abbot Suger's Program and the Early Twelfth-Century Controversy over Art*. Princeton, 1990.

Rupprecht, Friederike. *Die Ikonographie der Josephsszenen auf der Maximianskathedra in Ravenna*. Heidelberg Inaugural Dissertation, 1969.

Sablon, Vincent. *Histoire de l'auguste et venerable église de Chartres, dediée par les anciens Druides à une Vierge qui devoit enfanter: Tirée des manuscrits et des originaux de cette église*. Orléans and Chartres, [1671] 1835.

Salet, Francis. *La cathédrale de Tours*. Paris, 1949.

Salisbury, John of. *Policraticus. Of the Frivolities of Courtiers and the Footprints of Philosophers*. Ed. and trans. Cary J. Nederman. Cambridge, 1990.

Salvini, R. *The Cloister of Monreale and Romanesque Sculpture in Sicily*. Palermo, 1962.

Sanfaçon, André. "Légendes, histoire et pouvoir à Chartres sous l'Ancien Régime." *Revue historique*, vol. 566, 1988, 337–57.

Sauerländer, Willibald. *Le sculpture gothique en France 1140–1270*. Munich, [1970] 1972.

Saulcy, F. de, ed. *Recueil de documents relatifs à l'histoire des monnaies frappées par les rois de France*. Vol. 1. Paris, 1879.

Schapiro, Meyer. "The Image of the Disappearing Christ. The Ascension in English Art around the Year 1000." *GBA*, ser. 6, vol. 23, 1943, 135–52.

———. "Two Romanesque Drawings in Auxerre and some Iconographic Problems." *Romanesque Art*. New York, 1977, 306–27.

———. "The Joseph Scenes in the Maximianus Throne in Ravenna." *GBA*, vol. 40, ser. 6, 1952, 27–38. Reprinted in Meyer Schapiro, *Late Antique, Early Christian and Mediaeval Art. Selected Papers*. New York, 1979, 34–47.

Scheller, R. W. *A Survey of Medieval Model Books*. Harlem, 1963.

Schiller, Gertrud. *Iconography of Christian Art*. Janet Seligman, trans. 2 vols. Greenwich, 1971–72.

———. *Ikonographie der christlichen Kunst*. Vol. 1, 3, and 4, pt. 1 and 2. Guterslöher, 1966–76.

Schindler, Reinhard. *Führer durch das Landesmuseum Trier*. Trier, 1980.

Schneider, J., "L'avouerie de la cité de Toul." *Le Moyen âge*, ser. 4, vol. 69, 1963, 631–40.

Schnitzler, Hermann. *Der Schrein des Heiligen Heribert*. Mönchengladbach, 1962.

Schreiber, Georg. "Untersuchungen zum Sprachgebrauch des mittelalterlichen Oblationswesens." Diss., Freiburg theol. Worishofen, 1913.

———. *Gemeinschaften des Mittelalters. Recht und Verfassung. Kult und Frömmigkeit*. Regensburg and Munster, 1948.

Seddon, George, et al. *Stained Glass*. New York, 1976.

Sheppard, T., and J. F. Musham. *Money, Scales, and Weights*. London, 1923.

Singer, Charles, ed. *A History of Technology*. Vol. 2. Oxford, 1956.

Slicher van Bath, B. H. "Le climat et les récoltes au haut Moyen âge." *Agricol-*

tura e mondo rurale in occidente nell'alto medioevo. Settimane di studio del centro italiano di studi nell'alto medioevo, vol. 13. Spoleto, 1966.

Souchet, Jean-Baptiste. *Histoire du diocèse et de la ville de Chartres.* 4 vols. Chartres, 1866–73.

Sowers, Robert. "The 12th century Windows in Chartres: Some Wayward Lessons from the 'Poor Man's Bible.'" *Art Journal,* vol. 28, 1968–9, 166–73.

Soyer, Jacques, and Guy Trouillard, eds. *Cartulaire de la ville de Blois (1196–1493).* Mémoirs de la Société des Sciences et Lettres de Loir-et-Cher 17. Blois, 1903–7.

Spiegel, Gabrielle M. *The Chronicle Tradition of Saint-Denis: A Survey.* Brookline and Leyden, 1978.

Spufford, Peter. "The Role of Money in the Commercial Revolution of the 13th century." *Etudes d'Histoire Monétaire,* 1984, 355–95.

Steigelmann, W. *Das Wein in der Bibel.* Neustadt, 1962.

Stoddard, Whitney S. *Art and Architecture in Medieval France.* New York, 1972.

———. *The Facade of Saint Gilles-du-Gard: Its Influence on French Sculpture.* Middletown, 1973.

Stookey, Laurence Hull. "The Gothic Cathedral as the Heavenly Jerusalem: Liturgical and Theological Sources." *Gesta,* vol. 8, 1969, 35–41.

Strong, E. "Professor Josef Strzygowski on the Throne of St. Maximian at Ravenna and on the Sidamara Sarcophagi." *The Burlington Magazine for Connoisseurs,* vol. 11, 1907, 109–11.

Swaan, Wim. *The Gothic Cathedral.* London, 1969.

Tardieu, M. "Un rébus sur le nom de Pierre." *Analecta Bollandiana,* vol. 99, 1981, 351–54.

Thibaud, E. *Considerations historiques et critiques sur les vitraux anciens et modernes et sur la peinture sur verre.* Clermont-Ferrand, 1842.

Thibault, Marcel. "Les métiers du Moyen âge dans les vitraux de la cathédrale de Chartres." *Notre-Dame de Chartres,* vol. 47, 1981, 10–18.

Thomas, Antoine, ed. "Les miracles de Notre-Dame de Chartres." *Bibliothèque de l'Ecole des Chartes,* vol. 42, Paris, 1881, 505–50.

Thomas, Marcel, ed. *Le Psautier de Saint-Louis.* Graz, 1970.

Tikkanen, J. J. "Die Genesismosaiken von S. Marco in Venedig und ihr Verhaltnis zu den Miniaturen der Cottonbibel." *Acta Societatis Scientiarum Fennicae,* vol. 17, 1889, 99ff.

Tirot, Paul. *Histoire des prières d'offertoire dans la liturgie romaine du VIIe au XVI siècle.* Rome, 1985.

Tits-Dieudaide, "Le grain et le pain dans l'administration des villes de Brabant et de Flandre au Moyen âge." *L'initiative publique des communes en Belgique.* 1982.

Trintignac, A. *Découvrir Notre-Dame de Chartres.* Paris, 1988.

Tsuji, Sahoko. "La chaire de Maximien, la Genese de Cotton, et les mosaiques de Saint-Marc à Venise: à propos du cycle de Joseph." *Synthronon. Art et archéologie de la fin de l'antiquité et de Moyen âge.* Paris, 1968, 43–51.

Ugolini, S. "La tavoletta eburnea delle fronte del bancale della cathedra de Massimiano." *Felix Ravenna,* nos. 107–8, 1974, 169–91.

Van der Meer, Frederick. *Apocalypse: Visions from the Book of Revelation in Western Art.* New York, 1978.

Van der Meulen, Jan. "Die Baugeschichte der Kathedrale Notre-Dame de Charters." *SAELM*, vol. 23, 1965, 70–126.

———. "A *Logos Creator* at Chartres and Its Copy." *Journal of the Warburg and Courtauld Institutes*, vol. 29, 1966, 82–100.

———. "Recent Literature on the Chronology of Chartres Cathedral." *Art Bulletin*, vol. 49, 1967, 152–72.

———. "Angrenzende Bauwerke der Kathedrale von Chartres." *Jahrbuch der Berliner Museen*, vol. 16, 1974a, 5–45.

———. "Lubinus (Leobinus, Lubin) von Chartres." *Lexikon der christlichen Ikonographie*. Ed. E. Kirschbaum, W. Braunfels. Vol. 7. Rome, 1974b.

———. *Notre-Dame de Chartres. Die vorromanische Ostanlage*. Berlin, 1975a.

———. "Sculpture and Its Architectural Context at Chartres around 1200." *The Year 1200*. New York, 1975b, 509–60.

Van der Meulen, Jan, and Jürgen Hohmeyer. *Chartres. Biographie der Kathedrale*. Cologne, 1984.

Van der Meulen, Jan, Rüdiger Hoyer, and Deborah Cole. *Chartres. Sources and Literary Interpretation: A Critical Bibliography*. Boston, 1989.

Vercoutre, A. T. *L'inscription de la verrière de St.-Vincent à la cathédrale de Chartres*. Paris, 1919.

Verdier, Philippe. "Dominus Potens in Praelio." *Wallraf-Richartz-Jahrbuch*, vol. 43, 1982, 35–106.

Vermeesch, Albert. *Essai sur les origines et la signification de la commune dans le nord de la France (XIe et XIIe siècles)*. Heule, 1966.

Verrier, Jean. *Vitraux de France aux douzième et treizième siècles*. Paris, 1949.

Vetter, E. *Der Verlorene Sohn*. Düsseldorf, 1955.

Viard, Paul. *Histoire de la Dîme Ecclésiastique dan le Royaume de France aux XIIe et XIIIe siècles*. Paris, 1912.

Vigreux, Pierre-Benjamin. *Le change manuel. La thesaurisation des lingots et monnaies d'or*. Paris, 1934.

Villette, Jean. *Les vitraux de Chartres*. Paris, 1964.

———. *Les vitraux de Chartres*. Rennes, 1979.

———. "Quel est le veritable donateur du portail sud?" *Notre Dame de Chartres*. September 1982, pp. 7–10.

———. "Les principales étapes de la construction de la cathédrale." *Notre-Dame de Chartres*. September 1988, 4–10.

Viollet-le-Duc, M. *Dictionnaire raissoné du mobilier français de l'époque carolingienne à la renaissance*. Vol. 3. Paris, 1872.

Vogel, Cyrille. *Le pécheur et la penitence au Moyen âge*. Paris, 1969.

Volbach, Wolfgang Fritz. *Elfenbeinarbeiten der Spätantike und des frühen Mittelalters*. Mainz am Rhein, 1976.

Von Simson, Otto. *Sacred Fortress; Byzantine Art and Statecraft in Ravenna*. Chicago, 1948.

———. *The Gothic Cathedral*. New York [1956] 1962.

Warnke, Martin. *Bau und Überbau. Soziologie der mittelalterlichen Architektur nach den Schriftquellen*. Frankfurt am Main, 1979.

Watkins, Oscar D. *A History of Penance: Being a Study of the Authorities*. Vol. 2. New York, 1961.

Watson, Andrew M. "Back to Gold and Silver." *The Economic History Review*, ser. 2, vol. 20, 1967, 1–34.

Weber, Jacques J. "Le corbeille de pains (des verrières de la cathédrale de Chartres)." *SAELB*, 1984, no. 2, 1–10.

———. "Remarques sur le vitrail de la Rédemption." *Notre-Dame de Chartres*. March 1986, 6–10.

Webster, James Carson. *The Labors of the Months in Antique and Mediaeval Art to the End of the Twelfth Century*. Northwestern Studies in the Humanities 4. New York, [1938] 1970.

Weitzmann, Kurt. "Die Illustrationen der Septuaginta." *Münchner Jahrbuch der bildenden Kunst*, ser. 3, vols. 3–4, 1952–53, 96–121.

———. *Studies in Classical and Byzantine Manuscript Illumination*. Chicago, 1971.

Wellesz, Emmy. *The Vienna Genesis*. London, 1960.

Werckmeister, O. K. "The Lintel Fragment Representing Eve from Saint-Lazare, Autun." *Journal of the Warburg and Courtauld Institutes*, vol. 35, 1972, 1–30.

Werner, K. F. "L'acquisition par la maison de Blois des comtés de Chartres et de Châteaudun." *Mélanges de numismatique d'archéologie et d'histoire offerts à Jean Lafaurie*. Paris, 1980.

Westlake, N. H. J. *A History of Design in Painted Glass*. London and Oxford, 1879–44.

White, Lynn, Jr. "The Iconography of Temperantia and the Virtuousness of Technology." *Medieval Religion and Technology: Collected Essays*. Berkeley, 1978, 181–204.

Wickersheimer, Ernest. "Textes médicaux chartrains des IXe, Xe, et XIe siècles." *Science, Medicine and History, Essays ... Written in Honor of Charles Singer*. London and Oxford, 1953, vol. 1, 164–76.

Wickhoff, F. *Römische Kunst. Die Wiener Genesis*. Vienna, 1895.

Wilmart, Dom Andre. O.S.B. "Un répertoire d'exégèse composé en Angleterre vers le début du XIIIe siècle." *Mémorial Lagrange*. Paris, 1940, 308–46.

Wilpert, Giuseppe. *I sarcofagi christiani Antichi*. 3 vols. Rome, 1929–36.

Wilpert, J. *Die Malereien der Katakomben Roms*. Freiburg im Breisgau, 1903.

Williams, Jane Welch. "The Pictorial Cycle of the Patriarch Joseph in Medieval Art" (abstract of computer study), *Census. Computerization in the History of Art*. Vol. 1. Pisa, 1984, 248–49. Republished in 1988 in *SN/G; Report on Data Processing Projects in Art*, "The Medieval Pictorial Cycle of Joseph the Patriarch," 531.

———. "The Windows of the Trades at Chartres Cathedral." Master's Thesis, UCLA. 1978.

———. "The Windows of the Trades at Chartres Cathedral." Ph.D. diss., UCLA, 1987.

Witzleben, Elisabeth Schurer von. *Les vitraux des cathédrales de France*. Fribourg, [1967] 1968.

Wolff, Philippe. "The Significance of the Feudal Period in the Monetary History of Europe." *Order and Innovation in the Middle Ages: Essays in Honor of J. R. Strayer*. Princeton, 1976, 77–85.

———. "Les villes de France au temps de Philippe Auguste." *La France de Philippe Auguste. Le Temps des Mutations*. Robert-Henri Bautier, ed. Paris, 1982, 645–76.

Woolley, Reginald Maxwell. *The Bread of the Eucharist.* London, 1913.

Zahn, Eberhard. *Die Igeler Säule bei Trier.* Cologne, 1976.

Zylbergeld, Léon. "Contribution à l'étude des ordonnances du pain du XIIIe siècle: l'exemple de la *Brodtaxe* de Lübeck (1255)." *Revue Belge de la Philologie et d'Histoire,* vol. 15, 1982, 263–304.

INDEX

(The windows of Chartres are numbered here according to the system in Yves Delaporte's 1926 monograph.)

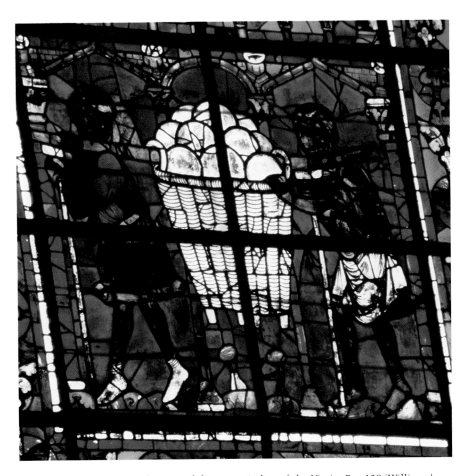

1. Bread-basket carriers, bottom of the apse window of the Virgin, Bay 120 (Williams)

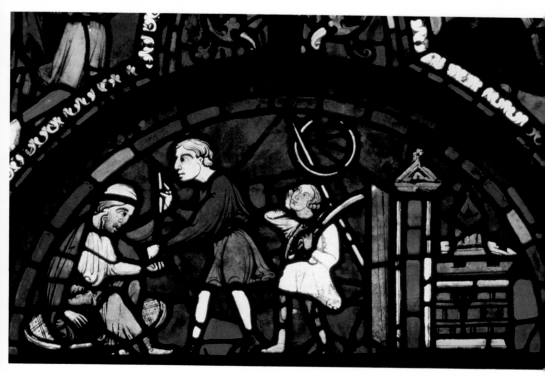

2. Wine-crying, bottom panel of the window of St. Lubinus, Bay 63 (Williams)

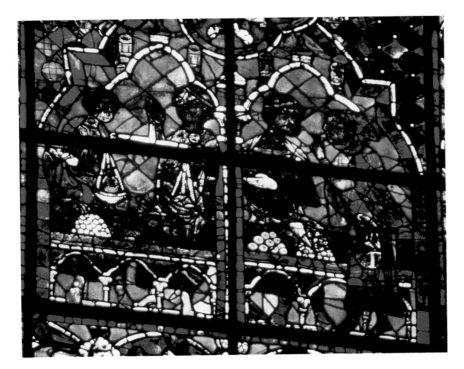

3. Money changers, window of St. Peter, Bay 123 (Williams)

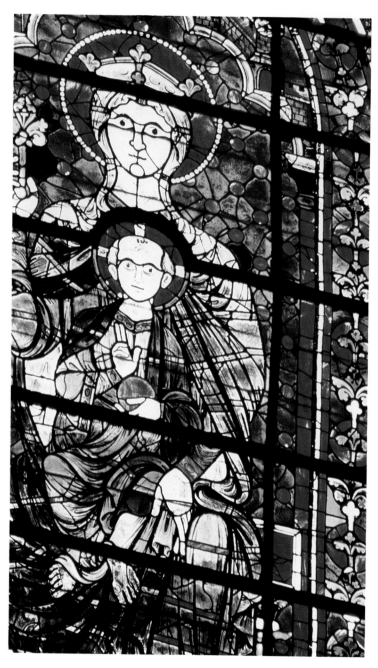

4. Virgin Enthroned, top of the apse window of the Apostles, Bay 120 (Getty Center for the History of Art and the Humanities)

PLATES

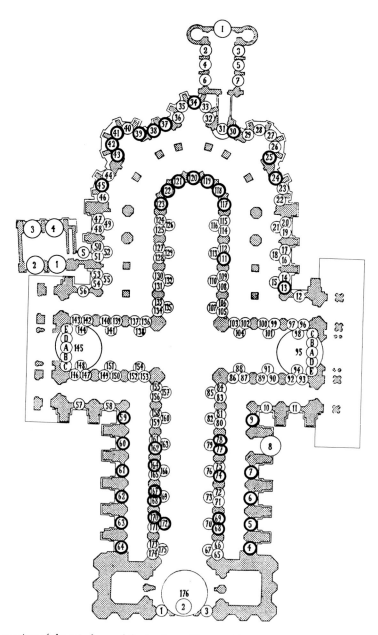

2. Location of the windows of the trades at Chartres (Sinram)

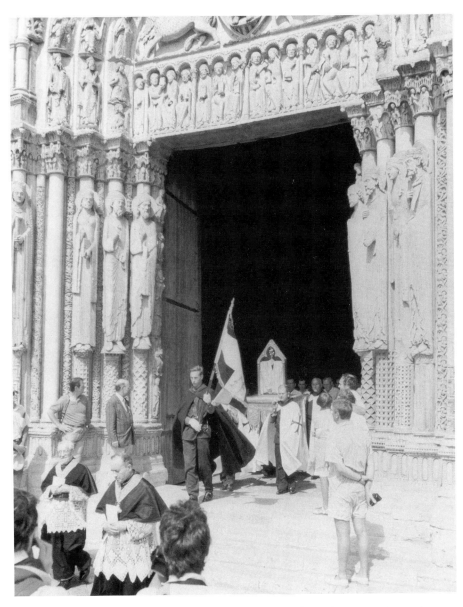

3. Veil of the Virgin being carried out through the Royal Portal in procession on Assumption Day, 1990, at Chartres (Williams)

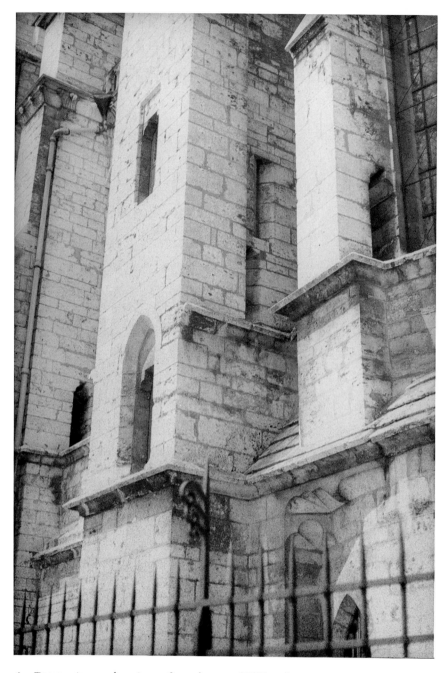

4. Doors going nowhere in southeast buttress (Williams)

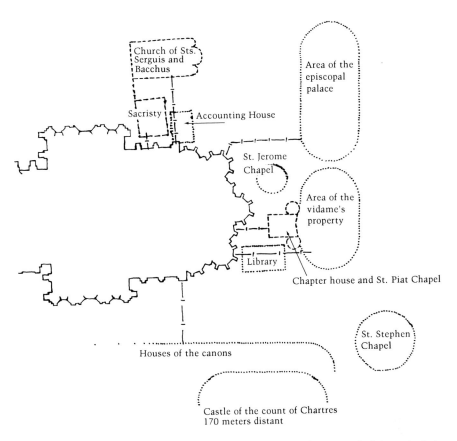

Church of Sts. Serguis and Bacchus

Area of the episcopal palace

Sacristy Accounting House

St. Jerome Chapel

Area of the vidame's property

Library

Chapter house and St. Piat Chapel

St. Stephen Chapel

Houses of the canons

Castle of the count of Chartres
170 meters distant

5. Van der Meulen's reconstruction of bridges connecting the east end of the cathedral to adjacent structures (*Jahrbuch der Berliner Museen*)

U

P

Interior

D

N

Stairs

6. Drawing of eastern buttress doors by John James

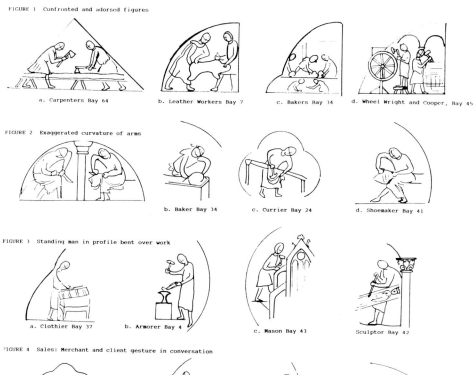

FIGURE 1 Confronted and adorsed figures

a. Carpenters Bay 64

b. Leather Workers Bay 7

c. Bakers Bay 34

d. Wheel Wright and Cooper, Bay 45

FIGURE 2 Exaggerated curvature of arms

b. Baker Bay 34

c. Currier Bay 24

d. Shoemaker Bay 41

FIGURE 3 Standing man in profile bent over work

a. Clothier Bay 37

b. Armorer Bay 4

c. Mason Bay 43

Sculptor Bay 42

FIGURE 4 Sales: Merchant and client gesture in conversation

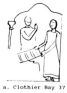
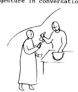
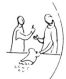

a. Clothier Bay 37

b. Fish Monger Bay 13

c. Changer Bay 61

d. Wine seller Bay 63

7. Repertoire of poses (Williams)

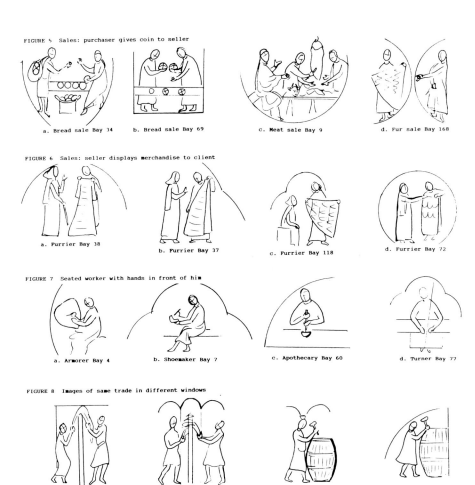

FIGURE 5 Sales: purchaser gives coin to seller

a. Bread sale Bay 34 b. Bread sale Bay 69 c. Meat sale Bay 9 d. Fur sale Bay 168

FIGURE 6 Sales: seller displays merchandise to client

a. Furrier Bay 38 b. Furrier Bay 37 c. Furrier Bay 118 d. Furrier Bay 72

FIGURE 7 Seated worker with hands in front of him

a. Armorer Bay 4 b. Shoemaker Bay 7 c. Apothecary Bay 60 d. Turner Bay 77

FIGURE 8 Images of same trade in different windows

a. Leather Workers Bay 167 b. Leather Workers Bay 111 c. Coopers Bay 45

8. Repertoire of poses (Williams)

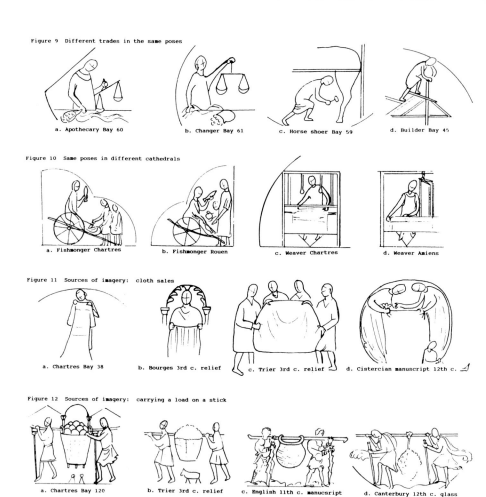

Figure 9 Different trades in the same poses

a. Apothecary Bay 60 b. Changer Bay 61 c. Horse shoer Bay 59 d. Builder Bay 45

Figure 10 Same poses in different cathedrals

a. Fishmonger Chartres b. Fishmonger Rouen c. Weaver Chartres d. Weaver Amiens

Figure 11 Sources of imagery: cloth sales

a. Chartres Bay 38 b. Bourges 3rd c. relief c. Trier 3rd c. relief d. Cistercian manuscript 12th c.

Figure 12 Sources of imagery: carrying a load on a stick

a. Chartres Bay 120 b. Trier 3rd c. relief c. English 11th c. manucsript d. Canterbury 12th c. glass

9. Repertoire of poses (Williams)

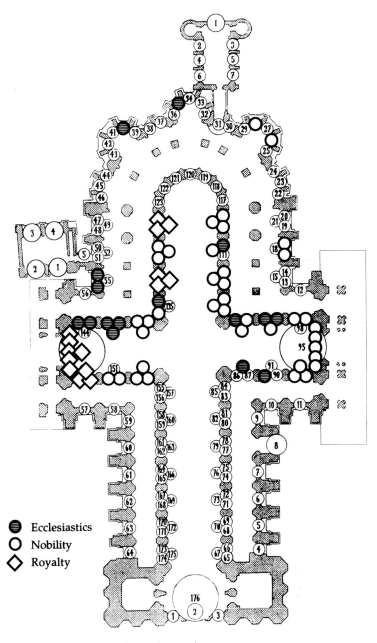

10. Location of upper-class donors (Sinram)

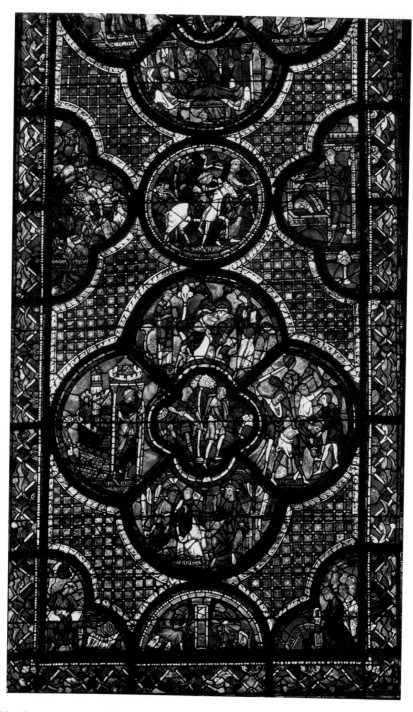

11. Bottom register of the window of the Good Samaritan, Bay 6 (Williams)

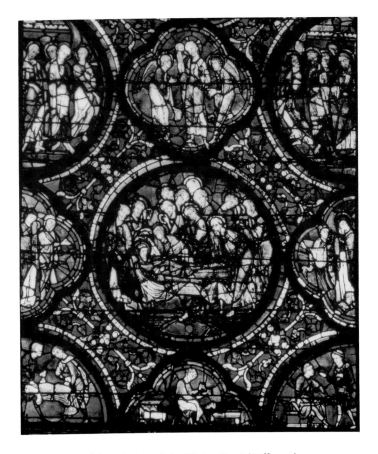

12. Bottom register of the window of the Virgin, Bay 7 (Williams)

13. Bottom register of the window of St. Stephen, Bay 41 (Williams)

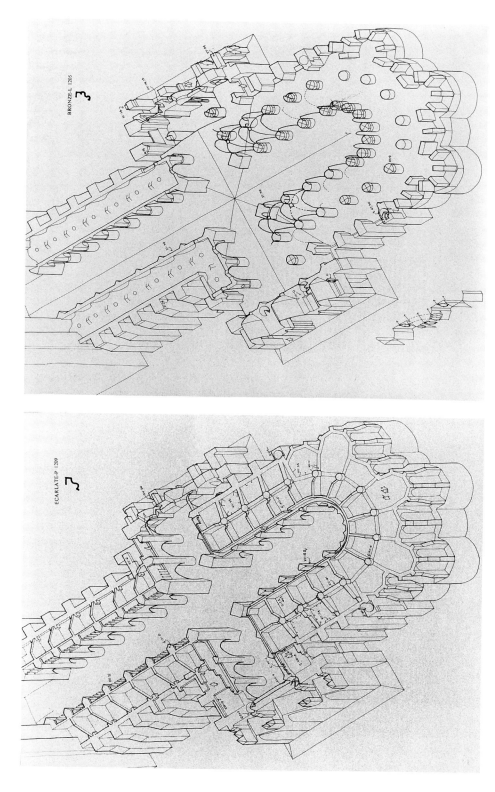

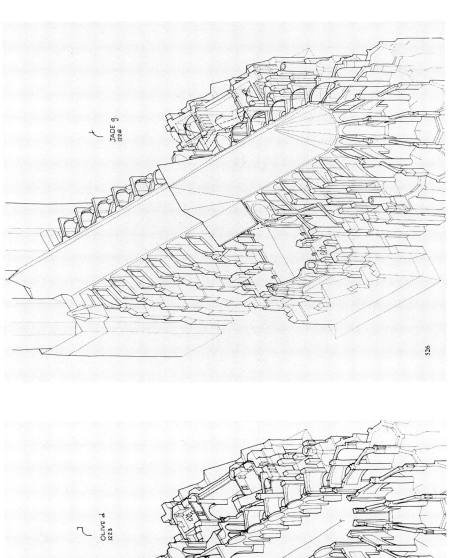

16. The cathedral in 1223, reconstruction drawing (John James)

17. The cathedral in 1226, reconstruction drawing (John James)

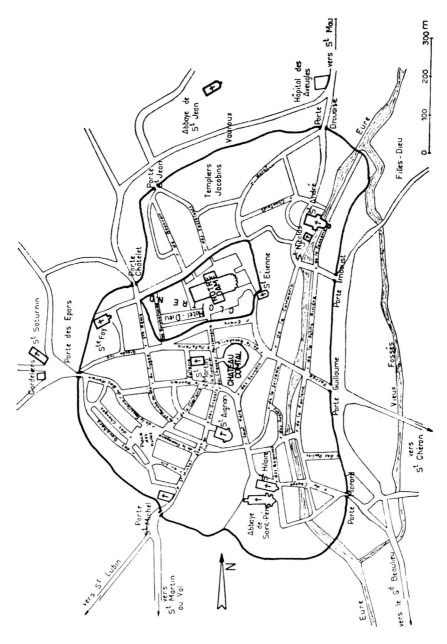

18. André Chédeville's map of Chartres at the end of the thirteenth century (Éditions Klinck-sieck)

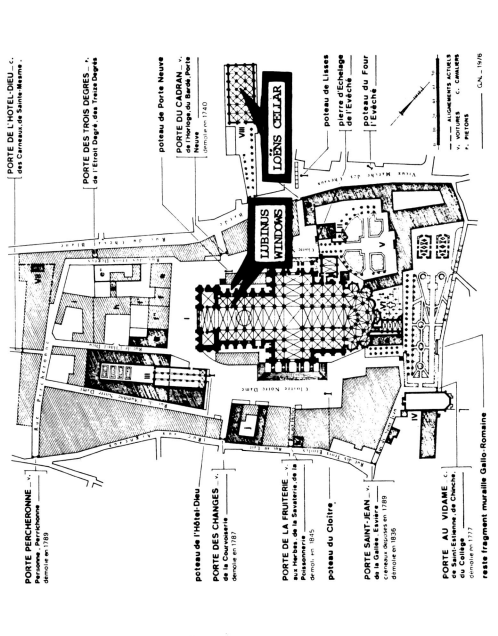

PORTE DE L'HOTEL-DIEU — c.
des Carneaux, de Sainte-Mesme.

PORTE DES TROIS DEGRES — P.
de l'Etroit Degré, des Treize Degrés

poteau de Porte Neuve

PORTE DU CADRAN — v.
de l'Horloge, du Bardé, Porte
Neuve
demolie en 1740

poteau de Lisses

pierre d'Echelage
de l'Evêché

poteau du Four
l'Evêché

LÖENS CELLAR

LUBINUS WINDOWS

ALIGNEMENTS ACTUELS
v. VOITURES c. CAVALIERS
P. PIETONS
G.N. — 1976

PORTE PERCHERONNE — v.
Perionne , Perrichonne
demolie en 1789

poteau de l'Hôtel-Dieu

PORTE DES CHANGES — v.
de la Courvoiserie
demolie en 1787

PORTE DE LA FRUITERIE
aux Herbes, de la Savaterie, de la
Poissonnerie
demoli en 1845

poteau du Cloître

PORTE SAINT-JEAN — v.
de la Gailée, Esvière
creneaux déposés en 1789
demolie en 1836

PORTE AU VIDAME c.
de Saint-Etienne, de Chinche,
du Collège
demolie en 1777

reste fragment muraille Gallo-Romaine

19. Cloister map after plan of 1750

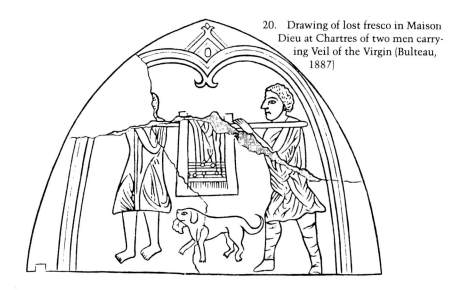

20. Drawing of lost fresco in Maison Dieu at Chartres of two men carrying Veil of the Virgin (Bulteau, 1887)

21. (*top right*) André Chédeville's map of the location of the Miracles of Notre-Dame de Chartres (Éditions Klincksieck)

22. (*bottom right*) Construction cash-flow chart (John James)

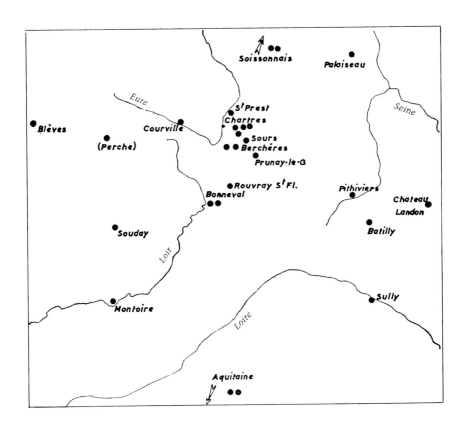

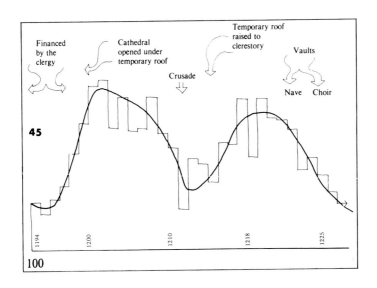

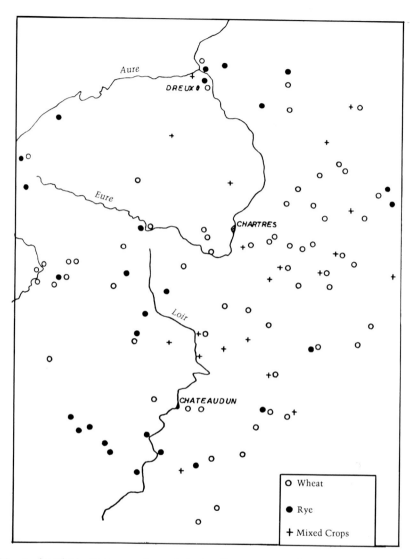

23. André Chédeville's map of cereals in the Chartres region (Éditions Klincksieck)

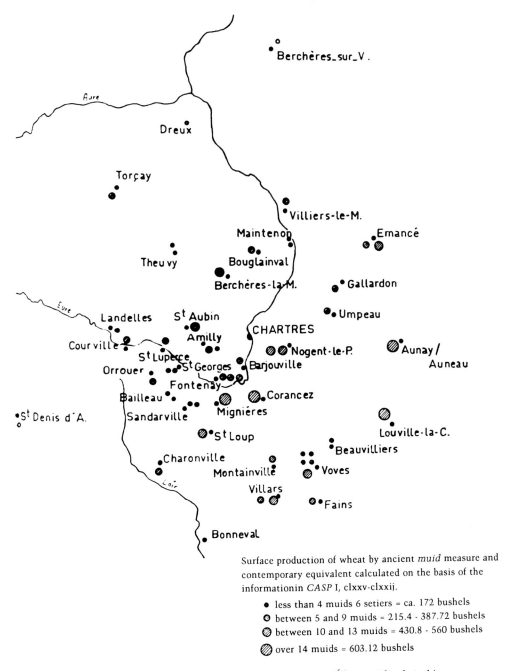

Berchères_sur_V.

Dreux

Aure

Torçay

Villiers-le-M.

Maintenon

Emancé

Theuvy

Bouglainval

Berchères-la-M.

Gallardon

Umpeau

Eure

Landelles

St Aubin

CHARTRES

Courville

Amilly

St Luperce

Nogent-le-P.

Aunay /

Orrouer

St Georges

Barjouville

Auneau

Fontenay

Bailleau

Corancez

St Denis d'A.

Sandarville

Miguières

Louville-la-C.

St Loup

Beauvilliers

Charonville

Montainville

Voves

Villars

Loir

Fains

Bonneval

Surface production of wheat by ancient *muid* measure and
contemporary equivalent calculated on the basis of the
information in *CASP* I, clxxv-clxxij.

- less than 4 muids 6 setiers = ca. 172 bushels
- between 5 and 9 muids = 215.4 - 387.72 bushels
- between 10 and 13 muids = 430.8 - 560 bushels
- over 14 muids = 603.12 bushels

24. André Chédeville's map of the chapter's cereal income (Éditions Klincksieck)

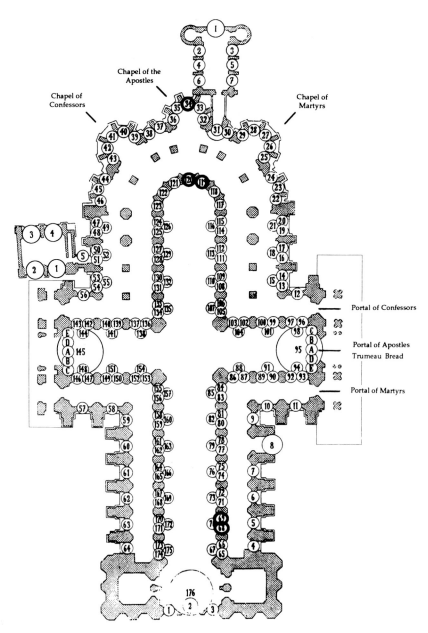

Chapel of the
Apostles

Chapel of
Confessors

Chapel of
Martyrs

Portal of Confessors

Portal of Apostles
Trumeau Bread

Portal of Martyrs

25. Location of major scenes of bread at Chartres (Sinram)

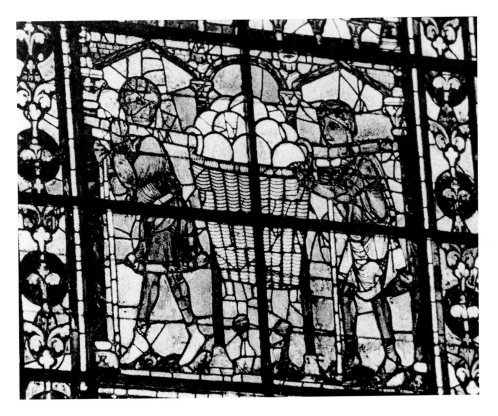

26. Detail of bread-basket carriers in Bay 120 (Williams)

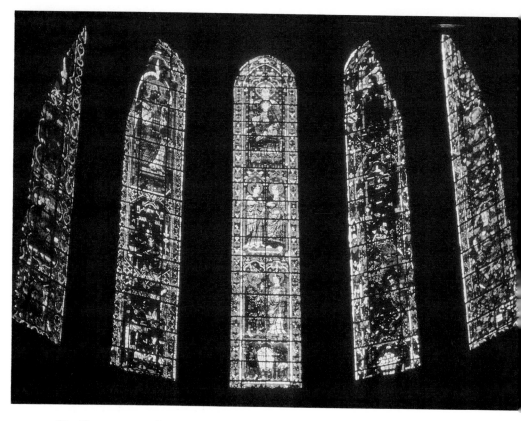

27. Five center windows of the apse clerestory

28. Detail of bread distribution in Bay 119 (Williams)

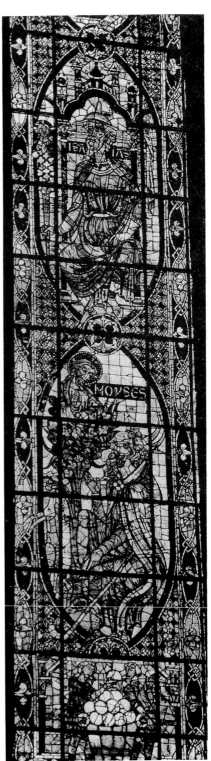

29. Bread distribution, Moses, and Isaiah, Bay 119

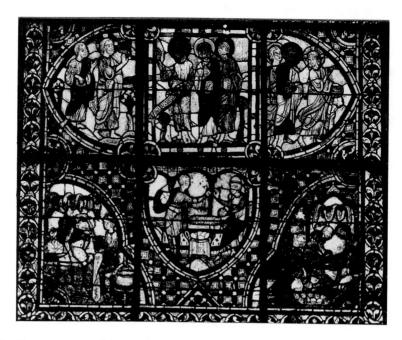

30. Bottom register of the window of the Apostles, Bay 34

31. Bread sale, window of the Apostles, Bay 34

32. Kneading dough, window of the Apostles, Bay 34

33. Shaping loaves, window of the Apostles, Bay 34

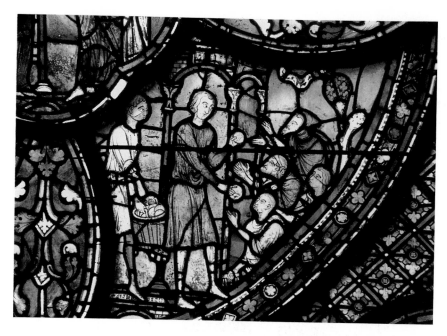

34. St. Anthony distributing bread, window of St. Anthony, Bay 13 (Williams)

35. St. Thomas distributing
bread, window of St. Thomas,
Bay 46 (Williams)

36. Window of St. James, Bay 68

37. Bread scenes, window of St. James, Bay 68

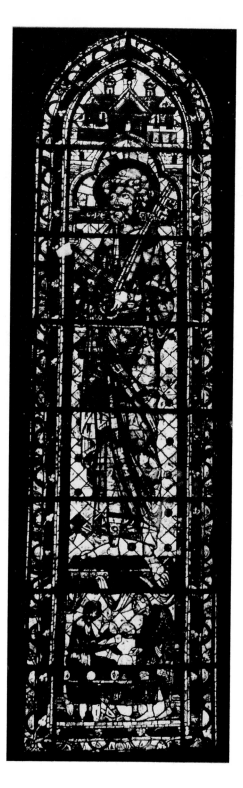

38. Window of St. Peter, Bay 69

39. Bread scene, window of St. Peter, Bay 69 (Arch. Phot. Paris/SPADEM)

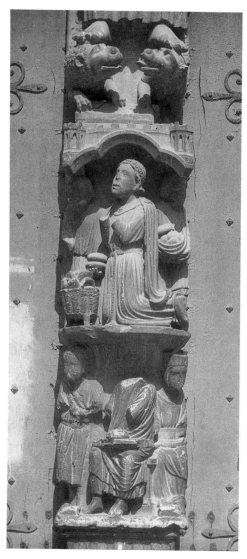

41. Detail, both registers of socle (Williams)

40. South porch trumeau of the Beau Dieu (Williams)

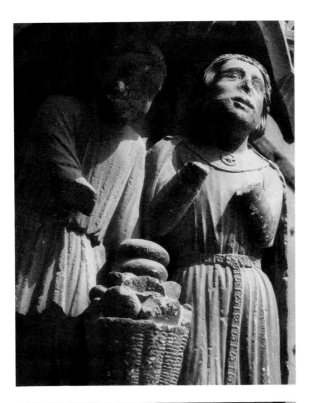

42. Detail, kneeling count on the socle (Williams)

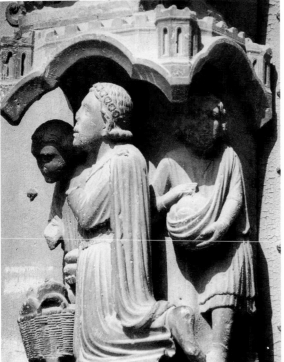

43. Detail, kneeling count (Williams)

44. View of socle, 1980 (Williams)

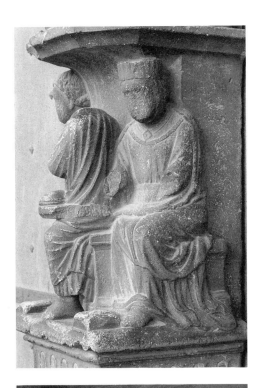

45. Detail, lower register of the socle (Getty Center for the History of Art and the Humanities, van der Meulen Collection)

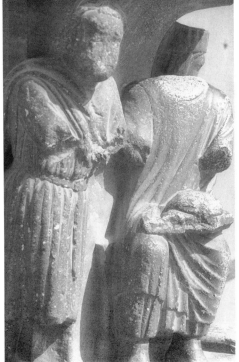

46. Detail, lower register of the socle (Williams)

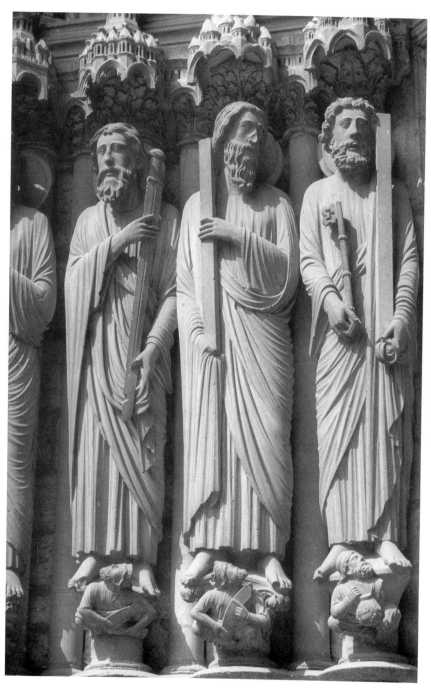

47. Sts. Thomas, Andrew, and Peter, column figures of left embrasure, central portal of the south porch (Williams)

48. View of the south porch (Williams)

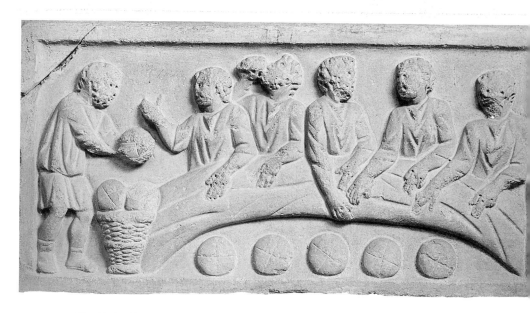

49. Early Christian sarcophagus relief (Vatican, Museo Pio Cristiano, Inv. 31515)

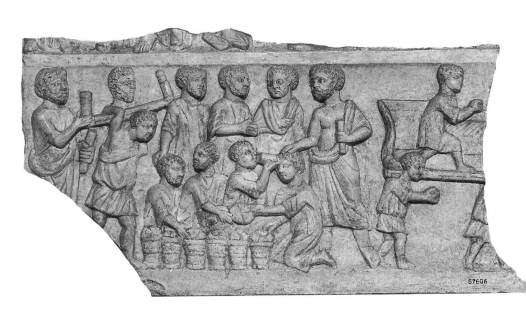

50. Early Christian sarcophagus relief (Rome, Museo Nazionale, Inv. 67606)

51. Igel Column, reliefs of bakers (Rheinisches Landesmuseum, Trier)

52. Late Roman relief of basket carriers (Rheinisches Landesmuseum, Trier)

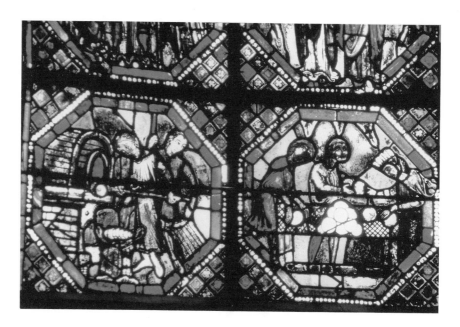

53. Bread-baking and bread sale, window of St. John the Evangelist, Bourges Cathedral
(Williams)

54. (*right*) Window of the Virgin, Bay 120 (SPADEM)

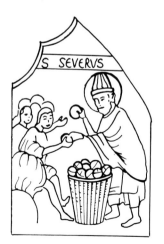

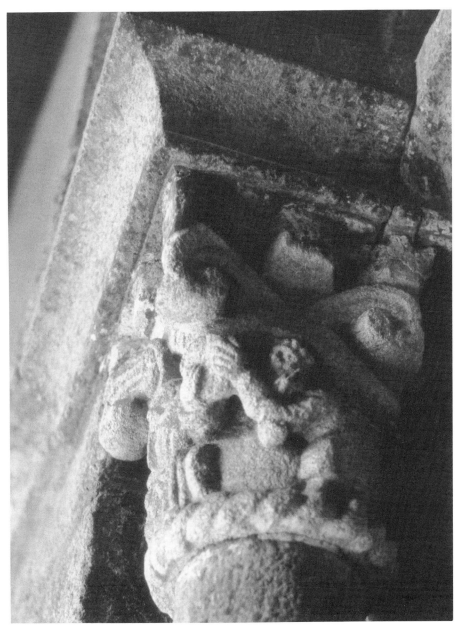

59. Bread offering, Le Puy Cathedral capital (Williams)

57. (*far left*) St. Severus distributing bread to the poor, Rouen Cathedral (Williams)

58. (*near left*) St. Austermoine distributing eulogy bread, Clermont-Ferrand Cathedral, after 1248 (Williams)

60. Annunciation, thirteenth century French Moralized Bible (Vienna, ÖNB 2554, fol. 27)

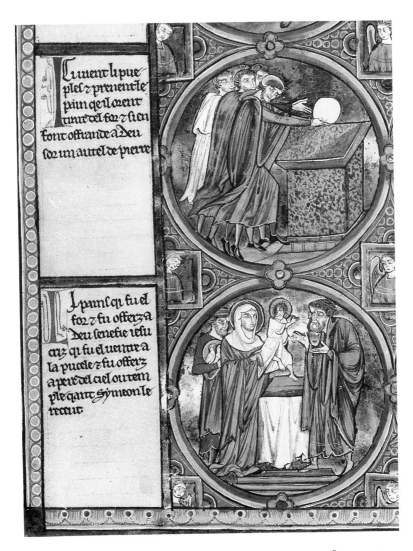

61. Presentation, thirteenth-century French Moralized Bible (Vienna, ÖNB 2554, fol. 27)

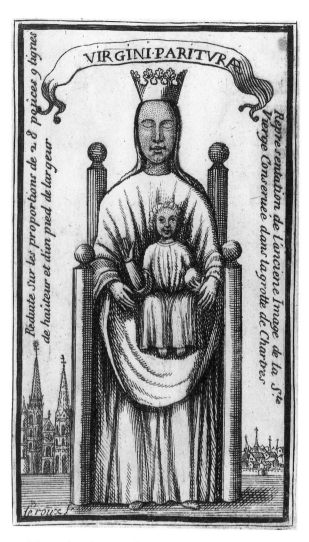

VIRGINI·PARITVRÆ

Réduite sur les proportions de 2.8 pouces 9 lignes de hauteur et d'un pied de largeur

Representation de L'ancienne Image de la Sté Vierge Conservée dans la grotte de Chartres

le roux f.

62. Engraving of the medieval statue of Notre-Dame-sous-Terre (Paris, Bib. Nat. MS fr. 32973)

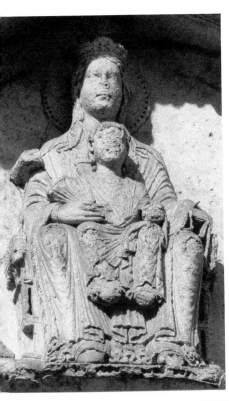

63. Detail, the Virgin Enthroned, tympanum of the right portal, west porch, Chartres, mid-twelfth century (Williams)

64. Cult of the Carts, Miracles of the Virgin window, Bay 9 (Williams)

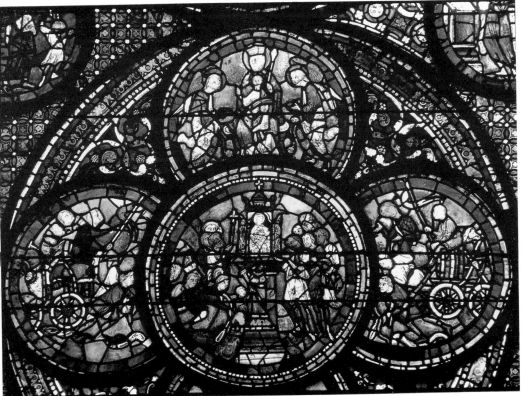

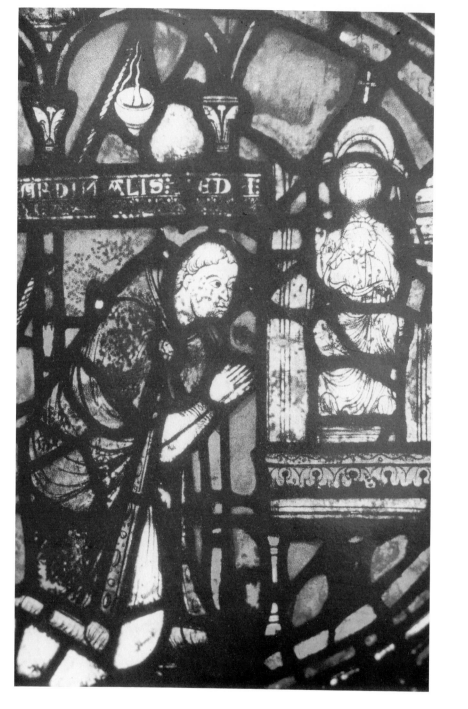

66. Miracle of the Distribution of the Loaves (Munich BSB, Clm 4453, fol. 163r)

65. (*left*) Cardinal Stephen kneeling before statue of the Virgin on the main altar, window of Saint Nicholas, Bay 53 (Williams)

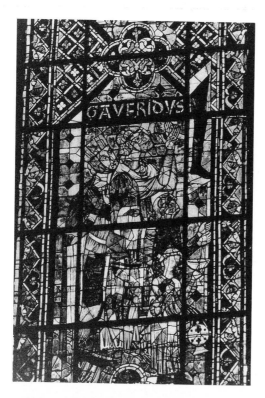

67. Gaufridus and worshipers, Bay 121

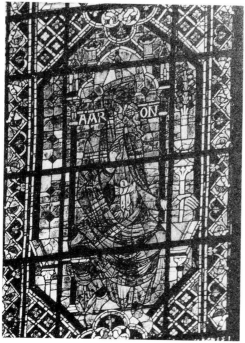

68. Aaron, Bay 119

69. Censing an-
gel, Bay 119

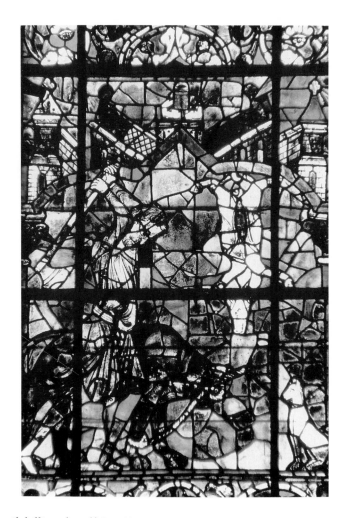

70. Detail, killing of a calf, Bay 121

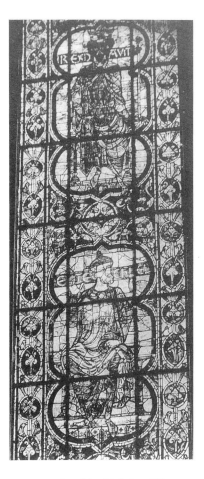

71. David and Ezekiel, Bay 122

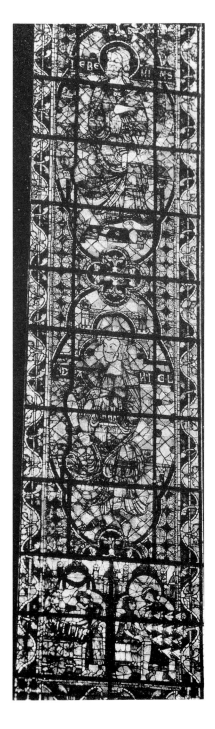

72. Wool and fur merchants, window
of Daniel and Jeremiah, Bay 118

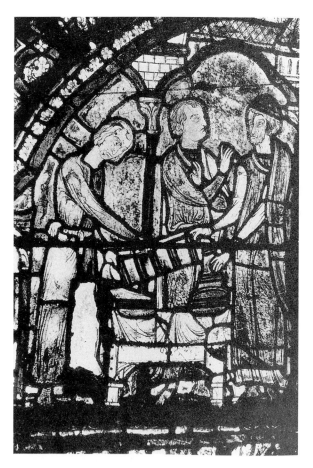

73. Wool merchants, window of St. James, Bay 37 (Williams)

74. Chart of window of the Apostles, Bay 34 (Williams)

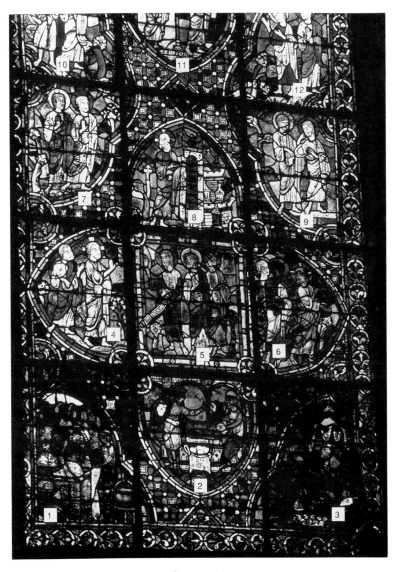

75. Window of the Apostles, Bay 34, lowest registers

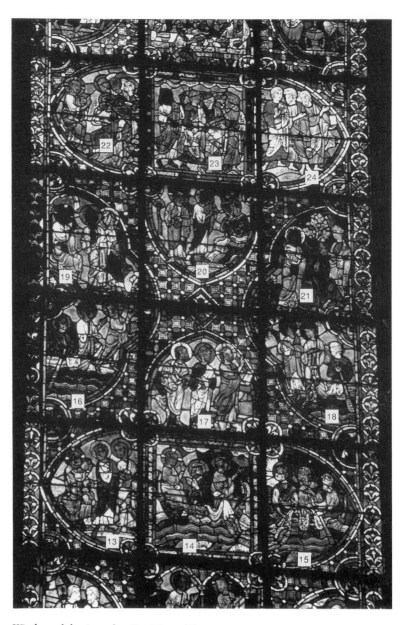

76. Window of the Apostles, Bay 34, middle registers

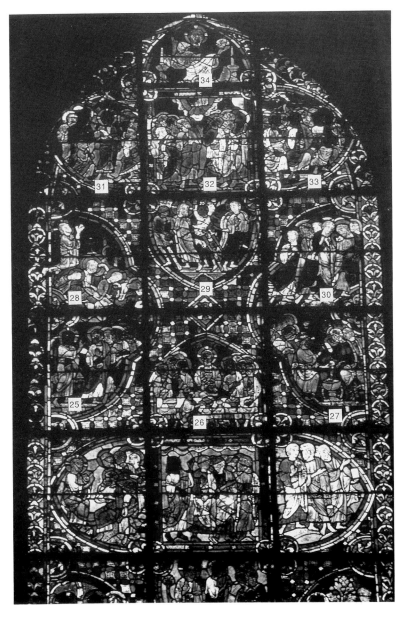

77. Window of the Apostles, Bay 34, upper registers

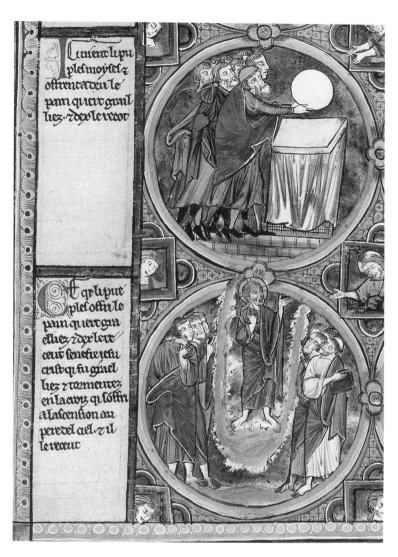

78. Ascension, thirteenth-century French Moralized Bible (Vienna, ÖNB 2554, fol. 28r)

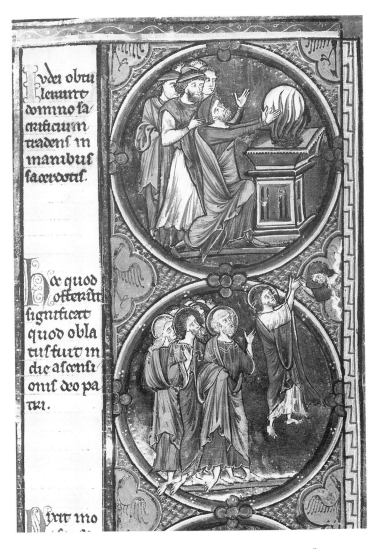

Yder obtu
lerunt
domino sa
crificium
tradens in
manibus
sacerdotis.

Hec quod
offerunt
significat
quod obla
tus fuit in
die ascensi
onis deo pa
tri.

Dixit mo

79. Ascension, thirteenth-century French Moralized Bible (Vienna, ÖNB 1179, fol. 28r)

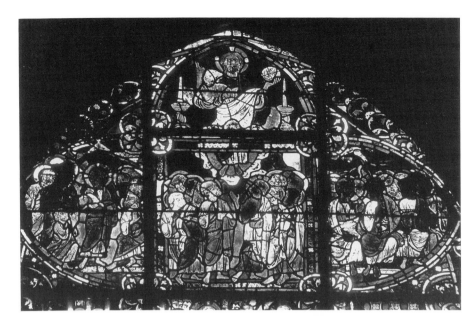

80. Top registers of the window of the Apostles, Bay 34 (Williams)

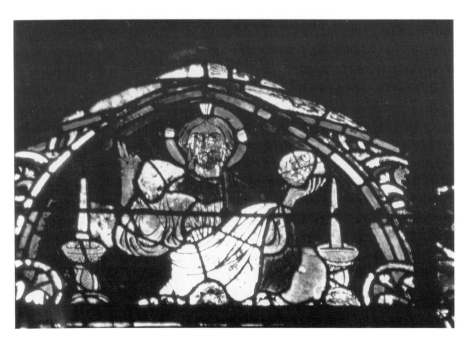

81. Christ at the top of the window of the Apostles, Bay 34 (Williams)

82. Christ standing on beasts, beginning of the Mass, Chartres Pontifical, thirteenth century (Orléans, Bib. Mun. MSS 144, fol. 71r)

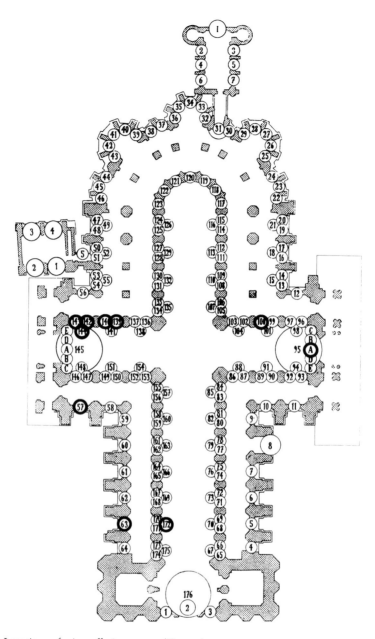

83. Locations of wine-offering scenes (Sinram)

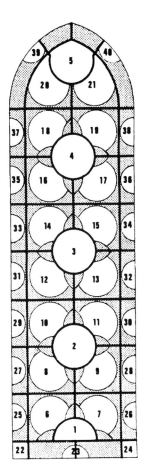

84. Chart of Lubinus window with numbered panels (Williams)

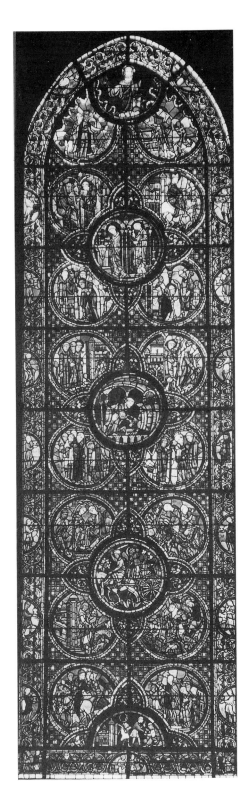

85. Overall of Lubinus window, (Fiévet)

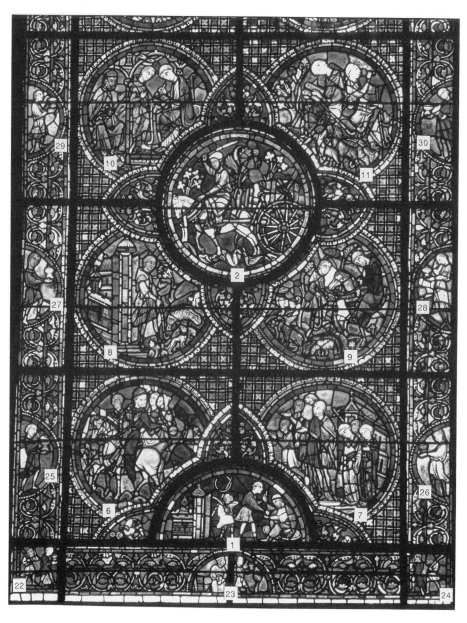

86. Lubinus window, Bay 63, bottom (Williams)

87. (*top right*) Lubinus window, Bay 63, middle (Williams)

88. (*bottom right*) Lubinus window, Bay 63, upper middle (Williams)

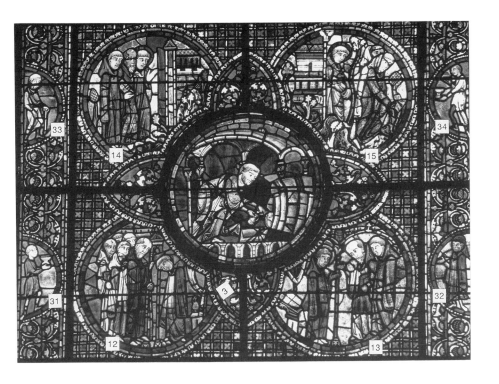

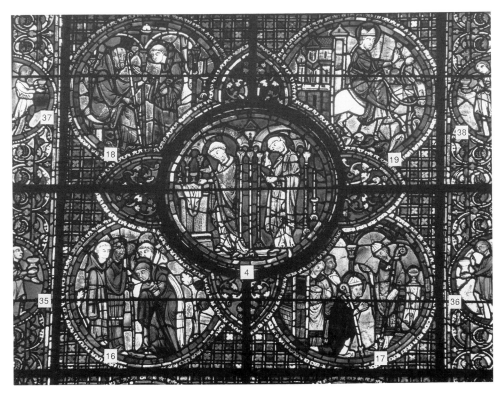

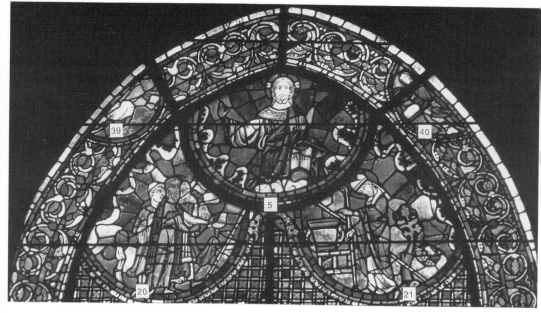

89. Lubinus window, Bay 63, top (Williams)

91. (*right*) Chart of St. Lawrence window, Bay 57 (Williams)

90. Lubinus oculus, Bay 172 (Williams)

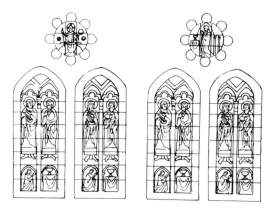

92. The east clerestory of the
north transept (Williams)

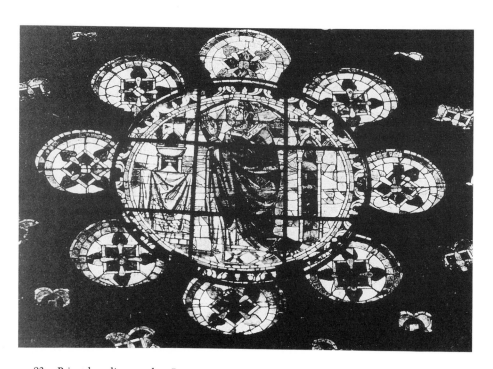

93. Priest kneeling, oculus, Bay 141

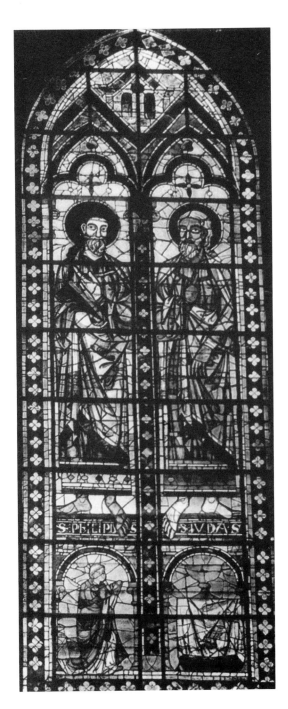

94. Sts. Philip and Jude with kneeling priest, Bay 139

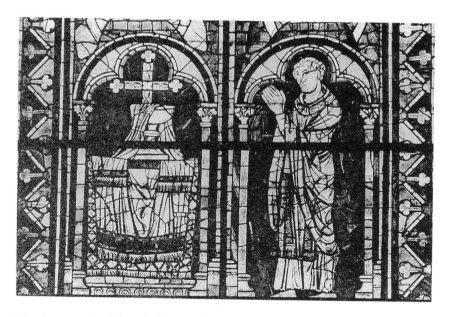

95. Priest praying before chalice, window of Sts. Gervais and Protais, Bay 100

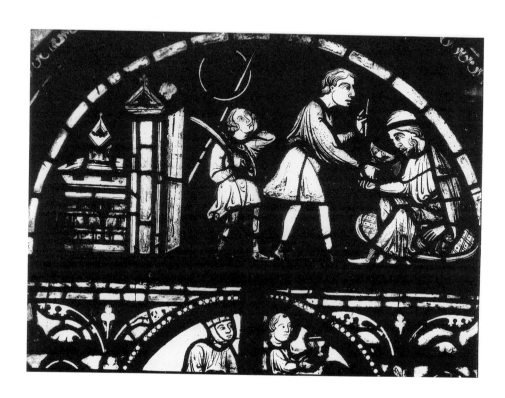

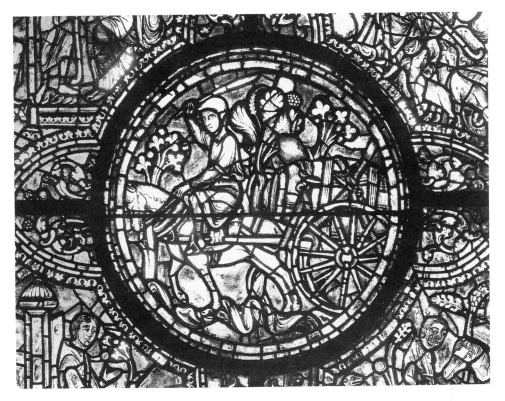

97. The winecart, window of St. Lubinus, panel 2 (Giraudon/Art Resource, N.Y.)

96. (*left*) Wine-crying, window of St. Lubinus, Bay 63, panel 1 (Williams)

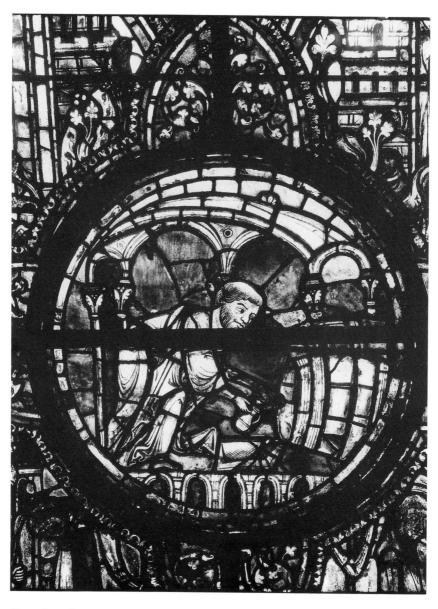

98. The cellar keeper, window of St. Lubinus, panel 3 (Arch. Phot. Paris/SPADEM)

99. Loëns cellar, early thirteenth century (Martin Sabon/Arch. Phot. Paris/SPADEM)

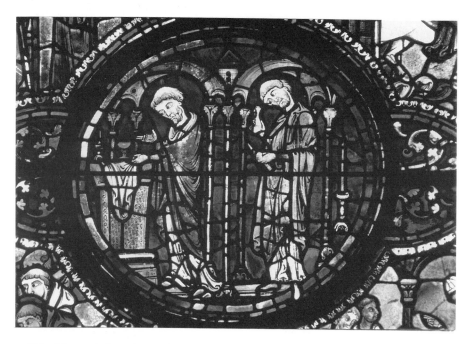

100. Mass, window of St. Lubinus, Bay 63, panel 4 (Williams)

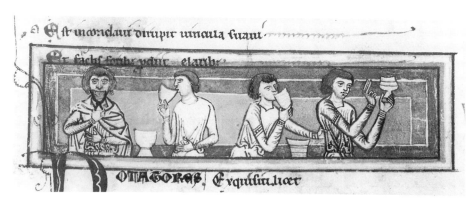

101. Potatores, *Carmina Burana*, thirteenth century (Munich, BSB, CLM. 4660, fol. 89v)

102. Death of St. Julian's master, St. Julian window, Chartres (Arch. Phot. Paris/SPA-DEM)

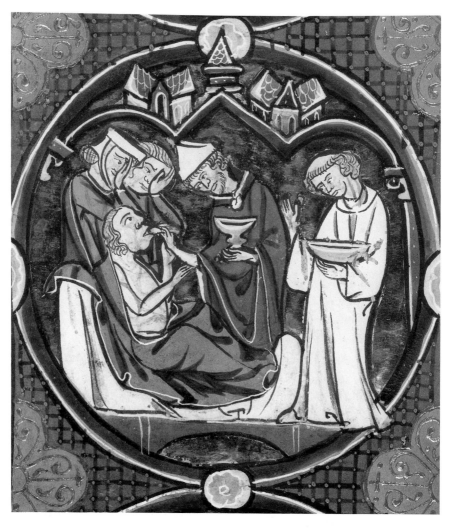

103. Mass for the dying, thirteenth-century French Moralized Bible (Brit. Lib. Harley 1527, fol. 23r) (By permission of the British Library)

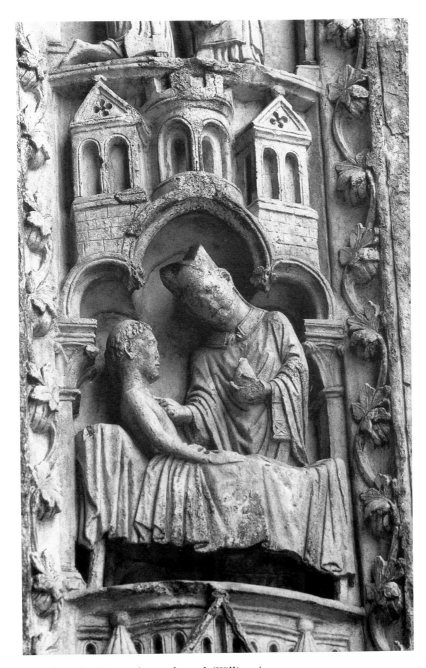

104. Lubinus healing on the south porch (Williams)

105. October, Necrology of Chartres, eleventh century (Merlet and Clerval, 1893)

106. October and September, Zodiac window, Bay 17, detail (Arch. Phot. Paris/SPADEM)

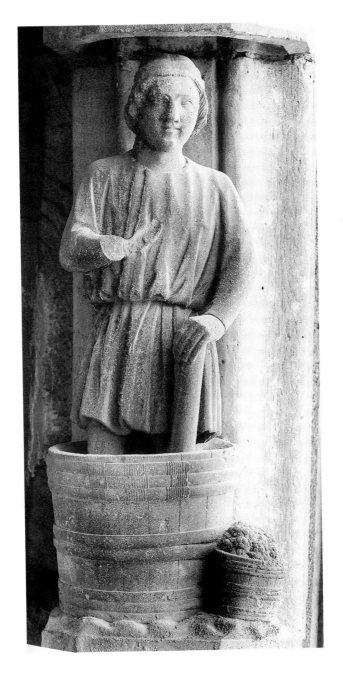

107. September as laborer making wine in barrel, west portal of the north porch (Lefèvre-Pontalis/Arch. Phot. Paris/SPADEM)

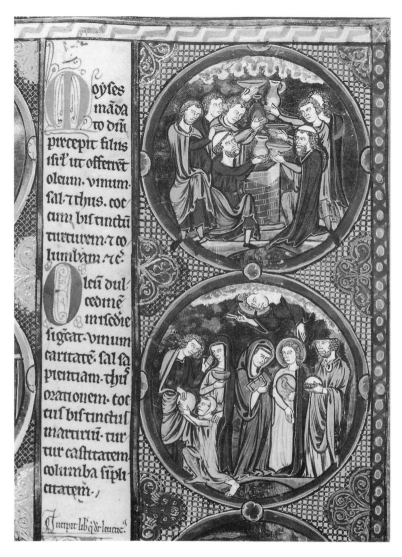

108. Sons of Moses offering wine and oil at the Old Testament altar, thirteenth-century French Moralized Bible (Oxford, Bodl. 270b, fol. 57v)

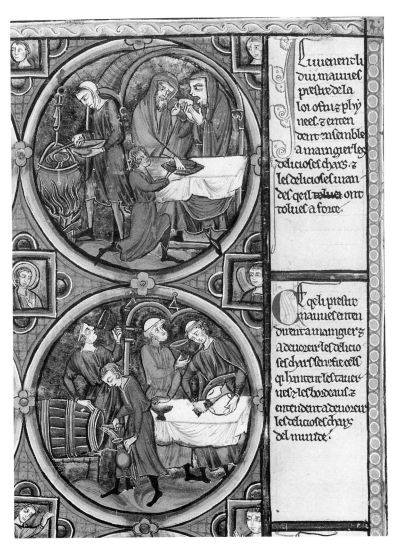

109. Bad priests of the Old Testament, and tavern scene, thirteenth-century French Moralized Bible (Vienna, ÖNB 2554, fol. 35)

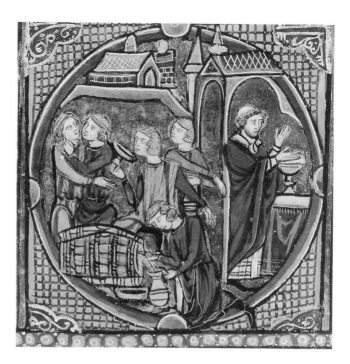

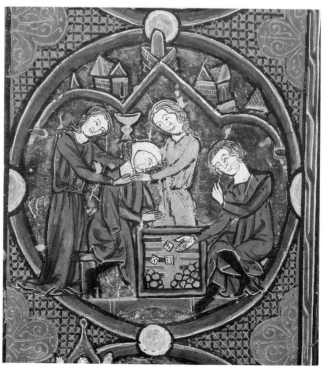

110. (*top left*) Tavern scene, thirteenth-century French Moralized Bible (Paris, Bib. Nat. lat. 11560, fol. 139)

111. (*bottom left*) The Prodigal Son, Oxford Moralized Bible, thirteenth century (Brit. Lib. Harley 1527, fol. 34v) (Williams)

112. Top of the Noah window, Bay 64 (Williams)

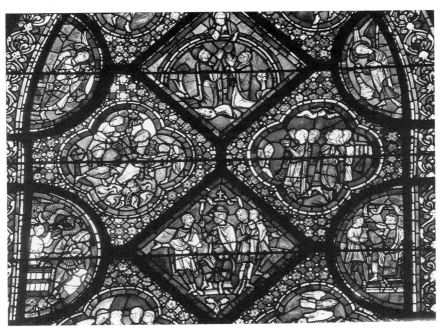

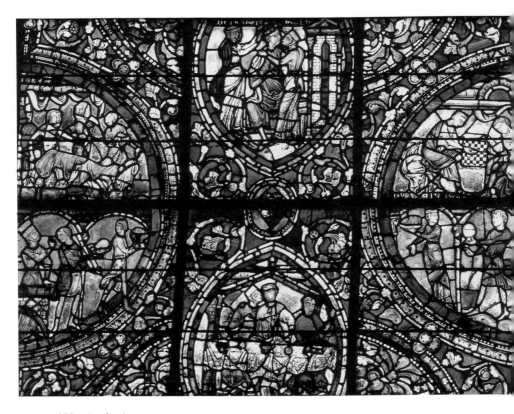

113. Prodigal window, registers 3 and 4 (panels 7–12), Bay 58 (Williams)

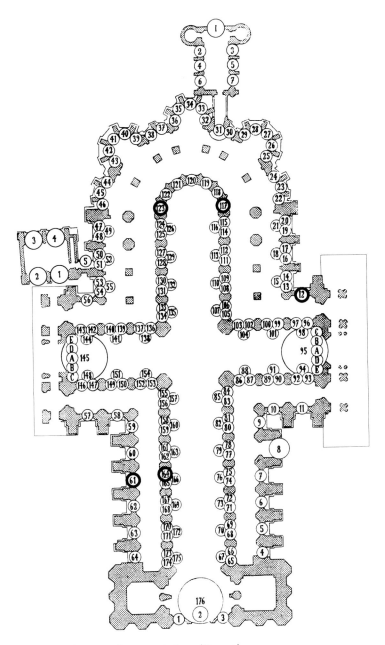

114. Location of money-changer windows (Sinram)

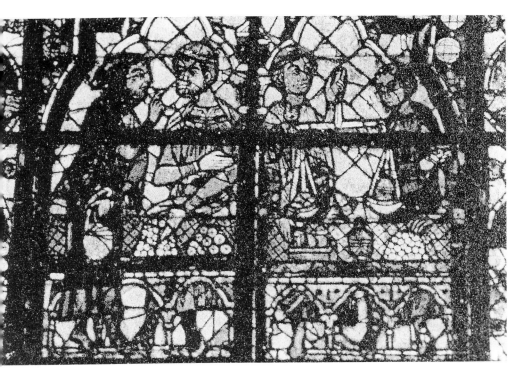

117. Changers detail, window of St. Peter, Bay 123 (Williams)

115. (*far left*) Changers, St. Peter and Christ, window of St. Peter, Bay 123
116. (*near left*) Upper registers, window of St. Peter, Bay 123

118. Changers, Zacharias and Angel,
window of St. John the Baptist, Bay 117

119. Upper registers, window of
St. John the Baptist, Bay 117

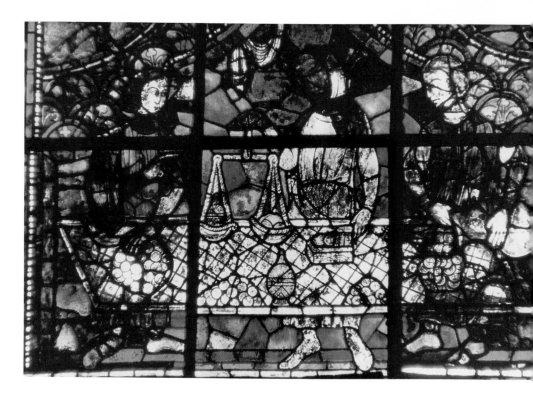

120. Changers detail, window of St. John the Baptist, Bay 117

121. Chart of window of Joseph, Bay 61 (Williams)

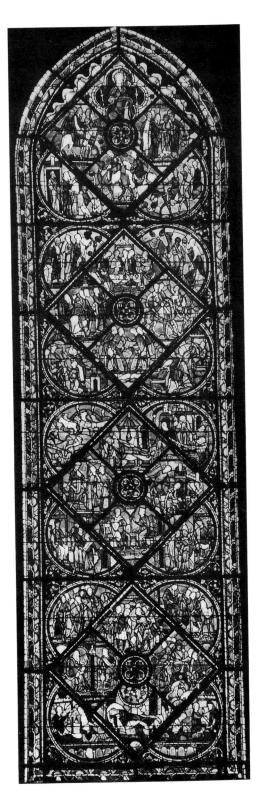

122. Overall window of Joseph, Bay 61 (Fiévet)

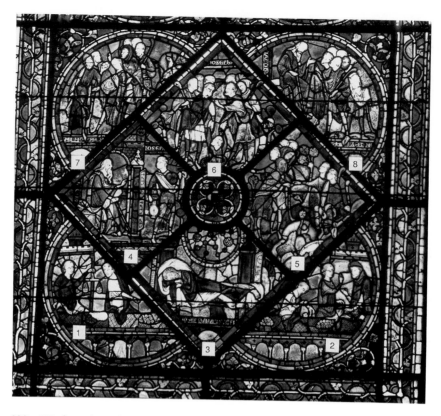

123. Window of Joseph the Patriarch, Bay 61, bottom portion (Williams)

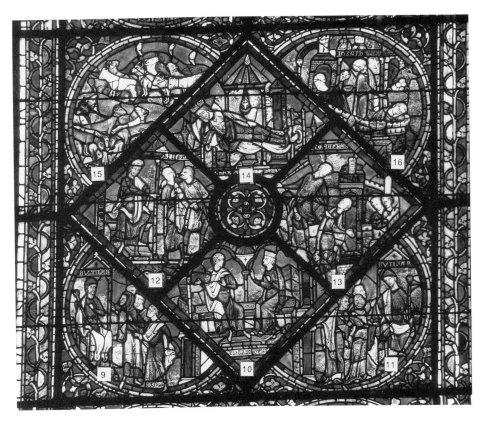

124. Window of Joseph, Bay 61, middle portion (Williams)

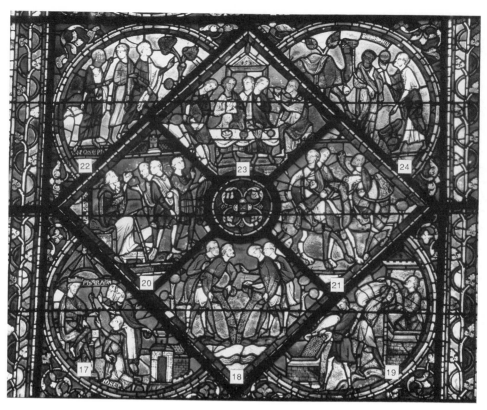

125. Window of Joseph, upper middle portion (Williams)

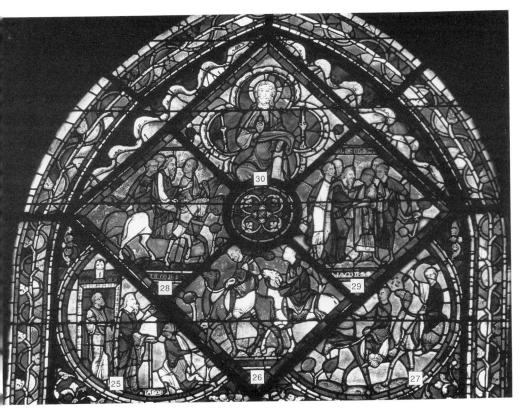

126. Window of Joseph, top portion (Williams)

127. Left changer Scene, window of Joseph, Bay 61 (Arch. Phot. Paris/SPADEM)

128. Right changer Scene, window of Joseph, Bay 61 (Arch. Phot. Paris/SPADEM)

129. Detail, right changer scene, Bay 61

130. Early painting of right changer scene, Bay 61

131. Window of an Apostle, Bay 164

132. Changers, window of an Apostle, Bay 164
(Williams)

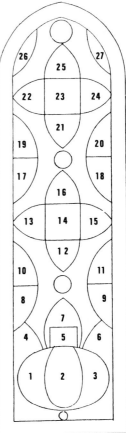

133. Chart of St. Blaise window, Bay 12 (Williams)

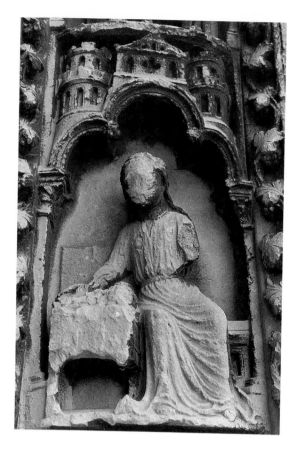

134. Personification of greed, north porch pillar (Williams)

135. Drawings of the coins of Chartres (Lépinois, 1854)

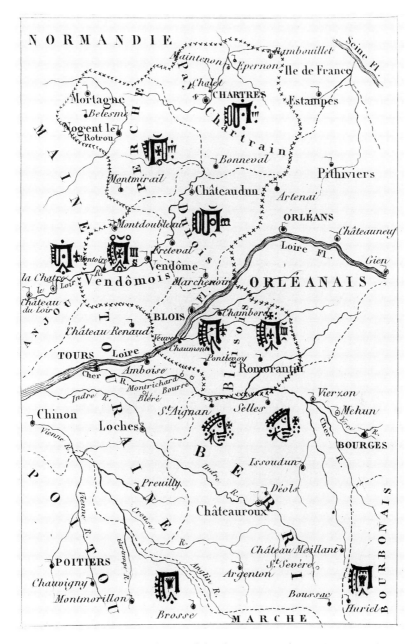

136. Map of the distribution of coins of the chartrain type (*Revue Numismatique,* vol. 9, 1844, plate XIII)

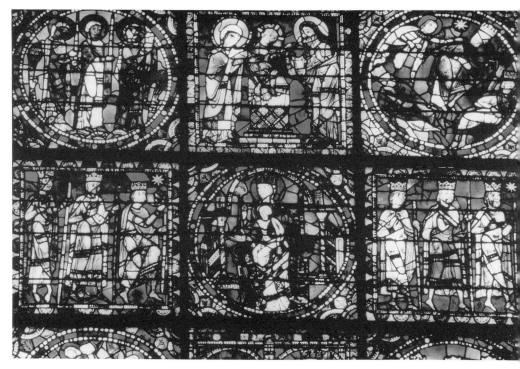

137. Life of Christ window, Magi presenting Coins to the Virgin, west facade, twelfth century (Williams)

138. Adoration of the Magi,
Bay 105

139. Early thirteenth-century pilgrim's token of Chartres (SAELM 6, 1876)

140. Thirteenth-century pilgrim's token of Chartres (SAELM 6, 1876)

141. Nineteenth-century arms of the town of Chartres (Lecocq, 1860)

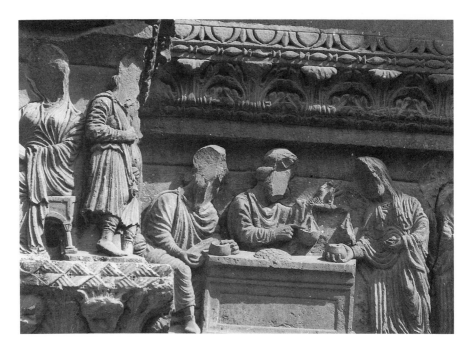

142. The three Marys purchasing spices, Saint-Gilles-du-Gard (Zodiaque)

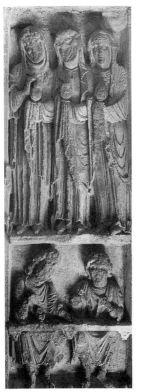

143. The three Marys purchasing spices, Saint-Trophîme, Arles (Zodiaque)

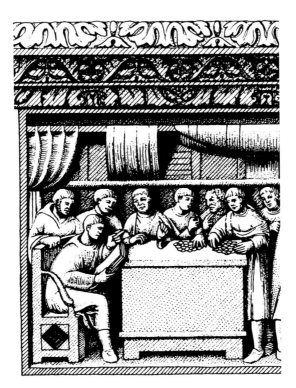

144. Drawing of money-counting on the Igel Monument (Rheinisches Landes-
museum, Trier)

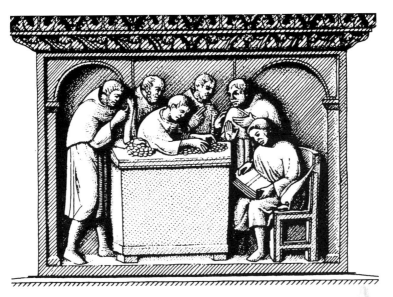

145. Drawing of money-counting on the Igel Monument (Rheinisches Landes-
museum, Trier)

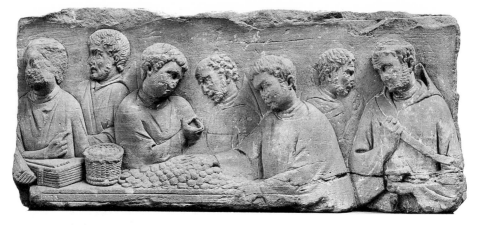

146. Relief of money-counting, Trier (Rheinisches Landesmuseum, Trier)

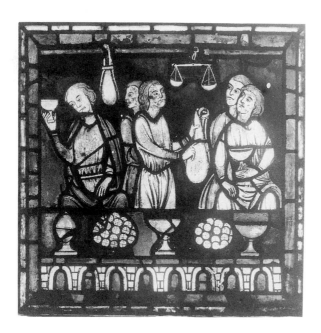

147. The Life of the Virgin window at Le Mans: the money-changers scene, ca. 1235 (Arch. Phot. Paris/SPADEM)

148. St. Anne carrying silver
coins to the temple, Life of the
Virgin window, Le Mans, ca.
1235

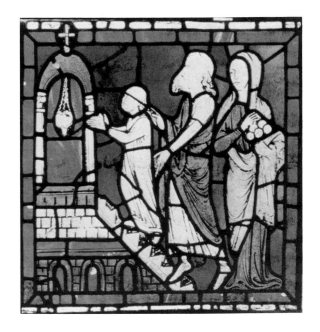

149. The Virgin replenishes a
monastic granary with golden
wheat, Miracles of the Virgin
window, Le Mans, ca. 1235

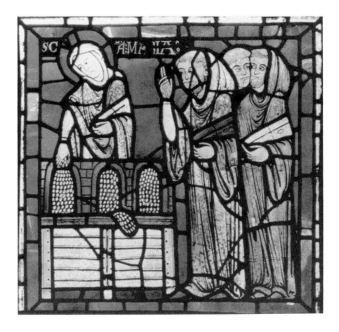

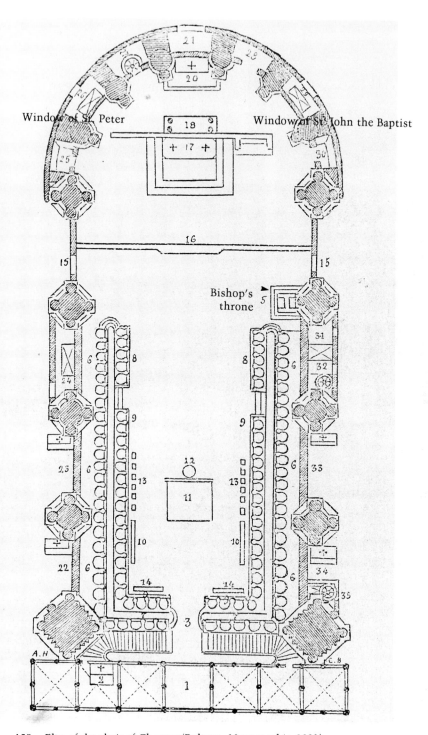

Window of St. Peter Window of St. John the Baptist

Bishop's
throne

150. Plan of the choir of Chartres (Bulteau, *Monographie*, 1892)

151. (*right*) View of Chartres Cathedral over the town (Zodiaque)

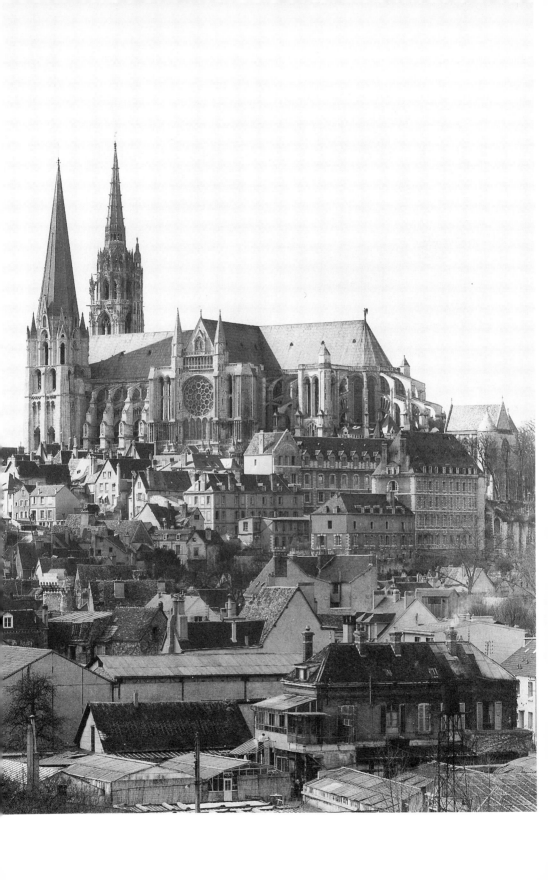